Robert Indiana

Figures
of
Speech

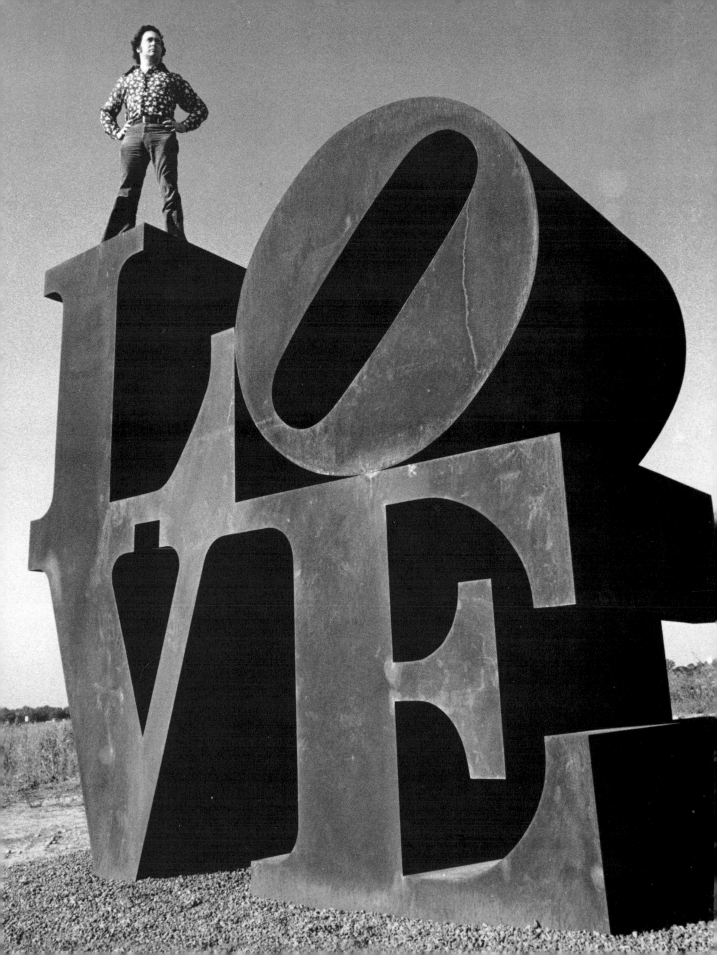

Robert Indiana

Figures of Speech

Susan Elizabeth Ryan

Yale University Press
New Haven and London

FRONTISPIECE
Robert Indiana with 12-foot *LOVE*, 1970
(artist's collection; photo by Tom Rummler).

For George Leonard Hersey

Designed by Daphne Geismar.
Set in Berthold Bodoni by Amy L. Storm.
Printed in China through World Print

Library of Congress Cataloging-in-Publication Data
Ryan, Susan Elizabeth.
Robert Indiana: figures of speech / Susan Elizabeth Ryan.
 p. cm.
Includes bibliographical references and index.
ISBN 0-300-07957-5 (cloth: alk. paper)
1. Indiana, Robert, 1928– – Criticism and interpretation.
I. Indiana, Robert, 1928– . II. Title.
ND237.I47R93 2000
709'.2 – dc21
99-37076

A catalogue record for this book is available from
the British Library.

The paper in this book meets the guidelines for
permanence and durability of the Committee
on Production Guidelines for Book Longevity of
the Council on Library Resources.

10 9 8 7 6 5 4 3 2 1

Contents

Acknowledgments

This book owes a debt of gratitude to its subject, Robert Indiana. Although the artist and I have not always agreed regarding the interpretation or relative importance of this work or that fact, discussions with him have always been challenging and rewarding. I thank him for opening his massive archives to me, even at times when there was much else to command his attention.

Much of the final research and writing was done with the support of a summer research grant from the Office of Research and Economic Development at Louisiana State University. In addition, special grants from the Office of the Vice Chancellor for Research and Graduate Studies and from the College of Design provided help with the costs of photography and permissions. The Tobin Foundation generously provided additional funds toward the costs of color reproductions.

The book would not have taken shape without the criticisms and really inspirational support of George Hersey, who read both the manuscript and the dissertation that preceded it, and who appreciates the changes that this project has undergone. Encouragement is every bit as important as more tangible forms of assistance. It expands the capabilities and strengthens the vision of a struggling writer. Professor Hersey knows this.

Diane Kirkpatrick, who directed my Ph.D. dissertation on Robert Indiana at the University of Michigan, made innumerable comments and corrections that carried over to this publication.

I have also benefited from the insights of Roger Conover; Edna Keyes; my colleagues at LSU, Panthea Reid, and Mark and Susan Zucker; and Judy Metro and Dan Heaton at Yale University Press. I was repeatedly buoyed up during my research by the enthusiasm and spirit of the late Alma deC. McArdle. A scholar known to the publisher but not to me also provided many helpful comments on the manuscript. People who granted me interviews or who otherwise made materials available to me

include Larry Aldrich, Arthur C. Carr, Robert Creeley, Aprile Gallant, Marian Goodman, William Katz, Vitaly Komar and Alexander Melamid, Agnes Martin, Pat Nick, Robert Tobin, Simon and Gilly Salama-Caro, Paul Taylor, and Jack Youngerman. Institutions that have helped in this regard include the Oral History Office of Columbia University and Columbia's rare book and manuscript collection; the Archives of American Art, Smithsonian Institution; the Menil Collection; and the Painting Department of the Museum of Modern Art. People who helped in various important ways were LSU College of Design Dean Christos Saccopoulos, LSU School of Art Director Michael Daugherty, LSU Vice Chancellor Lynn Jelinski, and Dr. Peter Hunt. I owe a special debt to Rosalie Benitez for assistance in preparing the manuscript, and to Tad Beck, Darren Clarke, and Mark Kleiner for photography. Finally, thanks to Paul Charlo for making this task a little sweeter.

A Note on the Illustrations

All works of art are by Robert Clark/Indiana unless otherwise stated. Media abbreviations are: o/c = oil on canvas; o/l = oil on linen; a/c = acrylic on canvas; a/l = acrylic on linen; w/c = watercolor. For items credited to the artist's collection, photos are provided courtesy of Robert Indiana, Vinalhaven, Maine, and photographed by the author unless otherwise stated.

Introduction

In 1970 Lippincott, Inc., a fine-art metal fabricator of North Haven, Connecticut, completed a twelve-foot-high Cor-Ten steel sculpture of the word *love* in capital letters, designed by Robert Indiana. This monumental *LOVE*, destined for the Indianapolis Museum of Art, originated as part of a series of the artist's portrayals of that word. *LOVE*s first appeared as paintings and small sculptures by Indiana in 1966 and 1967, then proliferated to include not only more of the artist's renditions but countless imitations and rip-off versions as well. By a rainy 29 November 1971, when the steel *LOVE* was installed for a six-month display in Central Park (Indianapolis's "Christmas Present to New York"), the artist claimed that the image was "the century's most plagiarized work of art."[1]

The statement would be difficult to prove, but has a legitimate claim to truth. Versions of the two-letters-over-two motif have appeared on paperweights, postage stamps, and wallpaper – in every medium from solid gold to solid chocolate. It is an internationally recognized icon that still circulates in new versions today. Almost a universal signifier, it has become a culturally owned image that no longer signifies its author. What accounts for *LOVE*'s longevity and multilevel appeal? And how did artistic authorship become emptied, rather than emphasized, in the process?

The answers to these questions involve issues that do not originate with *LOVE* but rather span Indiana's mature oeuvre of the sixties, works that combine short and highly charged words in richly hued and patterned, but essentially formalist, compositions. In an era that wished to keep words and visual elements distinct, differentiating between conceptual content on the one hand and pure optical sensation on the other, Indiana mixed these elements and in doing so created critical confusion and sometimes critical disdain. The snappy appearance of his canvases that contained words like EAT, DIE, TILT, and TAKE ALL seemed to place Indiana within the trend toward clean-cut commercial realism known as Pop

art. Initially that label bore the glamour of the avant-garde, for, like all avant-garde movements, its imagery was perceived as difficult to understand and certainly subversive of the previously established movement (abstract expressionism), both culturally and politically. As Max Kozloff wrote in an influential essay, "With Oldenburg, Lichtenstein, and Rosenquist, not to speak of Robert Indiana, the spectator's nose is practically rubbed into the whole pointless cajolery of our hardsell, sign dominated culture. . . . The probability of discovering their overall attitude to American experience is obstructed by their speaking farcically in tongues, as if, somehow, we were the witnesses of a demonic Pentecost of hipsters."[2] Pop was a sensation that was hardly thwarted by the negative reviews or by the intriguing, highly publicized debates as to whether it in fact was, or could ever be, "art." Indiana was ranked with artists like Roy Lichtenstein and Andy Warhol and treated in all the Pop art surveys that appeared during the sixties, and Indiana in turn embraced the trend and served as its spokesman. But for him the Pop epithet was a poor fit and evolved into an unshakable archaism. Unlike the other Pop artists, who seemed to gain legitimacy as cultural ironists or proto-postmodernists over the years, by the mid-seventies, as the "love generation" began to age, *LOVE* became a cliché, and Indiana endured the widespread disfavor reserved for relics of the sixties. The impression among some members of the art world was that he had ridden the crest of a trend past its time. More than any of his colleagues, Indiana's reputation has suffered from this periodizing and trivializing viewpoint, one that utterly misses the more fundamental issues animating his work, like its engagement with literature and poetry on the one hand, and with the popular rhetoric of the American dream on the other.[3]

The Pop art rubric has dictated the interpretive context for nearly all treatments of Robert Indiana by mainstream historians of mid-twentieth-century art, such as those by Sam Hunter, Irving Sandler, and Jonathan Fineberg. The last, the most recent survey text for contemporary art, barely even mentions Indiana.[4] Neglect of this artist extends to major museum shows, beginning with the Metropolitan Museum's "American Painting in the Twentieth Century" (1965), curated by Henry Geldzahler, and including the mammoth "Individuals: A Selected History of Contemporary Art, 1945-86" (1986) at the Museum of Contemporary Art, Los Angeles, and Kirk Varnadoe's influential "High and Low: Modern Art and Popular Culture" at the Museum of Modern Art in 1992. Indiana was excluded from all of these. Even in 1991, with the publication of Marco Livingstone's expansive *Pop Art: A Continuing History* (an outgrowth of a major exhibition at the Royal Academy of Arts in London), Indiana received only a few lines – briefer mention than any other artist even remotely connected with the original movement in the sixties. The situation is marginally better in the more narrowly defined exhibition "Hand-Painted Pop: American Art in Transition, 1955-62" (1993) at the Los Angeles Museum of Contemporary Art, in which several vintage Indiana canvases were hung but were barely

discussed in the catalog. Yet Indiana's work has continued to circulate in a wide range of exhibitions since the sixties. His sculpture has received a major retrospective at the Smithsonian Institution; his "Hartley Elegies" (paintings and prints of the eighties) have been exhibited and collected, especially in Europe; and he has received commissions from numerous institutions including the Metropolitan Museum of Art and the Pompidou Center in Paris. A major retrospective of his work was held at the Musée d'art moderne et d'art contemporain in Nice in 1998, and more major shows are scheduled in 2000. And the much maligned *LOVE* continues to reappear, as appropriation or reference, in works by new generations of artists.

Indiana's painting of the sixties, though lumped together with Pop art, actually does not hang well in its company. "Sign paintings," as they were sometimes called, his pieces refer to an entirely different order of reality from the commodity-oriented New Realism, to use an alternate designation for Pop art current in the sixties. Indiana's work requires a different mode of looking than does the satiny photographic realism of Rosenquist's canvases or the commodity and media graphics of Warhol. In the sixties and seventies many curators hung Indiana's work with canvases by formalists like Ellsworth Kelly, and indeed Indiana's surfaces are close to those of Kelly, who was painting mentor to the younger artist. Some critics recognized this orientation in Indiana's work. Lucy Lippard even called it "fundamentally nonobjective." At the same time, Richard Kostelanetz and Nicola and Elena Calas located Indiana's word-filled canvases alongside the rise of conceptual art, and, because of its high key color, Mario Amaya called Indiana's work "Poptical" – a combination of Pop and optical (Op) art.[5] Such waffling suggests that the criticism of the sixties, geared toward categorization and neologisms and insistent upon a linear succession of trends, could not successfully describe Indiana's paintings. But among the relevant literature there can be found persistent traces of a surprising, if sometimes repressed, mode of response.

After purchasing *The American Dream #1* for the Museum of Modern Art, Alfred H. Barr, Jr., called it "spellbinding" and wrote that he selected it "because I do not understand why I like it so much."[6] A perusal of the artist's reviews from the early and mid-sixties reveals the recurrence of words like *power* and *impact*; the works "emanate" and "radiate" but also "communicate," "insist," "enjoin," or "command" – all active verbs implying speech and a speaker. Collector Robert L. Tobin wrote of Indiana's work: "It is a phenomenon that a seemingly inanimate object generates an almost kinetic response. Sculpture does not exist in a simple static state; it moves. Paintings do not hang inert; they vibrate. The structural complexities are set in motion by the subtlest of harmonic contrasts and complements. . . . An environment is created out of the seemingly harmless arrangements of lines which we are taught to call letters or numbers, which we extend to phrases or messages. Lines now have meaning, overtones which plumb our depths, our emotions, recalled or rejected."[7] Amaya likewise found something "deep and troubling" in the paintings, that the

3

words in them "transmit a psychological and emotional jolt" and "gnaw into the sub-conscious."[8] Over and over they are described as presences. For Gene Swenson, looking at Indiana's paintings made him feel as if "the artist were masked, or hiding behind a scrim." Or again: "The surface of his work is like a scrim masking us from the play behind it. Sometimes we hear the voices, but usually it is only when we think we have forgotten that some half-sensed action returns to move us."[9] Swenson was a young critic from Kansas, Yale, and New York University. He wrote some of the most penetrating reviews of Indiana's work before dying tragically in an automobile crash in 1969, a loss that almost certainly affected the artist's subsequent career.

My study takes the position that these viewers' perceptions of Indiana's paint-ing bear closer investigation, and that the works may indeed engage us in a myste-rious, often aggressive, confrontation. Quite possibly, what some critics found to be fascinating or troubling aroused suspicion or resistance on the part of others, who may have been loath to venture onto psychological terrain during a period in which art discourse was geared to articulating formal qualities and philosophical or polit-ical statements. I hope here to rectify these oversights by examining meaning and enigma in Indiana's work. The method will not be to study his sixties paintings and sculpture via the common models of art-historical discourse for Pop art or art of the sixties. I shall not analyze relations between artworks and commodity culture or late capitalist economics; nor will I focus on questions like how artworks came to be formed through culturally determined dialogues with preceding abstract expres-sionism, or with queer art, or with some other subcultural group in New York, though such matters do enter the discussion at various points. I hope rather to build an analysis from the ground up by identifying the essential components of Indiana's work and paying close attention to how these components interact with each other and function (and seem in the past to have functioned) as dynamic signals for his viewers. Ultimately, I hope that this investigation into the power of Indiana's paint-ing will help explain the longevity of *LOVE* as a signifier in our cultural field.

Several central issues concerning the subject matter and the meaning of con-tent of the works emerged from my research, and these are recurrent themes throughout this book. First among these is that Indiana's work, particularly the paint-ings, represent storytelling, or, perhaps more accurately, contain signifiers of autobi-ographical stories told first by the artist to himself and then to his reader/viewers over the years, in some cases over and over again. The narratives deal with childhood memories and ground the paintings' words, numbers, symbols, and even colors, within allegories of triumph and timelessness or failure and loss.

Second, the stories about his life and works, together with the visual evidence in the works themselves, point to the artist's long-held concern with origins and influences. Because Robert Clark (the artist's name when he grew up in Indiana) was an adopted child, an interest in the subject of parents might be expected. But this alone does not explain the conflicted and complicated references to mothers

and fathers that suffuse his work. Most of the time these terms refer to Carmen and Earl Clark, the artist's adoptive parents. But in the works, the concepts "mother" and "father" expand beyond particular parents, known or unknown, and drift onto other key figures of precursors and mentors and what might be called personal heroes: earlier artists and poets, teachers, and older artists or professional people with whom he came in contact during his development. Ultimately, "mother and father" names the determining forces of desire and limitation in Indiana's art.

Third, accompanying his references to strong parents and precursors is his deep personal involvement with myths of heroes' journeys and destinies. Just as he named himself for his home state, many of his works commemorate personally significant places there, elaborated in stories of his childhood, like his fascination with the antihero John Dillinger, whose funeral he had witnessed in Mooresville, Indiana. Imagery of highways and traveling (the "sign paintings") link mother and father, who were avid motorists, with the herm figure, a classical roadmark that Indiana used as a model for his sculpture, or with the wanderings of Ahab or Palinurus, the Trojan pilot of the *Aeneid* in Cyril Connolly's *The Unquiet Grave*, references to which are woven into Indiana's paintings. Heroes and travelers converge in the American dream myth that formulates a progressive course of life expectations and serves as a leitmotif throughout his work. As important as the myths themselves is the idea of their reversal: the journey that never ends, the dream that fails. Finally, the idea of destiny or fate – that is, his own destiny to become an artist (artist-hero) – shapes his life stories in ways that fit apocryphal myths and legends of artists of the past.

Fourth, the works, particularly the paintings, contain structures of verbal-visual relations that can only be described as figurative language. Either verbal or visual meaning alone within the works is incomplete, but the two are rarely conjoined in obvious ways. Rather, the paintings manipulate us to compact the two systems as reader/viewers. Often artworks that contain words present either the image, or the word(s), as the dominant constituent, according to the poet and art critic Richard Kostelanetz, an acquaintance of Indiana's who dealt with the subject of word/image collaboration in art and concrete poetry in several articles and catalog essays in the sixties and seventies.[10] Kostelanetz calls these collaborations worded images, or word-images. But when a word or words so completely dominates the visual field that there is little extra observable incident, either verbal or visual, Kostelanetz uses the term *imaged words*. These challenge the difference between reading and seeing, and sometimes between hearing and seeing. Many of Indiana's sculptures and paintings fall into the category of worded images, in which two symbol systems combine to create meaning more or less consecutively, as we receive verbal and visual clues in sequences of seeing-reading. Indiana's *LOVE*, on the other hand, provides Kostelanetz with his best example of an imaged word, in which the visual and verbal are virtually coextensive and we perceive them almost simultaneously. I have followed

Kostelanetz's terminology in my own discussions. In either case, in Indiana's work, word and image systems function in a way that is similar to concrete poetry – not as a revolutionary avant-garde expression like Dada or Beat shaped poems, but in a way that acknowledges its precursors and positions itself within a strong tradition of American postromantic poetry.

Fifth, and complementary to Indiana's involvement with parents and precursors, is his concern for self-identity as a power that can transform time and circumstances. The works' orderly configurations contain references to self-portraiture and the look into the mirror, evoking what Lacan has identified as "see[ing] myself seeing myself," whereas the position of the seer slips between the artist and the viewer of the painting. It is precisely at these moments in the work that we do not see – do not see the evidence of individuality (no brushstrokes or expressive contours), do not see the image, or get the point. Not seeing, we default to reading and read both words and shapes that expand the question of identity (by encountering other voices), or confound it in endless chains or unsolvable puzzles. At his best, in works like *Year of Meteors*, *The Demuth American Dream #5*, or *USA 666*, Indiana has honed and configured his elements to draw us in or fascinate us with the array, leading us through layers of signifiers, all of which substitute for what cannot be depicted or said, circuiting the Sublime unsignifiable.

This book has a structure that resembles the traditional monograph – it treats the work of an artist within the framework of his life, work, and encounters with artistic, cultural, and political circumstances. But I have tried to avoid the pitfalls of externalized, linear biography: most of the information about the artist's life is drawn from Robert Indiana's own narratives. His telling of these narratives is closely related to the production of the artworks themselves and constitutes a secondary creative practice. It is irrelevant whether or not the stories deliver objectively "true" information or describe "real" events. They are true as stories.

Because Indiana's works are distinguished by their use of words, I have paid attention to the artist's words, both in the paintings and about them. Fred Orton, in a study of an artist bearing some stylistic relations to Indiana, makes a distinction between Jasper Johns and "Jasper Johns" – between the real person "who is known to no one but himself," and "the imaginary or symbolic character who stands in a causal relation with the works."[11] Orton writes that he has never had any reason to meet or interrogate Jasper Johns, but he does utilize recorded interviews and statements of others who have interrogated that artist, presumably not knowing they were speaking to "Jasper Johns." Unlike Orton, I have interviewed the subject of this study over the course of many years as background for my project. Whether to call him Robert Indiana or "Robert Indiana" is moot because his real name (still his legal name) is Robert Clark; but the distinction is also unnecessary because in my own interviews with him, as in his statements and interviews published elsewhere, the figure who stands in a causal relationship to his works is also the figure who

grounds them in stories of his life, and it matters little whether you read about them or hear them in the artist's own voice, booming within the dark and towering Star of Hope, his Victorian home in Maine. The manner is the same and changes little with the context, as the stories have changed little over the years. They may not give us the inner core of the man, if we can speak of such a thing, but they demonstrate an artist-narrator who is as seamlessly and consistently structured as his work, and who projects, both in presence and in print, the same sense of being masked or behind a scrim that has been associated with his paintings.

Indiana's autobiographical storytelling and his visual art are his parallel systems of creative production. In the latter, though, the terms have undergone bilevel coding into visual and verbal signifiers. That the works are more than fragments of stories or incomprehensible clusters of signs and symbols – that they are compelling compositions that seek to triumph over the limits of telling – is the aspect of his work that I have tried to bring to light. Art historians have long been suspicious of the usefulness of artists' statements. Perhaps the following can offer a model of how we might begin to listen to them again.

7

1

The Making of Autobiography (Robert Clark)

Robert Indiana has often called his work autobiographical. If this is his intention, and if intention, in the words of Michael Baxandall, is "the forward-leaning look of things," then it must be said that Indiana's paintings do not immediately *look* autobiographical.[1] They are not figurative – they do not depict any scenes centered on a man who might be the artist, and they are not gestural – they do not record his art making. In saying that his work is autobiographical, then, Indiana does not so much articulate an intention as convey a designation. The designation is a speech act, because in this case (the artist speaking about his work), saying it makes it so. He also makes it so not just by saying and designating but also by documenting. In the course of his career, Indiana has furnished autobiographical texts – or texts that he designates as autobiographical – that exactly reinforce the autobiographical claims for his art. These texts do not take the form of a single, coherent volume but rather constitute an irregular body of narrative fragments – stories and anecdotes – that the artist has written down himself or told to interviewers. The stories serve as texts and contexts for his mature painting style and for specific works of art. A system is created that ought to bind the artist to the work: artist/artwork/text. But Indiana's system is hardly a closed one. His texts raise more questions than they answer, and I shall address them in more depth later on. But they can provide a convenient, even traditional point of departure, for artists' monographs often begin with biography. Only note that the "biography" that follows here is constructed from fragments produced by the artist himself.

Storytelling is not the only way in which this artist has reified his past. He is also an avid record keeper and showed an early disposition toward this trait, when as a child he began to preserve his own scrapbooks, drawings, and writings. Collections are a way of holding on to the events and accompanying emotions of the past; they occasion recollections. Recollection and memory can be ritualized as commemoration,

externalized and ritualized remembrance. *Commemoration* is a word that Indiana often uses in regard to his work, and it describes the manner in which he connects himself with people, places, and events in his past.

Collecting and Recollecting

Indiana's fascination with the past is evident to anyone who has set foot in the old Odd Fellows' hall, the Star of Hope, that is his home and studio on Vinalhaven Island today (fig. 1.1). Constructed around 1880 on a base of two preexisting storefront buildings, it dominates the harbor village on this small island off the Maine coast. "On my way to catch the ferry, I saw the old lodge towering over Main Street. I was struck by its desolate yet majestic appearance – right out of an Edward Hopper painting," so the artist later described his first impression of the place. Indiana moved the entire contents of his New York loft and studio by truck and ferry to the island in 1978. What he once said of his Bowery address now applies to the Star of Hope: "Everything that ever happened to me – with few exceptions – is right here. . . . Over a period of time things have accumulated, and I'm a keeper."[2]

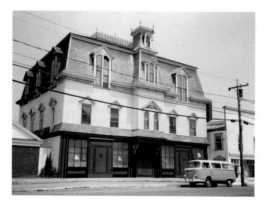

1.1 Star of Hope Lodge, Robert Indiana's home
and studio on Vinalhaven Island, Maine.

Things that he found in the lodge were also kept: old Odd Fellows' ceremonial hats and sabers, officers' photos and certificates, and the four baldachinos at the points of the compass in the ritual hall. So the building has remained an archive of itself while incorporating the archive of Indiana, receiving his collections: his own art and that of his friends; extensive photograph files; library of books, files, and records; and vast collection of memorabilia. The Star of Hope demonstrates the art-historical institution of the studio/home-as-archive. Its precedents include John Soane's museum and the studio homes of turn-of-the-century artists like Jean-Jacques Henner, Gustave Moreau, and Auguste Rodin, who arranged their domiciles as monographic museums. In such places, the art equals the life and thus the

body of the artist. Indiana is a supreme example of this retrospective consciousness that pairs collecting and recollecting – the art/life/body – that produces autobiographical subtexts for so much twentieth-century art. Indiana says that he "became his own curator" when he was a child, preserving the stories of his life. "My parents were never really interested, and everything that I kept, I kept myself."[3]

But he began to tell these stories only in the sixties, and he has told only certain stories about his life. Exactly what autobiographical events and ideas has he selected from the tumult of experience? And how and why are the narratives encoded in his art? The first question will be the task of this chapter; the second, that of the rest of the book. Do the stories, told as stories, precede the works of art that commemorate them, or vice versa? As we shall see, the situation is complex and often circular, as the stories give rise to paintings that then point to other stories, which in turn point to other paintings, and at any point in the circuit, or more than once, we are led back to the original stories again.

I have divided the presentation of Indiana's early life into two stages. Stage one is childhood through age eighteen, ending with Robert Clark's graduation from high school. The stories of that period furnish the greatest share of words and themes in his principal paintings of the sixties. His childhood corresponded to the years of the Great Depression and the Second World War, the period on which all the Pop artists have dwelt in their nostalgic view of a simpler, more pastoral mass-cult America.[4] Pop art America is generally not postwar America but rather a land of small towns, radio, *Little Orphan Annie*, and Spam. But for Indiana, unlike the others, it is his own childhood – not just American culture during that era – that is his subject. Indiana's stories and the art based on them relate to the strong childhood focus of literary autobiography since Rousseau and the romantic period.

Stage two is entirely different. It begins with Robert Clark's stint in the Army Air Corps, then encompasses his art education in Chicago, his European travels, and his first years in New York, when he changed his name. Compared with stage one, fewer events from stage two are signified in his paintings of the sixties.

My account of Indiana's early life for the most part retells the artist's own stories, but I have arranged them more or less in chronological order. I have saved my own commentary until the end of each section. Major sources for the stories include published and unpublished interviews of the 1960s and 1970s. Indiana's life stories also appear in various artist's statements that he wrote during the sixties, most of which are reprinted here as Appendix 2, and in his "Autochronology," an extensive artist's chronology written in the third person for the catalog of his 1968 retrospective at the University of Pennsylvania and republished and updated intermittently since then. The stories from these sources have reappeared from one interview to the next, and again in miscellaneous articles published in art magazines over the years. Only in rare instances has a story emerged in my own interviews with the artist that I have not found elsewhere. These are so noted.[5]

11

The Childhood of the Artist

Robert Clark was born 13 September 1928 in New Castle, Indiana, "a state more considered for its writers than its artists," according to the first entry in his "Autochronology." He says he remained in New Castle only about a half an hour, but he stresses that he shared this birthplace with *Raintree County* author Ross Lockridge, Jr. The comment exemplifies the connections the artist makes, throughout his writings and art, between himself and American authors.

Indiana has much to say about the people he knew as his parents (he does not mention his biological ones). His father, Earl Clark, of English descent, was born in Indiana, but other branches of his family lived in Alabama and Texas, and Robert Indiana reports visiting them as a young child. His paternal grandfather, Fred Clark, was a colorful frontiersman and an engineer on the Pennsylvania Railroad (referenced in Indiana's painting *Highball on the Redball Manifest*, 1963; see fig. 5.7), who later turned to farming. Robert Clark heard his paternal grandmother talk about setting type for a little Kansas newspaper shortly after the Civil War – the sort of fact that he repeated later on as an anecdotal underpinning for his own use of words in art. His mother's name was Carmen ("so named because it was her father's favorite opera"), and her family – Watters – was of German descent.

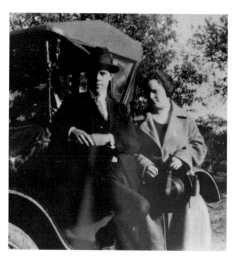

1.2 Earl and Carmen Clark with a family auto, ca. 1930. Artist's collection.

1.3 *Mother and Father*, ca. 1952. Lithograph, 11¹/₂ x 8¹/₄". Artist's collection.

Earl Clark made his career in the petroleum industry, and he and Carmen had at least one car even in hard times. Many of Robert Clark's early memories pertain to automobiles and driving, when the family explored the Midwest's new roads and highways that were built in the thirties and forties. "With roadmap in hand they devoured the American landscape, . . . trip after trip, Sunday drive after Sunday drive, evening spin after evening spin, for . . . 21 gasoline-gorging years" ("Mother and Father," Appendix 2).

In Indiana's telling of his childhood, mobility is always pitted against stability, and cars and houses are the principal themes. Earl's first employer that the artist remembers was James Henry Trimble, owner of a local company called Western Oil. Trimble's son occupied the coach house of Ladywood, one of the most imposing mansions in Indianapolis, originally built by the Fletcher family, who were bankers around the time of the First World War. Young Clark rode his bike through the grounds and fantasized about it, and it is prominent among the impressive recollections of his childhood. As a child, he saw the coach house burn down, and it became his "Manderley" – the name of the estate that burned down in Daphne du Maurier's novel *Rebecca*, translated into an Oscar-winning film by Alfred Hitchcock (1940), which Robert Clark probably saw when he was twelve.[6] Later in art school he made a wood engraving of the coach house conflagration. These mansion memories from childhood figure among the personal references for the later painting *The Rebecca* (see fig. 4.37).

Memories of Earl and Carmen as parental figures loom large in Clark/Indiana's art, and he characterized them in the mid-sixties statement "Mother and Father," written to accompany their iconic portraits (see fig. 5.9 and Appendix 2). In the painting they are posed with the family car, which, as he testifies in his "Autochronology," was "always the centerpiece of his family's life, was more stable than Home itself."[7] But Western Oil failed during the Depression. Earl lost his executive position and took various jobs, managing a small gas station, even pumping gas for a while, before finding another administrative post, this time with Phillips 66. The Clarks lost the house they were buying and were forced to rent. They were repeatedly uprooted, moving from home to home, apparently because Carmen, after giving up her own house, could not settle into the ones they could afford as tenants. Indiana says that he had to move more than twenty-one times before he was seventeen, mostly around the environs of Indianapolis. He recalls that Carmen was obsessed with houses and would take him on long drives to look at empty ones she had found. Among his collected juvenilia there is a scrapbook that he says he compiled about the time he began school, with the help of a family member, probably Carmen. Drawn from cut-up magazines and farm catalogs, the dominant images are of happy moms and dads and well-appointed single-family dwellings. One even shows an infant in a crib at the center of an elaborate, symmetrical arrangement of exemplary living rooms, dinettes, and gardens, as if to depict a level of order and dignity that Robert Clark's own world apparently lacked (fig. 1.4).

1.4 Collage page from childhood scrapbook.
Artist's collection (photo by Tad Beck).

As an adult of forty, in 1968, Indiana returned to Indianapolis and pho-
tographed every one of his former homes that he was able to locate, as well as the
sites where others had been demolished or replaced. The surviving homes appear
to have been mostly detached one-and-a-half-story bungalows built in the twenties
and thirties, the pre-Levittown version of the suburban dream (fig. 1.5). His trip pro-
duced an album, "Twenty-One Houses," which at one time was planned as a book,
with John Updike offering to provide a brief text.[8]

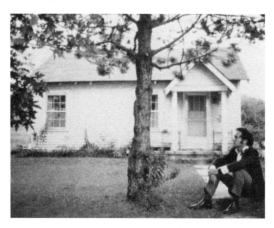

1.5 Robert Clark's childhood home, 1937-40: 1902
North Brazil, Route 11, Indianapolis, 1966.
Artist's collection (photo by William Katz).

Perhaps his experiences sensitized him to the plight of the misfit or under-dog. Most of the homes he lived in were located in lower-income areas, and one was across the street from the International Harvester plant in Indianapolis. Smoke from that plant apparently caused a pretuberculin condition in young Clark, age six, which kept him from starting school until the following year, and so the family moved to more rural Mooresville. There he witnessed a spectacular event: the return of the body of "public enemy number one" John Dillinger to his hometown. "He was the man whose name was always at the top of the newspaper and he was the man that everyone was talking about."[9] In Mooresville, most of the town turned out for what became a local celebration.

About that time Indiana determined to become an artist. He says that it was at age six and that the idea was discouraged by his parents. But an often-told story regards his first-grade teacher in Mooresville, Ruth Coffman (Haase): she kept drawings he did when he was a student (about age seven), including a copy of a Currier and Ives skating scene, saying that he would be a famous artist one day. When the artist returned to Indianapolis in 1971, he looked up his former teacher, who produced the drawings she had kept nearly thirty-five years. In some versions of these stories, however, his teacher is recalled not as Coffman but as Coffin – an odd slip, given that he has also said that the only other possible occupation he considered as a child was as an undertaker.[10] These remarks provide a context for the recurrence of the theme of death throughout his work as both a student and Pop artist.

Indiana says that he had almost no exposure to art as a child – his parents knew little about it and never went to museums. There was only an occasional fair where local art was shown. He encountered a small artist's colony in Brown County, a scenic district in the south-central part of Indiana, where a cousin named McDonald ran a general store in the tiny town of Bean Blossom. The area is known regionally as the subject of picturesque autumn and winter scene paintings. But Indiana says he thought of the art colonists as "primarily hacks."[11]

His childhood drawings were inspired more by magazine illustrations in periodicals like the *Farmer's Home Companion* than by local landscapists. Indiana says that he clearly recalls the day (in November 1936) his father brought home the first issue of *Life*. The young artist was fascinated by the cover photograph of Fort Peck Dam in Montana by Margaret Bourke-White, a crisp, precisionist, industrial image. In subsequent issues he would have seen illustrated articles on John Steuart Curry and the Surrealist exhibition at the Museum of Modern Art, as well as an article on the life of Christ illustrated with Renaissance paintings. And he no doubt saw a full-color reproduction of Reginald Marsh's painting *The Death of Dillinger*, which had been commissioned for *Life*'s Modern History Series. Young Clark collected every issue until his mother threw them away, something he has called "a loss."[12]

Other strong and repeated childhood memories consist of images rather than true narratives. One of these was of driving around Indianapolis Circle, with its Soldiers

and Sailors Monument, at the very center of the city. "It is a very impressive center-piece. For years they had an ordinance that no building could be higher than the monument," he recalls, and he associates it with the orbs and circles in his later paintings.[13]

When Robert Clark was ten (1938) his family became embroiled in a scandal. His step-grandmother (on his mother's side: Carmen's father's second wife) was murdered by a daughter-in-law named Ruby Watters (Carmen's brother's wife), and Carmen, who applauded Ruby's act, attended the trial and became emotionally distraught. The case, which ended in an acquittal, disrupted the family: Earl and Carmen separated during the trial and divorced shortly after. The boy was sent to stay at the Martinsville farm of a paternal aunt and uncle, Wayne and Gertrude Parker, where he spent much of his time alone. There, perhaps compensating for his loss of immediate family, he was surrounded by animals. He had a Boston bulldog named Muggsy, cats, cows, and chickens, and he kept his own garden. Beginning again in the years in New York, he has since always kept dogs and cats and has maintained at least an indoor garden that furnished a few subjects for his art.

Often denied close friendships because of his shifting circumstances, young Clark threw himself into his schoolwork and excelled. After his parents' divorce he lived at first with his mother in small towns and attended rural schools like Lawrence Junior High where, in 1941, he won a countywide seventh-grade competition with an essay about a covered bridge. But he reports that as a child he was aware of the provincialism around him and yearned to learn about art.[14] In a way, his education had already begun. His mother supported herself and her son by working in small restaurants and roadside cafes offering "home cooking." Later, when Clark was in the service, his mother and stepfather, Foster Dickey, opened a small bakery in Columbus, Indiana. On a visit Clark painted the advertising on the glass windows – his first "sign painting," as he says in the later accounts ("EAT," Appendix 2).

In his childhood accounts Indiana coolly describes what must have been another wrenching experience after his parents divorced, when he decided to leave Carmen and join Earl. When he was ready for high school, Robert Clark arranged on his own initiative to attend Arsenal Tech in Indianapolis. The school had a reputation for excellence and breadth of offerings, a large landscaped campus, extracurricular activities, and extensive courses on art. In order to go he had to live within the city limits, so at age fourteen (1942) he left the rural town where his mother lived and moved in with his father and a new stepmother, Sylvia, and stepsister. Sylvia insisted that he never see his mother again. In 1944 Carmen moved back into Indianapolis to regain her son, who insisted on staying at Tech. While Robert Clark lived in his father's house, jealousies arose (his stepsister was dull while Robert was a model student), and his stepmother demanded that he earn his keep by working after-school jobs. So he rode his bike as a Western Union messenger (he remembers once delivering a wire to the Ritz Brothers) and worked as a

copyboy and dispatcher in the advertising department of the *Indianapolis Star* for a year, hoping in vain for a chance to do something in the newsroom.

He did work on his school newspaper, the *Arsenal Cannon*, and contributed stories and poetry, among them a detailed architectural description of the local library, poems like "October" (inspired by Carl Sandburg's "Fog") and a very Hoosier "Jim Riley's Dead," an encomium to James Whitcomb Riley complete with Robert Clark's own illustration of Riley's Lockerbie Street home in Indianapolis (Appendix 1).[15] That residence joined the long list of auspicious houses that recur in Clark's history. He was also interested in languages and classical civilization and took four years of Latin, producing a set of "medieval" manuscript illuminations (more examples of words-and-art) of the second chapter of the Gospel of Luke for the Latin Club, of which he was consul.

By his last two years nearly all his classes were in art. In one, taught by a watercolorist from Philadelphia named Sarah Bard, he learned about American artists like Winslow Homer, Edward Hopper, and John Marin. He also visited the Indianapolis Museum when it was the John Herron Museum, where he took figure drawing classes during his senior year at Tech. He familiarized himself with European art and modernism but was persistently drawn to American urban and industrial themes, as in the work of the Ash Can School, Charles Sheeler, and Charles Demuth. Young Clark took a kit of watercolors around the city of Indianapolis, painting railroad crossings and factory equipment under the influence of Precisionism. But by his own account, it was living "on the other side of the tracks" most of his life that encouraged his preoccupation with "gas works and railroad yards" and the like.[16]

Robert Clark graduated from Arsenal Tech in 1946, valedictorian, photography editor of his class yearbook, an officer of the honor society, and recipient of the school's Latin and James Whitcomb Riley medals, the latter for excellence in English. With a series of pastel drawings in the style of Reginald Marsh he won a national scholarship to the John Herron Art School. This he turned down in favor of the longer-range advantages of the G.I. Bill: for three years in the Army Air Corps (which became the U.S. Air Force during his term) he received five free years of higher education.

He told Richard Brown Baker that he prepared himself for entering the military by taking a solitary bus trip to Mammoth Cave in Kentucky, to "overcome fears and doubts." It may also have been about this time that his self-awareness as a homosexual was developing. But he viewed himself as a loner, so basic training in San Antonio was difficult – he became sick, then wound up separated from his group of Hoosiers and in a platoon of "noisy" and "rowdy" boys from Georgia. At technical training in Denver, he qualified for all programs, but there was a waiting list for his choice, photography. So he wound up taking and eventually teaching typing. At Hobbs, "a terrible, dust-bound lost base" in New Mexico, he created his own job by

starting a base newspaper. Later, stationed in Anchorage, Alaska, and with the help of a Colonel Densford, he developed that base's little *Sourdough Sentinel* to a full-size paper, doing most of the writing and all the layout and graphics himself.[17]

While in the service and en route to Alaska, Clark stopped in Los Angeles and for the last time saw his father, Earl (who died in Florida in 1965). During his last year of service, in 1949, Carmen, who had been living in a tiny two-room house in Columbus, became ill with cancer. Family members arranged emergency leave for Clark, who arrived at her bedside just in time to hear her last words, spoken with difficulty because the disease had affected her vocal chords: "Did you have something to *eat?*" It was "the last gasped word," he later said in his poem about Carmen's death and burial, "August Is Memory" (Appendix 1). The same year, his stepfather also died, and Clark arranged for auction of all their possessions, most of which had surrounded him in one house after another throughout his childhood. These events form a caesura separating his childhood from his art training and travels.

From Indiana's childhood accounts it appears that all – even the trivial and light-hearted stories – were motivated by an impulse to show that the events described predicted his adult concerns. His anecdotes about typography and sign painting, as well as his many experiences working on newspapers, direct us to the adult who defines himself by his word paintings. Missing in all the artist's stories is any sense of the wonder, playfulness, or aimless behavior that have informed much autobiography of childhood. Rather than being a qualitatively different set of experiences from those of adulthood, the events are subject to the artist's rigorous retrospective revision: Indiana the child is much the same as Indiana the adult. There is a determination in his earliest artmaking and his attitude about becoming an artist. It is possible to speculate that such seriousness about childhood rubbed off from Earl and Carmen, whose own ideas that the boy might follow his father's career in petroleum are suggested by a photograph of him with a toy car (fig. 1.6). Adult Indiana in a sense fulfilled their prophesy, for routes and highway signs and his life with Carmen and Earl are major subjects in his sixties paintings (for example, *The American Dream #1, USA 666,* and *Mother* and *Father;* see figs. 3.11, 5.20, and 5.9).

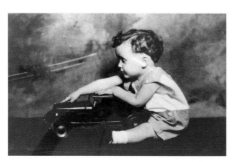

1.6 Robert Clark, age 2-3 years. Artist's collection (photographer unknown).

We find no expression of emotion in these accounts. Indiana never indicates how he felt when he was uprooted from one home after another, or during the calamitous events surrounding the Ruby Watters trial, or when his parents were divorced soon afterward, or when they died. Absent are moments of meditation and self-reflection (unless his trip to Mammoth Cave is an exception) or any indication of inner life. Absent, too, is any revelation of himself as a gay man. Although the artist himself bills his statements, especially the written ones, like his paintings, as autobiography, it is autobiography unfolded purely in terms of selected external events.

Also missing from all of Indiana's accounts is the startling fact that Earl and Carmen were his *adoptive* parents. His biological mother gave him up at birth, and nothing is known of her or of his biological father. His only cryptic public reference to this is his statement that he remained in his birthplace, New Castle, for about half an hour. He reports that he always thought of Earl and Carmen Clark as "the same as" natural parents. They in turn made him aware of his adoption as far back as he can remember.[18] Nonetheless, the themes of "Mother" and "Father" figure prominently in his works of the fifties and sixties. His longtime friend, William Katz, expressed the following opinion: "There are three people I know that are similar in temperament . . . and for all three, some aspect of it stems from their being abandoned as children: Jasper Johns, Edward Albee, and Robert Indiana. In some way or other, their mothers gave them up, and they've never quite gotten over that. Edward's completely come to terms with it, Jasper somehow on the surface has, and Bob never really has."[19] Clearly, Katz was convinced that there was trauma of loss in Indiana's childhood, and he is not the only one. In 1965 Indiana participated in an experiment undertaken by the New York psychologist Arthur C. Carr to explore sources and origins in the creative process. These were not therapy sessions, but Carr did probe the artist's memories of childhood in an effort to shed light on his artistic motifs. The results will be discussed further in Chapter 5. But some of Carr's findings bear mentioning here because they relate to Indiana's "official" childhood stories, like the ones about the death of the folk hero, Dillinger. Indiana told Carr, "There were all kinds of stories rife, the main one being that when [Dillinger's] body was brought to the undertaking parlor or home, his mother and father were brought to identify his body . . . and they both exclaimed, 'That isn't our boy!' And . . . they were taken to see the body a second time and the cloth was pulled back and they concurred, yes, that was their son after all. They had been 'mistaken' the first time."[20]

Another hero can be found in Robert Clark's childhood drawing of a civic statue, *The Hero* (fig. 1.7). He told Carr that the drawing was linked to hearing in first grade about the Dutch boy who stuck his finger in the dike and saved Holland. The drawing includes a mother pulling her child in a wagon bearing the inscription "Rum run" – Indiana's first "words in art," though their meaning in the picture is lost. Carr suggests that in the artist's mind there may have been an idea that "to be a hero . . . is to make it possible for one's parents to find him."[21] A bizarre reversal

19

of that motif occurred just after Indiana gained national attention: the last letter that he ever received from Earl Clark suggested that the adoptive parent had *lost* his son. Speaking of some newspaper clippings of art reviews he had seen, Earl wrote, "Who is 'Robert Indiana'? – Is it you?"[22]

1.7 *The Hero*, childhood drawing, 8¼ x 10¼", ca. 1936. Artist's collection.

The theme of homes and houses in Indiana's childhood stories is also noted by Carr. The "twenty-one" homes he lived in as a child must have had a strong impact on the boy, as the scrapbook cut-outs of "ideal rooms" and "perfect gardens" and his later project of photographing these houses attest.[23] Of course, during the Depression years there was much national attention in print and over the radio on the subject of home, which was sometimes treated as the antidote to the economic crisis. Carmen's domestic restlessness occurred in the context of publicity over Emily Post's best-selling book *The Personality of the House* (1930) and President Hoover's 1931 Conference on Home Building and Home Ownership, at which he said that "home" was central to the American "way of life." Carr suggests that, for young Robert Clark, problems with homes may have caused childhood depression, and indeed the artist told Carr that he cried after moving into at least one of the family's homes because the architectural features frightened him.[24] Recall, too, the impressions left on him by the mansions of the Trimble family and of James Whitcomb Riley, and think of the imposing structure that he occupies on Vinalhaven today. Other memorable houses will be encountered in connection with specific paintings.

But no mapping of anger or inner conflict is to be found among the artist's childhood stories. Of all the well-known autobiographical literature to which his narratives might relate, *The Autobiography of Alice B. Toklas* (1932), written sur-

reptitiously by Gertrude Stein and read by Indiana in New York, resembles the tone of his matter-of-fact, even-tempered dialogue, if not his language. For Indiana, Stein was "the most important woman America ever produced."[25] He seems caught up with Stein the literary figure as well as with her writing and attention to the concrete qualities of words. And he relates to what Stein does *not* say – about her own life, relationships, and feelings: "She never wanted to say very much about her private life. That's the way the times were. And one might think that a woman of her figure, intellectually so immense, might have overcome that. But she did not. Everything is convoluted and disguised."[26] The image of the author disguised in an autobiographic text resembles Gene Swenson's impression of Indiana "masked" or "hiding" in his work. Or, as Robert Tobin put it, "All attempts to approach the artist are challenges. They are challenges to find one's way through a deliberately constructed labyrinth as classically conceived as an English maze. . . . So, as one endeavors to trace the artist's path, as he seeks not to answer all questions but to offer clues and leave the conclusions to the beholder, one becomes a participant in the act of creation."[27]

The Artist-Hero

After Carmen's death, a lone and independent Robert Clark entered the School of the Art Institute of Chicago (SAIC) under the G.I. Bill. He majored in painting and graphics, and again through hard work he distinguished himself. Among his teachers were painting instructor Paul Wieghardt, a former student at the Bauhaus, and Vera Berdich, a committed teacher in graphics. Berdich remembered Clark as a "pleasant, but very serious student with an exceptional talent for etching."[28] His family and himself were frequent subjects for his prints, along with excerpts from literature – works that echo the same themes that emerge in his own life stories. His linocut *Once Paumonok, Sea Drift* is based on "Sea Drift," a poem about childhood memories from Whitman's *Leaves of Grass* that begins "Out of the cradle endlessly rocking."[29] At least one intaglio self-portrait was done in Berdich's class, as well as the woodcut, *Joseph et Filius*. (figs. 1.8, 1.9). The latter subject is the artist's invention – a biblical "moment" between Joseph the carpenter and Jesus, that is, a father and a godlike, not biological, son. It could easily be a wishful revision of Earl and Robert.

Clark did well in art history under Kathleen Blackshear, a former assistant to Helen Gardner on early editions of the survey text *Art Through the Ages*. Blackshear emphasized the Byzantine and medieval periods; Indiana later recalled having had to produce original art work in, for example, the Late Byzantine style. These experiences left traces on his stylistic development. Adrian Troy, his teacher in wood engraving, seems to have had an obsessive interest in philology. Troy discussed visual aspects of word forms, and a class project involved converting words in the English language to all three- and four-letter forms, an exercise that anticipates

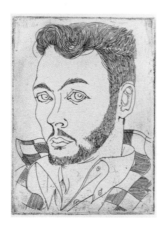

1.8 *Self-Portrait*, ca. 1952-53. Etching, 3¹⁄₈ x 3″. Artist's collection.

1.9 *Joseph et Filius*, ca. 1952-53. Woodcut. Artist's collection.

22

Indiana's later art. But on the whole he found SAIC too large, the program too rigid, and the teachers too distant – it was not as exciting as his childhood experiences at Arsenal Tech.[30]

He continued to support himself working as a night clerk in places like Ryerson Steel and Marshall Field's. And for a while he worked for R.R. Donnelly, printers of *Life* magazine as well as Chicago phone books, where he drew spot illustrations that accompanied ads in the *Yellow Pages*. All alike were "pure drudgery" and "too painful even to talk about," he later said, but a common enough experience among art students who had to work. The G.I. Bill allotment did not amount to enough to live on.[31]

Indiana remembers certain major exhibitions that stirred the SAIC students: a large Fernand Légér show at the institute itself, another of the work of Edvard Munch. Above all there was a Jean Dubuffet exhibition at the Arts Club of Chicago, where Dubuffet himself gave a talk – which Clark, unfortunately, missed hearing. He also recalls another, concurrent hanging of Dubuffet works in the environs of the city.[32]

In spite of his work schedule, he kept active in extracurricular events. He and two other artists had an off-campus exhibition at a bar in Chicago's then-bohemian Near North district; one of the others was Claes Oldenburg. (Indiana later marked the exhibition as his first connection to the Pop group, though the two were never close.) In his junior year Clark was elected local president of Delta Phi Delta, a nationwide art fraternity. Through Clark's initiative and planning, the SAIC chapter held a spectacular student costume ball called "Death of a Mansion" in the old Victorian Cyrus McCormick house that was soon to be demolished – another notable house in Robert Clark/Indiana's history. He punned on the subjects of demolition,

death, and the farm implement that made McCormick's fortune in a short poem he wrote for publicity entitled "It Started with a Reaper."

Clark had one older, probably gay friend during the Chicago years, Roland Duvernet, who was more savvy than his classmates and had already studied theater design in New York. Duvernet took Clark to visit his own hometown of New Orleans, where Indiana recalls seeing Tennessee Williams's house, and the playwright himself escorting his old grandfather around the French Quarter. Duvernet introduced Clark to the work of Gertrude Stein and gave him a recording of *Four Saints in Three Acts*, the Stein opera that had been set to music by Virgil Thomson (with whom Indiana would later collaborate). The opera, though ostensibly about sundry Catholic saints, focuses on St. Therese, who stands for Stein herself; thus, like much of her work, it is veiled autobiography. Even at this early point, Clark was aware of Stein's self-referencing habit of mind. Duvernet and Clark also shared a taste for the work of Oscar Wilde, whose mannered and gymnastic dialogue bears similarities with words in Indiana's painting.[33]

Upon graduation from SAIC, Clark was one of seven students to win coveted traveling fellowships. This enabled him to complete a B.F.A. with academic courses at the University of Edinburgh and to qualify for a fifth year of the G.I. Bill. For the summer, he received a second award, to attend the Skowhegan School of Painting and Sculpture in Maine.

At Skowhegan, Clark shied away from the "domineering" instruction of macho Jack Levine and opted for the fresco course offered at the school under Henry Varnam Poor. Clark finished two frescoes, the larger one commemorating the soldiers of the Korean War. The theme of a smaller one, under a window, was another scene from the life of Christ: *Pilate Washing His Hands*, a compressed grouping of intense faces and hands that earned him a share of the school's fresco prize. But looking back, as with SAIC, he gave Skowhegan a poor rating: it was too conservative, too devoted to the experience of nature and landscapes.[34]

In the fall of 1953 Clark boarded the *S.S. United States*, the fastest ocean liner then afloat, bound for Southampton. From there he traveled to London, where he spent a fortnight seeing the city before boarding a train to Edinburgh and enrolling in the university. He took courses in English literature, modern philosophy, and botany, finding the last by far the best, taught in the queen's botanical gardens.[35] But the visual arts in Edinburgh held no interest for him. He concentrated on poetry, composing some of his strongest verse, like "My First Spring in Scotland: For Alison Balfour," which describes in somewhat ambiguous terms his visit with the grand-niece of the former British prime minister Arthur J. Balfour (Appendix 1). He joined the university's poetry society and designed the cover of its journal, *Windfall*. He spent evenings in the print and graphics studios of the Edinburgh College of Art, printing his poems with hand-set type and illustrating them with his own lithographs (fig. 1.10).

24

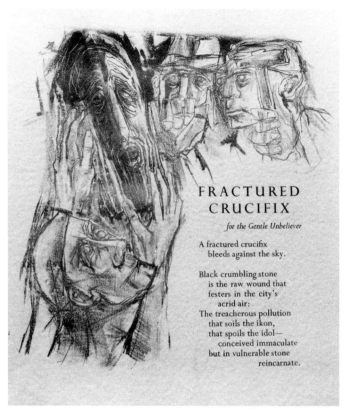

FRACTURED
CRUCIFIX

for the Gentle Unbeliever

A fractured crucifix
bleeds against the sky.

Black crumbling stone
is the raw wound that
festers in the city's
acrid air:
The treacherous pollution
that soils the ikon,
that spoils the idol—
conceived immaculate
but in vulnerable stone
reincarnate.

1.10 Poem, "Fractured Crucifix," 1954.
Lithography and typesetting, 15⅛ x 13".
Artist's collection.

In Paris for Christmas, Clark joined the art historian Bates Lowry, traveling on a Fulbright scholarship from the University of Chicago. Then Clark, Lowry, and Lowry's classmates Richard Carrott and Eugene Becker took off on a motor trip through northern France and Belgium to view the cathedrals and French and Flemish primitives and (at Becker's insistence) the Rubens in Antwerp. That spring Clark made a monthlong trip to Italy, which he enjoyed far more than France. Then, in the summer of 1954, he completed his schooling with a brief survey of seventeenth- and eighteenth-century art, music, architecture, and literature at the University of London. He indulged his love of mansions by viewing works by the brothers Adam and John Vanbrugh. Falling in love with Blenheim, he wished he could see all of Vanbrugh's great houses, "but they were so far from London."[36]

The fellowship spent, Clark borrowed fare from the American embassy for his return passage. When he disembarked in New York, he contacted a friend who found him a room for seven dollars a week in Floral Studios, a flophouse full of theater and dance hopefuls. Within months he found better accommodations on West 63d Street, and a job selling art supplies at Friedrich's on West 57th, near the Art

Students League, which put him amid a constant shuffle of artists, most as penniless as himself. Among them were James Rosenquist, Charles Hinman, and, most important, Ellsworth Kelly, with whom Clark would develop a relationship. But Clark was not immediately ready for Kelly's artistic influence. The younger artist was experimenting in assorted directions, including kinetic light compositions, when he assisted with John Hoppe's *Mobilux* "spectaculars" that aired on NBC. Later he recalled making the Kellogg *K* dance.[37]

Clark came face to face with abstract expressionists when he took another studio in 1955 at 61 Fourth Avenue (Book Row), the same building that would later house the Reuben Gallery. He recalls that he could look right into Willem DeKooning's studio on 10th Street and watch him paint – in the nude on summer nights. Clark's own work at the time was figurative and expressionist, reflecting a belated influence from Dubuffet, but he was temperamentally ill-suited for the New York School, and probably also realized that as a newcomer and homosexual it would be hopeless to break into the circle of morose, tough-talking artists – artists who acted, as Michael Leja has said, like characters out of film noir.[38] Clark felt uncomfortable at the artists' famous 8th Street Club ("one evening there was enough") and had no interest in the Cedar Tavern, the legendary artists' bar. He soured on it all, and later he characterized the period as a "zero" for his own development, and the art encountered in the 8th Street environment as "the work of alcoholics."[39]

The keen interest in poetry that began in Edinburgh persisted – Clark kept writing. But he did not become friendly with the poets who frequented the abstract expressionists' gatherings. He did not know Stanley Kunitz or the "action" poet Frank O'Hara. He wasn't reading the Beats and barely knew Ginsberg, who had come east and was warmly received at the "Club" after his publication of *Howl*, at the very time that Clark was on 4th Street. Instead, in 1955 Clark met a Filipino-American poet and protégé of Edith Sitwell's, José Garcia Villa, who was directing a writing workshop at City College. Villa was an inventive stylist who produced highly visual rhyming and punctuation (in his "comma poems") that anticipated concrete poetry, though these devices were dismissed by critics as typographical games. Villa's highly praised 1942 volume *Have Come, Am Here*, impressed Clark – not for existentialist intensity, but for its graphic language.[40] Villa took Clark to meet E. E. Cummings, "and after *tea* in Patchen Place," Clark (as Indiana) later wrote in his "Autochronology," "he [Clark] decides against the literary life." Within a few years his poetry writing lagged behind his production of sculpture and painting.

Although it is a subject entirely avoided in his interviews and artist's statements, Clark/Indiana's homosexuality undoubtedly accounted for many early artistic friendships, as with Duvernet and Kelly, and probably helped define his circle of friends in Edinburgh as well as in New York. And it points to supplementary meanings in many paintings – for example, his commemorations of artists and writers

25

known or assumed to be gay or associated with homosexual themes, like Walt Whitman, Herman Melville, Hart Crane, Charles Demuth, and Marsden Hartley.[41] Indiana's homosexuality adds a significant subtext to his interpretation of the American dream and his use of words in art. But given the nature of the autobiographical anecdotes that bear directly on his work, it seems unlikely that his sexuality was the sole or determining factor in the development of his sixties work. In order to better understand what might be called the mythic character of its self-referentiality, we need to look further.

Indiana's emotionless childhood accounts, strung together, embody a particular type of life format, an epic journey. The odyssey begins with the Clark family's roaming from house to house, in one automobile after another, around the state of Indiana; it continues with Robert's struggles to attend a good high school, his lone passage through the army and art school, his travels through Europe, and his arrival in the "capital of the art world," New York City. The overarching themes of the quest are Clark's sacrifice and determination to achieve a goal, to better himself and move beyond his poverty and chaotic upbringing, and, by following an enlightened vision, to become a creative artist. The thematically objectivized and economized childhood anecdotes reflect similar qualities in his sixties painting. Like his visual art, too, these accounts are self-aggrandizing despite their ordinariness of detail. There is something larger than life about them.

They might be compared, for example, to posthumous legends about the lives of ancient artists. Ernst Kris and Otto Kurz studied the common characteristics of accounts of artists' lives dating to the ancient world – not real, documented biographies but short narrative fragments or anecdotes.[42]

One standard anecdote among the popular legends is that the artist's special talents are discovered in childhood, usually by some mentor or father figure who supersedes the biological one. Giotto, for example, according to apocryphal stories by Vasari and others, was a shepherd boy who liked to draw in the sand until one fateful day he was "discovered" by Cimabue. Humble origins are typical in such stories for famous artists, who often have to triumph over obstacles to pursue their calling, which usually brings a marked rise in their social standing. The pattern fits Indiana's stories about his own life. Like many of the tales recorded by Kris and Kurz, Indiana's narratives are cobbled-together fragments or anecdotes. They tell of a disadvantaged, essentially provincial household come upon hard times, and of how young Robert Clark had to attend bad schools. According to his accounts – and this is one of the most often repeated of Indiana's statements in print – at an early age his talent was discovered by Ruth Coffman/Coffin, who pronounced Robert Clark's destiny and saved his drawings. (Coffman was not a famous artist, but the situation is repeated later in New York, when he is in a sense again discovered by, or taken under the wing of, Ellsworth Kelly.) Clark struggled against many obstacles to escape the mire of his family's difficulties and squabbles, even leaving the

only mother he had ever known in order to attend a good school in the city. By the time he was done he had won scholarships, and possibilities for a better life began.

In the legends of Renaissance artists' early lives, Kris notes an emphasis on autodidacticism, which conformed with recurrent suggestions, also in the legends, that artists, though from humble origins, are somehow of special birth.[43] Their talent is natural and they learn little from their ordinary teachers. Likewise, in Indiana's accounts, his art school experience and his travels are fraught with reports of disappointments, like the absence of visual arts in Edinburgh, or his dislike of Paris, or his encounter with the New York School as a "zero." In other words, his narratives of midwestern family life and childhood artistic endeavors loom large, whereas his formal art education is disparaged. It is as if he learned – or perhaps had taught himself – all he needed to know as a child, as if he was marked from birth as an artist-genius-hero, a notion implicit in the woodcut, *Joseph et Filius*.

Similar insight into the artist myth is offered by Phyllis Greenacre. She researched the accounts of lives of a group of prominent writers, basing her queries on Kris's and Kurz's profile of artistic legends. Although the study is flawed because of the randomness of her sources – some autobiographies, various biographies – her findings nevertheless expand upon Kris's and Kurz's type of myth profile. Members of her group of writers, which included Nikolai Gogol and Rainer Maria Rilke, were in some way reportedly abandoned by their natural parents, and when their special nature was discovered, so was the sense that they had an "alternate" lineage.[44] Most of them even changed their names as their careers matured, signifying renunciation of their natural childhoods, and even an imitation of Christ.

Indiana's anecdotal life portrayals follow a similar pattern. In his art history courses and his reading about artists' lives ("Artists have always interested me more than art," he once said in an interview), he likely encountered some of the very stories – from Vasari or other sources – that Kris and Kurz discuss. Knowing that he had parents who came before Earl and Carmen may have encouraged in him a mythic predisposition toward his own life all along. Catherine Soussloff has identified several significant qualities in the historical use of artists' biographical anecdotes that suggest implications for Indiana's evocation of the type. First, artists' anecdotes represent art discourse: beginning with Pliny, continuing through Vasari and Jacob Burckhardt, the longevity of the artist anecdote made it a traditional component of art history.[45] To refer to anecdotal biography is to invoke the tradition of art history, and Robert Indiana's stories do this. Moreover, the etymology of the word *anecdote* includes the notion of imparting something secret. This, too, applies to Indiana's life narratives. In the context of his paintings, the accounts illuminate and reveal the paintings' "secret" meanings. Furthermore, anecdotes have truth value as "snatches of reality" (even heightened reality, Soussloff suggests, because of their quality of secrecy revealed). Kris and Kurz and Soussloff point out that the accounts thus historically served as validation for the artist's work during a time of

changing political and economic circumstances, as when the medieval guild system was replaced by the academies, with their new systems of art regulation: "The commodity value of the mythic artist . . . is implicated in these more politically and economically strategic areas, with the 'real body' of the artist represented in the anecdote as the one 'standing behind' a given body of work."[46] The commodity value of the mythic artist is a concept that applies to Indiana's situation in the mid-sixties – the very period in which he articulated his own life narratives. His rise to fame along with the Pop artists must have seemed so much more rapid than that of his New York School predecessors. The artist's anecdote is one way of validating such new and commercially successful work as "art."

But the narrative-anecdotes have another function for Indiana. In collecting the episodes, the anecdotes or atoms of his life – curating them, as it were, as he curated his childhood drawings and lifelong possessions – he assumed control not only over how his life is told by others but also over his own history and thus his ability to speak that history. We might even compare it with a psychoanalytic dialogue with himself, in which he is telling his stories to himself, his symbolized Other, his own reflection in the Lacanian mirror. The question he asks himself about his life is summarized by Lacan's interpretation of the subject's question in psychoanalysis: "It concerns the subject's history inasmuch as the subject misapprehends, *misrecognizes*, it; this is what the subject's actual conduct is expressing in spite of himself, insofar as he obscurely seeks to *recognize* his history. His life is guided by a problematics which is not that of his life experience, but that of his destiny – that is, what is the meaning, the significance, of his history? What does his life story mean?"[47]

Modeling oneself as a hero or destined hero, like the heroes of artists' legends, contains an Oedipal component, that of rejecting one's father, the hero of one's family. This motif has a place in Robert Indiana's memories, too. As he told Carr, "It dawned on me at a fairly early age that my parents were not very competent people. They were very bad at handling their own affairs." In retaliation, it seems that when they told him not to become an artist, he says, "That in itself was a goad to me. . . . [It] gave me some incentive to become one."[48]

Thus he relinquished his father's name. Four years after his arrival in New York, while working at the Cathedral of St. John the Divine, he experienced a breakthrough in his art – with a painting of a crucifixion *(Stavrosis)*. At that time, like the writers studied by Greenacre, he abandoned his surname, Earl's name, and took a new, autogeographical one, commemorating the midwestern state where he grew up. Over the years he has cited various precedents for this: twentieth-century artists who in some way changed their names, like Picasso, Gorky, or Larry Rivers; Renaissance artists like Leonardo da Vinci or Domenico Veneziano whose names include those of their birthplaces; and even the author Tennessee Williams, who adopted the name of his family's native state and whose home Clark had seen in New Orleans. In 1979 Indiana explained, "Robert Clark didn't really exist artistically. It

happened at a psychological moment when, after struggling as a student, struggling for my own artistic identification, . . . things were just coming together. I could feel that something was going to be happening shortly . . . and it was just like going through a revolving door from night into day."[49]

His new name signified that emergence into daylight, that symbolic rebirth. In a sense – and if his story is true, it was while painting the death of Christ – he died as Robert Clark. Again Lacan's reading of the psychoanalytical dialogue is suggested, especially as it pertains to the Oedipus myth, which for Lacan must include the sequel, Sophocles' *Oedipus at Colonus*. There the hero who killed his father assumes his own destiny and dies. But at that point his life begins again, because his story becomes articulated as history and myth. The story is, "in other words, about the historization of Oedipus' destiny through the symbolization – the transmutation into speech – of the Oedipal desire."[50] For Robert Clark, this event came to fruition two years after he became Robert Indiana, when he began contracting his poetry into isolated words performed as hybrid synecdoches – conflated with symbolic shapes, colors, and rhythms – that forged restitution for his anguish of loss, incompleteness, and belatedness in works like *The American Dream #1*. Such works signaled his mature style and the means to speak his life in painting.

2

Constructing Robert Indiana

Robert Clark, like scores of other young artists in the fifties, was propelled by poverty toward New York's oldest neighborhoods. One of these was just below the financial district. There, Jasper Johns, Robert Rauschenberg, John Cage, and Barnett Newman already occupied buildings on Pearl and Water Streets. Around the corner on Coenties Slip, where the venerable waterfront was in decay, Clark, together with Ellsworth Kelly, Agnes Martin, Jack Youngerman, Lenore Tawney, and others, found quarters.[1]

Coenties Slip

Coenties was once the broadest and busiest of the slips – docking spaces between piers – along the "street o' ships," the stretch of South Street skirting the East River from the Battery to Corlears Hook. To the northwest, above Battery Park, was Bowling Green, where, according to legend, Peter Minuit bargained with the Manhattoes for land and founded New Amsterdam in 1626. In the 1950s, as today, three blocks below Coenties at the east end of Battery Park, South Ferry Terminal offers grand views of the Statue of Liberty and Staten Island. From many points along the slips, including places where Indiana's buildings stood, you can watch the ships sail under the Brooklyn Bridge.

Coenties is a Y-shaped street, reflecting its original function as an inlet for docking. Its head intersects Pearl Street (named, according to legend, for its preponderance of seashells), where the original shoreline on the East River was located before the slips were filled in the 1880s. At the intersection's northwest corner, New Amsterdam's Governor Kieft built the first City Tavern in 1641, later to become New York's first City Hall. Demolished in 1790, it is marked by a plaque at 73 Pearl Street.

Indeed, commemorative plaques, with their bronze-cast words, give history a tangible presence throughout the area.[2]

During the Federal period, merchants like ship chandler Peter Schermerhorn built stylish commercial blocks along Water and adjoining streets, some of which still stand. Their descendants filled in and built up the water lots east of Pearl – to Water, Front, and finally South Street. A fire in 1835 nearly leveled the busy area, but it was rebuilt in Greek Revival style: commercial buildings supported on huge granite piers offering open first levels, like Robert Indiana's addresses on the Slip (numbers 31 and 25), both of which announced their trades and wares graphically on facade walls, with legends like *Marine Works* and *Sheet Metal Goods* spelled out in two-foot-high letters (fig. 2.1). A few of the buildings contained mahogany or other hardwood timbers that had been recycled from eighteenth-century merchant ships.[3] Thus the slips embraced another history, that of the sea. Great ships sailed up the East River: the Civil War *Monitor* and Fulton's steamboat *Clermont*, and later the great passenger steamers, *Savannah*, *Great Western*, and *Great Eastern*. When Indiana was there, Jeanette Park, enclosed by lower Coenties and named for the ill-fated vessel of the 1879-80 Jeanette Polar expedition, afforded a place from which to view the East River.

2.1 Robert Indiana at 25 Coenties Slip, ca. 1965.
Artist's collection (photo by Abe Dulberg).

After the Civil War, New York's port activity moved to the West Side, nearer to railroad terminals in New Jersey, and the remaining East Side marine traffic tapered off after the stock market crash of 1929. In the late forties, Coenties and nearby slips were isolated by the elevated railroad, which ran from South Ferry along Front Street, through Coenties, and up Pearl before becoming the Third

Avenue El. When the Pearl Street Elevated was demolished in 1950-51, the financial district spread eastward.[4] In the early sixties the Slum Clearance Committee and the New York Stock Exchange pressed for demolitions in the area. These eventually led to the artists' exodus.

None of the artists who settled on the slip in the mid-fifties was a native New Yorker, and several, like Clark, had recently returned from abroad. Among the first was Mississippian Fred Mitchell, who had been living in Rome. He moved into studios on Water Street, then Front Street, and then to 31 Coenties Slip.[5] In 1954 Ellsworth Kelly, lately back from Paris, looked up his friend Mitchell, who convinced Kelly to move downtown as well, and in 1956 Kelly occupied a joined pair of classical counting houses at 3-5 Coenties Slip.

At Kelly's urging, Clark moved into 31 after Mitchell had moved on. In 1957, also from Paris, American artist Jack Youngerman, his wife, Delphine Seyrig (the French actress who starred in Alain Resnais's *Last Year at Marienbad*), and their son, Duncan, moved to 27 Coenties Slip and rented to Agnes Martin (from New Mexico), Lenore Tawney, and Ann Wilson – Indiana's nearest neighbors for a time. When 27 was torn down in 1960, Wilson and Martin relocated at 3-5 and were joined there by James Rosenquist and his friend Charles Hinman. Others, like Gerald Laing and Cy Twombly, passed through.

As a neighborhood in the fifties, the slip was entirely different from where the abstract expressionists lived, around 10th Street. South of the Bowery there was nothing like the celebrated 8th Street Club that served the New York School as a kind of "surrogate Parisian café."[6] Uppermost in the minds of waterfront artists were their buildings, and long and frequent battles against zoning regulations encouraged camaraderie. But life was utterly unorchestrated, and the often reproduced photograph of the artists on the roof of 3-5 records a rare gathering (fig. 2.2). They saw each other mostly at Henry's, the only grocery in the neighborhood. Agnes Martin recalled, "We all went often to Battery Park – but alone, not together."[7]

An atmosphere of marginality accompanied the general decline and derelict marine operations in the area – forgotten save for a trickle of city dwellers drawn to the sea. Indiana has often quoted lines, reflecting just this aspect of the area, from the opening chapter of *Moby-Dick*, as in his first artist's statement (see Chapter 4, Appendix 2). Jeanette Park served as a social center for immigrants, sailors, and artists, as well as the homeless and unemployed. So did the Seamen's Church Institute, known as the doghouse, in its location at South Street and Coenties Slip, which offered cheap meals and showers for anyone who could pass for a seaman (few of the lofts had plumbing). Indiana frequented the institute's library, which kept some art magazines and an array of model ships. All the artists knew the noisy Fulton Street market and ate at Sloppy Louie's on South Street. Indiana's second loft at 25 was above the Rincón de España, a restaurant serving the merchant seamen of the Spanish Lines, which docked some of the last big freighters on the East Side.

2.2 Artists on the roof of 3-5 Coenties Slip, ca. 1957:
from left, Delphine Seyrig, Duncan Youngerman,
Robert Clark, Ellsworth Kelly, Jack Youngerman,
and Agnes Martin. Artist's collection (photo by
Hans Namuth).

2.3 Agnes Martin, *Burning Tree*, 1961. Wood and metal
construction, 13 x 21". Israel Museum, Jerusalem
(photo courtesy of the Israel Museum).

Experimentalism reigned among the neighborhood's artist inhabitants. Virtually all of them experienced breakthroughs or major developments there, and most of them dabbled in collage and assemblage. The architectural debris all around them inspired a kind of construction fever, and most of the painters tried their hand at sculpture. The results include Agnes Martin's *Burning Tree* (1961, fig. 2.3) and Kelly's early bent metal pieces. They all picked through urban renewal's bounty of waste materials. Wharf and building timber, some of uncertain age, some pieces having done duty on both ship and shore, turned up in works by Rauschenberg, Mark di Suvero, and others, as well as in Indiana's.

Other works were inspired by the area's historic ambiance, like Mitchell's South Street drawings; Kelly's *Atlantic* (1956, fig. 2.4) and Brooklyn Bridge series begun about the same time; Jack Youngerman's *Coenties Slip* (1959); and Ann Wilson's *Moby Dick* (1964).[8] Melville was as popular among the slip artists as he was among the abstract expressionists, but for more specific geographical reasons, and Clark's own reasons differed still. His works, like *The Slips, The Marine Works*, or his own paintings and sculptures based on *Moby-Dick* (see figs. 2.46, 3.5, 3.2, and 4.10), reflect his involvement with the area's heroic literature.

2.4 Ellsworth Kelly, *Atlantic*, 1956. O/c, 2 panels, total 80 x 114". Collection of Whitney Museum of American Art, New York, purchase 57.9 (photo by Geoffrey Clements, © 1999, Whitney Museum of American Art).

In this maritime landscape, surrounded by voices of past and present, Robert Clark changed his outlook and his name, and wrestled with some of his most powerful influences: historic American authors, contemporary poets like José Garcia Villa, and abstract painters like Jean Arp, Ellsworth Kelly, and Jasper Johns. "Poets tend to incarnate by the side of the ocean," Harold Bloom writes in the second volume of his trilogy on the role of influence in strong poetry.[9] The ocean, a universal poetic allusion, as Indiana knows, is also Bloom's metaphor for that soothing anonymity against which poets struggle but toward which they are ever drawn. Poetic precursors, according to Bloom, are often composite, and even though Indiana as a painter and sculptor and only part-time poet may not fulfill Bloom's concept of a strong poet (few do), Bloom's theories of precursor-ephebe relationships provide useful maps for dissecting Indiana's development – the task of this chapter – and the images in his mature word paintings, in the chapters ahead.

For Bloom, and for Indiana, poetry stems from a sense of disjunctiveness or (Bloom's term) *thrownness*, a kind of loss that "informs [the poet's] more intense awareness of the precursors." And Indiana's precursors only begin with Earl Clark. "A poem (or a painting) is always *the other man*, the precursor," Bloom writes, "and so a poem is always a person, always the father of one's Second Birth. To live, the poet must *misinterpret* the father, by the crucial act of misprision, which is the rewriting of the father."[10]

Poems and Portraits

As in Edinburgh, where Robert Clark had laid out and printed his own verse, so in New York writing remained his dominant interest for roughly a year. During this time his poetry changed significantly before it was eclipsed by his painting in 1956. We need to backtrack and take a closer look at the poems of Robert Clark.

His poems from Scotland bear clear marks of conflicts created by his background experiences of loss and relocation. At first he was drawn to the work of another midwesterner in Britain, T. S. Eliot. Eliot's traditionalism and metaphysical symbolism, and his theme of civilization's decay (*The Waste Land* of 1922), appear in some of Clark's poems, like "Fractured Crucifix" of 1954 (see fig. 1.10; Appendix 1). Clark was also interested in Eliot's *Four Quartets* (1942). But it is the dislocated, "overheard" private voice of "The Love Song of J. Alfred Prufrock" (1910) that is discerned – in intensified form – in Clark's lyric poem "August is Memory" (1953), which is about Carmen's death and burial four years before. The writer-narrator of Clark's poem is a desperate "helpless witness," feeling the impact of events in the August heat (Appendix 1). The first voice in the poem is joined, however, by a second, impassive voice that speaks to an unknown undertaker. The line pattern is broken and varied, with lots of italics. The sense is of a dislocated or split subject, and the poem is concretely visual.[11]

"My First Spring in Scotland," written the same year, is an ode to a woman he was somehow taken with, the niece of the former prime minister Arthur Balfour. Here Clark turned to the work of Dylan Thomas, who had died only a few months before while touring America (Appendix 1). Clark probably felt in accord with the autobiographical cast of Thomas's poetry and the Welshman's earthy botanical imagery. But it may have been Thomas's forcefulness and communicative power that impressed Clark most, and "My First Spring" can be compared with Thomas's "Poem in October," from *Deaths and Entrances* (1946).

In New York Clark attended readings, and at one of these he met José Garcia Villa. Under the influence of Villa, Edith Sitwell's protégé, who sometimes wore a third eye painted on his forehead, Clark's style became freer, with shorter, more direct phrasing and experiential rhythm and sound, as in his "When the Word Is Love," written in New York in 1955 (Appendix 1). Its bluntly onomatopoeic style reflects certain poems in Villa's best-known publication, *Have Come, Am Here*. Lines from the untitled sixth poem of Villa's book may have particularly inspired Clark:

> I will break God's seamless skull,
> And I will break his kissless mouth,
> O I'll break out of His faultless shell
> And fall me upon Eve's gold mouth.

I will pound against His skull,
I will crack it by my force of love:
I'll be a cyclone gale and spill
Me out of His bounding groove.
.
Cataract of Adamhood. There would I be
My Lord! there would I rebuild me Thee
There alone find my Finality.[12]

"When the Word Is Love" addresses a related subject. Like Villa's poem, Clark's is physically violent, but unlike Villa's, it mixes images of actions with a concrete presence of language. Letter by letter, the poem enacts the word L-O-V-E (the straight line, the circle, the "jutting diags," and "three-pronged / Trinity"), and enacts it violently, as if the letters are blows. Clark "Dent[s] the head / With the word," scars the skull, and the poet's object is literally wounded by the letters of love. The author is both present and, because he cannot simply say the word, absent. Such work has moved well beyond Eliot's dislocatedness.[13] In constructing its subject in "striking" imagery, the poem is aggressive and equivalent to the painter's big and brilliantly colored words. In avoiding direct emotion, it is Clark's first construction of a verbal mask.

His attention to poetry and thus his exploration of Villa's style ended, but in a sense it survives in a tendency toward spiritual or religious scenarios. When he returned to painting, his method of study resembled his approach to poetry. Clark drew from various models, sampling precursors in a way that again evokes the typology of artists' legends suggested by Kris and Kurz, wherein the mentor establishes for the hero/artist a place in a special genealogy.[14]

Artistic Genealogizing

At the School of the Art Institute of Chicago, Clark had used a figurative style to portray subject matter that was often only slightly veiled personal history, like *Joseph et Filius* (see fig. 1.9). Another, more bizarre autobiographical excerpt was a lithograph of a child vomiting out his heart, with his mother in the background. The print was probably an allusion to Carmen's first (and only) natural child, who died of heart failure connected with whooping cough. Indiana recalls that a picture of the child, named Charles, was always in Carmen's bedroom, and the image obviously remained with Clark during his years in art school.[15]

When Clark had painted for a while in London, he had been drawn to the figurative style of the Kitchen Sink School (Jack Smith, Edward Middleditch, and John Bratby), which used mundane imagery.[16] Clark then became familiar with the work of other young artists through a collector named Patrick Woodcock. Also

through Woodcock, Clark met Keith Vaughan, an artist who concentrated on male nudes that candidly reflect a homosexual viewpoint. Then at the Hanover Gallery, Clark saw the more expressionistic work of another gay artist attracted to the male figure, Francis Bacon.[17] But if these men offered role models and psychological support for the young artist's sexual affiliation, neither Vaughan's nor Bacon's portraits stylistically influenced Clark, whose portrait of poet friend David Philips (fig. 2.5), done while abroad, retains the character of the earlier Chicago work.

2.5 *David Philips*, 1954, crayon. Artist's collection.

In New York, when Clark was able to establish a studio and begin painting, his portrait and figure studies became more agonistic. He later dismissed these attempts as "A brief spate of heavily influenced anguished Women (& Men) purging himself of the Chicago Monster, European Angst, and New York Grim Reality Schools," the "heavy influence" being the belated one of Jean Dubuffet.[18] But the human figure would remain always an ambivalent image, often submerged in his later work. In 1957 he even ran a figure drawing workshop with Jack Youngerman, though it lasted only a few months (fig. 2.6). Otherwise, Clark concentrated on portrait heads. An example from 1955, just before he moved to Coenties Slip, is the *Portrait of Paul Sanasardo*, a dancer, friend, and former classmate at SAIC (fig. 2.7; he altered the painting in 1992 and retitled it *Upharsin*). It is built up in extremely thick paint mixed with sand that recalls Dubuffet's *Corps de dames* or his portraits of artistic and literary figures that Clark had seen years before in Chicago. Like Dubuffet's, Clark's head is frontal and iconic. But unlike the French artist's portraits, *Sanasardo* is fastidiously schematic. The facial features even form a cross via intersection of eyeline horizontal with vertical running from Adam's apple through chin and up the long, thin nose. Clark had seen this facial cross in paintings by Joseph Glasco, who

showed several times in 1955 at the Catherine Viviano Gallery on East 57th Street (fig. 2.8). In spite of its rough surface, *Sanasardo*'s dark, almost phallus-shaped head stares at us rivetingly; the stark whites of its eyes glare eerily. Sharply drawn against a red ground, the figure evokes an earthy, glassy-eyed icon of early Christian descent. In 1963 the artist affirmed that in such portraits he was making an art-historical "reference to Byzantium."[19] Clark even gave one a background of gold leaf.

2.6 Robert Clark and Jack Youngerman, brochure
for Coenties Slip Workshop, 1957. Artist's collection
(photo of Robert Clark by Jack Youngerman).

2.7 *Paul Sanasardo* (now *Upharsin*), 1955,
altered 1992. Mixed media, photographed after
alteration. Artist's collection.

2.8 Joseph Glasco, *Three Blue Heads*, 1953. *Arts Magazine*,
November 1955, 36.

As his explorations progressed, he expressed increasing aspiration to a unique personal style. His journal entries for the years 1959-60 are rife with notations about influences, and with worries about being "too Kelly" or doing motifs too similar to Youngerman's or Martin's.[20] There were several failed directions. The first took place in 1956 when Clark met Cy Twombly, who was only just beginning to work with scratched and scribbled crayola on canvas thickly coated with paint. Twombly had quarters nearby, but a close deadline for a show at the Stable Gallery forced him to seek more space, so Clark let Twombly use his studio for a time. Twombly left behind some rejected canvases that he had "canceled" by pressing newspaper onto the wet paint. Instead of scraping them down to fresh surfaces, on two of these Clark tore off the layers of newsprint in a sort of *papier déchiré*. He liked the results but put them aside when Jack Youngerman moved to the slip. Youngerman's paintings are different in surface and technique from the newspaper collages, but in Clark's eyes their motifs were similar: they were "so close to what Jack had already been doing for so long . . . that I was kind of thrown and discouraged. . . . Here we'd be two neighbors who'd be working much too much alike."[21]

Despite his fear of being too much like someone else, Clark's relationship with Ellsworth Kelly opened the door to influences so important that they required setting hesitations aside. Biomorphic abstraction had become characteristic of Kelly's work in 1954-55, when he lived on Broad Street near Coenties Slip, and earlier in Paris he had visited the studios of Jean Arp and Constantin Brancusi.[22] Acquiring the loft at 3-5 provided Kelly with a large light-filled space, which he filled with plants, an interest he shared with Clark. (Recall Clark's childhood garden and botany course in London.) Sketches and paintings by Kelly between 1958 and 1961 were based on observations of loft vegetation (fig. 2.9).[23] Kelly also made portrait drawings of artists and other denizens of Coenties Slip, and Kelly and Clark did portraits of each other (figs. 2.10-11).

2.9 Ellsworth Kelly, *Corn*, 1959. W/c, 28 1/2 x 22 1/2".
Private collection.

2.10 Ellsworth Kelly, *Robert Clark*, ca. 1957. Pencil, 20 ½ x 24 ½". Artist's collection.

2.11 *Ellsworth Kelly*, ca. 1957. Pencil. Artist's collection.

In 1957, in reaction to Kelly's botanical abstractions, Clark began his first near-abstract, hard-edged paintings of ginkgo leaves, inspired by the trees that grew in the otherwise solidly paved Jeanette Park (fig. 2.12).[24] Clark doubled the leaf, creating a form that recalls a variety of images, including human testicles and Motherwell's abstractions of bull's balls, as well as a schematized portrait head. He associated it with his first encounter that year, in Kelly's and Youngerman's company, with the *I Ching*. Clark/Indiana eventually did *I Ching* readings for other artists, including Andy Warhol, but it is hard to assess how the Chinese *Book of Changes* influenced Clark's own ideas about chance. He shared an interest in chance with Ellsworth Kelly. Clark's version, however, is not quite the "chance" of objective observation that Kelly used in his technique for inventing abstract composition.[25] Kelly would fix on some object or phenomenon, like a shadow, then take a fragment of what he saw and abstract it so that it was no longer recognizable to anyone but himself; the identity of the original thing became a secret content. No doubt Clark was impressed with this idea, and happenstance enters his work with the ginkgo leaves, which he selected because they are simply there, in *his* neighborhood. Thus Clark's "chance finds" immediately become subjective signs: the double ginkgo is his personal revision of the *Tai Chi*, symbol of the Yin and Yang (see "The Sweet Mystery," Appendix 2). His concept of "found" (he prefers the word *discovered*) objects or subjects begins with himself as finder. Things found or discovered by chance then take their places among his life stories – forming connections

2.12 *Gingko*, 1959. O/c with gold leaf. Artist's collection.

that are totally secret (until he tells of them), known only to himself and a few friends, like Kelly's secret content, but more personal still.

As a botanical image, Clark's frontal, symmetrical ginkgo leaf is also very different from Kelly's casually posed leaf forms. Clark's are sexualized, anthropomorphized, and aggrandized like a Byzantine head. The double ginkgo leaf painting illustrated here is even done in gold leaf on a flat red ground.[26] The religious quality may have resulted from the artist's new association with the Cathedral of Saint John the Divine. Weary of working in the art supply store at seventy-five cents per hour, early in 1958 Clark got a part-time typing job at the cathedral through an ad in the *New York Times*, and he worked there until 28 January 1959.[27] The job paid almost as poorly as Friedrich's and involved a long trek uptown, but the setting of Cram and Ferguson's lofty neogothic architecture (1914) offered a change of pace. The cathedral reminded Clark of the grandeur of London.

Crosses and Orbs

Clark was also impressed with the cathedral's indefatigable Dean James A. Pike, who then was preparing to move on to a new post as bishop of California. Pike was well known, unconventional, and outspokenly liberal on matters like civil rights, fair housing, and planned parenthood. Clark helped answer Pike's correspondence and

also read the proofs for Norman Laliberte's and Edward N. West's *The History of the Cross*, thereby absorbing some detailed iconography.[28]

Clark's second Coenties Slip loft, at 25, had at one time served as a print shop, and with "discovered" materials – paper and ink – that had been left there he began a mural called *Stavrosis*, the Greek word for crucifixion (fig. 2.13). The large black-and-white dry-brush mural was a dramatic departure from his previous work and apparently so important that it occasioned his change of name.[29] It is linked to his own symbolic "death" as Robert Clark and birth as Robert Indiana. It was also his first work to arouse gallery interest, but the artist refused to exhibit it.[30]

2.13　*Stavrosis*, 1958. Printer's ink/paper
(44 sheets), 99 x 225". Artist's collection
(photo by Bruce C. Jones).

Stavrosis, done on forty-four sheets of paper pieced together, is organized in a tripart composition representing Christ between the two thieves. Indiana says that it was inspired by traditional crucifixions, like that in Matthias Grünewald's *Isenheim Altarpiece* in Colmar, France. Indiana had never seen Grünewald's piece, but Kelly had, so Indiana, in citing it, is commenting on Kelly's mentorship.[31] Other possible precedents for Clark/Indiana in this project – or precursors, because his relationships with these artists of crucifixions is one not of formal indebtedness but of artistic belatedness – included Picasso's well-known 1930 *Crucifixion* in Paris and Francis Bacon's *Three Studies for Figures at the Base of a Crucifixion* (1944, in the Tate Gallery, London), both also indebted to Grünewald's. But undoubtedly Clark/Indiana was inspired most of all by Laliberte's and West's manuscript.[32]

The mural's somewhat surrealist style also reflects the artist's awareness of Jean Arp's work, an influence by way of Kelly, with whom he had viewed the Museum of Modern Art's large Arp exhibition the same year. *Stavrosis* utilizes the personal motifs of ginkgo leaf and avocado seed – the latter, in the mind of Clark/Indiana, was related to Arp's similar ovoids in relief and carved stone.[33] Actually, the mural's organic, vaguely bonelike forms reflect the general spectrum of bio-

morphic surrealism. In *Stavrosis*, two monstrous, headless, but highly abstract figures – the thieves – flank a frail abstract Christ, just recognizable as nearly naked in triangular loincloth and crown of thorns (based on the aloe plant), and marked by a dark avocado-seed heart.[34] *Stavrosis*, corroborated by the artist's synchronous name change, may reflect more than just identification with Christ as artist/hero. There may be a signal here, too, of the imaginative empathy with the homoeroticized nude body, pierced and bleeding, that Richard Rambuss has shown appears in Christian metaphysical poetry since the Renaissance (for example, in works by John Donne) and is alluded to in some queer pornography of Indiana's own day. Moreover, this body is intimated in much of Villa's poetry, for whom Donne is a precursor. As Rambuss says, "The fluid permeabilities of Christ's own male body, localized around the physical wound, the hole in the body, become so many opportunities for staging identifications with him and for an ecstatic union with his saving flesh."[35] But as in his Villa-inspired poetry, Clark/Indiana's painting that evokes this subject also denies it by denying the body – that is, by abstracting it beyond any sensual appearance. He denies the body, as he had denied the sensual presence of love by focusing on its linguistic signifier in his 1955 poem "When the Word Is Love." In fact, and following Kelly (as this is Indiana's first major hard-edge work that registers Kelly's influence), the body is doubly denied, first by substituting an abstraction for a recognizable figure, and second by denying the touch of the brush (the hand of the artist) on the canvas.

Stavrosis also evokes forms in the architecture and furnishings of St. John the Divine – for example, the tripartite French Gothic high altar, or the carved stone crucifixion surrounded by cusped openings above the Martyrs' Portal in the North Tower (fig. 2.14). Clark earlier had connected the crucified Christ and his cathedral in the poem "Fractured Crucifix" (see fig. 1.10; Appendix 1). *Stavrosis* appears like

2.14 Martyr's Portal with Crucifixion. North Tower, Cathedral of St. John the Divine, New York (courtesy of Cathedral of St. John the Divine).

43

an image of light and shadow, or of light shining behind a silhouetted screen of forms, perhaps like the cathedral's stained glass lancet windows. Pertinent to this light-and-shadow quality are Kelly's black-and-white paintings and drawings of 1956-57, when he and Clark were closest. Kelly's early versions of *Brooklyn Bridge* or his mural relief for the Penn Center Transportation Building in Philadelphia (fig. 2.15), the installation of which Indiana had witnessed when he accompanied Kelly there in 1957, incorporate Kelly's own ideas about shadow as concrete form. Moreover, in some of Kelly's works of ca. 1951-56, like the blue-and-green collage *Study for "Meschers"* (artist's collection) or the two-panel painting *Atlantic* of 1956 (Whitney Museum of American Art, see fig. 2.4), he assembled separate squares of paper or canvas, using the seams as design elements – all related to the seams between the sheets of printer's paper in Clark's crucifixion.[36] In this regard *Stavrosis* might be seen as a kind of "misprision" or "corrected Kelly" – straight and hierarchical where Kelly's organization was (at that time) asymmetrical and dynamic, corresponding to its chance-observation origin. In this way *Stavrosis* records Clark's struggle with the work of his mentor, to avoid imitation and find his "own style." The mentor relationship is generational in its essence, and it is mirrored in the mural's paired ginkgo leaves and avocado seeds, which look like microscopic living cells reproducing by division (mitosis or fission), as opposed to sexual reproduction by a parent pair.[37] In an odd way these doubled forms serve as tropes for the renamed (thus reborn and parentless), self-created artist.

2.15 Ellsworth Kelly, "Sculpture for a Large Wall," 1956-57. Anodized aluminum, 11'5" x 65'5"x 2'4". Originally installed in the transportation building, Penn Center, Philadelphia, now in the Museum of Modern Art, New York. Gift of Jo Carole and Ronald S. Lauder (photo by Matthew Marks Gallery, © 1999, The Museum of Modern Art).

The mural as a grand scheme turned out to be a stylistic dead end, but from it emerged a body of smaller works with biomorphic egg, avocado seed, and gingko leaf forms, and referencing themes of man, woman, parentage, and birth, demonstrated by sketches in the artist's journals through 1959. One done on 8 January 1959 (a vaguely circular or vaginal form) alludes again to the theme of parents: Indiana's notes suggest a title like "Mom" or "Mom Garments" (fig. 2.16). But by the twenty-

2.16 "Mom Garments." Journal-sketchbook 1959-60, 8 January [1959]. Artist's collection (photo by Tad Beck).

fourth of the month, the notion of a "Mom" or "Woman" image became submerged in symbol. With characteristic acknowledgment of awareness of his place in an artistic lineage, Clark recorded in that entry having painted over what he called "my only oil giant female" with a simple black egg entitled *The Source*, which was still indebted to "Jack [Youngerman]'s *Naxos*, Sugaï's *The Brook*, and Arp's "Birth of the Rock" (figs. 2.17-18). But *The Source*, he wrote, was not only covering his "female painting, but somehow very much including her and incorporating her essence." Here the artist simplifies his symbolism by telescoping his images in a kind of visual synecdoche, where one form overlays and subsumes another and thus stands for it. "Woman" and "man" paintings, constituted either as parent- or self-formations or simply reflecting influence from the "New Images of Man" show at MoMA, continued through 1960, then temporarily ceased.[38]

2.17 "The Source." Journal-sketchbook 1959-60, 24 January [1959]. Artist's collection (photo by Tad Beck).

2.18 Jack Youngerman, *Naxos*, 1958-59. O/c, 56 x 75". Collection of Gordon Bunshaft estate, New York, © Jack Youngerman/licensed by VAGA, New York, N.Y.

46

A new direction, also rooted in *Stavrosis*, is the repeating motif of the circle, which he would next use in severe monochromatic paintings that often featured the surface grain of plywood in their compositions (fig. 2.19). In *Stavrosis*, spheres or orbs were multidetermined symbols: they represented general ideas like unity and purity. But Indiana assigned specific codings as well, as when he recorded that the group of twelve orbs arranged as a vertical row of six pairs, to the right of the central egg in *Stavrosis*, are the twelve apostles, and the three larger spheres balancing them on the left refer to the Trinity.[39]

2.19 25 Coenties Slip, showing Indiana with orb paintings on plywood, ca. 1959. Artist's collection (photographer unknown).

Now under his new name, Indiana, he experimented with paintings of different configurations and numbers of orbs, from one to as many as twenty-one, and he sometimes entitled them "states" (*Fourth State, Twenty-First State*, and so on).[40] All but a few of these works have been destroyed. The numbers in these paintings mark autobiographical meaning by ritualistically counting phenomena or events in his life (for example, twenty-one childhood homes). The circle as a motif for Indiana also has religious roots: its symbolism was the subject of a memorable Christian Science Sunday school class he attended in Indianapolis.[41] It was associated as well with Indiana Circle, a geographical axis of his childhood.

The orb paintings are characteristically frontal and symmetrical and conform to two formal directions. In one group, circles in rows and columns create gridlike "fields," void of directional thrust, exemplified by numerous sketches for pieces like fig. 2.19. Indiana quickly found these too close in appearance to gridded circle paint-

ings that his neighbor Agnes Martin briefly produced at virtually the same time, causing him soon to veer off for fear of not having an original style.[42]

Alternatively, Indiana's orbs configured as horizontal or vertical rows, and a number of panels were even done with a linear division between rows. The sense of a straight directional element in such works may have been influenced by seeing Barnett Newman's French and Company show in March 1959; Newman's canvases with vertical stripes impressed Indiana. Already in April, writing about a plywood piece called *Twenty-First State*, sketched in a horizontal position but displayed when finished in a vertical one (figs. 2.20-21), the artist wrote, "This is what I have been wanting to turn to for some time, it coming essentially from the twelve orbs, or apostles, but stymied when I saw Agnes' direction into circles. It comes from 'ΣΤΑΒΡΟΣΗΣ' [roughly, STAVROSIS] and I think very really, in rearthink, from seeing Newman's show. The natural line down the length of the board I intend to use to set up a tension, not yet seen in my work."[43] The "tension" referred to, whether it be from the unequal numbers of orbs the line separates, or effect of the

2.20 "Twenty-First State" (sketched horizontally). Journal-sketchbook, 1959-60, 16 January [1959]. Artist's collection (photo by Tad Beck).

2.21 25 Coenties Slip, showing *Twenty-First State* in vertical position. Artist's collection (photographer unknown).

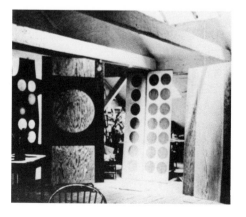

line itself (or both possibilities), seems to have been an element that the artist now sensed was missing in his painting and that he sought to supply. He wanted his paintings to work on some deeper level – through elemental means, to elicit from the viewer a specific response that grids or material facts alone (like numbers of orbs, symbolic though they may be) could not do. This sense is supported by another passage in Clark/Indiana's journal-sketchbook, written less than a week after the remarks above, after he had seen the April 1959 show at French's of Morris Louis's "veils," a show "even more meaningful to me – more instructive and helpful than the Barnett Newman. [Louis] is very much an artist of image: a large, forceful image, magic and mysterious."[44] Although Indiana does not say so directly, it seems likely to have been that a trace of anthropomorphism, though abstracted to its extreme, was what Indiana saw in Newman's erect columns of paint. (He may also have read Newman's published comments about line as the equivalent of man's first utterance.) In Louis's work, on the other hand, Indiana found more lush optical experiences and confrontational power, and he was drawn to the thin wash on Louis's surfaces. More than Newman, even more than Kelly, Louis had banished from the work the imprint of labor (gesture and brushstroke), distracting textures, and organic contour, and achieved an image that was self-removed and authoritative.[45]

"Vision Binoculaire"

Paintings during these impecunious years were done either on plywood found in the neighborhood or on a cheap panel material called homasote. Paint and stretched canvas were too expensive, and many of the orb paintings are done in gesso only. Under the circumstances it is not surprising that Indiana began doing assemblage in 1959. At the end of the previous year, while still at the cathedral, Indiana had the opportunity to take over Jack Youngerman's art classes in Scarsdale. It was Indiana's first paying job as an artist and virtually his only teaching experience. He recalls that during his first year he taught painting to children. Sometimes they did landscapes around Scarsdale, and sometimes Indiana brought bags of vegetables with him on the train for still lifes.[46] The following year he also had adult students, and he started them on constructions with materials found around the school. *Owl* (1960) was made from a rough end of timber used as a model for such classes (fig. 2.22).[47] Indiana soon began scavenging around lower Manhattan, and on 18 November 1959 he recorded in his journal-sketchbook the beginning of his first construction and sketched a small wall hanging of wood and rusted iron that eventually became *Sun and Moon* (figs. 2.23-24).

In part he was participating in the infectious trend of assemblage or junk art that, together with the related environments and action pieces (for example, "happenings"), was taking New York by storm. William Seitz began already in 1959 to

2.22 *Owl*, 1960. Construction. Artist's collection.

2.23 "First Construction" (later *Sun and Moon*).
Journal-sketchbook 1959-60, 18 November [1959].
Artist's collection (photo by Tad Beck).

2.24 *Sun and Moon*, 1959-60. Wall construction,
34³/₄ x 12". Artist's collection (photo by
Eric Pollitzer).

2.25 *Wall of China*, 1959-60. Wall construction, 48 x 54".
Private collection (photo by Eric Pollitzer).

51

plan the Museum of Modern Art's 1961 "The Art of Assemblage" exhibition. Hearing of Indiana's work in Scarsdale, MoMA's Victor D'Amico invited him to conduct a class in the new art form, although the project was eventually canceled.[48]

Indiana designed several more wall constructions at the end of 1959 and the beginning of 1960, constructions that took anywhere from a few months to a few years to complete. Among these, *Wall of China* (fig. 2.25), begun in mid-January 1960, is a composition of circular and rectangular pieces comparable to *Stavrosis*. Just as with many of the orb paintings, the plywood here contributes its own texture and character to the composition. But *Wall of China* has greater centrality than the earlier painting because of large spherical elements are placed in the center of the piece.

According to the artist's records, his title refers punningly to both the monument in Asia and a wall-hung work of art.[49] The piece is thus in part a vehicle for Indiana's political consciousness. A conflict had arisen between the United States and China in 1959, when China attacked Quemoy and other islands in the Formosa Strait. The crisis had intensified with threats of Soviet involvement and nuclear war.

The prominent red sewer plate in the piece suggests red communism. But the exact title, *Wall of China*, seems to have been drawn from a different source: José Garcia Villa's poem "The Anchored Angel," which Sitwell quoted in an article in the *Times Literary Supplement*. The poem mixes sexual and religious allusions:

> And lay he down, the golden father
> (Genesis' first, all gentle now)
> Between the Wall of China and
> The tiger tree (his centuries, his
> Aerials of light). . . .
> Anchored entire Angel![50]

Thus the wall construction is associated with an angel (hero) father. Indiana initially thought that *Wall of China* was a formal breakthrough, leading toward his sought-after signature style. But he abandoned it because, as he said characteristically, "I began to get a feeling it was too much like Rauschenberg." Indiana's anxious search for a style acknowledged the energy and imagination of his precursors. "The anxiety of influence descends as a myth of the father," Bloom tells us in describing his theory of intrapoetic relationships as parallels of family romance.[51]

Assemblage also may have had a particular homosexual ring to it within the Coenties Slip environment. Neighbors Rauschenberg, Johns, and Cage all contributed prominently to the aesthetic of the found object and helped attract attention to assemblage, and their sexual status was well known within the art community. As a member of that community, Indiana had seen Jasper Johns's groundbreaking exhibition at Leo Castelli Gallery in January 1958, as well as Rauschenberg's the following March. Both artists led the pack in using construction as a means to expand their paintings. Through Kelly, who was part of the local gay circuit, Indiana visited their studios. He recalls that once he helped Rauschenberg and Johns (collaborating as Matson Jones, a name they used for commercial work) assemble some massive displays that were to travel to a national chain of stores. But there were cliques and alliances among members of the group, and at some point Kelly had a falling out with Rauschenberg, which may have affected Indiana too.[52] In any event, the objective materialism and busy surfaces of Johns's and Rauschenberg's art are different from what Indiana was doing. They – and for that matter Kelly as well – sought to eliminate personal will from their pieces and draw on objective chance. But Indiana still saw "discovered" objects as signifiers of himself as artist. This attitude is revealed in the way he wrote of making *Wall of China* in relation to himself: out of pieces of junk found near his home (Water Street), and (in his notes) "my old draining board" – that is, a personal artifact.[53]

Jeanne d'Arc (fig. 2.26), a wall construction begun immediately after *Wall of China*, is formally and thematically different – tall and narrow and calling to mind

the erect vertical stance of Newman's motifs, especially his narrow vertical paintings of 1950 (for example, *The Wild*). Thematically, *Jeanne d'Arc* relates to *Stavrosis* and Indiana's experience at the cathedral, which contained a neoclassical statue of Joan of Arc by Anna Hyatt Huntington. It also echoes the burning witch scene (which in turn evokes St. Joan's martyrdom) from Ingmar Bergman's *The Seventh Seal*, a movie Indiana saw twice while assembling this construction. The "saint" acquired the red monogram *J* later, in 1961.[54]

2.26 *Jeanne d'Arc*, 1959-61[?]. Wall construction,
83″ high. Private collection.

Jeanne d'Arc also relates to Indiana's vertically oriented orb paintings and other constructions, like an eight-foot-tall one done next, entitled in the journal-sketchbook, *Stele of Four Orbs* (fig. 2.27). The top orb of that piece is a rusted iron wheel, also a transition from wall hanging to freestanding construction.[55] Although the title references a classical grave marker (stele), this work reads visually as a standing figure. The anthropomorphizing embodied in the constructions is based on "facial" circles as well as on "standing" verticals. The 1959 drawing for "first construction" reiterates his orb paintings via a rusted bicycle wheel and an ancient stove lid. Under the sketch Indiana made the following annotation: "From an old piece of wood found . . . on the loading platform of a long vacated loft on Front Street, within sight of my front dormer, I made my first real construction (outside of those examples made for Scarsdale), and in it I followed a theme already pursued in my paintings: the 'vision binoculaire' of the birds."[56] The last sentence suggests that the orb paintings were somehow meant to evoke ideas of eyesight and gazing or seeing. The French term *vision binoculaire* seems enigmatic: binocular vision in art customarily

refers to depth perception. But in Indiana's context it is purely a literary allusion: it is a phrase from Cyril Connolly's *The Unquiet Grave* (1945), in which the narrator is Palinurus, the Trojan pilot of the *Aeneid*. But Connolly's is a contemporary odyssey that masquerades as ancient myth while recycling a wide range of literary references. It ends with the suicide of its frustrated hero-author, as Palinurus flings himself into the sea before the end of his journey.[57] In the book's epilogue, Connolly explains that Palinurus stands for "an urge towards loneliness, isolation and obscurity."[58] It is what Bloom also means when he speaks of the poet's ocean.

2.27 "Stele of Four Orbs," sketch of construction. Journal-sketchbook 1959-60, 18 January [1960]. Artist's collection (photo by Tad Beck).

The Unquiet Grave was hailed by postwar critics as a rare and unique genre, autobiography embedded in impersonation, belles lettres, and aphorism.[59] And newly renamed Indiana was exactly tuned to such mythological self-referencing. *Vision binoculaire* occurs late in the text of *The Unquiet Grave*, in a discussion of artistic sight and insight, the gist of which is:

> "Your time is short, watery
> Palinurus. What do you believe?"
>
> I believe in two-faced truth, in the Either, the Or
> and the Holy Both
>
> To attain two-faced truth we must be able to resolve
> all our dualities,
>

> We must learn to be at the
> same time objective and subjective – like Flaubert,
> who enjoyed what Thibaudet called "la pleine logique
> artistique de la vision binoculaire," or with that
> "double focus" which Auden beautifully describes in
> *New Year Letter*.[60]

The Auden verse cited is about the legend of the magic lamp:

> So, hidden in his hocus-pocus,
> There lies the gift of double focus,
> That magic lamp which looks so dull
> And utterly impractical
> Yet, if Aladdin use it right,
> Can be a sesame to light.[61]

Thus vision binoculaire is interpreted by Connolly (with a nod to Auden) not as two-eyed vision (depth perception) but as two opposing kinds of sight. As Indiana edited Connolly's meaning of inner and outer vision – "'vision binoculaire' of the birds" – a marked separation is suggested, as if each eye sees a different thing. The *Owl*, for example, unlike its real counterparts but like some other birds, has eyes looking in different directions (see fig. 2.22). Following from this connection, the artist's logic of double focus would mean that only one eye observes objective reality – the other (as in Auden's passage) sees in "magic" light. In the "first construction," *Sun and Moon*, this doubleness suggests light of day (the sun) versus the reflective light of night (moon). In evoking vision binoculaire Indiana assigns to his unblinking orbs and wheels this combination of seeing and subjective reflection, outer and inner sight. Furthermore, from Indiana's journal comment that links *Sun and Moon* (with its circles and wheels; see fig. 2.23) and his circle-filled paintings, it seems that he connected this idea to his own frontal, "staring" orbs, those symbolic "eyes" that distill his earlier iconic portrait heads and gingko leaves. In that case, vision binoculaire translates as "two-eyed stare" (as in *Paul Sanasardo*) and brings us to the orbs in their most ocular-morphic manifestations, demonstrated in any number of constructions, from *Owl* to *Ahab*. Their stares enact a specular doubling of our viewer's pose – that is, a mirror gaze.

In art the "look out of the picture" has often been a look into a mirror: a sign of self-portraiture.[62] This mirror gaze, *cogito* as self-recognition, has a developmental parallel in Lacan's "mirror stage," a pivotal concept in the child's perception of identity, in which, between six and eighteen months of age, the child recognizes his mirror image as a unified one, a Gestalt, in contrast with his own feelings of chaos and disorganization: "But the important point is that this form situates the agency

of the ego, its social determination, in a fictional direction, which will always remain irreducible for the individual alone, . . . will only rejoin the coming-into-being of the subject asymptotically, whatever the success of the dialectical syntheses by which he must resolve as *I* his discordance with his own reality."[63] We will see that Indiana's most important constructions that suggest such a mirror relation are ones that he calls herms. His longtime friend William Katz put it most simply: "The early sculptures, the totems [herms] are absolutely the very first real statement of his ambition to be an artist. And what he did was to make them like surrogates of himself."[64]

Built up from "discovered" bits of his environment (wood from the slips) and invested with aspects of autobiography (both Indiana's and Clark's), the herms resolve his discordance of experience as a system of fictional gestalts. They mirror the artist without resembling him physically – like Christ in *Stavrosis*, they deny the body. They are also a means of introjecting himself with his surroundings, the scarred timber of the slips. But the constructions resolve his duality, as Lacan said, only asymptotically, just as Connolly's fictitious alter ego, Palinurus, described: "to obtain two-faced truth."

Herms

Indiana's early herms, which sprang from the fabric of Coenties Slip, never ceased being what they had been: wood pieces from old demolished buildings, some of which may have served previously in the structures of ships. They were already sculpture, he told one interviewer: "They were beautiful because not only did they have a gorgeous patination – the rain dripping on them, the age, they were all well over a hundred years old – but they had this peculiar shape on the top called a haunched tenon, which is simply the key for fitting one beam into another beam. There would be the female piece, and there would be the male piece and the two would lock thanks to some very rudimentary carpentry provided by Scandinavians at that time."[65] So he left the wood splintered and unpainted (painting rare examples, like *Ahab*, only if the wood was too badly damaged), and allowed the scars or discolorations of a beam to suggest its subject, as in *Hole* or *Soul* (see figs. 2.44, 2.36).

McCoubrey has pointed out that Indiana's materials – the beams and ancient rusted machine parts or ship or warehouse hardware – are historical and thus set him apart from most of his assemblagist contemporaries, who tended to opt for more ubiquitous urban debris or mass-produced commercial detritus of their own day.[66] Indiana's constructions also differ in their manner of transformation. They seem more closely to coordinate with William Seitz's prescription in his essay in the MoMA exhibition catalog, "The Realism and Poetry of Assemblage." Seitz wrote that, in spite of the form's quotidian materiality, contemporary assemblage "metaphysically" transformed its materials. The artist was like an alchemist who trans-

muted the physical properties of things. Moreover, "Certain works of assemblage, with an attraction like that of green-encrusted bronzes or the unnamable artifacts of a people far away or long dead, seem to emit a magical halo: an aura too ephemeral to be ascribed to sensory stimuli."[67] Indiana's alchemy has a personal program. Rather than display objective "aesthetic" transformation, the way the other artists did, he gave his historical material a home, just as he himself had found a home on Coenties Slip. As he said of the herm *Moon*, exhibited in Seitz's show, "The technique, if successful, is that happy transmutation of the Lost into the Found, Junk into Art, the Neglected into the Wanted, the Unloved into the Loved, Dross into Gold."[68]

Moon was one of the earliest herms that Indiana completed (fig. 2.28). Its character is that of a heroic figure, grounded in the majesty and integrity of the heavy beam, mortised and tenoned in this case, a hermaphrodite. *Moon* also displays a row of orbs, rendered as the lunar phases. Compared with other anthropomorphic assemblages in the MoMA show, like Richard Stankiewicz's *Untitled* (1961) or even George Herms's *The Poet* (1960), which seem by comparison to be illustrative and narrative, *Moon* is erect and authoritative, like an orator poised to declaim, or a female oracle – or like memorials to such figures.

57

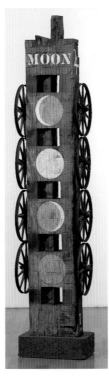

2.28 *Moon* (formerly *Moon Machine*), 1960.
Herm construction, 78″ high. Museum of Modern
Art, New York. Philip Johnson Fund
(photo © 2000, The Museum of Modern Art).

A group of mostly unfinished herms, begun shortly after *Sun and Moon*, were photographed in early 1960 under the skylight of 25 Coenties Slip (fig. 2.29). Mostly between roughly four feet and six feet high, they pose with their gessoed and colored bands, their wide-eyed circles animating the ancient wooden shafts. The group portrait conveys the power of presence these beam constructions can convey – as if one has come upon a meeting of a secret society or a cult of worshipers, or perhaps their emissaries, like kouroi collected at a Greek shrine. They are apotropaic, eye-intense charms protecting a psychological space. Several critics have commented that the herms create a sense of family around the artist. As if inspired by his mythical genealogizing, they enact a "family romance." The artist recalls that there was "excitement in the studio" as the herms began to take form.[69] Some of them sport rusted bicycle and carriage wheels. At the time the photo was taken, only two had words. But the point is that they had begun to bear attributes. They recall the sculptures of saints in the chapels of St. John the Divine, but unlike the saints, these herms bear attributes of the artist himself.

Indiana's beam sculptures are also sexual personae, thus the identification with herms (or hermae) – stone pillars bearing heads and phalluses found throughout much of the ancient world. To give his herms autobiographical lineage, Indiana points to his years of high school Latin, his interest in classical art, and especially to the herms that he had seen at the Ashmolean Museum, probably including the one shown in fig. 2.30.[70] His use of the term, however, was ultimately based simply on

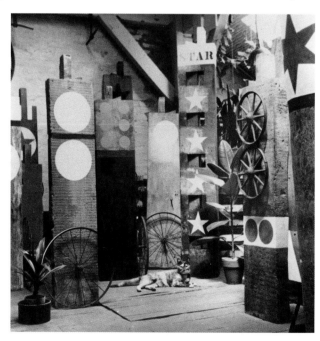

2.29 Herms grouped under skylight of 25 Coenties Slip, 1960. Artist's collection (photographer unknown).

2.30 Terminal figure (Herma) of Aurelius Appianus
Chrestus, from Athens, second century A.D.
Pentelic marble, 1.44 meters high. Ashmolean
Museum, Oxford (courtesy Ashmolean Museum).

the beams themselves: "I set them upright, and they really did look like hermae, the classical marble sculptures which would be set at roadsides and so forth, as road markers to the next town."[71]

Classical herms probably originated in the sacred stone or pillar of stones that represented a prehistoric worship of certain unhewn rocks. But mythologically the form commemorates the trial of Hermes. The story goes that the first murder among the gods took place when Zeus ordered Hermes to kill Argos, the guardian of Io, whom Zeus pursued. When Hermes was tried on Olympus, no one wanted to condemn him for fear of Zeus. The gods acquitted the defendant but threw their voting pebbles at him, so that a pile of stones grew at his feet.[72]

Indiana's herms are headless, but the power of the ancient herm lay not in the sculpted head on top (symbol of the herm's self-knowing nature) but in its distinctive four-square column (the proportions of the human body) and its quadratic ground plan (offerings were sometimes specified for the "four-square God"). Both Indiana's beams and the ancient four-square columns are ithyphallic. They are related to priapic monuments and to the sexual nature of the god Hermes as a bearer and source of the male principle.[73]

Most familiar as messenger of the gods, whose winged sandals Indiana's herms evoke with their metal spoked wheels, Hermes also appears frequently in the *Odyssey* as a god of the journey, tending those whose lives are always in movement,

flux, or flight.[74] The longest of the Homeric hymns recounts Hermes' birth, on the fourth day of the month (his number is four, thus the quadratic column), from the liaison of Zeus and Maia, daughter of Atlas – that is, from divine and heroic parentage. Apollo made Hermes the god of flocks and herds, but more generally he is god of propagation and increase, one reason that herms were put in fields. They also served as boundary markers. Via male erection display, they claimed territory and warded off interlopers.

Found in city as well as in country, herms were also placed at the doorways of homes, and domestic examples were cherished and passed along as heirlooms. This practice reflects Hermes' connection with increase, and from ancient times with fertility. He is the male progenitor and source, or "source of the source," as Karl Kerényi puts it.[75] He is the father of Eros, Pan, and Priapus (according to some traditions), and Hermes and Aphrodite brought forth the hermaphrodite. As the masculine source of life, Hermes is also Psychopompos, guide of souls, and as such a frequenter of Hades. Indiana's references to some constructions alternatively as stele show his awareness that herms also served as grave markers.

Finally, Hermes is the herald of the gods – their mouthpiece – and the "whisperer" (Psithyristès), the god of dreams. Hermes is also thought by some to be the inventor of language. Kerényi traces this connection: "The word for the simplest mute stone monument, *herma*, from which the name of the God stems, corresponds phonetically to the Latin *sermo*, 'speech' or any verbal exposition. The word *herma*, which in the Greek does not have this meaning, does however form the basic verbal root for *hermèneus* ('interpreter'), a linguistic mediator."[76] Although it is impossible to know whether Indiana, who began reading about herms as his constructions developed, was aware of Hermes' linguistic association, the fact is that Indiana's herms bore the first words in his art. Words articulate the herms as reflections of his own myriad dimensions and interests. Moreover, the herms offered a laboratory for ideas and expanded the informational range of his endeavors. Very quickly – by the summer of 1960 – words also appeared alongside orbs in some canvases, like one he sketched out in July entitled *Fun* (fig. 2.31).

Indiana was not unique in the New York art world in his employment of language. In the late fifties, words figured in works by many artists as an outgrowth of assemblage, which often showcased printed materials, as did environments and happenings (Allan Kaprow's verbal environment *Words* at the Smolin Gallery in 1962, for example, or the Fluxus scores of George Brecht). But Indiana's words are distinct from those in such works because for him alone words are autobiographically specific. He even roots his use of them in a story of "discovery": he found old die-cut stencils in the abandoned buildings – stencils for applying trademarks and labels to commercial freight. The very first one he found in his own loft was from "The American Hay Company," a company, coincidentally, located in the Midwest (see fig. 4.29).[77] These made stenciled words as personal a part of his life on Coen-

2.31 "Fun" sketch." Journal-sketchbook 1959-60,
14 July 1960. Artist's collection (photo by Tad Beck).

ties Slip as the herms' oak beams. Moreover, the terse words boldly painted on the bases of the constructions are more than titles; they are utterances. Through the words, Indiana's herms speak and call their names.

The herms adhere to a basic formula dictated by the "male" (topped with haunch tenons), and "female" (mortised) beams and informed by the spirit of classical herms – a phallic peg projects from the front of many herms. Indiana combined in various ways among the pieces an emerging vocabulary of wheels or other rusty attachments, plus words, numbers, orbs, and other assorted markings (on *Moon*, for example, the astrological sign for Jupiter) in paint or gesso. By the end of 1960 and increasingly in 1961, natural weathered wood and rusted iron constructions gave way to highly colored and articulated herms. All, however, are confrontational and possess something of the double or reciprocal focus via orbs and words that implicates Indiana's use of the phrase from *The Unquiet Grave*: vision binoculaire.

The herms begun in 1959-60 and finished either immediately or over the next several years elucidate subject matter groupings that carry over into Indiana's paintings of the sixties: there are classical/mythological herms, religious/spiritual herms, number herms that also bear autobiographical and mythological references, political herms, and literary herms.

A few constructions bear words/titles with classical connections in line with the herm's origins. *GE*, a herm with piggy-back wheels and a pair of orbs like breasts, refers, despite its tenon and peg, to the goddess Gaia or Gea, the ancient Greek equivalent of Mother Earth (fig. 2.32). Another was begun as *Zeus* (father of Hermes), though its name was changed when it was altered (in 1961-62) to become

Zig (fig. 2.33). Gaia and Zeus qualify as mother and father personae among the gods and thus relate to Indiana's leitmotif of parents. In fact, the initial sketches for *GE* and *Zeus* are paired side by side on the page in his journal-sketchbook, like "mom and dad" (fig. 2.34).[78] Unlike Earl and Carmen, whom Indiana had depicted in his student days, these herm parents are divine, certifying heroic offspring.

2.32 *GE (Gaea)*, 1960. Herm construction, 59" high. Private collection (photo by Bruce C. Jones).

2.33 *Zig* (formerly *Zeus*), 1960-62. Herm construction, 65" high. Museum Ludwig, Cologne (photo by Eric Pollitzer).

2.34 "GE" and "Herm Zeus" (with "Cuba"), sketches of Herm constructions. Journal-sketchbook 1959-60, 21-22 September [1960]. Artist's collection (photo by Tad Beck).

2.35 "Law" (formerly "Machine for Roman Justice").
Journal-sketchbook 1959-60, 15 February [1960].
Artist's collection.

63

Machine for Roman Justice, a herm with a roulette-wheel "face" (later renamed *Law*; fig. 2.35), qualifies as classical if not mythological. Celestial bodies, *Sun and Moon* (though not a herm; see fig. 2.24) and the herm *Moon* also relate to mythological astrology. *Soul* (fig. 2.36), a phallusless construction incorporating an old sewer or drainhole cover and a beam with a jagged waterstain, evokes Hermes himself, the guide of souls (the stain suggesting the flames of Hades).[79]

Alternatively, the soul is a central concept of Christianity. It is the motivation for the life of Christ and especially the crucifixion. Themes of *Stavrosis* persist in the herms' iconography – for example, the artist has also referred to the lower disc with projecting nails on *Sun and Moon* as a "crown of thorns."[80] Such themes recur in *Virgin* (again a mother, the mother of Christ, who was present at the crucifixion of her son; fig. 2.37); the herm *Womb* (attribute of mother, the "Source," to recall another title in Indiana's repertoire; fig. 2.38); the nonherm construction *Jeanne d'Arc* (Christian saint, a self-sacrificer and imitator of Christ); even perhaps *Machine for Roman Justice*, because Christ's cross delivered Pilate's ruling and so fulfills the title. Indiana would not have missed another fundamental connection between the wooden beams and the crucifixion, spelled out several times in the manuscript by Laliberte and West that Clark had worked on at the cathedral: "In the picture of Isaac bearing wood to the mountain for his own sacrifice [there is] a direct symbol of Christ. Some even went as far as to insist that Isaac carried the wood in cruciform shape. The important thing, however, was the wood itself. Wood always spoke of a cross."[81] Indiana's rechristening of *Machine for Roman Justice* as *Law* was ironic because he had been arrested on the slip for washing his windows on Sunday.[82] Thus

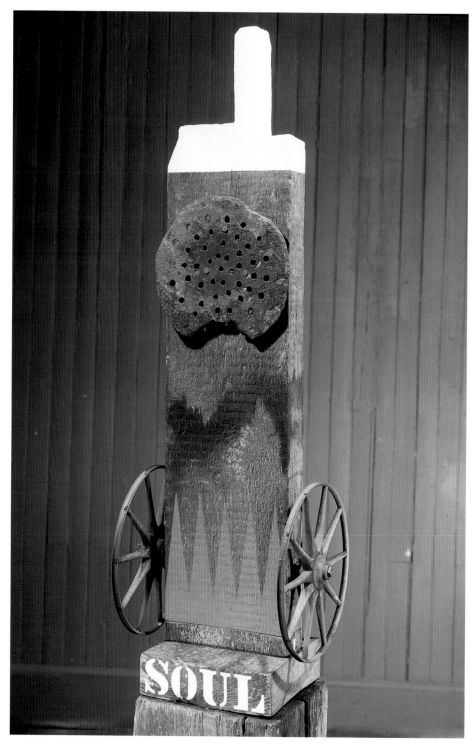

2.36 *Soul*, 1960. Herm construction, 42" high.
Private collection.

he became a religious transgressor, paralleling Christ in the eyes of the Romans. *Eat* (fig. 2.39) is more deeply personal, referencing his mother's last word. But in its original conception, with a pitchfork instead of a peg (fig. 2.40), it is also moralistic and scriptural, and could as easily be one of Christ's last words to his apostles when they broke bread; or it could refer to the "false" promise of full bellies for all, implicit in the American dream, a topic the artist also addressed in his paintings.

The names of other herms, together with the comments about them found in the artist's journal-sketchbook, reveal Indiana to be knowledgeable and involved in political events, a contrast to the "aesthetic of indifference" that scholars have assigned to his neighbors Rauschenberg and Johns. *French Atomic Bomb,* begun on

2.37 *Virgin,* 1960. Herm construction, 42" high.
Artist's collection.

2.38 "Womb," sketch of Herm construction.
Journal-sketchbook 1961-62, 10 April [1961].
Artist's collection.

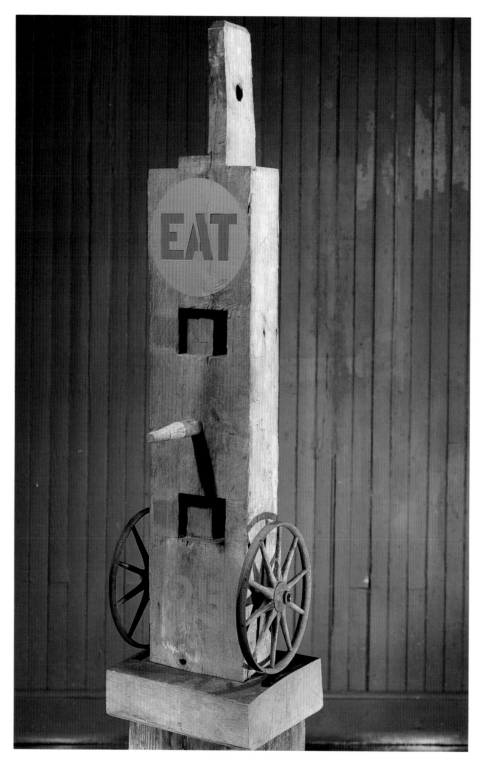

2.39 *Eat*. Herm construction in final form with
peg, 59³/₄" high. Private collection (photo by
Bruce C. Jones).

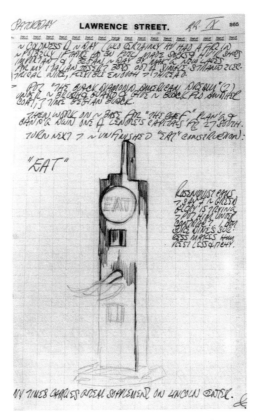

2.40 "Eat," sketch of first state of Herm construction showing pitchfork. Journal-sketchbook 1961–62, 22 September [1961]. Artist's collection.

13 February 1960, is based on the explosion of France's first nuclear weapon in the Sahara Desert, which was reported in the headlines that day (fig. 2.41). This small (just over three feet tall) herm, incorporating a rusted disk from Fire Island, was Indiana's first major work to be exhibited: the following June it was included in the first of two "New Forms, New Media" shows hung at the Martha Jackson Gallery.[83] *French Atomic Bomb* was followed by other chronicling herms. One called *Cuba* refers to reports of Fidel Castro's alliance with the Soviet Union (see fig. 2.34), and *U-2* commemorates the downing of Francis Gary Powers's spy plane over the USSR. *Moon* (originally *Moon Machine*) symbolizes America's pursuit of the Cold War space race with Russia. The idea that such ill-founded or ill-fated events should be memorialized — given a herm or landmark — is the work of a mind trained in irony, with a certain fatalistic view of whether or not right can prevail over wrong. It is an attitude that informs the appearance of the roulettelike wheel on *Machine for Roman Justice* (later *Law* — the laws of chance), or the confluence, in his notes for the herm *Bar*, of "seat of judgment" (courtroom bar) with "place of downfall" (for example, the Cedar bar).[84]

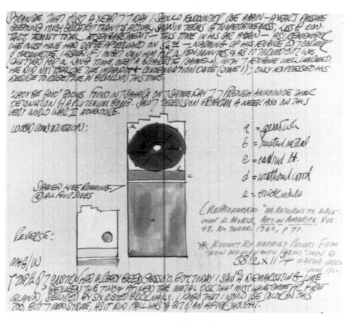

2.41 "French Atomic Bomb," sketch of Herm construction. Journal-sketchbook 1961-62, 13 February [1960]. Artist's collection.

Number herms (like classical herms) mark boundaries and milestones by counting, having evolved from the numbered orb paintings and the nonherm *Stele of Four Orbs*. Indiana was no doubt aware of Jasper Johns's number paintings (like *The Figure 5*, 1955; see fig. 4.47). Johns presented the deadpan factuality of numbers, and perhaps also, as has been suggested, used numbers as covert symbols of gay culture.[85] These ideas may well carry over to Indiana's number-subjects, beginning with the orbs and herms. But numbers are vastly more important in Indiana's developing system of private reference and representation. His numbers are figures that tally up things in his life. For example, *Two* and *Pair* (both 1960-62; figs. 2.42-43) reiterate the polarity of *Sun and Moon* and vision binoculaire, but like the double ginkgo, they suggest other pairs and polarities, such as parents and lovers. *Orb* (1961) bears the number three, probably referencing the Trinity, after *Stavrosis*. The herm *Four* gives us Hermes' number, which also (according to Indiana) means either youth or danger, or both.[86] The number of the herm *Six* (1960-62) is, for reasons that will be discussed in Chapter 5, associated with the artist's father.

The same is true for herms whose names derive from specific works of literature. These began to appear late in 1960 and reveal best of all Indiana's process of constructing identity. We have touched upon his interest in English and American poetry and prose of the thirties and forties and his education in Gertrude Stein, via Duvernet and Agnes Martin (who was a "walking Stein seminar on the Slip"). With the herms, selected other literary examples entered his art. In August the artist

sketched a design in his journal for a scarred herm called *Hole*, with a note about *Molloy* – Samuel Beckett's novel that is another hopeless odyssey (like Palinurus's), in which "mother" serves as a leitmotif and holes take both earthy and anatomical forms (fig. 2.44).[87]

Chief and *Ahab*, both started in 1960, were worked on side by side through mid-1961 (figs. 2.45-46).[88] These herms bear words from nineteenth-century American literature, but they also exemplify the artist's tendency to project himself into mythical contexts. *Chief* draws on Henry Wadsworth Longfellow's poem *The Song of Hiawatha*. An epic that is presented (via the poem's introduction) as a story and as an inscription on a grave, the tale recounts the journey of a mythological Indian hero. *Ahab* evokes Melville, *Moby-Dick*, and the ships and slips of New York. The herm stands for that American epic of man versus nature, with the former personified by the peg-legged captain. *Chief* and *Ahab* both represent their famous texts' heroic personae, who position themselves – and by extension Indiana – between man and cosmos. Altogether, Indiana's constructions itemize the terms of his evolving sixties art and advance the artist beyond the searching process of the

69

2.42 *Two*, 1960-62. Herm construction,
 62½″ high. Private collection, New York
 (photo by Bruce C. Jones).

2.43 *Pair*, 1962. Herm construction, 62½″ high. Artist's
 collection (photo by Bruce C. Jones).

2.44 *Hole*, 1960. Herm construction, 45" high. Private collection (photo by Bruce C. Jones).

2.45 *Chief*, 1962. Herm construction, 64″ high. Private collection, New York (photo by Bruce C. Jones).

2.46 *Ahab*, 1962. Herm construction, 61″ high. Private collection, London (photo by Bruce C. Jones).

fifties that this chapter has traced. Having threaded his way amid a host of contemporary influences, he thus planted himself among a pantheon of dead precursors wielding an array of figurative allusions via shape, number, and language.

Again, a model useful for understanding the place of the herms in Indiana's work is provided by Lacan, who writes that the "unconscious is the discourse of the Other." Lacan illustrates this concept with a clinical incident in which Melanie Klein makes Dick, a child seemingly incapable of coherent speech, successfully use language by introducing to him the terms of the Oedipus myth in a game: the words *mommy* and *daddy* and Dick, in proper symbolic usage, open to the child a system of linguistic relations that resonate in his unconscious. Klein becomes the Other whose discourse structures Dick's directionless desires. The herms enact an analogous situation. In Indiana's art, symbols, colors, and shapes become tropes of relationships in his world – a discourse of power and fate, of parents and origins. But the discourse crystallizes only with the words. As he told Richard Brown Baker, "The constructions just needed the words; they did not look complete without them."[89]

Thus the herms make tropes of processes and lend language to relationships, and so they become rhetorical figures, but not necessarily figures of revelation. As Harold Bloom explains, rejecting the rhetorical trope as a figure of knowledge, "For me, it is always a figure of willing and not knowing" – of rhetorical deception.[90] The wooden herms that utter forth their stenciled dicta, projecting apotropaic orbic stares, are such figures of deception.

73

3

Dreaming "American Dreams"

Throughout 1960 and early 1961 Robert Indiana completed more than a dozen herms and other constructions that enabled him to break down his personal experiences and encode their fragments in short, epigrammatic components. He arranged this secret content within brilliant, impersonal verbal-visual compositions – works that would launch his career. Next we shall examine the transition whereby Indiana's orb paintings and articulated wooden herms together gave rise to a mature oeuvre that resolved a dilemma of inside and outside via a synthesis of painting and poetry.

As with *Stavrosis* and the first herms, the artist's creative genealogizing accompanied his new breakthrough in painting, and it centered on the figure of Ellsworth Kelly, his mentor and former intimate partner (they had a falling-out in 1959). Kelly served as a significant precursor stylistically and also as a professional role model. As Indiana later told an interviewer, "It was certainly Ellsworth who made me first think very heavily on the subject of galleries." Yet Indiana fastidiously avoided the wrong galleries and resisted showing his work prematurely. He explained to Richard Brown Baker, "I felt that it was very necessary to be able to work consistently in a given style for given period of time." His continuing concern for having the right personal style, a signature style (and in this he followed in the footsteps of the abstract expressionists), was, in his mind, prerequisite for obtaining the right venue.[1]

An acceptable opportunity came about through Rolf Nelson, a friend and neighbor on Coenties Slip who worked at the Martha Jackson Gallery. Through Nelson, Indiana gained entrée in 1960 to Jackson's landmark "New Forms, New Media" exhibitions, an auspicious beginning for a young artist in New York. That exposure led to his inclusion in the Museum of Modern Art's "Art of Assemblage" show in autumn of the following year. In May 1961 Nelson became director of the David Anderson Gallery, owned by Jackson's son, and Indiana showed there with assem-

blage artist Peter Forakis. The same year Indiana showed with friends Stephen Dur-
kee and Richard Smith in a show called "Premiums" at Paul Sanasardo's dance stu-
dio gallery. By early 1962 Indiana's name and work were well enough known for
Eleanor Ward, whose eye for new talent had established her Stable Gallery in the
mid-fifties, to seek the artist out on her own.[2]

In the ensuing months most of the large beams Indiana had collected were
used in completed herms or ones in progress, and he began a second genre of found-
wood sculpture, painted columns. He told Baker in 1963, "They were originally the
masts of old sailing ships, and you can still see the worn areas where the iron rings
that held them together were once fitted into. Then they became columns for these
warehouses that were built after the fire of 1835."[3] While scavenging in the old
warehouses Indiana had found the nine-foot-tall masts; unfortunately, he had to cut
them in half to move them into his loft. As with the herms, he left the columns
unpainted and sporting their scars. Indiana explained to Baker that these were not
assemblages, because nothing was added to them "except words painted around the
perimeter." Only one of these was completed in 1960, a small one with black, red,
and white lettering called *Duncan's Column* (fig. 3.1).[4] A journal sketch of it lists the
words and numbers painted around the column's patined surface, recalling classi-

3.1 *Duncan's Column*, 1960/62-91.
Painted found wood sculpture, 75"
high. Artist's collection (photo by
Jay York).

cal commemorative schemes like the reliefs on Trajan's column. On *Duncan's Column*, stenciled names and numerals form three color registers. At the top, black letters spell out clipped legends: Ship Slip, 27 Beacon, Gull Pier, Barge Tug, 3 Bridges, Jeanette, Love Pier, 15 Ginkgoes, Doghouse, J, Orange, Tars Pier.[5] Below these are ranged similar staccato inscriptions in red oil paint and white gesso. Altogether, it is an inventory of the artist's neighborhood.

Another construction begun in March 1960 took yet a different format that directly reflected his simultaneous struggle with painting: *Marine Works* (the title referencing his own loft, thus a place, an autogeographic signifier) uses an old loading ramp as a ground (fig. 3.2). After removing its metal plates, the artist added red-and-white stripes across its top and bottom, and finally in 1961 the piece was finished when wheels were attached and numbers and arrows painted on. These animate the piece via symbols: the arrows indicate that the wheels spin around. In his journal

76

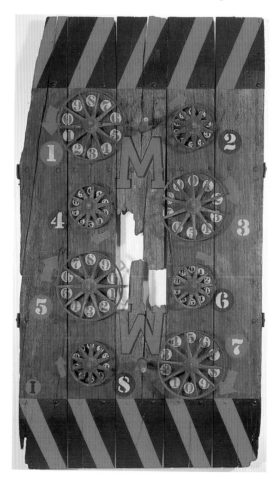

3.2 *Marine Works*, 1960-62. Wall construction, 72 x 44".
Collection of Chase Manhattan Bank, New York
(photo courtesy of Chase Manhattan Bank).

3.3 "Agadir," sketch of painting in process.
Journal-sketchbook 1959-60, 2-3 March [1960].
Artist's collection (photo by Tad Beck).

entry for *Marine Works*, "barber pole" stripes that had been noted on some earlier sketches for herms are now referred to as "danger" stripes. The new term suggests continuing concerns about strong viewer impact, the kind evoked by stripes on the roadway ("Danger," "Stop"). The motif appears on additional early 1960s constructions like *M*, *Mate*, and *Zig* (the former *Zeus*; see fig. 2.33), and reappears on early sixties paintings as well.

With money from his teaching job he was able to buy canvas and supplies by early 1960. The evidence of one painting, begun on 3 March, suggests that, as with the herms and perhaps reflecting their influence, he was now aiming for more explicit content. He called the 3 March work *Agadir*, after a town in Morocco that had been razed by an earthquake on 29 February. The *New York Times* had run a story on the tragedy the previous day (fig. 3.3). The proposed painting, like the herms *French Atomic Bomb*, *U-2*, and *Cuba*, would have referred to current events – or disasters – only more covertly.[6]

The preliminary design for the new painting displayed little information about the earthquake. Instead, *Agadir* was similar to other orb paintings done the same winter. These works began to take on additional shapes after Indiana saw Martin's paintings with circles and as a result became dissatisfied with his own grid patterned orbs (fig. 3.4). The lines across the new canvas bisected four orbs into two

pairs, an idea that had probably evolved from lines in earlier canvases like *Twenty-First State* (see fig. 2.20). But in *Agadir* the borders slanted and the bisector zigzagged, as if disrupted by the Agadir upheaval. The painting was sketched out in green oil paint and white gesso. While the scheme for it is still frontal, the figure-ground relation is no longer fixed but active and unstable. Indiana clipped the *Times* story and attached it next to his sketch, and in a note conflated the Moroccan cataclysm with a personal, intimate memory: "Possibly a commemoration of last year's event of today: the madness of the two of us sharing a loft . . . a South Street fiasco for sure . . . more probably [the painting] will be called for the terrible earthquake in Morocco, where possibly 5000 people met their death in the middle of the night."[7] The personal reference may refer to his falling-out with Kelly, a disaster that would have been both commemorated and masked by the chronicle of the loss in northern Africa. But *Agadir* was never finished. Instead, it became a palimpsest, repainted with a compositionally related work: *The American Dream #1*.[8] It is one of a small, seminal group of paintings done during the concentrated period of herm production.

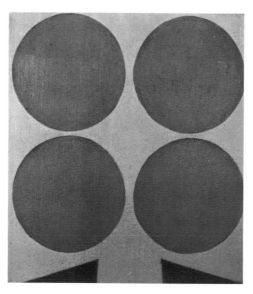

3.4 *Ra*, 1961. Part of a triptych of one-, two-, and four-orb paintings. O/c, 12 x 11″. Artist's collection.

These paintings explore new relations between words and images. A small canvas divided into upper and lower zones, for example, creates an analogy between a pair of orbs (lower half), and the word *FUN* (upper). Given its near-pagelike size (ten by eight inches), *Fun* is a whimsical and direct approach to the visual presentation of text (see fig. 2.31): the word is borne up by the "binocular" orbs like a sign by a schematic sign bearer.[9] The content of the word (fun) is not otherwise referenced in the image. In two other works begun as orb paintings, *The Slips* (fig. 3.5) and *The American Sweetheart* (both 1960), the use of language is entirely different.

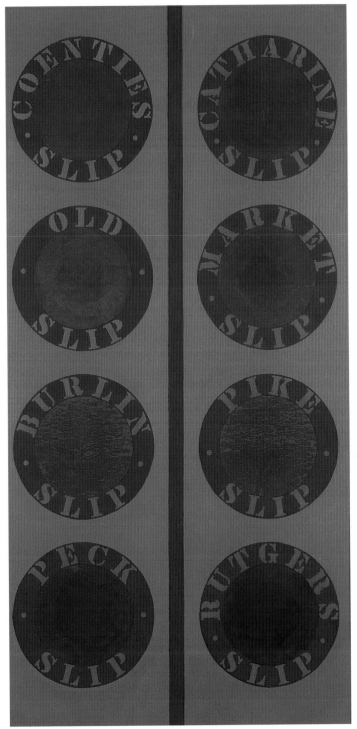

3.5 *The Slips*, 1960. O/homasote, 96 x 48".
Private collection. © Robert Indiana-
Morgan Arts Foundation/ARS, New York
(photo by Hugo Glendening).

Here large orb paintings were inscribed with words later, and in *The Slips* the words circle the orbs' inner perimeters, just as words turn circles around *Duncan's Column*. Replacing the arrows around the orbs in *Marine Works*, these circling words indicate language in motion.

A painting entitled *Eidolons* also embodies the binocular gaze (fig. 3.6). It has two circles over chevroned rows of closely hued stripes that point up at the center of the painting, implying a bisecting vertical line. The title word, written along the alternating chevron stripes, refers to Walt Whitman's "Eidólons" from *Leaves of Grass*. More specifically, it evokes that poem's suggestion of the ultimate image (or portrait), the soul.[10] As an eidólon or phantom image, in the context of this poem, the painting's title succinctly describes the lingering presence of the frontal portrait heads (also visible in certain orb paintings, for example, fig. 3.4). *Eidolons*, though it was later damaged and then destroyed, must qualify as a major attempt to ground a single repeating text in a "forceful" and "mysterious," minimally anthropomorphic image, similar to what Indiana had perceived in Newman's and Louis's work the previous year.

3.6 "Eidolons," sketch of painting in process. Journal-sketchbook 1959-60, 13 July [1960]. Artist's collection.

Other important paintings emerged rapidly at this time: *Terre Haute* (1960), *The Sweet Mystery* (1960-62), *The Triumph of Tira* (1960-61), *Electi* and the closely related work, *Ballyhoo* (1960), and *The American Dream #1* (1960-61; the former *Agadir*). All combine circles (orbs) and stripes or stars with words and (in two cases) numbers. Unlike the earlier orb paintings on exposed wood grain, these are entirely covered with flat, hard-edge color and anonymous-looking words and phrases and thus vaguely resemble some advertising layouts on packaging or television. At the same time, the words in these Indiana paintings create narrative or allegory – simultaneous self-revelation and self-concealment – programmed in bits and pieces. Like *Eidolons*, the most important examples of this group bear the trace of a speaker, a *deixic* – the "binocular" orbs – that identifies the utterances as from the artist himself.

These canvases progressed more or less simultaneously during several months, and all six were exhibited in the Anderson Gallery show in 1961. All possess "dead" black or black-and-brown grounds that recall the ancient stained wood of the herms and constructions.[11] Certainly all are related to the hanging construction *Marine Works* with its rows of orblike wheels.

Two of the paintings chronicle John F. Kennedy's election as president in 1960. *Electi* (fig. 3.7), in somber black, brown, and blue, and the more brilliantly colored *Ballyhoo*, in red, blue, green, purple, and yellow, continue the politicizing thread of works like *Cuba* and *Agadir*. Both combine spans of dominant stripes with rows of orbs, inviting comparison with Jasper Johns's targets and stars-and-stripes paintings of the 1950s. Indiana was certainly aware of his neighbor's work and his exhibitions at the Leo Castelli gallery. Johns's art must have borne some interest for the midwesterner, if only because as a queer artist, Johns articulated something similar to Indiana's own disenchantment with the machismo of the New York School. Johns's withdrawal from the prevailing grand manner of that school was a subversive artistic statement clothed in symbols of the mainstream (expressionist brushstrokes, American flags), and would have provided Indiana with a successful example of art that forged a covert sign system based on the culture around him.[12]

Electi was originally one-quarter wider, it had four vertical stripes and four orbs instead of three of each, and it was called *Election*. The circles here are quartered, in alternating dark and light hues, and were suggested, he says, by the "wheels that spun around on those computers on television in those days" during election coverage.[13] *Ballyhoo* also contains four vertical strips or columns, in the form of upward arrows topped by blank yellow circles; above that are squares containing the stenciled letters of the title. For Indiana, *ballyhoo* is a word that captured the spirit of political events in 1960. With its arrows thrusting at orbs (balls), however, it probably also refers to the most popular pinball game in America during his childhood, *Ballyhoo*. This pinball association cross-references the painting with *The American Dream #1*.[14] And there is one more connection: *Ballyoo* was a popular

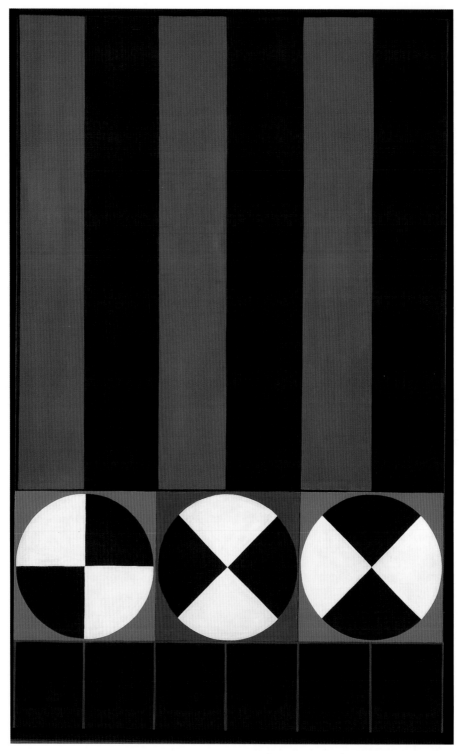

3.7 *Electi* (formerly *Election*), 1960-61.
O/c, 77 x 44¹/₂". Portland Museum of Art, Maine,
gift of the artist (photo my Melville McLean).

humor magazine in the thirties that often made fun of American advertising's commercial take on the American dream.

Personal iconography in the other four paintings is more insistent. *Terre Haute* is autogeographical (fig. 3.8). Although the artist lacked specific connection with the Indiana city, he told Richard Brown Baker that the painting is a "homage to my home state." As such, it is among the first of many works that (like his new name) refer back to his place of origin, or to significant locations in his life. A few years earlier Indiana had pursued the idea of personal geography in a group of abstract paintings named for Indiana counties, and *Terre Haute* is painted over one of these. These paintings may have issued from an impulse like the one that the autobiographical scholar Elizabeth Bruss assigns to those of somehow uncertain birth and parentage: for such individuals, "a birthplace becomes a spiritual as well as a physical location, and the knowledge of it a source of self-control." The artist himself echoed this impulse in a roundabout way when he spoke of Terre Haute in terms of his birth. Although he never lived there, he said, the town "intrigued me because it's on the *opposite* side of the state from where I was born . . . on the west side of Indiana [and] New Castle is on the east side." Indiana calls *Terre Haute* a landscape (a symbolic one), which relates it to later place-paintings like *The Geography of the Memory* and the "Confederacy" series.[15]

The mostly brown-and-black *Terre Haute*, the smallest and most vertical (60 by 36 inches) of the group of paintings begun in 1960, links it recognizably to the herms (compare, for example, figs. 2.33 or 2.37). Like many of these, the painting has three zones or registers: the topmost features, against a brown ground, a pair of black orbs enclosing brown six-pointed stars. Below these the title words appear in red stenciled letters. The painting's narrow bottom zone consists of brown-and-black danger stripes leaning left. The large black middle zone contains pentimenti (in black on black) of another pair of stars. But the flat dark zone is really articulated only by the legend *Wabash 40*, in white stenciled letters that rise in an arc from a point on the left top edge of the bottom zone. The words combine effectively with the slanting danger stripes to evoke movement, appropriate here since "Wabash" is a river and "40" a highway.[16] With its trilevel composition, pair of circled stars, and curve of white lettering, *Terre Haute* also evokes a physiognomy that perpetuates the thread of portraiture.

The last three paintings of this period, and the most significant, are larger and more squarish, roughly 72 by 60 inches each, proportions the artist would prefer from this time on. The first of these, *The Sweet Mystery*, was begun in 1960 and completed sometime in 1962 (fig. 3.9).[17] It is Indiana's last and most declarative use of the double ginkgo. In connection with *The Sweet Mystery* he told Baker that although *Terre Haute* came about as a word painting, *The Sweet Mystery* began mute: "I found there was a reason and space to add words to [*The Sweet Mystery*] and with *The Triumph of Tira*, which is a companion painting and had also existed previously without words – these became two of the very first word paintings."[18]

83

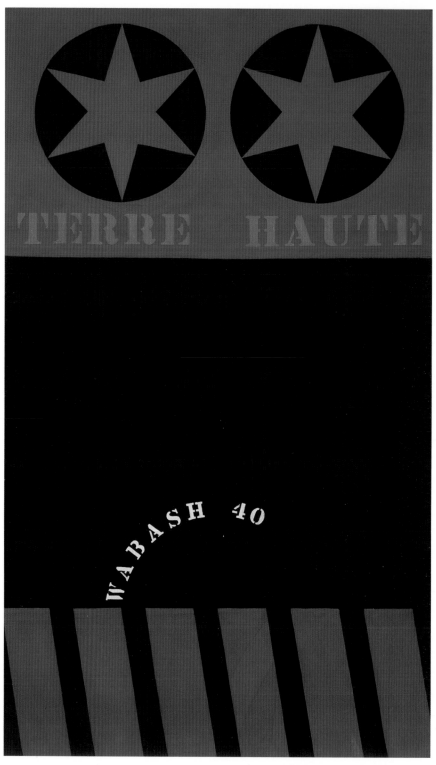

3.8 *Terre Haute*, 1960. O/c, 60 x 36". Private collection, London (photo by Bruce C. Jones).

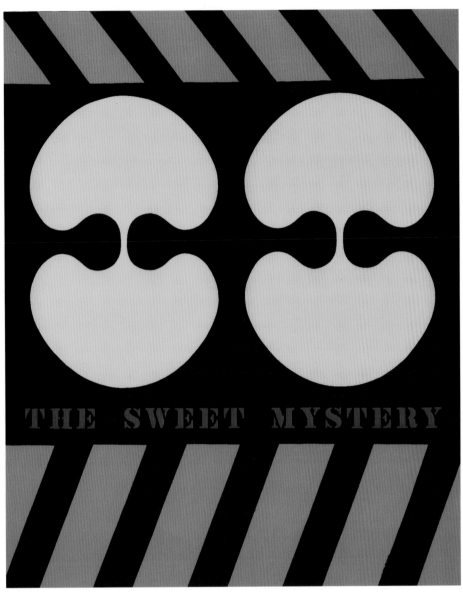

3.9 *The Sweet Mystery*, 1960-61. O/c, 72 x 60".
Private collection, London (photo by Eric Pollitzer).

Rather than having three vertically stacked zones, *The Sweet Mystery* incorporates spans of danger stripes along the top and bottom of the canvas that read as borders. The black middle ground here is filled with a pair of bright yellow double ginkgoes, and below them in modestly sized, royal blue stenciled letters, is the painting's title. Indiana's characteristic ginkgo is really a schema of the natural leaf, its contours symmetrically arched and rounded. Paired in yellow against black, they are dazzling "binocular" analogies.

Again, the painting's danger stripes in "stop red" are references to the stripes on barriers at railroad crossings and construction sites marking risky routes and roads. *The Sweet Mystery*'s reliance on highly saturated primary colors (red, blue, and yellow) suggests influence from both Kelly and, again, Johns. The primaries constitute a kind of found palette, and the zones of the Indiana painting reflect the zones of Johns's late fifties works like *Flag Above White with Collage* (1955), or the targets with rows of anatomical casts above. Yet Indiana fills his middle zones with, and sets his high hues against, flat black fields that add an edge of drama entirely unlike the work of the other two artists.

In 1966 or 1967 Indiana wrote a ten-point explanation for *The Sweet Mystery* (Appendix 2). In it, he personifies the ginkgo and identifies himself with the tree "casting off leaves at autumn" (point no. 4 – as he had cast off his former life). He also identifies with the ginkgo as a "new" Yin and Yang (no. 2, Indiana's single-sex – that is, homosexual or hermaphroditic – variety); and he identifies with the color yellow (no. 6). He connects the painting with "vision binoculaire" in statement no.7, and he links Connolly's suicidal Palinurus with a similarly lost poet friend from Chicago who had stayed with Indiana briefly during the latter's early months in New York, and who later took his own life. There are other personal references, including one to his mother, Carmen (no. 5), and another to a piece of land that his father once owned (no. 6), all of which make this painting more profoundly autobiographical than *Terre Haute*. Moreover, in the statement, Indiana strongly evokes the idea of music – Spanish strains welling up from the Rincón d'España beneath his loft (no. 5). In the end, the words of the title become a verse being sung (no. 10), probably the lyrics of Victor Herbert's popular song, "Ah, sweet mystery of life." The visually intense but subtly animated painting with its ginkgo eyes acknowledges presence and death – "hereness and nonhereness" (no. 9) – via the voice of a poet.[19]

The painting Indiana called a companion to *The Sweet Mystery*, *The Triumph of Tira* in the Sheldon Memorial Art Gallery at the University of Nebraska, is compositionally closer to *The American Dream #1* (see fig. 3.10). The Nebraska painting was begun in early November 1960 and reuses a canvas that previously had been a free-form abstraction (reminiscent of Youngerman and Kelly) called *Image of Man*, begun earlier in the year.[20]

The Triumph of Tira is built of two zones like the herms *Pair* or *Zeus* (later *Zig*; see fig. 2.33). Painting and herm productions were closely linked for Indiana at

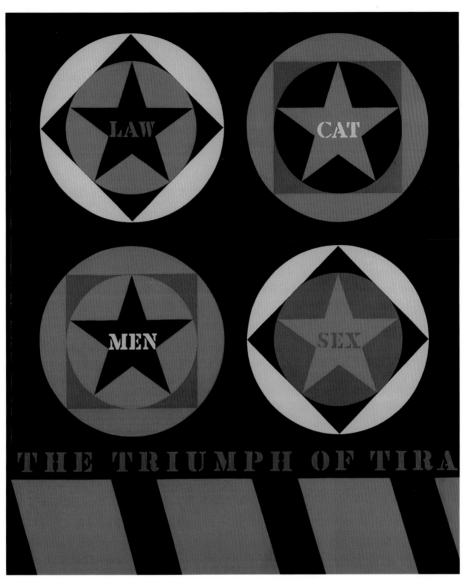

3.10 *The Triumph of Tira*, 1961. O/c, 72 x 60".
Sheldon Memorial Art Gallery and Sculpture Garden,
University of Nebraska, Lincoln, Nebraska
Art Association, Nelle Cochran Woods Memorial
Collection (photo courtesy of Sheldon
Memorial Art Gallery and Sculpture Garden).

the time, as shown in his notes for *Tira*: "Add raw sienna danger stripe and O's; same as those of tall vertical construction."[21] With its danger stripes and rows of paired circles, *Tira* also reflects *Marine Works*. The nearly square upper zone of the painting encloses four circles (also recalling orb paintings like fig. 3.4) against a black background, with the painting's title in stenciled letters across the bottom from edge to edge. Below that, the bottom zone is a border of broad danger stripes in red, leaning and leading our eyes to the left. But the orb formula is complicated with kaleidoscopic geometry and bright primary colors in addition to black and white. Each orb encloses a square or diamond (tilted square), then another orb, then a star, and finally at the center of each a three-letter word: LAW (top left, blue), CAT (right, yellow/gold), MEN (bottom left, blue), and SEX (right, yellow/gold).

The star-studded composition is appropriate to the artist's declared inspiration for it: stage and film star Mae West. The artist's major reference for the painting is West's 1933 film *I'm No Angel*. In it she played a lion tamer named Tira (who performed in the center ring, under the big top), and her escapades involve the big "cats," lots of "sex," and her "men" in trouble with the "law" (although LAW is also a cross-reference to Indiana's herm of the same name, which, as we have seen, has religious connotations). There is a generic connection also with West's earlier film, *She Done Him Wrong*, which had catapulted her to Hollywood fame and which she based on her previously successful Broadway play and signature title role, *Diamond Lil*.[22] Both films, *I'm No Angel* and *She Done Him Wrong*, were altered by Hollywood censors not only for references to sexual acts but for unprecedented directness of language. Her first produced play, which opened in 1926, was precociously entitled *Sex* and filled with bawdy repartee. She wrote in her autobiography, "The censor man asked me, 'What do you mean?' 'I can't tell you because it isn't something you can explain by numbers. You take it or leave it.'"[23] In other words, her repartee has communicative force, but its exact meaning is hard to pin down. It is on this primal and powerful level of multidetermined monosyllables and eye-intense visual direction that the painting and the films relate. Although she was diminutive in stature, West's screen presence is massive and slinky; as Tira she is like the cats she tames. Like them too she casts penetrating, pagan glances. *I'm No Angel* projects the catlike persona of West through a bilingual discourse of looks and utterances. Through orbic "vision binoculaire" and terse tokens of characteristic text, Indiana does the same.

Moreover, Tira, and West herself, are triumphant heroines, rising from humble, anonymous origins. Her persona presented a rare, renegade rendition – female and sexual – of the myth of the American dream, during some of the darkest years of the Depression. Following *I'm No Angel* (in 1934), *Vanity Fair* ran a cover on which West posed as the Statue of Liberty. For Indiana, West was a role model. Moreover, she was a heroine of homosexuals.[24] To cite her as Tira was to ally himself with an alternatively sexualized American dream.

West also figures into one of Indiana's personal narratives. He relates the story of his visit to Earl Clark in Los Angeles in 1949, on his way to service in Anchorage. The two men took a drive in Observatory Park, where at one point they watched a limousine stop and saw Mae West herself get out and scurry into the bushes (where they presumed she went to relieve herself).[25] But the comic anecdote only highlights, and in a way represents, the visit. It turned out to be the last time Indiana saw his adoptive father.

Dream-Work

The most important work of the period, in terms of both the artist's development and the amount of publicity he received, is *The American Dream #1* in the Museum of Modern Art (fig. 3.11). Of the group of paintings initiated in 1960, it is also the furthest removed from formulas derived from the herms.

The American Dream #1 developed slowly: on 15 July 1960 the green-and-white *Agadir* was overpainted black. Indiana's thinking on the new project continued for several months: on 30 October he noted in his journal, "It seems that having my recent tour of galleries put me back in a painting mood (plus a tiredness with constructions), but especially *Ronald* show, with a marked insight into use of black ground."[26] Predominantly black-white-and-brown abstractions by Canadian painter William Ronald, involving primitivistic geometry and subject-ground contrasts, were then on exhibition at the Kootz Gallery and no doubt reinforced or influenced Indiana's use of these colors in his paintings at that time. Two days later, Indiana sketched the general composition of *Agadir* in an upended position, with its former figure-ground equivalency replaced by noticeably vacant orbs on a dark and retiring field. It appears as if awaiting further articulation (fig. 3.12).[27]

The completed canvas was hung in the Indiana/Forakis show at the David Anderson Gallery in May 1961, where it was spotted by Alfred Barr and shortly after acquired by MoMA.[28] In a review of the show, Gene Swenson approvingly separated the painting from the expressionist idiom that still dominated the art world: "The American Dream, like a cosmic pin-ball machine, says – in stencil, 'Tilt,' 'Take All,' '40-29-66-37' (the numbers of highways), and 'The American Dream'; each legend is in a large circle with a five-pointed star inside. They light up in green, yellow, white, blue and orange over giant ocher stripes on a black canvas. . . . None of [Indiana's] work looks very much like Art; it is simple, direct and full of wonder."[29] With *The American Dream #1*, Indiana's style matured so that form and content – color, shape, symbol, language – coincide. If we now recall the palimpsest *Agadir*, we can see how it initiated a process of wandering meaning, or meaning, as Harold Bloom says, that "becomes multiformly determined, or even over-determined, interestingly explained by Lacan as being like a palimpsest, with one meaning always written over

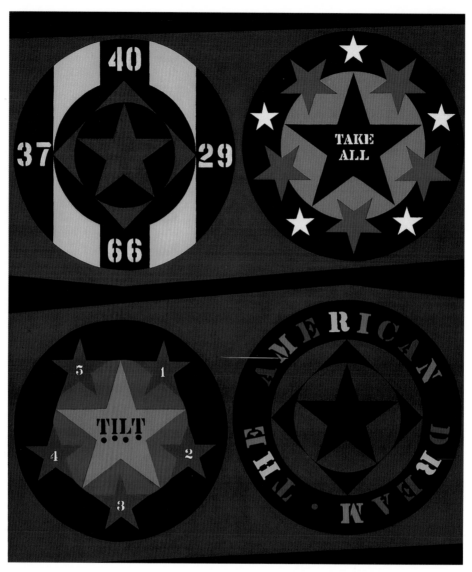

3.11 *The American Dream #1*, 1960-61. O/c,
72¹/₈ x 60¹/₈". Museum of Modern Art, New York,
Larry Aldrich Foundation Fund, 1961
(photo © 2000, The Museum of Modern Art).

3.12 "Originally Agadir," sketch of the *American Dream #1* in process. Journal-sketchbook 1959-60, 1 November [1960] (handwriting at upper right of sketch is artist's later notation). Artist's collection (photo by Tad Beck).

the other one." Wandering meaning is, according to Bloom, a primary process (in Freud's term), the kind found in dreaming or wishing – elsewhere Freud uses the term *dream-work* – that is linked to "poetic thinking."[30] In terms of the canvas under discussion, wandering meaning or dream-work began rooted in personal and figurative catastrophe *(Agadir)*.

Useful in decoding the finished painting is Indiana's "Artist's Questionnaire" from MoMA, which Indiana completed in December 1961. The document is probably his earliest real exercise in narrative elaboration of his paintings. In it, he outlined some of his ideas, beginning with another reference to the star of *The Triumph of Tira*:

> My "model" was Mae West (appearing at the time of execution of this painting on the television Late Late Show in "Night After Night" – 1932) who is the *most* American bloom to have flowered on this "scene," which in my case, is obviously *A*M*E*R*I*C*A*N*, and loaded with "personal," "topical," and "symbolic" significance, namely all those dear and much-traveled U.S. Routes #40, #29, #37 (on which I have lived) and #66 of U.S. Air Force days; those awful five [*sic*] bases of The American Game; the $T_I L_T$ of all those millions of Pin Ball machines and Juke Boxes in all those hundreds of thousands of grubby bars and roadside cafes, alternate spiritual Homes of the American; and star-studded Take All, well-established American ethic in all realms – spiritual, economic, political, social, sexual and cultural. Full-stop.[31]

Here, multiple narrative fragments subsumed in the work become juxtaposed and operate simultaneously: references to the screen star and other aspects of American culture are intermixed with autobiographical details, like being bused around while in the service. It is another tribute to, and identification of himself with, Mae West. We learn more, however, if our reading of the questionnaire's statement is informed by his exposition "Mother and Father," written in 1966-67 to accompany his parents' portraits. There he explains how their presence, too, pervades *The American Dream #1* (Appendix 2). Father was "American Dreamer #1"; and in this later explanation, highways numbered 37, 29, 40, and 66 are the ones father traveled, the last of which he ultimately disappeared on. Next to automobiles, pinball and slot machines (like *Ballyhoo*) were his parents' "favorite devices," and it should be noted that pinball, originating in the Midwest (Chicago), developed and gained popularity during Robert Clark's childhood, in the early years of the Depression. During the thirties the games had no flipper arms – the metal balls once launched merely ambled from bumper to bumper. So early pinball was a game of chance, a form of gambling like slot machines. Like the latter, pinball machines were equipped either to pay out winnings or at least tokens or gumballs ("Take All") or to signal a proprietor to do so.[32]

Finally, although Carmen was not exactly a Mae West (who in *Night After Night* was the old girlfriend of a social climber, perhaps like "dad"), Indiana portrays his mother (a personal "star") as a follower of Theda Bara – she "styled herself into a 'vamp,'" draped her clothes seductively, and curled her hair with marcelling irons and her bangs with spit. His own midwestern family, destroyed by the Depression, are ironic tropes for the American myth of upward mobility and its symbols of promised prosperity. Indiana reframes the myth Hollywood style as a sexy "family romance," with larger-than-life versions of Earl and Carmen, set in a roadside cafe.

The painting conflates personal and cultural history in numerous ways. In addition to stars, phrases, and colored numbers redolent of the popular amusements of the thirties and forties, he wrote in the MoMA questionnaire that the stenciled letters evoke the craft of the "lowly" American sign painter. In citing these honest artisans, enhancers of shopfronts and steamer trunks, Indiana associated himself with a figure from American folklore. Similar was his mention of the "raiment of the American soldier" – familiar from his own Army Air Corps days (especially the prominent circled star on the corps' uniforms and aircraft). He even gave to the term *hard-edge* a patriotic valence, commenting, "How American can a technique get?" Calling his own highly impure mix of words and abstraction "downright *miscegenatious*," he used the terms of contemporary art to satirize the myth of the melting pot.

In a different MoMA questionnaire the artist's answers surge to a rhetorical pitch as Indiana locates himself in relation to a bevy of precursor painters. When the questionnaire asks how his ancestry, background, or nationality are relevant to

the work, he answers, "Only that I am an American. . . . Only that for the last five years I have lived and worked on the Slip and the waterfront. . . . Not wishing at all to unsettle the shades of Homer, Eakins, Bellows, Sheeler, Hopper, Marin, et al, I propose to be an American painter, not an internationalist speaking some glib visual Esperanto; possibly I intend to be a Yankee."[33] Asked about his "program" as an artist in relation to society, Indiana's reply is his most Whitmanesque: "I am an American painter of signs charting the course. I would be a people's painter as well as a painter's painter."

Indiana's determination to cast his quest in such expansive terms may have jelled when he encountered a dramatic work bearing the very title that he later chose for his painting. Indiana explained years later in an interview with Donald B. Goodall: "The phrase [the American dream] I knew all my life and I certainly can't remember how I first heard it. . . . But there's no question that the focus was brought into being with [Edward] Albee's play, and my own first *American Dream* painting was done at the time of his play."[34] Indiana says that he probably saw the play in January 1961. He did not know Albee at the time; he met him only some years afterward, and they were never friends.[35] But seeing the performance immediately caused Indiana to abandon *Agadir* and give his painting a theme that was closer to home. He considered Albee a kindred spirit, and a number of parallels between them can be drawn. Both men intimate that their works spring from personal, that is to say autobiographic, experience. Both were adopted and neither knew his real parents. Both grew up in the Depression era (although Albee's adoptive parents, in contrast to Indiana's, were wealthy), and both are gay. Furthermore, the Fred, Carmen, and Robert Clark of Indiana's American Dream are counterparts to Albee's characters, Mommy, Daddy, and the unsatisfactory adopted baby and its replacement, the more satisfactory Young Man (the American Dream), who stand for Albee's own family.[36]

Both Indiana and Albee projected their personal experiences to the level of cultural allegory, and with corresponding components of satire. Indiana told Goodall that the first American Dream painting, along with the next one or two in the series, "were cynical. I was really being very critical. . . . 'Dream' was used in the ironic sense."[37] Similarly and about the same time, Albee wrote in his preface to the first published edition of his play: "[It] is a stand against the fiction that everything in this slipping land of ours is peachy-keen. Is it offensive? I certainly hope so; it was my intention to offend. . . . *The American Dream* is a picture of our time – as I see it of course. Every honest work is a personal, private yowl, a statement of one individual's pleasure or pain; but I hope that *The American Dream* . . . transcends the personal and the private, and has something to do with the anguish of us all."[38]

Both "dreams" aim part of their criticism at American habits of language, an element of the play that Indiana appreciated.[39] Albee himself has explained that the play, like many of his others, is largely about the breakdown of communication.

That is, in speech, words uncouple from "real" objective meaning and take on idiosyncratic or absurd meanings.[40] An example is the play's dialogue about a hat, which becomes an entirely different item as battling characters describe it as wheat-colored, as opposed to cream, or beige. Mommy's mysterious lunchbox in the play is a metaphor for the masking quality of language: she'd never open it – it was a beautiful object all wrapped up – and she deliberately misled others about what was inside. Albee's plays are typically full of semantic ploys and linguistic comedy. Indiana particularly recalls the moment in *The American Dream* when Mommy greets her visitors: "Are you sure you're comfortable?" But instead of the conventional "Won't you take off your coat?" she asks, "Won't you take off your dress?" The visitor answers, "Don't mind if I do," and complies. The dialogue mimics vaudevillian burlesque, which the playwright was versed in, for his adoptive grandfather managed such shows.[41]

Indiana's submerged subject, Mae West, also had a genius for farcical language. She rose through the ranks in the vaudeville circuit, starting out as a male impersonator. But she became an innovator of the "one-liner," charging discourse alone with the gag rather than relying on slapstick action.[42] She wrote all her own material, which, we have seen, was aimed at box-office appeal, not communication. Dialogue in her plays and films is smart, risqué repartee that caused constant battles with the Hays Office and kept her continually in the news. Her linguistic gifts resulted in a lexicon of epithets still current today, like "Goodness had nothing to do with it" (the title of West's autobiography); "Why don't you come up sometime and see me?" (customarily misquoted); and "Is that a gun in your pocket or are you just glad to see me?"[43] Using language as a veil and manipulating innuendo, West premiered subjects like prostitution, homosexuality, satyriasis, and interracial love on the American screen.

Robert Indiana's terse but highly charged word-and-symbol combinations in *The American Dream #1* seek a similar effect. Although they might originate in autobiography, his monosyllables and numerals can't be pinned down in their context: the enigmatic progression 40-29-66-37, TILT, TAKE ALL (in *I'm No Angel* West quips, "Take all you can and give as little as possible") ends with the phantom message THE AMERICAN DREAM. Letters and numbers appear to sparkle, spin, and, through the alternation of colors, to light up and flicker on and off. Clothed in the design of popular amusement and national symbol (Hollywood/military/Old Glory's "stars"; baseball diamond/"Diamond Lil"), the painting uses terms everyone can understand (its artist a self-proclaimed "people's painter"). Language in the painting is objectlike and tangible on the one hand, private and elusive on the other. It is also hierarchic and confrontational. This kind of language is brilliantly displayed by certain homosexual authors, writers sensitized to manipulation of meanings and audiences, like Oscar Wilde. Gwendolyn's lines in Wilde's *The Importance of Being Earnest* are described by Camille Paglia in terms that can also be applied to lan-

guage in Indiana's paintings: "Her speech, like his own epicene witticisms, has a metallic, self-enclosed terseness. . . . The bon mot, prizing brevity, is always jealous of its means. It is a sacramental display, baring the self in epiphanic flashes, like the winking of a camera shutter. The bon mot's spasms of delimitation are attempts to defy the temporal character of speech, turning sequences of words into discrete objects."[44] The effectiveness of *The American Dream #1*, what Alfred Barr called its "spellbinding" quality ("I don't know why I like it so much") is based on a careful design of language whereby it alternately masks and magnifies meaning. We have seen that, in moving beyond the powerful influence of Ellsworth Kelly, Indiana drew much from literature – from the classical myths of Hermes, contemporary drama and epic (Albee and Connolly), and American classics (Whitman and Melville). In spirit and method, he also drew from the verbal abstraction of Mae West, Oscar Wilde, and Gertrude Stein.

American Autobiography

For Robert Indiana, *The American Dream #1* signified, on the one hand, the past, childhood, Robert Clark, and disappointment, and on the other, the present, the new Kennedy era, Robert Indiana, and success. The MoMA painting generated a series and became axis of his sixties oeuvre. In 1982 he wrote, "It's a pivotal canvas and a crucial one to me. It changed the entire course of my life, and forms a bridge with my earlier work. . . . It's a comment on the superficiality of American life; its images are taken from pin-ball machines and the neon glare and the road signs of America. When I did that painting, I had no idea its theme would occupy most of my life."[45]

I have said that Indiana's mythology of mother and father, and of himself as the Robert Clark symbolically left behind in the Midwest, exemplifies the archetypal syndrome that was driven hard into American consciousness during the artist's childhood in the years of the Great Depression. The roots of the American dream run at least as far back as the time of Alexis de Tocqueville and can no doubt be detected even earlier in American writing.[46] The concept was forged from the Puritan doctrine of man's work as his second calling (his first being the one from God). The virtue of earthly industriousness evolved as a secular, materialistic faith in perfectibility and self-improvement. Thus, throughout the course of the slogan's history, its conflation of money and morality has remained its troublesome peculiarity.

Unlike some ideological tools, the American dream is not so much a collective belief as it is a nationally shared individual one. It is a promise of a personal success story, an "everybody's autobiography" (to use Gertrude Stein's term), and the right to one's very own happy ending. As such, the concept is traceable via

countless individual testimonies from the very founding of the republic. Benjamin Franklin's *Autobiography*, in some ways a first-person rewriting of John Bunyan's *Pilgrim's Progress*, is a blueprint for the American dream.[47]

As Franklin's example indicates, the American dream is lived by the self-made man, a term first recorded in Henry Clay's 1832 speech on his "American System" of early capitalism. The American hero was a man who pulled himself up by his own bootstraps. Humble origin was the birthmark not only of Ernst Kris's artists of legend but of exemplary American leaders like Clay himself ("mill boy of the slashes") and log cabin-bred Abraham Lincoln.[48]

Echoes of self-improvement, self-reliance, and self-help, customarily with the implication of financial reward, characterize nineteenth-century American popular literature. The rags-to-riches narrative contributed to the flourishing of biographical and autobiographical genres in the United States, from examples like *Hunt's Merchant's Magazine*, founded in 1839, a whole journal devoted to businessmen's life stories; or Charles C. B. Seymour's popular anthology *Self-Made Men* (1858); to hundreds of biographies and articles that filled the pages of magazines like the *Saturday Evening Post* and *Success* at the end of the century. Naturally, fiction that presented the life story of a (usually male) protagonist fighting his virtuous way to the top was equally popular. Such fictive life stories culminated with the novels of the Unitarian minister Horatio Alger (1832-99), whose pseudobiographies in the same vein sold by the millions. Viewed via the dream, the individual's life story is American allegory. By the twenties, Bruce Barton even applied the formula in a best-seller on the life of Christ, whom Barton presented as a biblical businessman, a manager from a manger (*The Man Nobody Knows*, 1924). Mae West and Edward Albee fit a pattern of direct, parodistic countertypes to these models.[49] So does Robert Clark/Indiana, in his progress from poor childhood to successful artist via application and enterprise. And his enterprise is nothing less than a cold, hard look at the dream itself.

The actual phrase *the American dream* was coined during the Depression – that is, during Indiana's childhood. It is credited to the historian James Truslow Adams, whose lightweight history *The Epic of America* was published in 1931 and topped the best-seller lists for two years. Adams's message is utopian and didactic, a dogged cheer in the face of growing evidence nationwide that prosperity is not always the reward for hard work: "The American dream that has lured tens of millions of all nations to our shores in the past century has not been a dream merely of material plenty, though that has doubtless counted heavily. . . . It has been a dream of being able to grow to fullest development as men and women, unhampered by barriers which had slowly been erected in older civilizations."[50] Adams's *Epic* was followed in 1937 by a saccharine novel entitled *American Dream* by Michael Foster. Such material bulked large in middle-class leisure reading in these years, and no doubt some of it was to be found in the Clarks' numerous Indiana

homes. Young Robert's childhood scrapbook, assembled during some of his family's darkest years, with its pictures of bungalows and gardens, interiors of kitchens and living rooms, faces of happy moms and dads and kindly politicians like Franklin D. Roosevelt, are the artist's earliest, hopeful essays on the American dream (see fig. 1.4).

At the same time the troubled American dream or American nightmare emerged as a theme in serious literature. In 1932-33 George O'Neil wrote a pessimistic play entitled *American Dream*, in which a nineteenth-century protagonist dies in defeat and his twentieth-century descendant/counterpart commits suicide – the play was not a box office success. Other works, like John Steinbeck's novels *Of Mice and Men* (1937) and *Grapes of Wrath* (1939), Eugene O'Neill's play *The Iceman Cometh* (written in 1939), James T. Farrell's *Studs Lonigan* trilogy (1932-35), and Nathanael West's novel *The Day of the Locust* (1939), feature characters who cling to dreams of better lives, dreams that have no chance of materializing. Indiana most recalls reading O'Neill's trilogy *Mourning Becomes Electra* (1931), which, though not set in the same era, similarly traces the misfortunes of a family whose members try to escape their fate of sin and tragedy but cannot. In American popular literature, failure or "riches to rags" stories became increasingly common and popular during the thirties, and the notion of the successful business hero was replaced by the antihero: the little guy, tough guy, gangster, or other outsider. The classic gangster movies, like *Little Caesar*, *The Public Enemy*, and *Scarface*, premiered in the early thirties.[51]

In real life, J. Edgar Hoover made the pursuit of "Public Enemy Number One," John Dillinger, a national cause. In Robert Indiana's account of his own childhood, the return of Dillinger's body to Mooresville in 1934 and the subsequent funeral, which brought the whole town out in compulsive curiosity, are major memories. Indiana's stories illustrate how an antihero of the success myth could capture popular imagination. During the thirties, writers, actors (like Mae West), and, to a lesser extent, artists – not criminals, but outsiders nonetheless – replaced businessmen in fiction and biography as role models of upward mobility.[52] Perhaps some sense of this shift informed Indiana's early determination to become an artist.

After the Second World War the American dream was reasserted in a self-congratulatory manner. Frank Capra, who immigrated from Sicily, celebrated the dream in films like *It's a Wonderful Life* (1949). As a cliché the term gained momentum in the late forties and fifties.[53] Scholars like Vernon L. Parrington (*American Dreams*, 1947) and Stewart Holbrook (*Dreamers of the American Dream*, 1957) connected the concept with reformist and utopianist ideologies. Amid the flag-waving of those years, the American dream was an easy catchphrase, a verbal salute emptied of meaning. By 1960 even a writer like Archibald MacLeish was capable of using the trope as a platitude: "There are those, I know, who will reply that the liberation of humanity, the freedom of man and mind, is nothing but a dream. They are right. It is. It is the American dream."[54] The idea of the American dream was briefly reconstituted in the optimism of Kennedy's "New Frontier." Its hopefulness was reframed

three years later when the Reverend Martin Luther King, Jr., announced that his interracial vision was "rooted in the American dream."

Albee's biting parody and Indiana's starry-eyed canvases are part of the tradition of intellectual criticism of the American dream that continued throughout the sixties and included such other examples as Norman Mailer's *An American Dream: A Novel* (1964), which is about the deterioration of the dream via the corruption of power in public and private life. But in 1960 Albee's and Indiana's critiques of the American dream were those of cultural "outsiders" – a writer and an artist who were both also gay and adoptees. As the decade progressed, others continued to redefine the dream as a dysfunctional mainstream mythology of birthright, unavailable to nonheterosexuals, nonwhites, nonmales, and others of marginalized status. In this sense, the visual arts descendants of Indiana's MoMA painting extend from Faith Ringgold's *American Dream* painting of 1964, an attack on the materialist obsession of the myth, to Gary Simmons's 1993 *American Dream* installation, done in several locations, of chalkboard, paint, an erased chalk drawing of a picket fence, and red-and-white flowers spelling the title in elegant letters.[55] Simmons defines the American dream as a site of gardens and lawns that are always seen from the other side of the homey white barrier – a mythical space also contemplated by the young Robert Clark when he assembled his childhood scrapbook.

Pop Art and Poetry

In the early sixties, the stylish new president and first lady helped broaden popular appeal of the arts. In this hopeful climate, artists began to use urban consumer objects less in the manner of assemblage, as ragged evidence of being-in-the-world, and more as spanking new cultural signifiers. Early in 1962 Sidney Tillim announced that artists had discovered "Mass man, a sort of Paul Bunyan made over by the Industrial Revolution," and commented on how the "perverse genius of the 'beatniks'" had given way to "a subversive form of reconciliation with society on the one hand, with subject matter on the other, or at least repressed desire for both."[56] Collectively, these artists and their patrons and audiences were, in Tillim's account, the "New American Dreamers."

Tillim's comments appeared in his review of the "Recent Acquisitions: Painting and Sculpture" exhibition then hanging at the Museum of Modern Art. Representing the show, Robert Indiana's *The American Dream #1* was illustrated with the review, and though it was made the subject of some scathing remarks, the painting obviously furnished Tillim with his theme.[57]

MoMA curator Alfred Barr's strong impression of the painting appears to have been shared by others. Two months before, on Christmas Eve, the painting was reproduced in the *New York Times*, and in March it appeared in another major

review of the MoMA show, in which critic Max Kozloff called *The American Dream #1* the "most blatantly 'American' painting exhibited." Kozloff went on, "Its juke box imagery, its buckeye paint handling, the outrageousness of its derivations, and its rhetorical flare were hard to ignore, if not to dislike."[58]

Critical dislike or not, such attention helped Indiana to retain a current presence through the summerlong wait for his premiere at the Stable, scheduled for October 1962. It was a crucial time. The opening of the MoMA show took place the previous winter (December 1961) and coincided with Claes Oldenburg's "The Store" exhibition, held in conjunction with the Green Gallery: a real store on East 2d Street, in which Oldenburg sold works that were three-dimensional, expressionistic re-creations of popular commodities ("The Store" was the second subject of Tillim's review). American Pop art emerged via these shows and the succeeding one-man exhibitions, in the late winter and following autumn of 1962, of Jim Dine (Martha Jackson, January), James Rosenquist (Green Gallery, January), and Roy Lichtenstein (Leo Castelli, February).[59] Indiana's Stable show in October (containing paintings that further elaborated the American dream theme; see Chapter 4) was followed in November by Andy Warhol's premiere at the same gallery. By then, Indiana had featured in several more critical articles that served to circumscribe the new movement. Writers discussed not just Pop art's obvious qualities, its subject matter drawn from twentieth-century mass production and commercial graphics, its general return to figuration (or explicit images), its connections with Dadaism, and its emphasis on formal qualities of the picture plane, but also its visual overload (a parity of the environment of contemporary life) and above all its self-conscious, sometimes obsessive Americanness. Gene Swenson and Emily Genauer, placing Robert Indiana at the forefront of the trend, independently coined the phrase *sign painting* in early fall 1962, referring to the evocation of road signs or commercial signs.[60] The term reflected the partnership of words and pictures in much of the new art, just as these are conjoined in real world signage and advertising.

At a symposium on Pop art on 13 December 1962 at MoMA, which was reported in *Arts Magazine*, the art historian Leo Steinberg reiterated the new cultural participation of Pop art. It had to be considered in terms of viewer response, not just objective criteria: "The artist does not simply make a thing, an artifact, . . . What he creates is a provocation, a particular, unique and perhaps novel relation with reader or viewer."[61] Steinberg realized that impact and response were as crucial to the new art as to the world of commerce.

The fact that Pop art, Indiana's like other artists', indeed sought an intensified relationship to the viewer was noticed by most critics, who spoke about Pop's heightened immediacy, and how it forced the viewer back on his own associations to interpret – say, a Coca-Cola bottle.[62] Indiana's painting *The American Dream #1* demonstrated the linguistic dimension of this idea: everyone knows the meanings of the words TILT, TAKE ALL, and THE AMERICAN DREAM. But their context in the

99

artist's autobiography was not known. That is their "secret content." Viewers had to provide their own connections – which they could easily do – for these common but confrontational words and phrases.

Allan Kaprow, in a March 1963 talk at the Jewish Museum, pointed out that Pop art has the same vitality and popular appeal as commercial art, not just similar subject matter. Invoking the theories of John Cage, he asserted that Pop art has potential for "illuminating the real material world and our attitudes toward it." Kaprow also noted that much Pop art taught us about ourselves through a kind of useful nostalgia. As Robert Indiana's work, for example, touches something like cultural memory, his "signs are not from Madison Avenue but the small-town drugstore pinball machine, flashing 'Tilt!' crying out 'America!,' the word he prints on them so often, the America of Dillinger holdups and 'Hellzapoppin!'"[63]

In the work of all the Pop artists, insistent references to America and its commercial icons, plus the lack of clear messages, suggested possible subversiveness. Its capitalist imagery, like Lichtenstein's comics-style commodities or Rosenquist's fractured advertisements, invited ceaseless speculation as to the work's political content. Despite its "cool," as Max Kozloff later wrote, "few people could speak coolly about it at all."[64] Just as abstract expressionism took a position on European modernism in the postwar period, so Pop art took a position on the American dream, exposing its confusion of acquisition, fame, and morality. The icons of American culture were all present: food, sex, Hollywood stars. But what exactly were the artists saying about these things?

The fact was, as Kaprow was among the first to realize, most Pop art dodged clear references to "issues" – it was too "timid," he said, "too much the product of a hot-house milieu."[65] Indiana, with his interest in topical subject matter exemplified by his herms *Cuba*, *U-2*, and *French Atomic Bomb*, was an exception. His critical posture was obvious and deadpan. And while most of the other Pop artists tended to skirt issues of subject matter and even avoided discussing Pop art head-on in print, it was on just these points that Indiana became a spokesperson. In a definitive series of interviews with eight artists, conducted by Gene Swenson and published in *Art News* in 1963-64 under the heading "What Is Pop Art?" only Indiana and Warhol stressed the "popular" character of the movement and offered definite comments as to what it was all about. Lichtenstein, Dine, Johns, and Wesselman all professed to be unsure as to what "Pop art" meant. Lichtenstein divulged that his cartoons were intended only as momentary diversions from his work's formal content, and Rosenquist stated, "[my real] subject matter isn't popular images . . . at all." Warhol, on the other hand, was forthrightly outrageous and a little sardonic when he stated that Pop art is "liking things."[66] But only Indiana offered statements that revealed an outright involvement with the new style. He spoke autobiographically and with enthusiasm and a momentum born of the recent success of his keynote canvas: "Pop is everything art hasn't been for the last two decades. It is basi-

cally a U-turn back to a representational visual communication, moving at a break-away speed in several sharp late models. It is an abrupt return to Father after an abstract 15-year exploration of the Womb. Pop is a re-enlistment in the world. It is shuck the Bomb. It is the American Dream, optimistic generous and naive." In line with its autobiographical nature, Indiana's representation of the new style is gendered and uses the terms of family relationships. Perhaps his "return to Father" suggests sexual preference in terms of a patrilineal identity or otherwise hints at the depths of his own "secret content."

Another quality separated Indiana's involvement with cultural symbols from that of his colleagues: a tendency toward what we might call pattern poetry. Indiana himself describes his work of the 1960s in terms of versification: "My own thought on how my paintings are like poetry involves the use of repetition, series, and sequence."[67] In the 1960-61 group of paintings that I have been discussing, the same words do not reappear from painting to painting, but a visual consistency is evident overall. All the works of the 1960-61 group present a binocular frontality that we might consider an overarching motif. All possess, as major compositional forms, circles that are either paired or quadrupled. In addition, all the canvases are divided vertically by horizontal zones or bands. All contain stenciled letters, and two of them numbers. Three have stars within circles (five-pointed or six-pointed). Two (*The Sweet Mystery* and *The Triumph of Tira*) have upper and/or lower borders of danger stripes though their width and angle varies; the other three (*The American Dream #1*, *Electi*, and *Ballyhoo*) echo that feature with vertical stripes. The recessive black- or brown-and-black-colored ground is common to all. Moreover, primaries red, blue, and yellow, plus ochre and cadmium green light, complete Indiana's palette for the group.[68] Finally, all the paintings have some sense of movement that is left to right, or upper left to lower right, which coordinates with the way we read the words in the compositions. A feeling, if not of poetry or song (explicitly referenced in the artist's statement for *The Sweet Mystery*), then certainly of recitation or melodious oral discourse, is generated overall.

In the sixties, repetitive formatting of imagery was not uncommon and achieved increased attention among critics and curators who often labored over theories and definitions of terms like *serial imagery*, the title of John Coplans's book on the subject.[69] But as Coplans pointed out, serial repetition directed attention toward identical (mechanical) repetition in life, not just in art, because it drew its imagery from mass production. Nearly everything about Pop – from Oldenburg's cheap commodities in "The Store" and the Benday dots of Lichtenstein's comics to Rosenquist's imitation of commercial photography's satiny, succulent surfaces and Warhol's silkscreen photoreproductive techniques – spoke of the endless sameness of objects of popular appeal. Warhol and other artists like Robert Watts even used exact replications of already-replicated objects, like Coca-Cola bottles or postage stamps, in works that were micro-ordered (internal) series – that is, near-identical images

assembled in modular or gridded arrangements. As if in argument against Walter Benjamin's well-known thesis concerning the weakening effect of reproduction in works of art, put forth in his famous essay "The Work of Art in the Age of Mechanical Reproduction," Warhol's relentless, media-inspired repetition of personalities (Marilyn, Jackie) or horrors (car crash, electric chair) achieve a haunting, stroboscopic, almost dreamlike effect. The psychological dimension of this is evident in Warhol's *Art News* interview:

SWENSON And liking things is like being a machine?

WARHOL Yes. Because you do the same thing every time. You do it over and over again.[70]

Warhol is parodying obsessive repetition, the kind that Freud linked with retrogression and the death wish. Repetition, according to Freud's theory, is partly "a need to restore an earlier state of things," answering a movement always toward a lower state of tension and energy, for tension and energy are necessary for concerted action but traumatize humans, like all other organisms, at the cellular level. The sinister flavor of Warhol's Factory-produced repetitive imagery accurately expresses Freud's suggestion of affinity between pleasure and death.[71] But in the same essay Freud links repetition also with life in organisms via their inexplicable internal counterthrusts to expend energy. Freud himself discussed the repetition compulsion on a less primitive – that is to say, less biological – level, as a transformation mechanism that can turn an unpleasurable experience into play, as in the example of his infant grandson, who acted out his mother's leaving and coming back with a game involving a wooden spool on a string and the exclamations, "fort" (gone) and "da" (here). In adult patients, Freud found that psychological trauma from the past is kept in a continual present by turning into some compulsively repeated behavior. According to Lacan, too, linguistic or verbal repetition contains the effort to control the trauma by making time stand still. Lacan elaborates on Freud's story of the child with the spool by pointing out that the past is reversed in repetition so that the trauma and play are experienced simultaneously through language by a split or polarized self. "If the child now addresses himself to an imaginary or real partner, he will also see this partner obey the negativity of his discourse, and since his appeal has the effect of making the partner disappear, he will seek in a banishing summons the provocation of the return that brings the partner back to his desire. . . . Thus the symbol manifests itself first of all as the murder of the thing, and this death constitutes in the subject the eternalization of his desire."[72] In Indiana's mature paintings that begin with the 1960-61 series, something of this controlling of catastrophe by murdering its objects manifests itself not in immediate and mechanical repetition of morbid images, as with Warhol's electric chairs and disasters, but in sequential rep-

etition from canvas to canvas that renders ambivalence as a kind of visual play. *The American Dream #1* and its companion canvases are, in this analogy, like intensely colored game boards on which are symbolically played out both the artist's loss and his desire to transcend time – that is, both to banish and become some imagined partner or precursor. According to Harold Bloom, whose own precursors include both Freud and Lacan, such repetition is a mark of the poet. In this sense, repetitive behavior has its source in a fixation ultimately based in some unspecified or unknown "primal repression" that is itself a fixation upon the precursor who functions as a mortal god.[73] "'Creativity' is thus always a mode of repetition *and* of memory and also of what Nietzsche called the will's revenge against time and against time's statement of 'It was.'"[74]

We have seen how, in the hands of a character from Wilde, the bon mot's spasmodic character seeks to subvert the fleetingness of speech. Robert Indiana's own propensity for repetition – of words, stripes, and stars that are projected from canvas to canvas – was directly reinforced by his interest in another verbal innovator, Gertrude Stein. During his early years on the slip, Indiana indulged that interest in company with Agnes Martin, who read Stein out loud to guests in her loft, especially the erotic verse of *Tender Buttons*. Indiana met Virgil Thomson, another Stein enthusiast and friend (who wrote the score for Stein's opera *Four Saints in Three Acts*), in 1964, and the two exchanged portraits of each other (Indiana's canvas, *Yield, Brother Virgil* and Thomson's piano portrait of Indiana, *Edges* – both 1966). Indiana based the words in his later *Mother* and *Father* paintings on a Stein text.

Stein's verbal repetition, employed as her alternative to narrative, is explicitly delivered in an example like her Martha Hersland chapter of *The Making of Americans* (1925), in which language unfolds in a way that connects "repeating" with "living" and "loving" and finally with peoples' "bottom nature."[75] It is a rhythmically, ritualistically repeating text, yet one that moves slowly forward through incremental variations. At one point in the chapter, for example, Stein writes: "There is always then repeating, always everything is repeating, this is a history of every kind of repeating there is in living, this then is a history of every kind of living"(159). A few pages later, the theme progresses: "Every one has in them always their own repeating, always more and more then repeating gives to every one who feels it in them a more certain feeling about them, a more secure feeling in living" (163). Stein's prose is a rhythmic edging or grinding forward wherein certain key words are captured, provide a rhythm, and are exchanged one by one for others in an ongoing process. In Stein's 1934-35 *Lectures in America*, she further elucidates her technique: in "Portraits and Repetition," she links it with formal synchronism in portraiture. She wrote, "Each time, and I did a great many times say it, that somebody was something, each time there was a difference just a difference enough so that it could go on and be a present something." Stein called this kind of repetition, which keeps the process always in the present, "insistence," saying that it was not

really repetition because it had to do with expressing something, and "the essence of that expression is insistence, and if you insist you must each time use emphasis and if you use emphasis it is not possible while anybody is alive that they should use exactly the same emphasis."[76]

Robert Indiana's use of repetition is comparable. In 1962, with his artistic breakthrough followed closely by art world recognition, his involvement with issues of repetition, portraiture, and self-portraiture began to take shape. Like Stein's style, which sustained Indiana's fascination throughout his formative period, Indiana's works, beginning with the group discussed above, deliver a thematic cluster of verbal-visual characteristics that are manipulated in repeating but continually changing ways. Indiana's 1960-61 paintings define a vocabulary that is projected as rhythm and pattern from canvas to canvas. Earlier, his portraits and ginkgoes were already gravitating toward repetition and series. True serial order was achieved in the orb paintings, but their content was mute. The open-ended series of automorphic herm constructions, however, demonstrates the use of systems of signifiers to encode various aspects of the artist's own personal history and concerns. Combining atomized representations of an imagined identity, the herms mirror Robert Indiana just as Narcissus was mirrored by the pool.

In a more articulate yet less obvious way, Indiana's early word paintings crystallize autobiographical headlines and identity impulses (and "figures," like Mother, Father, and Mae West) as word-and-symbol systems possessing pattern and rhythm. The phrase *The American Dream #1* – as a trope for his family as his personal precursors, both real and imagined – is the title of one painting, the theme of the group as a whole, and the theme of a second group of "American Dream" paintings subsequently generated, which will be discussed in the next chapter. Partly consciously and partly unconsciously, this man who split himself between child and adult, Midwest and East Coast, all-American boy and homosexual, lost and found, created, from the groundwork of the herms, the means to become Robert Indiana. The door is opened to further speculations that the balance of flat, hard-edge form, brilliant unmodulated color, basic cultural symbols, and short popular words and terms provides satisfying verbal-visual resolutions that displace emotional content of Robert Clark's actual experiences of a troubled childhood and perhaps (but only perhaps) being denied his natural mother. The emergence of certain forms as pattern and repetition, over the course of the group of 1960-61 paintings that I have been discussing, underlines the representational economy characteristic of symbol-charged form. Repetition here offers similar sensations of accomplishment, completeness, and security that Norman Holland has noted in our responses to rhyme in poetry.[77] This recycling of word, sound, and form seeks the power of presence over time, and a relentless insistence (in Stein's sense) on symbols of identity.

4

"Verbal-Visual"

Indiana's patterns of self-referencing, which emerged in 1958-61, matured during the following years in ways that are worth examining. One stage of the maturation process took place during the winter of 1961-62, in paintings that went on view before his Manhattan debut, in a small gallery in Mamaroneck, New York. It was an opportunity that grew out of his Scarsdale job, so minor that it has never been listed in any Indiana vita. The show comprised small, intimate paintings, like *Fun* (see fig. 2.31), that are close to the dimensions of a typical typewritten page. They are reductive compositions featuring words within simple arrangements, addressing verbal-visual interaction in the most direct manner possible.[1]

In most of these works (figs. 4.1-6), upper and lower zones are created, with one or the other containing, in anonymous-looking, stenciled letters, a monosyllabic word usually denoting an action or emotion. Some canvases, like the 1961 *Love* (later named *Four Star Love*) and *Joy*, suggest quadrants or crosses and link backward to *Stavrosis* and the orb paintings (like fig. 3.4), and forward to *LOVE*. The small concrete word compositions seem at first glance to reflect Indiana's reading of Gertrude Stein during this period. His friend William Katz cites, in connection with Indiana's use of such short words, Stein's assessment of American speech, which is based, as she wrote, on "words of one syllable made up of two letters or three or at most four."[2]

But the Mamaroneck paintings all display word/context disjunctiveness that goes beyond Stein's emphasis on the materiality of language. One might compare them, for example, with precedents in Surrealist painting that involved ideas about symbolism from discoveries in the field of psychoanalysis, particularly the work of Freud on dreams. Surrealist artists often sought to employ language not in its conventional usage but in ways that display unconscious operations like the condensation and displacement characteristic of dream imagery. Figurative language and metaphor were explored by surrealist artists particularly in nonanalogous or unresolved

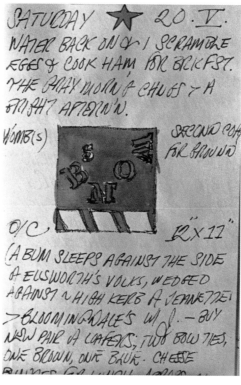

4.1 "JOY" and "LOVE," sketches of paintings in progress. Journal-sketchbook 1961-62, January [1961]. Artist's collection.

4.2 *Wombs*, sketch of painting. Journal-sketchbook 1960-61, 20 May [1961]. Artist's collection.

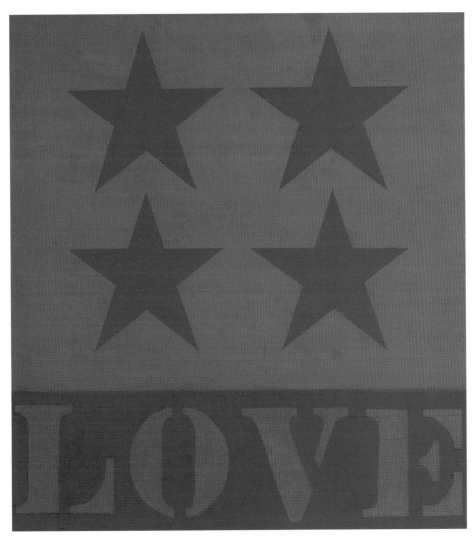

4.3 *Four Star Love*, 1961. O/c, 12 x 11$^{1}/_{8}$". Portland
Museum of Art, Maine, gift of Todd Brassner in
memory of Doug Rosen (photo by Melvin McLean).

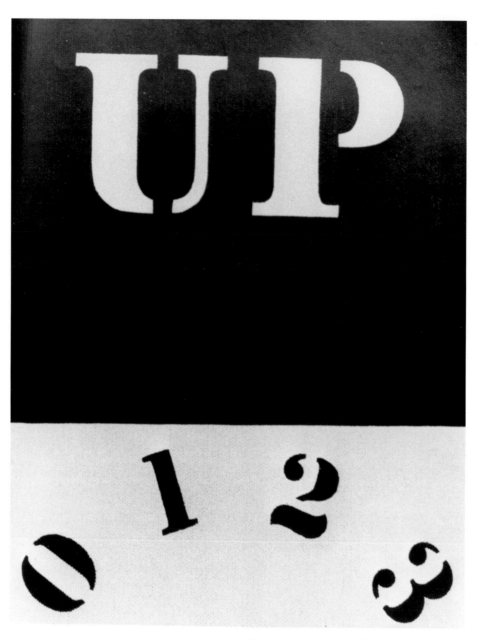

4.4 *UP*, 1962. O/c, 26 x 21 cm. Karl Ströher Collection,
Darmstadt Hessisches Landesmuseum, Darmstadt.

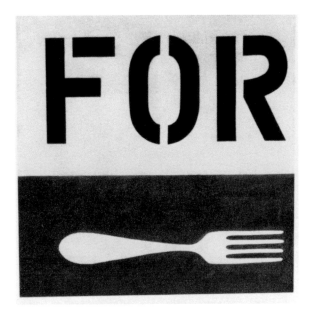

4.5 *FOR*, 1962. O/c, 12″ square. Herbert Lust Gallery, New York.

4.6 *HUG*, 1962. O/c, 12″ square. Herbert Lust Gallery, New York.

forms, as means for giving "to the abstract, the mask of the concrete," as André Breton put it.[3] His ideas are reflected in word works as disparate as Joan Miró's enigmatic *48* of 1927 and René Magritte's diagrammatic word-image paintings of the late twenties (for example, *La Clef des songes* in Munich, fig. 4.7), in which pictures of things are paired with unrelated words. These are precedents for the pictographic riddles that Indiana exhibited in Mamaroneck.

4.7 René Magritte, *La Clef des songes*, 1927. O/c, 15 x 10⅞". Staatsgalerie moderner Kunst, Munich, Theo Wormland Collection.

It is interesting if somewhat speculative in this connection to note that both Indiana and Magritte suffered some sense of maternal loss during childhood, though Magritte's was more direct (his mother committed suicide by throwing herself into a river when he was thirteen). In Indiana's case, the loss of a biological mother (whom he could not have remembered but of whom he always knew) may have been symbolically present in his mind when at fourteen he left his adoptive mother, Carmen, to attend school in Indianapolis. Both artists moved from home to home during their childhoods and had strong autobiographical impulses that appear in their paintings. Martha Wolfenstein, a psychologist who studied Magritte, concluded that the coexistence of unresolved opposites and dualisms in that artist's work may be due in part to defensive splitting and condensation stemming from these traumatic childhood events. Something similar in the case of Indiana's word-image works seems plausible, especially in light of paintings like *Wombs* − the word in the plural suggesting more than one birth-giving organ, more than one mother (fig. 4.2).[4]

Of the word art that abounded in late fifties and early sixties in New York, most influential was that of Jasper Johns, who was himself interested in Magritte. Johns's *TANGO* (1955), *TENNYSON* (1958), and *NO* (1961) all bear comparison

4.8 Jasper Johns, *TENNYSON*, 1958. Encaustic and
collage on canvas, 73¼ x 48¼". Collection of the
Des Moines Art Center, purchased with funds from
the Coffin Fine Arts Trust, Nathan Emory Coffin.
© Jasper Johns/licensed by VAGA, New York.

with Magritte's surrealist dissociations of word and context. In the Johns examples,
words appear in otherwise scarcely articulated painted fields (fig. 4.8). The viewer
tends to search the canvas for clues to complete the meaning.[5]

Texts in the Mamaroneck Indianas, which share this quality of being isolated
signs, are at first glance seemingly without context, save for what can be construed
from canvas, color, and exhibition wall. Simple, inexpressive frontal letters domi-
nate these paintings and our views of them, just as the orbs in the artist's previous
binocular compositions did. The words on the small paintings draw upon but differ
from those on Indiana's automorphic herms, where they serve as titles and come
across as proper names. Also, the small paintings give out less information and are
less complex visually than the group of larger paintings including *Terre Haute*, *The
Sweet Mystery*, and *The American Dream #1*, with which they are contemporary.

But the Mamaroneck paintings are different from Magritte's or Johns's works
in a significant way. These artists critique our understanding of representation.
Magritte's paintings point out that they are *not* something (not really pipes, for
example). Johns's flags, though they qualify technically as flags, still cannot be
waved, and Johns's words oppose the act of viewing painting to that of reading. As

Philip Fisher says, "Looking at a word [as in the Johns painting *No*] involves not seeing or considering that it is black or linear or oppositional or anything else." They are in that sense transparent. Indiana's words, on the other hand, are just the opposite. They are short and isolated and thus assertive as abstract shapes. More important, they possess the kind of power that words have in commercial graphics, where they both imply objective narrative and also float free of it and point subjectively, directively, toward the viewer. The mystique of such words resides in their economy. In extreme cases (*FUN, JOY*) words in the Mamaroneck paintings are like signs adrift of sign systems. They exemplify what Roland Barthes observed generally in Pop art, "the attempt . . . to abolish the signified, and thereby the sign; but the signifier subsists, persists, even if it does not refer, apparently, to anything."[6]

Given Indiana's literary leanings, there could be another way to view these terse, semiotically mixed canvases. Perhaps their bilevel or zoned appearance cues the reading of them as pairs of related statements – that is, in terms of literary parallelism.[7] They evoke the comparisons of likeness or contrast to other words and meanings, as in metaphor or simile. For example, in a painting called *GRASS* (probably a reference to Whitman's great metaphor for America), the title word is painted above a rectangle of unmodulated green. More suggestive is *HUG* (see fig. 4.6), which embodies a word for an emotional action in the paradoxically anonymous format of stenciled lettering. Then that paradoxical unit is placed above a vacant rectangle implying emptiness or absence (the denial of both the word and the intimate activity that it describes). In *Four Star Love* the pairing of the four-letter word with four stars signals an analogy, though one that is hard to understand, like a riddle or rebus (see figs. 4.1 and 4.3). Like figures of speech as traditionally encountered, the Mamaroneck paintings are meant to exploit and empower words by mixing idea and palpable thing, through comparison.

The difference embedded in the structural pairing of words with symbols (or simply with shapes and colors) in these abbreviated verses has much to do with the distance between the sign and the thought or idea to which it is linked. Charles Peirce embedded the notion of distance in his theory of signification types: indexical signs are close to their referents, symbols much farther away.[8] Humans create symbols when they respond to immediate situations by producing words – frozen responses – that can be stored up for future use. These words bridge psychic distances – between, say, the traumatic reality and the spool on a string and its verbal accompaniment *(Fort/Da)*, as in Freud's case of the child whose mother goes out.

With their diagrammatic frameworks, the Mamaroneck Indianas activate the distance between meaning and word, and, by extension, between sender/subject and recipient/viewer (the communication function of the sign). Indiana's painting *UP* (see fig. 4.4) exemplifies directional thrust denotatively, connotatively, and mimetically via composition: the simple adverb is announced above (in inexpressive, stenciled Roman capitals), while the 0-1-2-3 below illustrate counting up, and their

semicircular ground line, which points up, also calls to mind floor signals above old elevators. Thus the idea of "up" is embodied five different ways, some immediate, some remote. *FOR* offers an interpretive journey from word to picture, guided by the preposition's implication of direction ("toward" a prepositional object), and the image of a fork posed as an arrow (see fig. 4.5). It has an artistic precedent in the puns in cubist paintings that are based on fragmented words (for/fork). In *FUN, JOY*, and *LOVE*, the position of the simple "messages" is occupied by totally opaque, generic symbols (stars and circles) that nevertheless retain some of the same physiognomic, spectral references found in Indiana's orb paintings and herms (see figs. 2.29, 3.4). But that is background, unknown to most viewers. Simply seen as pairs of statements or lines, they are like pictographic verses evoking unresolved, poetic parallelisms. We find a pair of orbs or four stars where we might expect information clearly applicable to the concepts of joy and love. We are presented not merely with negation of meaning but with the assertion of enigma. As with *The American Dream #1*, the viewer of the small paintings with their verselike images must apply her own symbol and word associations, complete the riddle, and grasp the semiotic rhyme. The space between word (sign) and meaning (idea) intersects with – is creatively synthesized by – the spaces between subject and audience, and painting and viewer.[9]

Plays on Words

The small paintings shown in Mamaroneck by no means exhausted Indiana's verbal explorations in 1961-62. In another group of paintings begun that winter he incorporated American literature: texts by Whitman, Melville, and Longfellow, and even an American gospel song. As we shall see, these "literary" paintings reflect his awareness of environment, dance, and performance media developing around him in New York. Seeing Tinguely's vast wheel- and gear-laden machine *Homage à New York* in 1960 (in the same MoMA assemblage show in which Indiana exhibited *Moon*) may even have stimulated Indiana's enthusiasm for wheels on his constructions, which appeared about the same time. That year, too, Indiana attended performance pieces by Jim Dine and others.[10]

Indiana worked with dancers – transforming one, Fred Herko, into a living "herm" (fig. 4.9) – when he designed a set for James Waring's *In the Hallelujah Gardens*, performed at Hunter College in 1963. Herko wore pairs of wheels like those on Indiana's totemic constructions. The dancer turned two large ones at his sides slowly with his hands, making his way across stage uttering piercing screams as if a hidden axle were mangling his insides.

During the 1960s Indiana had ideas that were never realized in exhibition about painting-sculpture pairs or groups. His black-and-white *Melville Triptych* (*Whitehall, Corlear's Hook, Coenties Slip*; 1962), for example, was formulated for

113

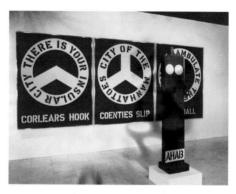

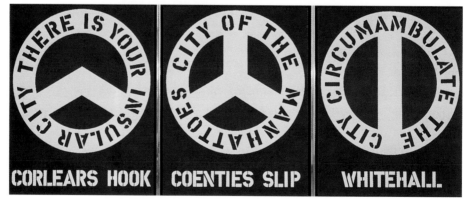

4.9 Fred Herko as Icarus in James Waring's ballet
 In the Hallelujah Gardens, Hunter College, 1963.
 Artist's collection (photo by Basil Langton).

4.10 (BOTTOM) *Melville Triptych*: *Corlear's Hook,
 Coenties Slip, Whitehall*, 1962. O/c, 5 x 12' each.
 Private collection, Switzerland.

4.11 *Melville Triptych* and *Ahab* installed together,
 ca. 1972. Artist's collection (photo by Denise René
 Gallery).

the black-painted "male" herm *Ahab* of 1961-62 (fig. 4.10; see also fig. 2.46). The artist thought of the triptych and *Ahab* as being mated (fig. 4.11). In such pairs, the paintings played a feminine role and the herms, naturally, a masculine one (only "male" herms were used as such) in a conjugality (or parental configuration) that expands the implication – which we have seen the herms alone evoke – of the artist's works as sexual personae spun off from and mirroring his own psyche.[11]

Moreover, just as the Mamaroneck paintings pose riddles that engage their spectators, these multidimensional gendered ensembles were also intended to draw viewers to/into the works. The artist recalls being impressed by this aspect of performances and happenings: "In them the spectator was often surrounded, immersed in the work of art. . . . [Likewise, Louise Nevelson's works, for example,] were presences that filled the whole room and when you entered you couldn't escape it."[12] Indiana no doubt realized that words also contribute to a kind of situation or special space that could involve viewers more intimately. Coincidentally, in the early sixties, an action-oriented branch of linguistic studies known as speech act theory was formulated, paralleling the proliferation of word and performance practices in art, much as Saussurean linguistics paralleled the word art of the early century.

Speech act theory, the creation of the British linguistic philosopher J. L. Austin, emphasizes language as discourse, determined by its active and contextual contingencies. At bottom, the theory holds that most word usage involves a kind of performance. Earlier writers had addressed the functional dynamics of the "speech event."[13] But speech act theory went much further. Without describing its complicated program, which posits cumbersome rules and categories for discourse, speech act theory contains certain ideas that are germane here. First, language is a practice that inscribes a subject, or at least a subject position, as well as an object or audience position. It has direction. Second, our speech can be divided into simple descriptive statements (which Austin calls locutionary acts) and other kinds of statements (illocutionary acts) that are aimed at making something happen (questions and commands, for example, and statements like "I promise"). Illocutionary acts are distinguished by communicative force originating from the subject position. Through them, a speaker exerts a degree of power over his or her hearer.[14]

Whatever its virtues or faults as linguistics, speech act theory furnishes an operational model of message transmission in humans that helps us to understand the dynamics in Indiana's word/symbol art. If the herms are presences, they are objectified ones – they bear words that are nouns/names (just like most of the words in the Mamaroneck paintings). Beginning with the TILT and TAKE ALL of *The American Dream #1*, his paintings often (though not always) prominently feature verbs or predicatory statements that can function as imperatives and posit direct address.[15] Thus a change takes place from the earlier work. The early and mid-sixties

canvases begin to imply a subject position somewhere within the design. They soon became subjects themselves as they personally engaged the viewer in a communicative situation that involves a dynamic and represents what might be called illocutionary force.

In the early sixties, Indiana certainly knew that words in his works involve a complex enterprise with the viewer that goes beyond the mere reading of text. He described it in 1963 in a fascinating segment of his interview with Richard Brown Baker:

RB In these cases when you have an idea – you might call this a literary idea [to do a "Titanic" painting, say] . . . I don't know whether that's a literary idea or not, but it's not a purely visual idea.

RI I prefer to think of it as verbal-visual, not literary.

RB That's an interesting phrase.

RI What I am thinking about is the very elementary part that language plays in man's thinking processes and this includes his identification of anything visual. And that is . . . that the word, the object, and the idea are almost inextricably locked in the mind, and to divide them and to break them down doesn't have to be done. The artist has usually done it in the past. I prefer not to.

RB Certain painters recently – people that I'm sure you know – have actually incorporated sound into their painting.[16]

RI It's something that I haven't come to because I'm not very much given to mechanical dexterity but it is certainly something that I wouldn't necessarily scorn.

RB . . . A great actress says, "Corlears Hook" or something from behind the canvas.

RI I'd love it . . . but it's not what I'm thinking of . . .

RB . . . Part of the element could be in an act that is within the mind: one hears a sound, and I look at *The Figure 5* . . . am I supposed mentally to say to myself, "the figure 5"?

RI: You may very well do that on first confrontation, Dick, but I am very much impressed . . . how, with a little concentration and a little mental exercise, if one concentrates long enough on a word or a figure, it's very easy to lose the conscious grasp of what it is. . . . And I should like . . . this to be part of my work, too.[17]

Just as the words in the Mamaroneck paintings created enigmas based on verbal-visual versing, one gets the sense from these comments that the words and phrases in his other paintings combine letters and sounds to signify both meaning and forgetting. One might look at a word or hear it and forget what it means. In this connection, a particular series of works produced in 1960 present individual letters of the alphabet (for example, H, T, and R; fig. 4.12). Words are formed when one phonetically sounds out such letters, and the fact that Indiana thought of them this way is borne out by his journal notes, which call H, for example, "AITCH."[18] Much more complex is the case mentioned by Baker, *Corlear's Hook* (one of the *Melville Triptych* paintings), which is a noun and a name – a place near Indiana's home in New York, and also a famous place in literature. Language here is rhetorical, and the paintings' compositions activate its recitation. The triptych belongs to the group of "literary" paintings completed in 1960-61 and including *God is a Lily of the Valley*, *The Calumet*, *Year of Meteors*, the *Melville Triptych*, and *Melville*, paintings that incorporate whole lines from American literature.

4.12 "Six Aitches," sketch for painting.
Journal-sketchbook 1960-61, 16 May [1961].
Artist's collection.

Of the group of so-called literary paintings, three are based on verse. *God is a Lily of the Valley* (fig. 4.13) is anonymous folk literature, a spiritual that Indiana heard on the radio one evening. *The Calumet* (fig. 4.14) quotes the first, third, and seventh lines from the first stanza of Longfellow's *Song of Hiawatha* (Indiana "mated" *The Calumet* to the herm *Chief*). *Year of Meteors* (fig. 4.15) incorporates the fourteenth and fifteenth lines from Walt Whitman's poem of the same title that telescopes into a single year events of 1859-60, including the death of John Brown, the Lincoln-Douglas presidential campaign, and comets and meteor showers (of various years), as well as the entrance of the British iron steamship, the *Great Eastern*, into New York harbor.[19]

In all cases the oral evocations of the original poetry, transferred to canvas, are free of quotation marks. The same is true of the prose clips in the *Melville Triptych* and *Melville*, all first-person dialogues from *Moby-Dick*. Without the externalizing reference marks (in a bit of benign plagiarism), we the viewers are on the scene of the text, reading from the source.[20] Indiana, American dreamer, is himself donning the cloaks of these literary patriots/patriarchs, whose utterances represent what Quentin Anderson has called the American imperial self. Anderson points out that certain nineteenth-century authors – Emerson, Thoreau, Whitman, Melville – are voices "conditioned by the failure of the fathers," the failed American dream. These famous literary sons "were men who had either been let down by their fathers or acted as if they had" and proceeded with magnified concerns for self-definition.

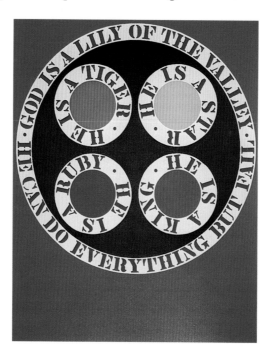

4.13 *God Is a Lily of the Valley*, 1961-62. O/c, 60 x 48",
R. Osuna Collection, Washington, D.C.

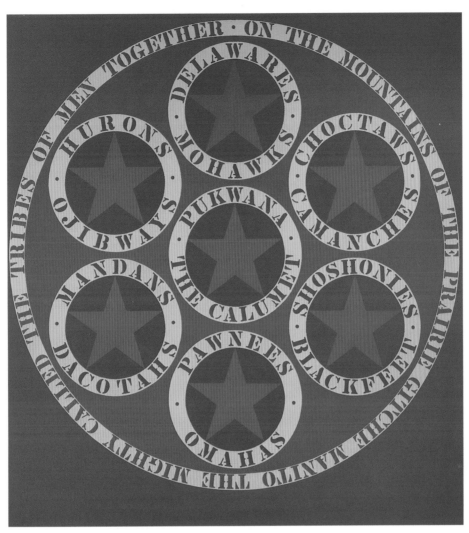

4.14 *The Calumet*, 1961. O/c, 90 x 84". Rose Art Museum, Brandeis University, Waltham, Massachusetts; Gervirtz-Minuchin Purchase Fund.

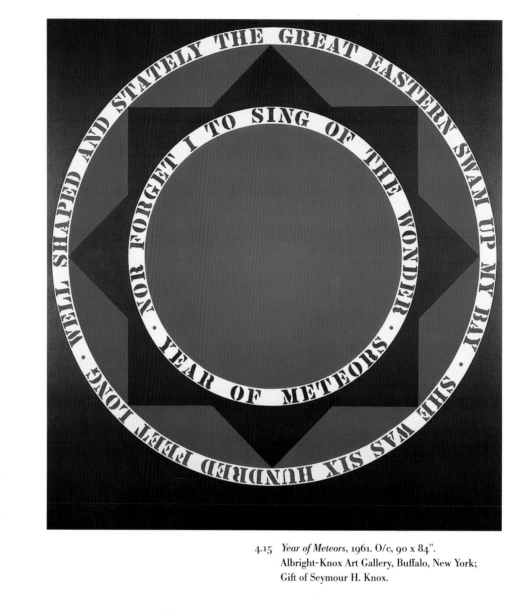

4.15 *Year of Meteors*, 1961. O/c, 90 x 84".
Albright-Knox Art Gallery, Buffalo, New York;
Gift of Seymour H. Knox.

Indiana, whose own father relationship was problematic, summons up these presences as alter egos, imaginable as epic, upright, speaking subjects. Their words form a screen of identity upon which Indiana projects his own.[21]

Other than the absence of quotes, with these paintings, like the Mamaroneck ones, few clues are provided that contextualize the words. Even color has very simple, conventional signification. In *God is a Lily of the Valley*, for example, the words on the interior circles – *tiger*, *star*, and *ruby* – correspond reasonably to orange, yellow, and red centers, respectively. (A second version of the painting is entirely in blue and green and bears a different verse of the song that extends the flower metaphor.[22]) Red in *The Calumet* reflects "red stone of the quarry," and "red willow," but also "blood" and Indians and the painting's (and *Hiawatha*'s) inventory of tribes (altogether the word *red* occurs six times in Part I of Longfellow's poem). The overall blue-green of *Year of Meteors* suggests the sky or cosmos, appropriate to events of cosmic importance.

The black-and-white *Melville Triptych*, bearing Ishmael's narrative distributed over three canvases, is the only example of the "literary" group to use stenciled lettering and no color. The idea of geography is bolstered here by schemas suggesting the shapes of the places named, although the inverted *Y* of *Coenties Slip* (the center painting) also evokes a peace sign. Moreover, it is associated in a note in Indiana's journal-sketchbook with a plate in a SAIC exhibition catalog, of Constantin Brancusi's genitalia-shaped *Portrait of a Young Man* (fig. 4.16).[23] That association supplies a sexual subtext for the paintings and, by extension, for *Moby-Dick*, and associates geography with the gendered body (Indiana's presence among the homosexual inhabitants of the slip).

4.16 "Brancusi's Terminals," sketch related to *Coenties Slip* in the *Melville Triptych*. Journal-sketchbook 1961-62, 8 June [1962]. Artist's collection.

121

Otherwise, color and words combine with minimal elements: five-pointed stars in *The Calumet* (geographic reference for America), and a compass rose in the case of *Year of Meteors*. The works codify Indiana's geometry and geography. But they do more than that. The sets of circles, which have evolved from the visually riveting paired and lined-up orbs of his earlier paintings and herms, are now magnified as great circles, like mandalas. A mandala is traditionally a chart for focusing consciousness, what Gertrude Stein called "being existing."[24] Her circular "Rose" poem

is a mandala; so, in a sense, are her "insistent" rounds of gerund-riddled verbal chains (for example, "loving repeating"). Words in perpetual revolution, with no beginning and no end, are incantatory. Perpetually repeating, they freeze time and experience, remembering and forgetting. Like Stein's "Rose" poem, and as a refinement of the title words in his own *The American Dream #1*, the verses in Indiana's literary paintings encircle, and perpetually end and begin on, the peripheries of mandalas, in an ever-present act of being said (or read). They behave like the cyclical pseudoautobiography of Alice B. Toklas, or, in another Steinian metaphor, "like a kaleidoscope slowly turning."[25]

Moreover, like Stein's *Autobiography of Alice B. Toklas*, the subject position in Indiana's paintings flickers between perceiver and perceived. The centers of the wheels of words in these verbal-visual mandalas are forms without special valence, as in the center circle of *The Calumet*, identical to six other star-circles around it (though there it is at least the title sphere).[26] Centers of other paintings are unmarked or empty, as in *God is a Lily of the Valley*. In *Year of Meteors*, hailed by critics as the best of the group, the central void is haunting, as Swenson put it: "The only 'image' in *Year of Meteors* is a blue compass-rose; the green central circle is simply plain – as if nothing were left of that voyage on 'my bay' but my remembering."[27] Unlike the binocular, self-surrogate herms, here the circular text celebrates emptiness, a quality of absented presence. The rings obscure recognition like ripples in Narcissus's pool. Swenson suggests that the vacancy is linked to remembering. Indeed, related to and, in a sense, behind all the literary paintings is a canvas, *The Geography of the Memory*, that was left unfinished from 1962 until 1992, when it was changed and completed with the word *Columbus*, the name of the town in which Carmen died (figs 4.17-18). *The Geography of the Memory* was painted over an even earlier botanical abstraction (reminiscent of Youngerman and Kelly) called *Green County*, one of the planned group of paintings commemorating the color-named counties of the state of Indiana. The term "geography of memory" evokes complex notions of mental mapping and terrestrial commemoration, notions that serve to bridge dimensions of identity and loss.[28]

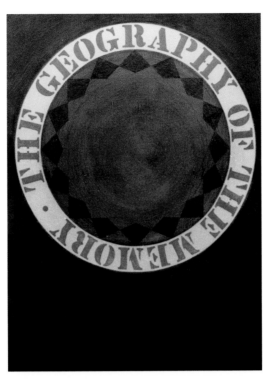

4.17 *The Geography of the Memory*, in unfinished state
as it stood from ca. 1962 to 1992; in 1992 altered as
Columbus. O/c, 42 x 31″. Artist's collection.

4.18 "Compass Rose," sketch for *The Geography
of the Memory*. Journal-sketchbook 1961-62,
10 January [1962]. Artist's collection.

Geography and memory link Indiana's life with those of kindred predecessors. Lawrence Alloway pointed out that *Year of Meteors* was done close enough to a hundred years after Whitman's poem (which, though its subjects are events of 1859-60, first appeared in 1865) to serve as its memorial or commemoration.[29] It is another way in which Indiana annexed Whitman's words to his own autobiography – and of course, a view of the Great Eastern's passage would have been available through the windows of the artist's own building on the East River (Brooklynite Whitman's *and* Indiana's, "my bay"). Likewise, the compass rose of *Year of Meteors* and the cartographic positions of *Melville Triptych* underscore the fact that Whitman and New Yorker Melville describe features of Indiana's own lower Manhattan terrain.

Further, the paintings' mappings connote not only geography but traces of physiognomy and identity. This is explicit in *Melville*, one of Indiana's earliest symbolic or commemorative portraits (1961; fig. 4.19). In genre and spirit, it connects with the portraiture and self-portraiture the artist had been concerned with since the mid-fifties. A link is a 1959 painting related to the ginkgo works (in gesso on plywood) entitled *Homage to José* (fig. 4.20). It contains a single central comma, wittily standing for the identity of Indiana's poet friend, whose then-recent works made excessive, expressive use of that mark. Also at that time Indiana did the abbreviated star-plus-nickname painting *Dick*.[30]

4.19 *Melville*, ca. 1961-62. O/c, 72 x 60". Collection of Walter A. Netsch, Chicago.

4.20 "Homage to José." Journal-sketchbook 1959-61, 12 December [1959]. Artist's collection.

In *Melville*, the literary mandala or wheel of words encloses a stable equilateral triangle. Both geometric figures comprise thick white outlines that separate equal-toned areas of red, blue, and green. The white bands contain lines quoted from *Moby-Dick*, Ahab's outcrys against cataclysmic odds "THIS BRAIN TRUCK OF MINE NOW SAILS AMID THE CLOUD SCUD [circle]; WILDEST WINDS WERE MADE FOR LOFTIEST TRUCKS [triangle]."[31]

In using the author's (or his character's) own words, Indiana's *Melville* is tangential to the realm of "cubist" portraiture in literature – like the work of William Carlos Williams, Max Jacob, and Gertrude Stein. It is especially close to Stein, who sought to present the individual (as in her "George Hugnet") via words, as a system of movement. But Indiana's *Melville* is a power portrait, a portrait engaged with the viewer in acts of seeing and speaking. Although much earlier, Marius de Zayas's primitivistic portrait of Alfred Stieglitz *(L'Accoucheur d'idées)* is comparable (fig. 4.21). With its paired circles (not unlike Indiana's binocular orbs), inspired by Pukapuka "soul-catcher" sticks that reminded de Zayas of Stieglitz when he saw them in an ethnographical collection, the Mexican artist's portrait "head" (complete with algebraic cipherings) confronts the viewer in a fixating moment of reciprocal gaze. A similar quality of potent countenance is evoked in Indiana's mandalic literary paintings, which, like de Zayas's Stieglitz, bear comparison better with ancient or primitive magical images than with traditional portraiture.

125

4.21 Marius de Zayas, *Abstract Caricature of Alfred Stieglitz*, 1914. Charcoal/paper. Metropolitan Museum of Art, New York, Alfred Stieglitz Collection, 1949, 49.70.184 (photo courtesy of Metropolitan Museum of Art).

Dreams and Variations

The Mamaroneck and literary paintings were not the only works conceived in 1961-62. A typological framework emerged from those and others done during that winter that shaped Indiana's production over the next half-decade. The result, his works through 1966, can be seen as a system of intersecting series articulated by theme-and-variation modalities. Their commercial-looking, hard-edge style is contradicted by the fact that they are actually hand-wrought, the product of the artist's meticulous, time-consuming technique. Thus Indiana's execution of nearly 150 major paintings in roughly five years suggests a breakthrough, a culmination of ideas accompanied by tremendous creative energy.[32]

Instead of foregrounding "pop" objects, Indiana's visual language maintains strong ties with geometric abstraction. These years saw his growing reputation as a quasi-formalist and an artist who was somewhat outside the mainstream. This impression was especially fostered when *The American Dream #1* was featured, along with seven other Indiana works, in a prestigious Museum of Modern Art exhibition, "Americans 1963," that toured the United States. Dorothy Miller assembled that show with a mixture of formalist and Pop content. In his review of it, Gene Baro lumped Indiana not with the Pop artists but with a group he called "colorists," alongside Anuszkiewicz and Reinhardt. But already the previous October, reviewing Indiana's Stable premiere, Michael Fried had noted the artist's particular strength, "to work in broad areas of close-valued high-keyed color," and lamented Indiana's dependency on words and signs: "the better the sign, the worse the painting." In fact, Indiana's 1961-62 vacillation between formalist shape and color concerns (clearest in *Year of Meteors*), on the one hand, and verbal and autobiographical impulses on the other, was shortly to be resolved.[33]

At the same time, a cult of personality – the artist as star, whose success story was a new American dream – overtook the Pop milieu. Pop symposia and Pop interviews gave way to far more grassroots media attention, like *Life* magazine's September 1963 article "Sold Out Art," which included Indiana with a group of emerging American artists who were enjoying a new middle-class market. Artists now appeared to have interesting, upbeat lifestyles and created chic "scenes," like Warhol's Factory and Max's Kansas City. But Indiana frequented neither. He had met Warhol in 1959 in the unfashionable St. Adrian's Bar in the old Broadway Central Hotel. The two artists shared an atmosphere of risk and camaraderie at the Stable, where they had back-to-back shows in 1962. They remained in close touch until after Warhol moved on to Leo Castelli's gallery late in 1964. With Warhol, Indiana attracted media kitsch like *Vogue*'s culinary piece "Robert Indiana, Andy Warhol, A Second Fame: Good Food," illustrated with a full-page photograph of the artists with cats, ensconced in a corner of Andy's new studio (fig. 4.22). The piece was related to one of Warhol's earliest film portraits, *Eat*, shot in late 1963 (fig. 4.23). The film

featured Indiana eating a mushroom, thereby reflecting a major theme of his new painting. But in spite of the impulse for self-recording that seemed to propel his art, Indiana was not drawn to the spotlight. Gerard Malanga, Warhol's production assistant at the time, recalls that Indiana chose to remain a peripheral figure, was rarely at the Factory, and almost never showed up at Andy's famous parties.[34]

4.22 Indiana and Andy Warhol in Warhol's loft. *Vogue*, March 1965, 184 (photo by Bruce Davidson, reproduced courtesy of Magnum Photos, New York).

4.23 Robert Indiana as he appeared in Andy Warhol film, *Eat*, 1964 (photo by Gerard Murrell, © The Andy Warhol Museum, Pittsburgh, a museum of Carnegie Institute).

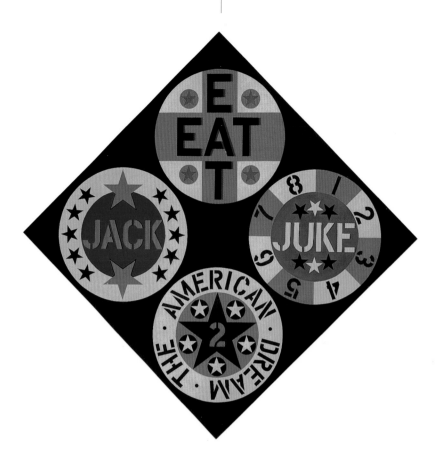

Instead of magnifying his own personality, the body of work Indiana produced between 1961 and 1966 records a lexicon of multiple, sometimes alternative narratives. Repeatedly the paintings verbally invoke one or another of the artist's pantheon of literary and artistic personalities, while visually they evoke other unnamed and shadowy images. At the center of this oeuvre is the American Dream series, generated from the MoMA painting (figs. 4.24-27, and see figs. 3.11, 5.20). This series encompasses all other themes. All six paintings are of symmetrical configurations of circular word and symbol emblems and thus retain the stamp of the earlier orb paintings. With their rotating, repetitive infrastructures, the Dreams (so called by the artist) reflect Steinian imagery: kaleidoscopic circularity and repetition, and short, concrete words and numbers. Color is highly saturated. The black of *The American Dream #1* remains prominent, while that painting's browns are replaced by greater amounts of "cautionary" reds (as in *The Black Diamond American Dream #2* and *The Red Diamond American Dream #3*) and reds and yellows (*The Beware-Danger American Dream #4, Demuth American Dream #5*). Here color symbolism has personal derivations. In a recent interview Indiana said, "If it's a subject I'm feeling intensely about, it's apt to be black and red," but in other statements, particularly "Mother and Father," he associates these two colors with his adoptive parents, Earl and Carmen Clark.[35]

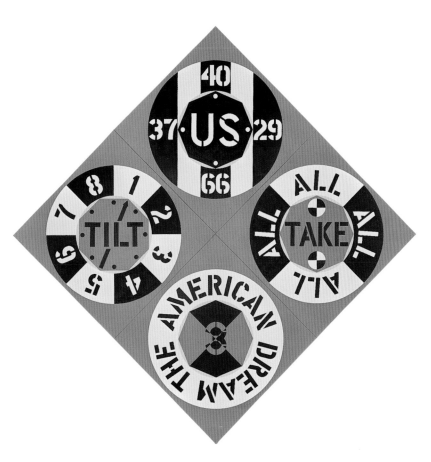

4.24 (OPPOSITE) *The Black Diamond American Dream #2*,
 1962. O/c, 85" square. Sintra Modern Art Museum,
 Lisbon; Berardo Collection (photo courtesy of
 Sintra Modern Art Museum).

4.25 *The Red Diamond American Dream #3*,
 1962. O/c, four panels totaling 8'6" square.
 Van Abbemuseum, Eindhoven, The Netherlands
 (photo courtesy of Stedelijk Van Abbemuseum).

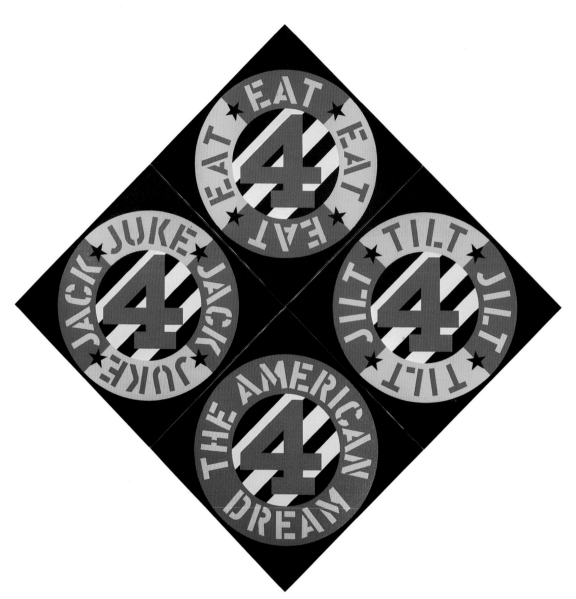

4.26 *The Beware-Danger American Dream #4*, 1963.
O/c, four panels totaling 8'6" square.
Hirshhorn Museum and Sculpture Garden,
Smithsonian Institution, Washington,
D.C. Gift of Joseph H. Hirshhorn Foundation,
1966 (photo by Lee Stalsworth).

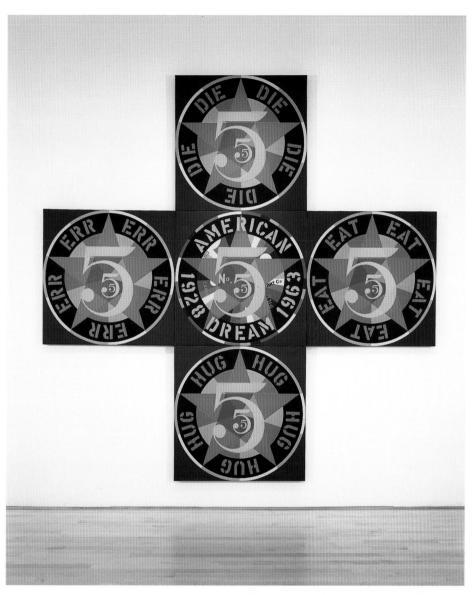

4.27 *The Demuth American Dream #5*, 1963. O/c,
five panels totaling 12' square. Art Gallery
of Ontario, Toronto; gift from the Women's
Committee Fund, 1964 (photo by Carlo Catenazzi,
Art Gallery of Ontario. © Art Gallery of Ontario).

Imagery of highway and roadside signage, nationalist and autobiographical, is strongest in Dream numbers one, two, four, and six. Numbers one, two, four, and five bear five-pointed American stars; numbers one, two, and three have roulettelike number wheels; and numbers one, three, and four feature stripes (beware/danger stripes in three and four), all reminiscent of the mechanical game boards of roadside amusements. The paintings bear their titles and numbers in the series as part of their compositions, in central or lower-central circles. Dream number one's TILT, TAKE ALL, and US (obviously the first person plural pronoun as well as the monogram for United States) are joined by new words: JUKE and JACK. JUKE refers to roadside amusements popular from the thirties (and so like TILT and TAKE ALL, from the days of family auto trips), but the word comes from *jouk* or *jook*, West African for a disorderly or wicked house – that is, a brothel. Jack has many meanings, including money, applications to games of money (blackjack, jackpot), and penis and masturbation (jack off). In British usages, which Indiana could have encountered in 1954, besides Union Jack, the word can also mean to cheer up or get high on drugs (jack up), policeman (Jack), boredom, ass and asshole, or death. All these meanings suggest earthly pleasures or vices and their consequences. But jack is also a moniker in the American dream, particularly as it applies to the Kennedy presidency (Jack and Jackie), a special interest of Indiana's. On an even more personal level, Jack was the nickname of fashion designer John Kloss, with whom Indiana was having a relationship at the time, and of Jack Curtis, another former classmate from Chicago who was a close friend of Indiana's.

In Dream number five appear four cryptic three-letter words: EAT (associated with Indiana's parents, particularly with Carmen or "mother," it is also in Dreams two and three), HUG, ERR, and DIE. The quartet summarizes the cycle of life – or perhaps Christ's Passion, as a Christian reading of a cross combined with EAT, as in Dream numbers two and five, suggests the Blessed Sacrament.[36]

The Demuth American Dream #5 is symbolic portraiture in the same way as *Melville*.[37] But this case involves a double portrait of painter Charles Demuth and poet William Carlos Williams, with Indiana's work appropriating the motifs of Demuth's earlier painting *I Saw the Figure 5 in Gold* (fig. 4.28). Just as words and symbols in the paintings open to multiple meanings, so do numbers. The painting is cross-shaped and consists of five panels arranged in two rows of three that intersect at 90 degrees. Accordingly, much of the painting references threes and fives: in each panel, a five-pointed star encloses three fives in concentrically diminishing order, the same way three fives appear in Demuth's original painting done in 1928, the year Robert Clark was born. Three fives also combine as thirty-five, Indiana's age in 1963, when he did the painting. The keywords EAT, HUG, ERR, and DIE, a reference to the cycle of human life in *The Demuth American Dream #5*, reconstitute the earlier artist's work as the present artist's warning.

4.28 Charles Demuth, *I Saw the Figure 5 in Gold*, 1928. O/composition board, 36 x 29³/₄". Metropolitan Museum of Art, New York, Alfred Stieglitz Collection, 1949 49.59.1 (photo © 1986, Metropolitan Museum of Art).

Throughout the "core series" of American Dream paintings, references to death and crosses, as well as signs warning of danger or commanding beware or stop (for example, the left red octagon in *The Red Diamond American Dream #3*), reverberate and connect with other Indiana works. As statements addressed to a subject or viewer, the Dreams are illocutionary (in Austin's sense). Their words, overdetermined and ambiguous, are insistent and cyclical and thereby evocative. Meanings alternatively assert and absent themselves like twinkling stars. Mario Amaya described the Dreams and other works: "[Indiana's] huge 'signs' resembling highway directions, which order one to EAT, ERR or DIE, although they have a slick surface attraction, possess something deep and troubling beneath their road-sign simplicity. The words themselves transmit a psychological and emotional jolt and the artist appears to want them to gnaw into the subconscious and to come to terms with associations, past and present."[38] The Dreams are like roadside cantos whose refrains can be recognized in the balance of Indiana's early and mid-1960s work.

Critiquing Americana

Already in 1961 Indiana commenced other wheels-of-words (or mandala) paintings that are about aspects of Americana: American heroes, icons, and landmarks. These paintings form multivalent messages in their combinations of keywords, codes,

names, and symbols. Altogether they form a sharp critique of the American dream, always held at arm's length and addressed with epic language. Like Harold Bloom's American poet, but using both verbal and visual mechanics, Indiana proceeded "to merge voicing and revisionism into a single entity."[39] Sprinkled throughout the works of this period are enough references to his own private life to reveal the American dream as a grand and elaborate allegory of his personal struggles since childhood.

The paintings completed from 1961 through 1966 – still probably the most well known and best collected of his works (outside of the *LOVE*s) – are also the ones that defined and established his style. There are vast differences among many of these paintings, but a number of visual elements group them together stylistically. To many reviewers these works seemed to create a popular American regalia or heraldry related to insignia, emblems, and badges. That response reflects the emergence of a new compositional type in his work: phrases or titles within one or more concentric circles occupying the upper four-fifths of the canvas and a title or other word or phrase written across the bottom. The arrangement, with its word/image parallelism, recalls the riddles of the Mamaroneck paintings. I shall refer to it hereafter as the mandala-plus-legend format.[40]

All paintings of this group employ a similar range of words and shapes that amounts to a private vocabulary of signifiers. All these paintings use stenciled letters and call to mind Jasper Johns's slightly earlier paintings with stenciled letters and numbers (for example, *False Start* and *Thermometer* of 1959, or his map paintings, begun in 1960). But whereas Johns's stenciling signals letter shapes as preexisting designs randomly occurring in the world, Indiana's hang on an introjective narrative: they are traced from or stylistically connected to the crate stencils he had discovered in his Coenties Slip loft (fig. 4.29).[41]

The writers and artists whom Indiana commemorates in his literary paintings appear to be ones who created some of the broadest and most positive American myths.[42] But in 1962, in a critical atmosphere in New York charged with formalist theory, the artist became afraid that his idea of literary painting would be misunderstood, and he soon stopped using whole lines of famous text (as in *Year of Meteors, The Calumet,* and others), with the exceptions of his own words (in the Confederacy series), and excerpts from Hart Crane's poetry in paintings of the Brooklyn Bridge. (Indiana's artistic tributes returned later in his Marsden Hartley paintings begun in 1988.)

Johns's 1958 painting *TENNYSON* comes to mind as an eligible precedent for all of Indiana's literary tributes, and Indiana probably saw it in Dorothy Miller's "16 Americans" show at MoMA in 1959 (see fig. 4.8). In Johns's canvas we are given no specific information explaining the reference beyond the obvious one: the name generally evokes poetry, so its painted presence joins the two arts. But we do not know why it is Tennyson, as opposed to, say, Wordsworth. Indiana's specific connections to his subjects are not always made obvious in his canvases, either. But if

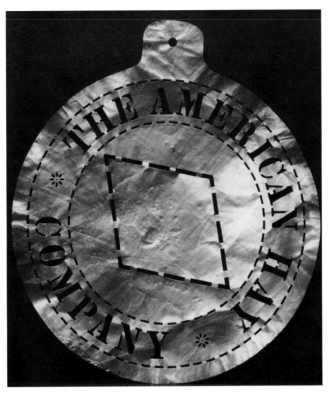

4.29 Nineteenth-century crate stencil for "The American Hay Company." Found by artist in his loft at 25 Coenties Slip. Artist's collection.

we look at more than one work and become an audience for the artist, not just for the painting, eventually he divulges the nature of such connections in interviews and in the statements and narratives he later began to write to accompany his art. Through his paintings' texts, his artists and authors speak for his own alter ego, and Indiana has some point of identity with each of them. The selection of "Indians" as a subject for *The Calumet*, for example, is a partial reference to his own name, Indiana, making the painting a rebus.

His use of Melville's *Moby-Dick* in several works repeats his earlier employment of Connolly's *Unquiet Grave*. Indiana, like Ishmael or Palinuros, sees himself as on a voyage. Virginia Mecklenburg has pointed out how closely Indiana, in a written statement of 1963, follows Melville's opening lines of *Moby-Dick*: "Some years ago – it was in the spring of 1956, the last week of June precisely – having little or no money in my purse . . . I came to the tip end of the island where the hard edge of the city confronts the watery part."[43]

Indiana's artists and authors, many of whom were idols of New York's homosexual community in the fifties, represent his identification with that marginalized group but also more broadly exemplify the classical dilemma of the artist: the choice

between isolation and community, and between genius and mass appeal. Whitman, Melville, and Longfellow tout self-reliant heroism as the substance of popular spirit. They offer the archetype that Indiana must reassess. In 1963 he added others via a group of works based on Charles Demuth's canvas, *I Saw the Figure 5 in Gold* (1928), which he saw in the Metropolitan Museum of Art (figs. 4.30-32; see also figs. 4.27-28). The Demuth painting was itself a symbolic portrait of William Carlos Williams, or, more correctly, a portrait of Williams working, via a poem he wrote while en route to the studio of yet another friend, the painter Marsden Hartley. Williams's poem (and Demuth's painting about it) captures the flashing presence of an urban creature, Fire Engine Number Five:

> Among the rain
> and lights
> I saw the figure 5
> in gold
> on a Red
> firetruck
> moving
> tense
> unheeded
> to gong clangs
> siren howls
> and wheels rumbling
> through the dark city.[44]

4.30 (OPPOSITE) *The Figure Five*, 1963. O/c, 60 x 50⅛".
National Museum of American Art,
Smithsonian Institution, Washington, D.C. © 1963,
Robert Indiana (photo courtesy of National
Museum of American Art).

4.31 *The Small Demuth Diamond Five*, 1963.
O/c, 51¼" square. Private collection (photo by
Eric Pollitzer).

4.32 *X5*, 1963. O/c, five panels, ea. 36" square,
total 108 x 108". Collection of the Whitney Museum
of American Art, New York; Purchase 64.9a-e
(photo by Sandak/Macmillan Company, © Whitney
Museum of American Art, 1999).

Indiana's series of five paintings on this subject, *The Figure Five, The Demuth Five, The Small Demuth Diamond Five, The Demuth American Dream #5,* and *X5,* are variations on a theme that portray himself (a poet/painter) via a painter (Demuth), in terms of that painter's portrait of a poet (Williams), via the poet's poem that is a portrait of a fire truck.

A similar idea of inserting oneself within successive overlays of portraits and poets is the Brooklyn Bridge series: *To the Bridge, The Bridge (The Brooklyn Bridge),* and *Fire Bridge* (figs. 4.33-35). Those paintings were conceived in reference to Joseph Stella's 1917 futurist painting of the Brooklyn Bridge but came more to refer to Hart Crane's poem about the landmark, *The Bridge.*[45] The largest painting of the group, the eleven-foot-plus, four-paneled *The Bridge (The Brooklyn Bridge),* reproduces in its four circles the thirty-sixth, thirtieth, fourteenth, and twenty-fourth lines (in that order) of Crane's "To Brooklyn Bridge," the "proem" that begins his verse epic. Once again, as with the fire truck in Williams's poem, the chosen lines here identify poet and reader empathetically with the bridge:

> And we have seen night lifted in thy arms
>
>
>
> How could mere toil align thy choiring strings
>
>
>
> Silver paced as though the sun took step of thee
>
>
>
> Thy cables breathe the north Atlantic still.[46]

Indiana's encircled, portraitlike image of the bridge evokes a similar sense of an urban being, personified, like Williams's fire truck. The Brooklyn Bridge mirrors Indiana's own subjectness in a psychological sense, and it is also an autobiographical marker: it was part of his view every day from his windows on Coenties Slip. *Fire Bridge* stems from an experience, not unlike Williams's of the fire truck or Crane's of the bridge itself ("Under thy shadow by the pier I waited . . . "), that prompted Indiana to write: "Back in the Fifties one late night as I was walking along the piers of South Street a great explosion took place before my eyes. Just under the Brooklyn Bridge a tanker and a freighter collided. They burst into flame, and the tanker's escaping fuel set the East River afire from the Manhattan side to Brooklyn's shore. . . . The Brooklyn Bridge was aglow . . . but it was the neighboring Manhattan Bridge that was ignited from below."[47]

For Crane the Brooklyn Bridge was a figurehead of America, which he surveyed geographically in his poem. For Indiana, the bridge is the link with a literary father, Crane, whom Indiana follows and whose voice he echoes. But Crane's verse *in the painting* also signals catastrophe and death while simultaneously recalling Indiana's own lost origins and parentage. The artist's bridge is a forceful descendant

139

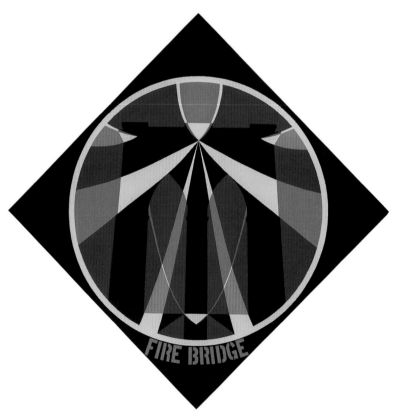

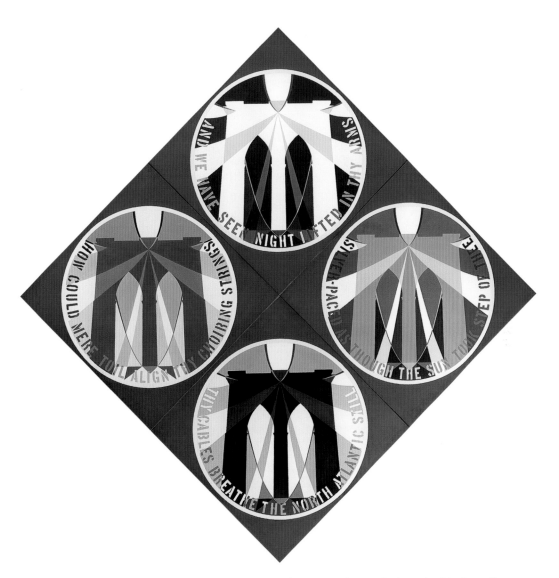

4.33 (OPPOSITE TOP) *To the Bridge*, 1964. O/c, 60 x 50".
Private collection, Toronto.

4.34 (OPPOSITE BOTTOM) *Fire Bridge*, 1965. O/c, 48"
square. Chrysler Museum at Norfolk, Virginia, gift
of Jean Outland Chrysler 75.103.

4.35 *The Bridge (The Brooklyn Bridge)*, 1964. O/c, four
panels totaling 11'3" square. Detroit,
Institute of the Arts; Founders Society Purchase,
Mr. and Mrs. Walter Buhl Ford II Fund
(photo © The Detroit Institute of the Arts).

of the classical herms that are termini of place and identity. We have seen how geography and identity inform the transitional painting *Terre Haute*; the unfinished series of Indiana counties; and early worded orb paintings like *The Slips*. The "literary" paintings – for example, *Year of Meteors* and above all the *Melville Triptych* (with its cartographic descriptions) – have strong connections with Coenties Slip. These are tropes for principal places of the artist's life, his autogeography, an idea explored in *The Geography of the Memory*. We can now appreciate a description of that painting by the artist's friend William Katz: "Embedded in the [the painting's] siennas and reds, of autumns near his father's Indiana property on Greasy Creek in Brown County, is a compass rose around which [the artist has] inscribed the legend 'The Geography of [the] Memory.' Looking backward, it seems to me that this tentative work foretells the visual vocabulary of all Indiana's later work and even its thematic preoccupations. If one aspect of geography is the description of the surface of the earth, then the title has to do with the description of the surface of the country or world of the mind."[48] Personal symbol of geography and memory, the compass rose (and its geometric relations, the various polygons) recur in many of Indiana's mid-sixties paintings. These are counterparts to the unbroken mandala: the points of the compass, each recorded as an angle, enact the repeated focus of human perspective (the cone of vision) around the circle of existence.

Some works that are not explicitly geographic are so by association. Connection with New York harbor (and Indiana's residency there), for example, underlies *Bardrock* (fig. 4.36), the title word of which is a variant of Traprock, the name of a rock-hauling company whose barges Indiana often watched from the slip.[49] The neologism actually refers to Indiana's art teacher (another mentor) Sara Bard. In mandala-plus-legend format, its center is an American/Hollywood five-pointed star, around which circulates the word *irresurrection* – another coinage, which presumably means not coming back from the dead – or, for an artist, anonymity. *Bardrock* is a Flying Dutchman – a vessel of enigma.

The Rebecca (fig. 4.37) also commemorates a ship, a famous slaver of Civil War days that sailed into the New York harbors that were the principal places in this country for the outfitting of such illegal vessels. The *Rebecca* was a swift, trim ship that slipped past both American and British authorities and delivered a full load of human cargo from south of the Congo to Cuba before being scuttled by its Spanish owners.[50] The painting, with its link to Indiana's New York vicinity, is didactic and moralizing. But it is also connected with the Hitchcock film *Rebecca*, with its great house called Manderly. The number eight in the painting links that reference to Carmen, a lover of great houses, who was born and died in August, the eighth month. Inhumanity, guilt, home, and mother are tropes that inhabit *The Rebecca*.

The painting *Made in USA* (fig. 4.38) deals with neither geography nor literature, but more directly with a troubled American dream. The painting's mandala is filled with a bold encircled *X* or pinwheel, a form derived from the gears of elec-

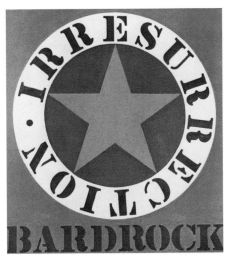

4.36 *Bardrock*, 1961. O/c, 24 x 22". Collection of
Campbell Wylly, New York (photo by John Ardoin).

toral gauges, as in *Electi*. But the *X* is a warning symbol in any number of traditions, from Rome, where the form signified a barrier, to St. Andrew's cross of martyrdom. Rotating around it is the lengthy word *andabatarianism*. Here, recalling the herms and Indiana's love of Latin, we find a classical reference: the keyword is a form of *andabata*, a gladiator in ancient Rome who fought on horseback wearing a helmet with no eyeholes. The archaic *andabatarian* means struggling blind, certainly a satirical accompaniment for the sloganlike "Made in USA."

The ironic voice of the troubled American dream that resonates in *Made in USA* and reverberates in the Dream paintings and works like *The Rebecca* or in herms like *Cuba* applies to other paintings of 1961-66. Even a "literary" painting like *The Calumet* might have a political dimension: Gene Swenson suggested that it was a "tongue-in-cheek . . . Geneva Conference."[51] Still other paintings are more explicit.

Indiana's interest in the 1960 election that produced *Electi (Election)* also gave rise to a mandala-plus-legend painting in red, white, and blue, entitled *The President* (fig. 4.39). Its revolving inscription, "A DIVORCED MAN HAS NEVER BEEN" (read together with the title), is the artist's own. The character of the national office is portrayed by the big bright five-pointed star in the center, symbolizing patriotism and personality (fame). It is one of Indiana's most common symbols (see, for example, *Triumph of Tira* and *The American Dream #1*). Although the painting's message is no longer accurate, in 1956 it could have been applicable to Adlai Stevenson, unsuccessful (and divorced) Democratic presidential nominee in that year's election. But Indiana intended the work as a portrait of Nelson A. Rockefeller, who ran unsuccessfully for Republican candidacy in 1960 and was an avid collector of contemporary art. Like *The Rebecca*, *The President* targets shallow morality. Swenson called it "a lament." But in another view, a president is not only a national hero but

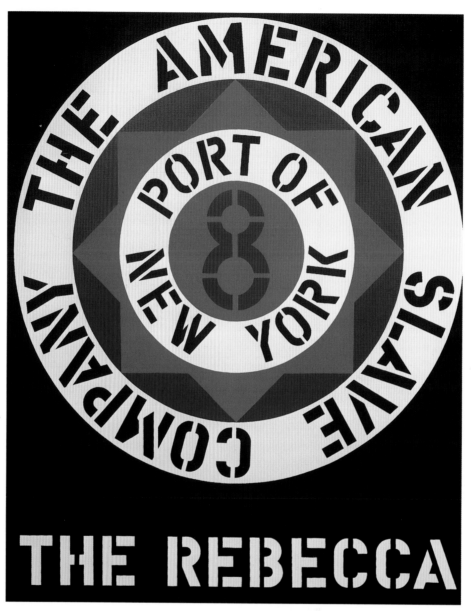

4·37 *The Rebecca*, 1962. O/c, 60 x 48". Collection of
Todd Brassner, New York (photo by Eric Pollitzer).

4.38 *Made in USA*, 1961. O/c, 24 x 22". Collection of Mr. and Mrs. Eugene Schwartz, New York (photo by John Ardoin).

4.39 *The President (A Divorced Man Has Never Been the President)*, 1961. O/c, 60 x 48". Sheldon Memorial Art Gallery and Sculpture Garden, University of Nebraska, Lincoln, gift of Philip Johnson (photo courtesy of Sheldon Memorial Art Gallery and Sculpture Garden).

4.40 *Yield Brother*, 1962. O/c, 60 x 50".
Whereabouts unknown.

also a father figure. In Indiana's family, Earl Clark was a divorced father (Carmen was his second wife) who also in a sense divorced Robert and his mother by leaving them, and failing to become a hero.[52]

Similarly, a group of paintings evoking the yield sign also refers to both politics and personal life. Indiana's first *Yield Brother*, done in 1962 (fig. 4.40), was his response to Bertrand Russell's worldwide plea for support of his antinuclear peace program. Characteristically, Indiana synthesized preexisting signs: the common American yield traffic signs that are, in the artist's phrase, "descending triangles," and the peace symbol utilized by Russell in demonstrations in England in 1958 (see artist's statement, "Yield Brother," Appendix 2). Indiana has explained the peace sign, as it appears in *Yield Brother*, as an old medieval symbol meaning "death to man," but it has also been described as a combination of semaphore signals for the letters N and D (nuclear disarmament) – signals, in other words, that transcribe these letters as positions of the human body.[53] To this the painting adds a homoerotic dimension: the "Y" also coincides with Indiana's schematic for Coenties Slip *(Melville Triptych)* and the sketch of Brancusi's torso "portrait" (see figs. 4.10 and 4.16).

In the red, yellow, black, and blue *Yield Brother* (which the artist donated on completion to the Bertrand Russell Foundation), Indiana's mandalic form encloses four orbs intersecting four peace signs at the four points of the compass. Instead of a wheel of words, the artist here has composed a cross or crucifix, with a faint visual echo of *Stavrosis*, making the painting a "visual catechism."[54] This reading encour-

ages the association of the peace symbol itself with the Y-shaped Pall or Forked Cross, associated with humility, or with the Thieves' Cross. As an anti-(nuclear)-war (or, in Indiana's words, a "right-of-way") painting, *Yield Brother* is empowered with an active voice. It is an exhortatory imperative with illocutionary force delivering visual messages of peace and brotherhood, coded in terms of highway, human anatomy, and Christianity.

The painting generated variations. *Yield Brother #2* (1963, fig. 4.41) stresses the idea of family, as "brother" is joined by "sister," "mother," and "father." Instead of peace signs, the painting uses circles bisected by single bars, which he identified as the Polaris (North Star) sign.[55] But on a psychological level, the artist's own problematic family relations are coded in *Yield Brother #2*, which makes it a more personal painting than the first. We recall that Indiana would have had a brother if Carmen's child, Charles, had lived, and that Indiana lived with a stepsister (daughter of Earl's third wife) for a brief time while in high school. But if the painting conjures sibling relations that the artist in fact never enjoyed, it also cautions against impending catastrophe, the fallacy of romanticizing the family. This theme persists in versions numbers three and four, which elaborate upon *Yield Brother #2*'s compositional circles, crosses, and diamond-shaped format.[56]

147

4.41 *Yield Brother #2*, 1963. O/c, 84½" square.
Collection of Elliot K. Wolk, New York.

4.42 *Mississippi*, 1965. The Confederacy series. O/c, 70 x
60". Collection of Mrs. Robert B. Mayer, Chicago
(photo by Eric Pollitzer).

Far more topical in content is another group of political/geographical paint-
ings done in 1965-66 and given the series title The Confederacy (figs. 4.42-43).
These works bear reference to attacks on nonviolent civil rights demonstrators in
the fifties and sixties at four locations in the South: Selma, Alabama; Philadelphia,
Mississippi; Bogalusa, Louisiana; and the state of Florida. Championing individuals'
rights and freedoms, these are didactic paintings. The series is an atlas of America's
racial violence from the viewpoint of that time.

The four similar works are organized in the mandala-plus-legend format.
Around the picture of the state in each case, concentric circles bear Indiana's own
message in stenciled letters: "JUST AS IN THE ANATOMY OF MAN, EVERY NATION
MUST HAVE ITS HIND PART." The state name is positioned as the legend across the
bottom. Indiana has called the series "history paintings," evoking the academic
genre familiar to Americans through oft-reproduced canvases by John Trumbull,
Benjamin West, and others. But that designation leads us off the trail by submerg-
ing the paintings' implicit connection of the body – "hind part" (the color of the
delinquent state is pink in each case, roughly a body color) – with human rights

4.43 *Florida*, 1966. The Confederacy series. O/c, 70 x 60". Institute of Contemporary Art, University of Pennsylvania, Philadelphia (photo by Eric Pollitzer).

abuse. Moreover, Indiana links his own homosexual body, via geography, with human rights in these paintings, just as he did in *Yield Brother*, with the confluence of the signs for peace, Coenties Slip, and phallic *Portrait of a Young Man*. In doing so he evokes the voice, if not the words, of Whitman, who expounded the morality of the body.[57]

Indiana's simple word-and-picture design, Sidra Stich notes, "has the visual potency of an advertisement, poster, product insignia, institutional logo, group emblem, or patriotic banner." If the paintings are exhibited together, The Confederacy series does compound its message like sequential installations of advertisements. One thinks of Burma-Shave billboards that appeared along roadways across the country, but especially in the Midwest, when Indiana was young. The series' geographic homilies are delivered in repetitive ("insistent") installments, each spinning in endless circles. Cyclical societal harangues expressing the externalized and alienated moral consciousness of the American mind, their descendants are the electronic billboards of Jenny Holzer, or Barbara Kruger's aphorisms camouflaged as ad slogans.[58]

Enumeration

Works like the Demuth Five series demonstrate a use of numbers in Indiana's visual vocabulary that developed from the number-determined orb paintings and some of the earliest constructions and herms with number words and numerals (see, for example, figs. 2.27, 2.42). Beginning in 1961-62, numbers function to locate paintings in a series (as in the American dream paintings), or as signifiers that add new content to a theme, or as cues for cross-references throughout his oeuvre (such as Carmen's number, eight, or Earl's number, six). Around the same time he commenced painting isolated numbers as central portraitlike images, as in *Polygons* (figs. 4.44-45), or the slightly later and more monumental *Cardinal Numbers* (fig. 4.46).

Once again, there is precedent in the work of Jasper Johns. Johns painted large individual numerals as early as 1955-56, *The Figures 1, 2, 5 and 7*. They were

4.44 *Triangle, Nonagon (1), Nonagon (2), Decagon, Undecagon, Duodecagon*, 1962. Polygon series, six of ten. O/c, each 24 x 22". Various private collections (photo by John D. Schiff).

4.45 *Heptagon*, 1962. Polygon series. O/c, 24 x 22". Whereabouts unknown.

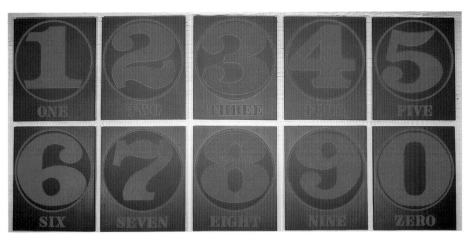

4.46 *The Cardinal Numbers*, 1966. O/c, ten panels, each 60 x 50". Private collection, Rome (photo by Eric Pollitzer).

exhibited at Castelli's in 1958, and while Indiana's work displayed no influence from them immediately, he undoubtedly saw the paintings and found Johns's sprightly Arabic characters presented as forms in and of themselves to be of interest. Johns's 1955 *The Figure 5* (fig. 4.47) is based on Demuth's *I Saw the Figure 5 in Gold*, the same painting on which Indiana later based his Demuth Five series that intersects with his American dream paintings. All these works – by Demuth, Johns, and Indiana – have in common a scale, centrality, and individualized treatment of single numerals that betoken human subjects.[59]

That connection acknowledged, the question of substantive influence of Johns on Indiana can once again be put aside, because the rationale and significance of numbers is so different for the two artists. For Johns, numbers were predetermined, available forms, like flags and alphabets. Their randomness and intrinsic meaninglessness provided means to foreground notions of "figure/subject" and "figure/ground." For Indiana, numbers are signifiers in his poetic and autobiographic programs. He dates his interest in numbers to his childhood, to Carmen's restless quest for a satisfying house and his serial experience of home: "It got to be . . . that this was house number six and this was house number thirteen. I was very concerned about it as a child and got even more interested in it later." He also relates that numbers gained prominence in his iconography when he found them allegorized and given human form in old etchings of the allegorical *Ten Ages of Man*, an example of which hangs in the Star of Hope (fig. 4.48).[60]

Counting as essential to both life and poetry was a point of reference Indiana shared with Gertrude Stein. "Natural" counting, to Stein, was related to the actual experiencing of life (being-existing) as repetition or insistence. She says on the subject:

4.47 Jasper Johns, *The Figure 5*, 1955. Encaustic and collage/c. © Jasper Johns/licensed by VAGA, New York.

After all the natural way to count is not that one and one make two
but to go on counting by one and one as chinamen do as anybody does
as Spaniards do as my little aunts did. One and one and one and one.
That is the natural way to go on counting.

Now what has this to do with poetry. It has a lot to do with
poetry.[61]

Stein's near-contemporary Sigmund Freud noted a similar attraction when
we "come across pleasurable effects, which arise from a repetition of what is simi-
lar, a rediscovery of what is familiar, similarity of sound, etc., and which are to be
explained as unsuspected economies in physical expenditure."[62] According to
Freud, this is most observable in children, who often employ counting in games. We
lose our ability to find pleasure in counting and repeating as we grow and develop
our critical faculties, but we revert to it via the structure of humor, or when critical
faculties fail, as in neurotic obsession. Stein also found that counting is most promi-
nent in the kind of poetry heard among children – in nursery rhymes. And she
appreciated a visual sense in such verses. She wrote, "I always like counting but I
like counting one two three four five six seven, or one little Indian two little Indi-
ans three little Indian boys counting more than ten is not interesting at least not to
me because the numbers higher than ten unless they are fifty-five or something like
that do not look interesting."[63] Stein's essay "A Birthday Book," published in 1957
as part of the collection *Alphabets and Birthdays*, is organized as a form of count-
ing, by means of which the numbers for days of the year are associated with vari-
ous events and things, or simply repeated as concrete poetic phrases ("February
seventh and so forth / February seventh and so forth," and so forth). In his journal
Indiana noted seeing that book at Agnes Martin's shortly after it was published in

4.48 Anonymous engraving, *The Ten Ages of Man*,
nineteenth century. Artist's collection.

the United States, and he even may have borrowed it.[64] Indiana tells a "personal discovery" story that allows him to adopt the Roman-type Arabic numbers: an old printer's calendar he found in his loft on Coenties Slip was his source of inspiration for number forms.

Like Stein, Indiana was drawn to the appearance of numbers as concrete texts. In his first series, the *Polygons*, which consists of numbers three through twelve, Indiana adds to the counting of numerals the idea of visual counting via geometry. The mandala-plus-legend format in these works features a central numerical figure superimposed upon or within its corresponding geometric figure (for example, three on a triangle), and the name of the polygon (legend) becomes part of a verbal-visual poem as the word sounds are reiterated in the word wheel: thus "Square, Quare, Quadrangle" or "Octagon, Octavia, Octaroon." (In "Triangle, Tintinnabulation," in addition to alliteration, the "sound" of the triangle as an instrument is named.) In these paintings, too, the number of sides of the polygons increase as they approach, but never arrive at, the status of the circle. They also count internally – not numerically but by one and one and one – as if each side counts some repeated experience in a frustrated effort to capture a continuous present. Again we find the trace of the compass rose, which William Katz described in Indiana's work as "a web of superimposed polygons expanding outward from a point, a person, toward the perimeter of a circle, the world, totality."[65]

Indiana arrived at other number compositions through thematic variation. In *Four Fours*, for example, the repeated numbers form a pattern with the figure in continuous forty-five-degree rotation (fig. 4.49; there is also a *Four Sixes*). Four, Indiana explained to Arthur C. Carr, was an unhappy number and "not a lucky number by common superstition"; he therefore painted it with the "difficult" (but self-referential) color yellow.[66] Four also counts the number of the archetypal family, rehearsed in the *Yield* series: mother, father, sister, and brother. Without such personal knowledge, the painting still claims attention on its visual facts alone, but it does not reveal itself fully to the casual viewer. Reviewing Indiana's second Stable Gallery exhibition in *Arts Magazine*, Donald Judd was struck by the diamond painting (under its alternative title, *The Big Four*) but did not know what to make of it: "[It is] the strongest painting in the show . . . with four yellow fours, each pointed away from the center and toward the corners and each in a red circle, all of which are on black. The painting is handsome, actually and not superficially, but that seems to be the end of it."[67]

Judd's bafflement offers an interesting comment, given his own frequent use of series of four in his minimalist sculpture.[68] Modularity characterized work by sculptors like Judd and Robert Morris, as well as Andy Warhol beginning in 1963-64, and mathematical seriality was featured by Robert Smithson, Sol LeWitt, and others from about 1966.[69] This trend achieved critical definition slightly later, with writings like Mel Bochner's "The Serial Attitude," published in 1967, and John

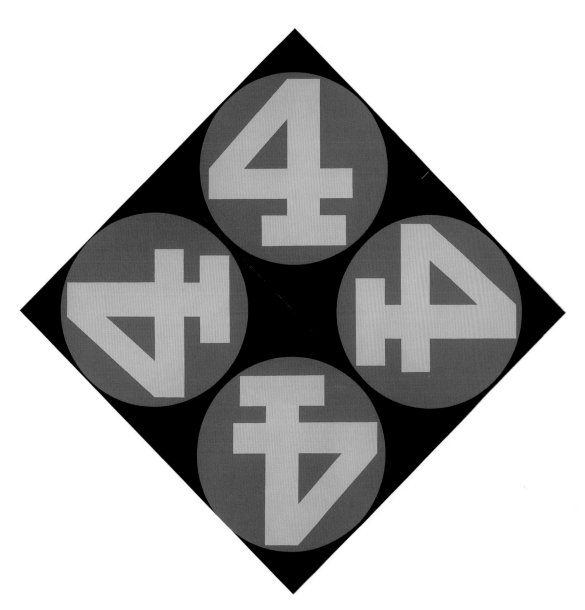

4.49 *The Big Four (Four Fours)*, 1964. O/c,
 four panels, each 24″ square. Artist's collection
 (photo by Eric Pollitzer).

Coplans's *Serial Imagery* exhibition catalog of 1968. Indiana's numeral quartet summing thirty of 1963 (fig. 4.50) anticipates these writers' developed regimens for seriality – for example, mathematical progression (Bochner) and interchangeability of units in the series (Coplans). Yet countering a content of cool calculation, Indiana's painting has a warm underbelly of narrative – according to his own account, thirty here "refers to 30 pieces of silver" – that is, the price of Judas's betrayal and thus another reference to crucifixion.[70]

In fact, because of the nature of his modules (actual numbers) and their ability to count themselves, Indiana's numbers series seem in retrospect to comment on or even parody serial art. Indiana's *Exploding Numbers* (1964-66; fig. 4.51) empha-

4.50 Small black diamond polychrome numeral quartet summing thirty, 1963. O/c, four panels, each 24" square. Collection of Robert L. B. Tobin, New York (photo by Jay York).

sizes progression of literal and numerical size and calls to mind Robert Smithson's expanding-modular works like *Alogon #1* (fig. 4.52) or *Plunge*, both of 1966, works that are based on mathematics and are at once literal and illusionistic. Unlike Smithson's "null structures and surfaces," Indiana's sequence of numerals is internally refined so that each figure formally fits together with, and points toward, the next, and the whole group, read sequentially, has a dancelike pattern: stasis (1); movement (2); more movement (3); and stasis with potential movement (4).[71]

4.51 *Exploding Numbers*, 1964-66. O/c, four panels: 12" square, 24" square, 36" square, and 48" square. Private collection (photo by Eric Pollitzer).

4.52 Robert Smithson, *Alogon #1*, 1966. Painted stainless steel units with square surfaces, 3, 3 1/2, 4, 4 1/2, 5, 5 1/2, 6", overall 35 1/2 x 73 1/2 x 35 1/2". Collection of Whitney Museum of American Art, New York; purchased with funds from the Howard and Jean Lipman Foundation, Inc. 67.8. © Estate of Robert Smithson/licensed by VAGA, New York (photo © 1999, Whitney Museum of American Art).

Unlike the modules of the anticompositional work around him, Indiana's numbers – presented as found shapes that are nudged in the direction of unique design – possess an anthropomorphic, certainly animated, sense of character. He explained to Goodall his story about finding the calendar: "I simply discovered the businessman's calendar and thought that the numbers had a kind of robustness and a kind of . . . crude vigor to them which I liked. I [made] certain refinements. It turns out that when you fit a given number in a circle, sometimes you have to tuck in a serif. And you have to squeeze in the bulge of a '5.' . . . So, although I didn't want to, I found myself refining these numbers."[72]

In 1967-68, at the request of William Katz, Robert Creeley wrote a series of poems about numbers responding to Indiana's *Cardinal Numbers*, which Indiana in turn revised as prints. The poems (in English and German) and prints were published in a book called *Numbers*.[73] Creeley's poems are autobiographic – he is expressing himself as different numbers – but they appear to respond to the character of Indiana's number "portraits," for example, Creeley's "One":

> What
> singular upright flourishing
> condition . . .
>
> As of a stick,
> stone, some-
>
> thing so
> fixed it has
>
> a head, walks,
> talks, leads
>
> a life.

Or, from "Three," which becomes a surrogate "family":

> They come now with
> one in the middle –
> either side thus
> another. Do they
>
> know who each other
> is or simply walk
> with this pivot between them.
> Here forms have possibility.

With an Indiana number, as Creeley puts it, "it is like someone's particular number, and [the artist] gives an extraordinarily emotional feel that he can make manifest in, say, 'Number Two.'"[74] Creeley recognizes the emotional presence within the painter-poet's cool patterns of geometry and number.

Just as Indiana portrays the American dream ironically in his early sixties painting, as allegory for unsuccessful elements in the artist's own life, so the works contain numerous figures for his own identity or the identity of imagined parents or mentors, like Whitman, Melville, Crane, Williams/Demuth, and even Stein. The predominance of poet forbears in Indiana's list of subjects reflects his fundamentally poetic approach to visual art. His paintings simulate verse, as he himself has often suggested. The compositions contain verbal-visual pattern and repetition that function like measure and rhyme, an almost obsessive tendency toward figuration (wherein the verbal figure stands for the visual one), and a poetic stance or speaking presence. From his letter-sound paintings to those with narrative or "illocutionary" statements, his paintings demand to be heard as well as looked at, an echo of Whitman's "hear my voice." Indiana "usurps" (to borrow Harold Bloom's term) the texts of predecessors and subjects, his creative parents and alter egos, to construct figures of his own struggle.[75] One can imagine Indiana's conceiving of the entire, tightly related group of early sixties paintings as stanzas of a single epic poem, like Crane's *The Bridge* or Whitman's *Song of Myself*, a poem expounding the character of America while covertly imprinting the writer/artist's own catastrophic experience within it.

As always for Indiana, a sharp dichotomy separates the works' impersonal, patterned forms and rhetorical subject matter, and the submerged network of memories and experiences that indeed manage to inflect the surface messages, as Creeley and a few other astute observers noted. This aspect of Indiana's art was easily overlooked by an art world that was preoccupied in the sixties with formalism and system theory. Yet to writers like Gene Swenson, the sense of something catastrophic or ominous was overwhelming. As he wrote of the canvas *The President*: "Long after [the] wry, amused experience, the mystery remains and, indeed, seems to grow; . . . one is moved almost secretly – in looking at a present beauty, sure and calm, in remembering an ominous presence, the cold breath of a comely apparition."[76]

The phantom described here relates to Freud's *Unheimlich*, "the uncanny": "a class of the frightening which leads back to what is known of old and long familiar," something "secretly familiar . . . which has undergone repression and then returned from it."[77] As the mask of the missed encounter, the uncanny embodies the anxiety of forgetting and remembering. In Indiana's masklike paintings, forgetting and remembering revolve cyclically, repetitively, around the subject of his origins – his parents and childhood – and his fixation on identity as against the abyss of nonidentity or death.

159

5

Sign, Screen, and Epitaph

In an interview in 1974 Robert Indiana said of his painting, "It's always been a matter of impact, the relationship of color to color and word to shape and word to complete piece – both the literal and visual aspects. I'm most concerned with the force of its impact."[1] In this comment, Indiana is talking about the synthetic nature of his art. But his enterprise was sometimes misunderstood in the sixties. Certain critics thought he was an artist who would shoot himself in the foot by corrupting the very formal concerns most in line with his talents, the formal concerns he has in common with Ellsworth Kelly. Because Indiana's paintings are formally strong – they are flat, symmetrical, hard-edged compositions clearly articulated by the shapes of simple words – they reproduce brilliantly. In printed matter accompanying any group show that includes him, it is his work that is usually illustrated. Throughout his career he has been a sought-after poster designer and printmaker, and certain writers in the sixties, who thought that the words in his art were too literal or even a bit corny, chose to discuss his flair for design. Michael Fried identified Indiana's talent for working "in areas of close-valued, high-keyed color." But he reprimanded the artist at the same time: "The general impression I got from Indiana's work was of a debilitating reluctance simply to let shapes and colors work in their own right. . . . I would argue that the sign-nature of [his] art has tended to obscure the true nature of his gifts even from him."[2]

Clement Greenberg, who has never published commentary on Indiana, has expressed an opinion similar to Fried's: "[His art has] more 'body' to it than the run of Pop. . . . It hit my eye more, was more 'plastic,' i.e. more 'formalist.' . . . He filled out more, worked more with the medium as against the schematicism or stunting of a lot of Pop. [But] my impression [is] that he wasn't ambitious enough, like the other Pop artists."[3] Indiana refers to himself as a colorist, and in 1966 critic Aldo Pellegrini concurred, placing him "in a zone between pop and optical painting."[4] But as

the artist himself points out, real impact, making the painting act forcefully upon the viewer, involves dynamic interplay between the strong, even disparate, acts of seeing and reading. His own term for his work is *verbal-visual*, and it goes beyond Indiana's "eye" for picture surface and precise execution, the aspects of formalist theory that he excels at and that writers like Fried and Greenberg can appreciate. But he also deploys dynamics that Fried and Greenberg seem to miss. Indiana plays on our eyes as conceptualizing receptors activating the creative and linguistic qualities of vision. His painting is very much about the volleying back and forth of impulses between the retina and the brain, and the way this volleying navigates us in the world and constructs our self-image in response to our perceptions of others.

Of course, formal strength, too, can tell us things about art beyond mere compliance with formal theory. It is sometimes suggested that crisp, hard-edged form and pristine design indicate artists' involvement with boundaries, in their art and in their identities. The anthropologist Mary Douglas studied how primitive societies deal with uncleanness through ritual acts. Douglas's view holds that clean shapes and edges are means of constructing defenses against chaos or nothingness.[5] Arthur C. Carr made a like-minded observation about Indiana: "It is not difficult to see why he would reject abstract expressionism as a form of self-expression. The 'new art,' with its appeal to the concrete, the objective, the literal (and literate) reality, represents a congruence with the personality of an artist who draws sharp lines in his distinctions about life and people, . . . as hard-edged as the lines of his paintings."[6] Boundaries, in psychoanalysis, demarcate the self from other − subject from object in the perceptual field − and often sustain influences from the infant's first separation-individuation experience. Carr wrote that "the hard-edge quality of [Indiana's] work could be a defense against some fear of loss of identity and union or fusion with the mother."[7] This is, of course, pure speculation. But it accords not only with Indiana's concerns for strong shapes with sharp contours but with the quest we have seen of determining a completely individual style that could not be confused with those of other artists. Carr's comment also tallies with the recurrence of themes of parents and, especially, mother, that seem to culminate in Indiana's art of the sixties, as in the painting, *Wombs*, in which the word for the organ of motherhood is plural and written backward (see fig. 4.2).

Indiana's working procedure is as meticulous as his surfaces. It generally begins with a long period of mental sketching and incubation of an idea, followed directly by its realization as a full-scale cartoon on the canvas that is the basis for multiple coats of solid color. Usually these are straight from the tube, applied by brush and without masking tape or other devices. Only in the case of some legends are stencils employed as tools in the cartoon stage, then abandoned. Contours are arrived at free-hand, requiring continuous mental and physical mastery. In the interest of flat and cleanly crafted designs, Indiana rarely makes changes once the painting process has begun.[8] His concern for method and structure are reflected in

the architectural metaphor he often uses: "My paintings are really built, and they're designed in the way an architect arrives at his buildings. My paintings are arrived at from patterns and (almost what you would call) blueprints. . . . This is a continuing characteristic of my work. This has nothing to do with words; this is the other part of the painting."[9]

Other formal aspects of his paintings that are set and regulated include the shapes and sizes of their canvas supports. These are limited in range, the same dimensions appearing repeatedly. As a result, his oeuvre displays a modular consistency and sustains a sense of overall coherency. These categorical formats of the early and mid-sixties paintings are summarized in Appendix 3. Five of the seven formats are axially symmetrical (squares, diamonds, crosses, Xs, and tondos). Two others that are vertical rectangles – in what is commonly called portrait orientation – bear the same proportion of height to width (either 6/5 or 7/6), regardless of size. The artist's explanation for these dimensions, which are broader than, say, the familiar golden section, is quite simple – they are exactly suited to hold a major circle or wheel of words (filling a square) in the upper field, with just enough length added for a proportionally sized word or phrase below – that is, it accommodates what I have termed the mandala-plus-legend format.[10]

Fields of Force

All these formats are constituents of the paintings' strong centralizing structures. They employ what Ernst Gombrich calls "fields of force," a heuristic term that "illuminates the powerful effect of symmetries and correspondences. In the Kaleidoscope the radial symmetry pulls the eye towards the center from which the redundancies are most easily surveyed. Conversely, the repeated elements, . . . lose something of their identity as they merge in the overall form."[11] The natural attraction of the eye or eye/mind to radial centers, Gombrich explains (via a Freudian economic principle) amounts to a course of least resistance. Human faces in traditional portraiture and religious icons (with haloes) are enhanced fields of force.

Rudolf Arnheim discusses the same phenomenon at length, with some different explanations. He cites actual research by Peter Dodwell and William Hoffman, who posit mechanisms in the brain that carry out transformations needed to maintain perceptual consistency despite our own physical movement and movement of light and objects in our environment. The eye/brain interprets changes by transforming them vertically, laterally, and centrally via dilation, constriction, and rotation. We are thus visually biased, this research suggests, toward forms that manifest these transformations, for example, parallel lines and concentric shapes like circles and mandalas.[12] But Arnheim also adds an empathetic description of centric vision: "Perceptually, a person is a viewer, who sees himself at the center of the world sur-

rounding him. . . . Looking at a sculpture means sending out a vector toward that object. . . . But . . . the dynamics of any center operate reciprocally. . . . The work of art sends out its own vectors, attracting and affecting the viewer. In fact, the power of the work can become so strong that it is no longer simply an eccentric target. It takes over as the primary center, seemingly governing its own structure, independent of the viewer, who has become immersed in the object, oblivious of his own outer existence."[13] This chapter addresses how that kind of two-way or mirror structure connects Indiana's verbal and visual elements and activates certain actions of memory – his, and ours – a dynamic that magnetizes the poles of subject and object in his art.

From canvas shape to internal design, Indiana's compositions easily qualify as strong fields of force. Indiana has often noted his own attraction to the circle, as in his comment that "practically every painting I've ever done has at least one circle or more and usually the circle dominates the canvas"; among his often repeated childhood recollections are Indianapolis's Indiana Circle and a Sunday school class on the religious symbolism of circles.[14] Indiana's early orb paintings illustrate this preoccupation, and so do some of his early transitional abstract sketches, like "Mom Garments" (see fig. 2.16).

Circles in art are also targets for the gaze and universal symbols. And they were relatively common forms occurring in the art of Indiana's peers in New York. Examples can be found in the work of Alexander Liberman (*Minimum*, 1950), Indiana's friend Richard Smith (*WADO*, 1961), certain paintings by Ellsworth Kelly (like *Running White*, 1959), Johns's targets (1955), and Kenneth Noland's concentric circles from 1959. Also, in the mid-sixties, a number of artists interested in optical research explored circles as illusionistic devices, like the Japanese artist, Tadasky (Tadasuke Kuwayama). In Jungian theory the circle is a symbol of the self. Examples of circular mandalas as a spiritual expression of self-identity can be found in paintings from the late fifties and early sixties by Alfred Jensen. That circles and mandalas appear so frequently in art of this period is further explained by the widespread interest in eastern religions; Indiana's own avid, though passing, involvement with the *I Ching* certainly gave him a channel to such ideas.[15] But his orbs and mandalas are descended from his paired and grouped circles associated with the double-valanced seeing of vision binoculaire, as in *The Sweet Mystery* and *The American Dream #1*. They are translated into the single great circular devices that attract the eye, like *Year of Meteors* or *To the Bridge* and slightly later diptychs like *EAT/DIE* and *Mother and Father*. These circles almost always hover in their vertical fields. Aside from recent examples among Indiana's "Hartley Elegies," only a few paintings in Indiana's oeuvre are circles without fields – that is, tondos that are read as objects rather than images.

Besides mandala-plus-legend paintings, Indiana's other compositional types are equally fields of force. Square paintings are recurrent in his work, both as modular panels and on their own (for example, fig. 4.51), and they became his featured

163

form for four-letter subjects, especially *LOVE*. Another important determining shape is the cross, which is embedded in the articulation of many of his square canvases and his equilateral diamond works, essentially square canvases turned forty-five degrees. As with Mondrian's diamond paintings, so for Indiana's, the cross is found by drawing lines between the opposite corners.[16] Indiana additionally either fills the diamond with four circles or other figures to articulate a cross configuration (as in Dreams numbers two, three, and four; see figs. 4.24-25) or fills his diamond with a single mandala (*The Small Demuth Diamond 5*, *The Metamorphosis of Norma Jean Mortenson*, see figs. 4.31 and 5.12). As a type of axial pattern schematically linked to the form of the human body, the cross is an intense, natural centric image, additionally charged with a deep heritage of religious and cultural potency.

Indiana's interest in the cross as an image goes back to his days at Cathedral of St. John the Divine and his typing of Laliberte's and West's manuscript, when he began his own crucifixion, *Stavrosis*. It dates further to the heads (like Sanasardo's) derived from Joseph Glasco's, with facial crosses created in their eye and nose lines (see figs. 2.7-8). In connection with a person, symbolically or realistically referenced, the cross invokes martyrdom. Even the reading of crosses in the negative fields or "backgrounds" of such works as *The Triumph of Tira* and *The American Dream #1* summons that concept. Crosses adapt to adjacent signification, adding, for example, both cosmic and mathematical possibilities to the shapes and spaces in diamond canvases like *The Big Four* and *Four Sixes*. The direct or latent presence of the cross pervades much of Indiana's output of the sixties.

He has done two cross-shaped works, the *LOVE Cross* and the *Demuth American Dream #5*; in both cases they are equal-armed crosses assembled from five square panels (see figs. 6.13 and 4.27). Indiana gives the crucifixion paintings of Cimabue (cross-shaped paintings that are, however, not equal-armed) as his inspiration for Dream five (in his statement, "The Demuth American Dream No. 5"; see Appendix 2). The cross rotated to form the X is used in the *X5* and *USA 666* (see figs. 4.32 and 5.20), and we recall its cultural lineage as a cautionary sign or taboo.

Indiana's use of shaped canvases relates to the widespread interest in the form of the painting's support among sixties artists. The year Indiana began his diamonds, for example, Stella was doing striped, metallic paintings on canvases in a variety of shapes, including crosses (such as *Ouray*, 1960-61, part of Stella's Copper Series). Like Johns's numbers, Stella's paintings are unfocused and visually nondirecting, creating no field of force, and thus they are the opposite of Indiana's magnetic frontal features. As if ignoring these stronger precursors (though his level of ambitiousness suggests that he did not), Indiana has stated that if he imbibed his inclination for shaped canvases from any one, it would have been a neighbor on Coenties Slip, Charles Hinman, who was exhibiting shaped paintings in the early sixties (fig. 5.1). But these other artists shaped their paintings as formal adventures intent on freeing the eye from considerations of meaning. Indiana categorically con-

tradicts that approach. The canvas supports that make up his painted fields are old and primal signs. Their formalism is aggressive, not passive, and it is combined with signlike content that is unmitigated by evidence of the artist's hand (what Norman Bryson calls the "body of labor"). It is characteristic of Indiana to work in tandem with major formalist artists but to swerve from them in the nature of his results.[17]

5.1 Charles Hinman, *Durango*, 1966. A/c, 24 x 30 x 6". Artist's collection (photo courtesy of the artist).

Faciality

Beyond the cultural codings of cautionary signs and religious symbols, Indiana's sixties paintings possess an additional, more allusive referent, one already found in the ocular orbs and mandalas, that corroborates the works' verbal program. The orbs and mandalas function as equivalents of the human face because they possess a quality of faciality that refers to portraiture, and self-portraiture in particular. Conventions having to do with the depiction and impact of the human face in the history of art contribute to our recognition of faciality or portraiture in abstract art. In Indiana's work, his early heads and portraiture preceded his interest in abstract symbolism. Their traces are the underpinning of his blueprint, the blueprint that expressed his needs so certainly as to propel his considerable early sixties output.

We have seen that portraiture connects Indiana's expressionist student work in Chicago and Edinburgh to symbolic portraits like *Melville*, the Demuth Five series, and the Brooklyn Bridge series. In an interview he summed up this tendency: "I was aware of Gertrude Stein's word portraits. I was aware of Demuth's word portraits. I was aware of Virgil Thomson's music portraits. I did self-portraits when I was in art school, and I did portraits of people when I was in London. I came to New York and did portraits of friends like Ellsworth Kelly. . . . Portraits are a thread that runs right through my work." Moreover, "I think that there's a general realization that any painting an artist does is possibly a self-portrait. He puts himself into it. It may not be the overt subject, but he's there, lurking in the shadows somewhere."[18] These comments validate viewers' reactions to the self-surrogate herm construc-

tions. It explains what often has been called a presence in his work, as Swenson said: "Long after that wry, amused experience, the mystery remains and, indeed, seems to grow; it is as if the artist were masked, or hiding behind a scrim."[19] Lurking in the shadows of *The Sweet Mystery*, which the artist accompanied with a list of autobiographic meanings, is a mirror gaze – an ocular image of the artist himself (see fig. 3.9 and statement, Appendix 2).

Perhaps this hitting upon the bottom essential of portraiture, a certain look with the eyes, was what fascinated Indiana with the term *vision binoculaire* in Connolly's *The Unquiet Grave*. That look equates with the sufficient "minimal schema" for a human face or portrait. According to research in infant psychology, three-month-olds can consistently recognize forehead, eyes, and nose as a face, and they will even respond to a Halloween mask having only these features, but not to a real human face in profile (that is, faces must be facing them). In fact, recognition of those features as a face may be an inherited configuration for organizing experience. Heinz Kohut explains that humans have an innate ability to identify human faces in a single act of apperception, not a reading of detail. Also, at three months or even younger, babies realize that the face is the source of auditory communication – voice. Perception of faceness, involving as it does essential relations with mother or other primary object figure, almost simultaneously brings about the first perceptions of mirroring: the infant sees that its actions or utterances elicit a reaction in the mother's facial expressions and sounds. This mirroring takes place at a stage of dependence and involvement with the mother figure that is still prior to language as speech. In Lacan's system, the recognition of face in connection with a maternal object would seem to function between the realms of the imaginary and the real. It is prelinguistic and prior to what he termed the mirror-stage, in which the child perceives her own face and body as a split, symbolic manifestation of herself, a moment that signals participation in social relations and employment of speech. At the very least, Indiana's long-sustained involvement with portraits and self-portraits and their distillations, the frontal orbs, resembles the infant's fascination with frontal – even specular – facial gestalts.[20]

There is also the artist's interest, in his early, searching work of ca. 1958-62, in schematic, frontal faces drawn from art history. Recall that his schematic heads, done in New York, were often given red or gold leaf backgrounds recalling Byzantine icons (see figs. 2.7 and 2.12). André Grabar has pointed out that conventions of portraiture in late antiquity evolved seamlessly into early Christian images of historical persons like Christ or saints. These, like the pagan portraits before them, tended to convey minimal information about physiognomy, but, as they increasingly stood for verbal doctrine, they defined a facial typology that persisted through early medieval times (fig. 5.2). More recently Norman Bryson concurred that Byzantine images, as architecturally enclosed places of textual relay, were kept minimal in form. One naturally thinks of the hieratic, frontal images of Christ or saints in

Byzantine art, like the Daphni Pantocrator (fig. 5.3). Customarily, such figures are presented as fields of force within haloes, medallions, and/or mandalas, often with identifying inscriptions, all of which bear analogy to Indiana's mandalic messages.[21]

Consider, for example, *God Is a Lily of the Valley* (fig. 4.13). The painting is a portrait format without a legend: its central circle is suspended in the top five-sixths of the composition, the way we experience (in others and ourselves) the head over the neck, elevated above the body. It is a wheel of words that comprises an unending song, a round like "Rose is a rose." But the circle also suggests frame and halo, components of, say, the Daphni Pantocrator. The hallowed cross in the Greek mosaic, the symbol of the sacred head, is answered in the painting by a cross read in the negative space between the four small orbs or wheels. These assert a presence

5.2 *Heliodorus, the Actuarius.* Painted plaster block from the House of the Scribes ceiling, 30.5 cm. high. Yale University Art Gallery, Yale-French excavations at Dura-Europos (photo courtesy of Yale Art Gallery).

5.3 Christ Pantocrator. Dome mosaic, Monastery Church, Daphne, Greece (Foto Marburg/Art Resource, New York).

verbally through circular repetition (via the being verb "he is a / he is a / he is a," and so on) and visually through their strict, frozen frontality, as parities of pairs of eyes, or eyes and hands, that correspond to four points of sacred focus in the Byzantine mosaic. Both compositions, the signlike song ("God Is a Lily of the Valley") and the signlike icon, are made powerful as objects and sources of vision. Image and text are immediate and coextensive as long as – as Bryson says of the archaic liturgical instance – the visual regime is not expanded "beyond the minimal schema . . . the threshold of recognition."[22]

Representations of human faces that evoke this kind of seeing are ones in which spiritual potency has replaced the goal of particularized resemblance. A scholar of Christian imagery and icons, Edwyn Bevan, has asserted that "it is very often the vague and indistinct suggestiveness which gives an idea power."[23] Religious portraiture of minimal inherited schema is portraiture of recognition and convention, but also of imagination. This kind of portrait is all sign and yet, mysteriously, possesses a metaphysical *vraisemblance*, a presence. Its cultural legacy is sketched by Deleuze and Guattari: everyman's reflection of the inhuman, all-encompassing "white wall of faciality" ("face-without-body / the White Man / Christ") that, from cradle to grave, organizes and subjugates our lives.[24]

Indiana's paintings, because they trigger sensations of indistinct faces and thus play on the power of vision, are also akin to apotropaic images, charms for warding off evil spirits that are activated by looking (fig. 5.4). He tends to regard his work this way in his personal life: he long retained many of his key paintings and constructions, keeping them with him even on remote Vinalhaven Island, somewhat

5.4 Hex-sign motifs on a 1601 miner's inn later used as a barn, Grunau (Grunow) County of Hirschberg (Jelenia Gora), Lower Silesia, Poland. Ludwig Loewe, *Schlesische Holzbauten* (Düsseldorf: Werner-Verlag, 1969).

as Leonardo kept the *Mona Lisa* with him until his death in France.[25] Lawrence Alloway wrote of *Year of Meteors*: "The closest analogy to [Indiana's] elaborately sustained concentric symmetry and his gay color are hex signs. Viewed in relation to hex signs, which have a protective magic function, one can, perhaps, see what has happened to Worringer's theory of geometric form as a defense against anxiety, which was used to confer human meaning on early abstract art. The desperate urge to hold still a threatening world, which Worringer saw in geometric patterns, is lightly treated by Indiana. In fact, his painting is not so much a tight knot against anxiety . . . [as] an emblem of personal and extensive meaning."[26] It is exactly that the works *are* "tight knots against anxiety," however — Indiana's, and, with certain works like *EAT/DIE* and *LOVE*, the transferred anxiety of an entire culture.

Structurally, Indiana's paintings of encircled stars and geometric shapes do call to mind the *hexenfoos* or *trudenfuss* that had protective function in early Germanic cultures, and their multitudinous relations, symbolic stars and circles that appear on furniture and architecture throughout Europe and the Near East. Such pentagrams, quartered circles, and "wheels of fortune" are prophylactic charms aimed against Satan or adversary witchcraft.[27] Indiana himself has never made a point of using such lore, although certain ancient symbols recur in his work, including crosses and astrological signs (as on the herm *Moon*). Hex signs are brought to mind because of their inherent but coincidental similarity to his motifs. Curiously similar, too, are the fifth- to eighth-century circular ampullae from Monza and Bobbio for carrying holy water (fig. 5.5), designed to reflect or perhaps even transmit the power of what is poured inside. David Freedberg speculates on the appearance of such charms: "One cannot help reflecting on the force of the frontally disposed, central element in each piece, whether cross, holy sepulchre, or the dominating and isolated figure of Christ himself. But that force is difficult to define. One can imagine — intuit — the warding off of devils; but why? Because of the force of frontality, symmetry, repetition, . . . the isolation of the central element, cyclical and circular patterns, or special kinds of framing and adornment?"[28]

All these images are pure field-of-force configurations. They are generators of vector fields in Arnheim's terminology, magnets for the eye through which they work magic on the viewer. In his book *Spiegelzauber* ("Mirror Magic"), Géza Róheim, a contemporary of Freud's, found in such phenomena a kind of mirror taboo, that what we look at will be reflected in us.[29] Róheim catalogs such powerful eye-target images and practices in a variety of European folk cultures: for example, the widely held belief that the eyes of the dead must be closed, lest they slay with their look those who still live.

We have noted a certain eeriness and ambiguity in Indiana's facial fascination, a rift between the unknowable and the recognizable that fits Freud's category of the uncanny. What is the origin of this effect — was it some rupture of his initial mirroring relationships, whether with his biological mother or (more probably) with

169

5.5 (a) Ampulla with martyr's head. Terra-cotta, Smyrna, fifth to seventh centuries. Paris, Musée de Louvre. Courtesy Réunion des Musées Nationaux (photo © RMN).

(b) Ampulla with cross and apostles. Silver alloy, late eighth century. Monza, Cathedral Treasury. André Grabar, *Ampoules de Terre Sainte* (Paris: Librairie Klincksieck, 1958), plate 25 (photo by Denise Fourmont).

Carmen, that strongly affected the infant, Robert Clark? Does attraction to strong mentors – artists and poets, personally known or otherwise – reenact his reactions to his earliest personal relationships? These are indeterminable issues, but they suggest themselves nevertheless because we can scrutinize their traces in the work. A complex relation between faciality and optical power, on the one hand, and words and verbal power, on the other, becomes increasingly apparent the more we look. Real, tangible portraits and self-portraits, such as those Indiana had once painted, in the mid-sixties are omitted or become repressed, replaced by circular and symmetrical configurations of words. But the relations between what the shapes and compositions intimate and what the painted words mean are ratios of figurations that simultaneously point in opposite directions. They behave like the dialectics of evasions and reversals that Harold Bloom finds in strong poetry. They appear as pairs: irony and synecdoche, metonymy and hyperbole, and metaphor and metalepsis.[30] Irony, the dialectic of presence and absence (equivalent, for Bloom, with Freud's primary defense of reaction-formation), embedded in the headlike circle and its vacant center in, for example, *Year of Meteors* (see fig. 4.15), is resolved by a restitutive return (in that painting) to the poet (Whitman) via synecdoche – through one of Whitman's lines ("Nor forget I to sing of the wonders – Year of Meteors").

Influence as metonymy defends itself by regression, often into patterns or repetition, observable throughout Indiana's painting, while its answering trope, hyperbole or Sublime representation, is found in Indiana's donning of the rhetorical voice of the American dream (as in *The American Dream #1*), or Anderson's "American imperial self." Metaphor, or substitution by resemblance, has its parallel in the paintings' faciality, while here the answering trope of metalepsis – the crossing or substitution of one trope for another, a "figure of a figure" – emerges, for example, in Indiana's cardinal number portraits that are figures of figures, but figures that return to precursors, either painters or poets (*The Demuth American Dream #5*), or parents (the symbolism of sixes or eights). Indiana's verbal-visual dialectic in his compositions and his painted words does not present the postromantic progressive ordering called for in Bloom's theory of poetry, but the paintings do act like poetry in that they provide the means of contact – by facing, and overcoming – one's relationships or influences. And according to Bloom, "Every poem we know begins as an encounter *between poems*. I am aware that poets and their readers prefer to believe otherwise, but acts, persons, and places, if they are to be handled by poems at all, must themselves be treated first as though they were already poems, or parts of poems. Contact, in a poet, means contact with another poem, even if that poem is called a deed, person, place, or thing."[31]

Figuration

Indiana's career hit its stride in the years just after Pop art emerged as a movement legitimized by the American press. He had regular shows at the Stable Gallery, major museums were buying his new work regularly, and a considerable bibliography on his work was accumulating. He chose at that time to make the personal and autobiographic connections in his work more explicit. That development took place just as two other related categories of imagery came to the fore between 1963 and 1966: a new representational figurative style, and a series of works featuring the words EAT and DIE.

Indiana's mid-sixties figurative style plays with his tropes and the meanings of his tropes by offering images that are superficially more visually described than his mandalic verbal abstractions. What Indiana calls his "realism" in fact involves neither photographic realism in any sense of that phrase nor the expressionist figuration that he had practiced in the past. Instead, he developed hard-edge representational schematics that ranged from depiction of objects in silhouette, to a linear, descriptive style bordering on caricature. The paintings are compositionally related to his earlier verbal/numerical abstractions but possess what we might call, after Peirce's semiotics, iconic or hypoiconic representation. His images of things and people are still thoroughly symbols, but ones with marked similarity to their

objects. It was at that time, too, that he began practicing verbal autobiography in the form of narrative stories about paintings, in recorded interviews and artist's statements written to accompany specific works. His narratives function to steer the works' interpretations away from the current Pop culture or consumerist contexts and towards a more personal one (see Appendix 2).[32]

One more watershed event for the artist occurred during the mid-sixties: a shift of domicile, always a traumatic event since Indiana's constant childhood uprootings. The sale of his building on Coenties Slip necessitated a move from a symbolically important dwelling – where he matured as an artist and lived six years, the longest-lasting home he had (at that point) ever known – to new quarters on the Bowery. One work, *Leaves* (fig. 5.6), displays within a mandala a silhouette of a dracaena plant. It evokes Indiana's mentor/ephebe relationship with Ellsworth Kelly (see fig. 2.9) when Indiana first arrived on the slip. The painting commemorates his departure from there (he "leaves"), another turning of a leaf, or a page, in his life.

His first major representational image of the period actually dates to 1963 and is not far removed from the abstract mandala paintings. *Highball on the Redball Manifest* (fig. 5.7) features a schematized front view of a locomotive within a mandala and ring of words that bear the title, and surrounds a central "25," his Coenties Slip address. But *Highball* refers to his grandfather, Fred Clark, an engineer on the Pennsylvania Railroad. Another painting of 1963 with a similarly encircled image, *Red Sails* (fig. 5.8), also commemorates a family member. It was prompted when Indiana heard an old tune, "Red Sails in the Sunset," sung by a vagrant in Jeanette Park. The event brought back the memory of Earl Clark's playing the song on the piano, upon which the song's sheet music was always kept. *Red Sails* is a "Father" memory – but the painting also refers to the ships and daily life Indiana knew on the waterfront. Other representational works – what Indiana called "object paintings" – of the same years are also connected with the slip, namely his Brooklyn Bridge series of 1964 (see figs. 4.33-35).[33] Those paintings "portray" the famous bridge representationally (which we recall he could see from his windows at number 25), but in the manner of the Demuth paintings, the bridge also is the symbolic portrait of its famous poet, Hart Crane – not a member of Indiana's family, but a sort of homosexual poet-precursor, a romanticized "father."

In the year of *Red Sails* Indiana began an important diptych, first exhibited at the Stable Gallery in unfinished form – because Indiana was so eager to show it – on Mother's Day, 1964: *Mother* and *Father* (fig. 5.9). The two parts are stylized portraits of Carmen and Earl that the artist based on old family snapshots and his own earlier drawings (see figs. 1.2 and 1.3). Two years later, he wrote a narrative, also entitled "Mother and Father," elaborating the meaning of the diptych (see Appendix 2).

In the paintings, Earl and Carmen are posed within their respective mandalic frames as travelers. They stand on either side of a Model T Ford with the license plate "IND 27," and "64" (the year of the Stable's Mother's Day show), in a wintry

5.6 *Leaves*, 1965. O/c, 60 x 50".
Marion Koogler McNay Art Museum, San Antonio
(photo by Eric Pollitzer).

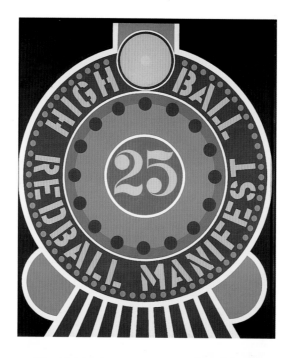

174

5.7 *Highball on the Redball Manifest*, 1961. O/c,
60 x 48". Jack S. Blanton Museum of Art, University
of Texas at Austin; Gift of Mari and
James A. Michener, 1991 (photo by George Holmes).

5.8 *Red Sails*, 1963. O/c, 60 x 50". Private
collection, Toronto.

midwestern landscape. The artist at one time planned a series of four such pairs – spring, summer, fall, and winter (the only one completed) – thus showing mother and father in an eternal seasonal cycle.[34] In spite of the apparent cold, Earl is barefoot, while Carmen, in vampish hairdo and bright red cape (the only strong color in the diptych), is partly bare breasted, which could emphasize her nurturing role in Robert's life. But it also relates to the classical convention for female allegorical figures. According to the artist, whose statements divert us from the sexualized reading of Mother, the hint of the single bare breast refers to the myth of the Amazons – an androgynizing attribute denoting strength and heroism.[35]

Posed within mandalic circles, *Mother* and *Father* again recall icons, the madonnas and saints of Christianity. *Mother* and *Father* are portraits of ideas, not simply memories – what Freud called imagoes.[36] They are parental images (the 27 on the license plate stands for the year of the artist's conception), and strongly Oedipal ones, with mother's vivid Theda Bara look and painted eyes contrasting with father's grays, his eyes in shadow. They were, according to the artist, inspired by Arshile Gorky's *The Artist and His Mother* (ca. 1926-36) in the Whitney Museum of American Art. Indiana, however, rather than portraying himself with his mother as Gorky had, fulfilling the Oedipal suggestion, instead puts Earl (as it were) back in his place. It is the poetic dialectic of absence and presence, answered by ironic reversal: the gray, half-clothed, impotent figure of Earl. The surface perfection of the paintings, wrote Gene Swenson, "combined with the nakedness of the man under his topcoat . . . sets our teeth on edge and lies uneasily on the edge of parody."[37] At this successful moment, when his own life most fits the pattern of the American dream, Indiana expresses Earl's failure.

The artist is represented in the diptych in two ways: first, via his gaze. The large pair of circles, taken together, match Indiana's earlier orbic vision binoculaire. Second, the "IND 27" indicates the place and time of Indiana's conception. It is as if the artist – in disguise, or peering through binoculars – witnessed his parents' primal scene (a traumatic moment but also a "factitious fact," as Lacan calls it[38]) and represented it here, in a vehicular or traveling version – a doubly factitious fact, because in reality his conception was attended by parents other than Carmen and Earl.

Mother and *Father* also pay homage to a strong poet and influence, Gertrude Stein. The legends in the paintings, "A Mother Is a Mother" and "A Father Is a Father," besides affording comment on adoptive parenthood, are rewritings of "[A] rose is a rose." Mother with a Model T alludes to Gertrude and Alice in their Model T, "Godiva" (fig. 5.10). The arrangement also reflects Indiana's involvement with the Gertrude Stein-Virgil Thomson opera *The Mother of Us All*. In fact, Indiana's 1964 Mother's Day opening at the Stable included a concert with some of Thomson's music for that opera, sung by the Metropolitan Opera Studio Group under direction of John Gutman. Shortly after, at Thomson's invitation, Indiana began making set and costume designs. These occupied him over the next few years and

175

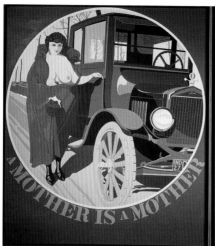
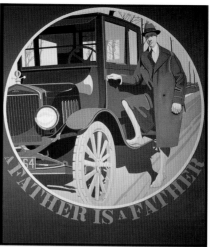
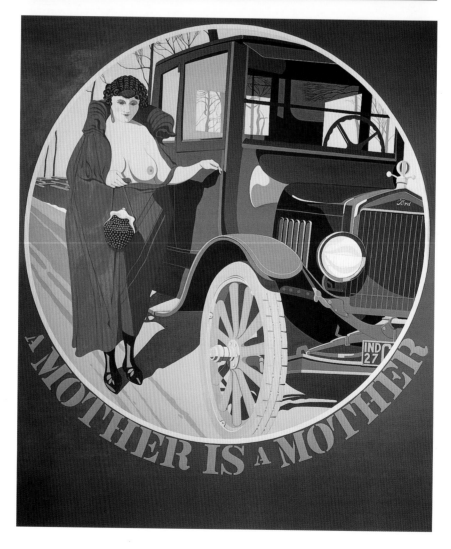

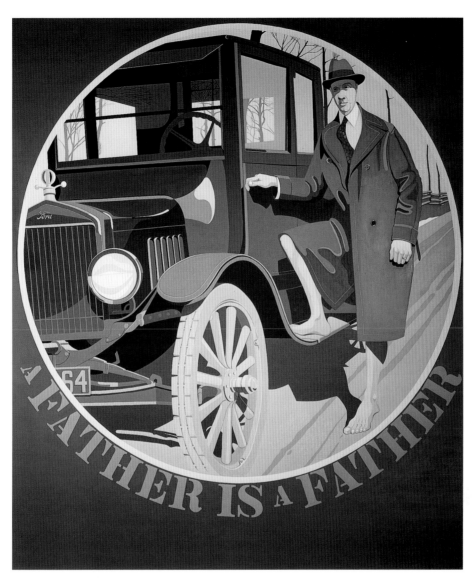

5.9　(a) *Mother* and *Father* diptych, 1963-67. O/c,
two panels, each 70 x 60". Artist's collection
(photo by Eric Pollitzer).

(b) *Mother*.

(c) *Father*.

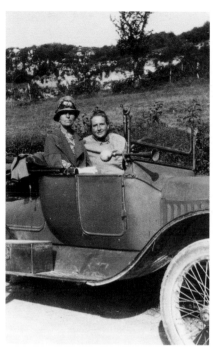

5.10 Gertrude Stein and Alice B. Toklas in "Godiva,"
ca. 1920s. Gertrude Stein Collection, Yale Collection
of American Literature, Beinecke Rare Book and
Manuscript Library, New Haven.

appeared in the Center Opera production of *The Mother of Us All* at the Tyrone
Guthrie Theater in Minneapolis in 1967. One of Indiana's key designs for the opera
(a full set of mock-ups were done as *papiers collés*) is that for the character of Susan
B. Anthony, who appears, like Carmen (and Stein), with a Model T as a kind of
attribute. Alone, the auto in this production is a leitmotif of "Mother" (fig. 5.11).[39]

Two more representational paintings can be mentioned although they were
done later, in 1967, within the *LOVE* period. *The Metamorphosis of Norma Jean
Mortenson* (fig. 5.12) is Indiana's tribute to Marilyn Monroe five years after her
death. In a tondo within a diamond-shaped canvas, Indiana overlays Marilyn (who
is depicted bare-breasted, like "Mother" in his parents' diptych) with his own auto-
biographical references, much as he had done with his symbolic portrait of Demuth.
But this time Indiana connects himself with the starlet as a name-changer and a vic-
tim (or martyr) of the American dream. The work was occasioned, he tells us, by his
finding an old calendar that had been printed in Indiana (the artist's personal link),
for which the starlet had posed nude (see "The Metamorphosis of Norma Jean
Mortenson," Appendix 2).[40] As he studied the subject he discovered a tragic
numerology in her life, all twos and sixes (love and evil, in Indiana's number usage).
For example, she was born in 1926, died in 1962, and acted in her first dramatic role

5.11 Presentation designs for *The Mother of Us All*,
Tyrone Guthrie Theater, Minneapolis. *Papiers collés.*
Marion Koogler McNay Art Institute, San Antonio
(photos by Bruce C. Jones).

(a) *Susan B. Anthony.*

(b) *The Model T.*

when she was 26. For Indiana, Marilyn's reported suicide triggered some autobiographical parallels with some of his aspiring dancer and writer friends who themselves had been suicides. Moreover, Norma Jean had been a foster child, and, like Edward Albee, shared a similar distinction of uncertain origins with the painter.

Also in 1967 Indiana did the colorful mandala-plus-legend painting *Parrot* (fig. 5.13).[41] The bird was intended to represent another family figure, Uncle George Potts, who lived with Indiana's maternal grandparents and had a parrot that would perch on his shoulder. *Parrot, Mother and Father, Red Sails,* and *Highball on the Redball Manifest* together form a family album or portrait gallery. But *Parrot* is no more or less a "portrait" than calendar girl *Marilyn,* the idealized *Mother and Father,* or even *The Figure 5,* and it furthermore bears the convention of self-portraiture, the "look out of the picture" that signals the look into a mirror.[42] The mirror stare, as we have seen, is a field of force, and according to Lacan, its image portrays not our self but our imago, our other.

In *Parrot,* multicolored letters spelling EYPHKA appear to issue from the bird's beak. The artist explains this as a variant of "Eureka": "I have found it." It relates to found objects, and the Greek to his classical bent. Alternatively it might mark the moment of poetic double-vision ("vision binoculaire of the *birds,*" in the

5.12 *The Metamorphosis of Norma Jean Mortenson,*
1967. O/c, 8'6" square. Collection of the McNay Art
Museum, gift of Robert L. B. Tobin.

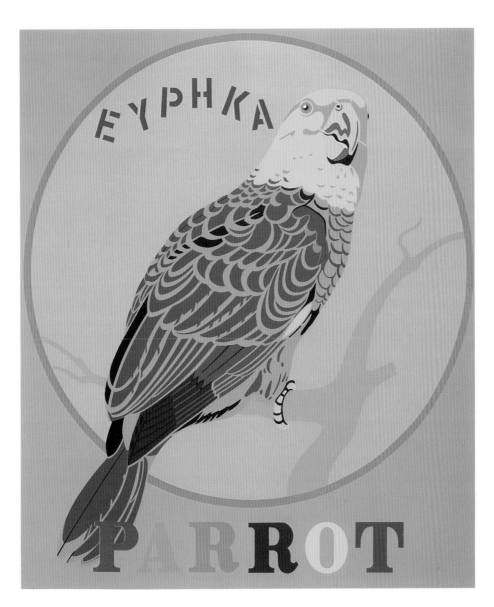

5.13 *Parrot*, 1967. A/c, 70 x 60". Collection of Professor and Mrs. John A. Garraty, New York.

artist's earlier enigmatic note) – the hoped-for resolution of opposites, in ourselves (Eureka!). Thus the mirror-gaze is what George Potts's pet personifies for us, as it stares directly out of the canvas like a self-portrait painter before his glass.[43] Moreover, "to parrot" means to act or look like or otherwise mirror someone, to be a double or *doppelganger*. Our mirror image is our double and our parrot, as Narcissus's image in the pool was his. Although Indiana has never read Lacan, the painting illustrates the irony of the mirror relation. *Parrot* is not only a mascot of Indiana's supposed family identity; it is his self-reflection in the work of art that parrots our gaze into the canvas. *Parrot* parodies us, his viewer-doubles.

Memento Mori

Slightly earlier, in 1962, in several paintings Indiana conjoined the words *eat* and *die*, one-half of his EAT/HUG/ERR/DIE quartet of the cycle of life. While *eat* certainly fits Pop art's nostalgic involvement with consumerism and American capitalism ("a chicken in every pot" in Herbert Hoover's 1928 campaign slogan), together *eat* and *die* comment on the fleetingness of life. They verbally translate that traditional genre of painting, the moralistic still life known as the *vanitas* that became especially popular in the religious environment of northern Europe in the seventeenth century. These paintings combine luxury or sensory items like food (especially delicacies) with such memento mori as skulls and smoking candles, all of which Indiana's "signage," like the *EAT/DIE* diptych, reduces to their fundamental message (fig. 5.14). In its Pop art context *EAT/DIE* rings out against the excesses of consumerism. But Indiana's terse imperatives are intensely polysemic: EAT not only signifies popular roadside memorabilia (especially diner signs of the highway days of his youth, the type already disappearing in the sixties), but a focus of his own life. Dinner menus are standard daily items in his journals. The conjoined words *eat/die*, besides having Christian connotations (bottom-lining the Passion, as it were), are private autobiographical words evoking a number of traumatic or at least unpleasant events of his childhood – the outlays of food connected with family funerals, perhaps. The connection might also suggest the first child that Indiana ever saw being breast-fed. Indiana remembers that he hit that child one day as the two quarreled over a small plaque of Abraham Lincoln they had found, and – in a later and completely unconnected event (though perhaps connected psychologically) – he recalls hearing that this onetime playmate was dead. The story has an eerie similarity to the oftener-told one that *eat* was the last word spoken by Carmen on her deathbed. And recall Indiana's association of mother and diners in his stories of his childhood. Diner equals mother equals Carmen equals red. Black equals father (dressed in gray in Indiana's portrait) equals death. Indiana called the *DIE* his "own hex sign."[44]

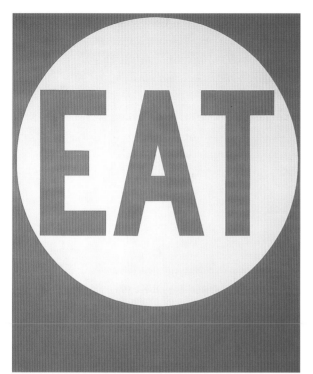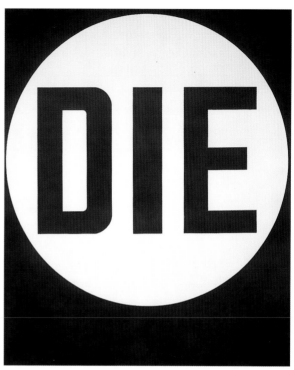

5.14 *EAT/DIE* diptych, 1962. O/c, two panels,
each 72 x 60". Private collection, New York.
© Robert Indiana-Morgan Arts Foundation/ars,
New York (photo by Camerarts, New York).

The *EAT/DIE* diptych is made up of one red-and-white and one black-and-white painting, the encircled words in each spelled in bold sans-serif letters. They are reductive and immediate, and for the art world of 1962, they must have been startling. For John K. Sherman they were like "those stop-look commands we've all obeyed or regarded all our lives. Certainly there's a special reflex involved in looking at signs" – the kind of knee-jerk reaction that bypasses rational thought.[45] *EAT/DIE* is a "binocular" diptych like his parents' portraits: a pair of orbs or mandalas like snake eyes in dice, but evoking the poet's "double vision."

When we look at Robert Indiana's *EAT/DIE* diptych and meet its binocular stare back at us, or when we view it sequentially, focusing individually on the elevated disks, each with its clipped message – shotlike commands – we feel its aggressiveness.[46] If read like his reductive Mamaroneck paintings, *EAT/DIE* poses a startling association of seeing and consuming, or eyes and mouth, rendered more macabre in the use of brilliant blood-red *(EAT)* and black *(DIE)*. The combination of eating and seeing is associated in Freudian theory with the narcissistic phase of libidinal development. In fact, one could argue that *EAT/DIE* issues from the crushed state of melancholia, which Freud discusses in his 1904 paper on that sub-

ject, in which "an attachment of the libido to a particular person, had at one time existed, then, owing to a real slight or disappointment coming from this loved person, the object relationship was shattered" and the libido withdrew into the ego, in fact identifying with the abandoned object. As a child Indiana's relationships with both parents – particularly with Carmen (dressed in red in his parents' portraits) – were intensely ambivalent. To Carr, Indiana expressed feelings of bitter disappointment with them: "It dawned on me at a fairly early age that my parents were not very competent people. They were very bad at handling their own affairs and, as a child, I saw this, and so, if they gave me any advice it couldn't be taken too seriously because they were conducting their own lives so badly. They were failing at everything that they did – their own marriage, economic aspect, the aspect of creating a home. I never had a home."[47] But bitter disappointment could also stem from the experiences of his parents' deaths.

In the paintings *Mother* and *Father* the ocular orbs that signify the artist's presence in the work ("lurking in its shadows") thus identify him with them, but more convincingly with "Mother." Freud points out that the melancholic's regression from object to narcissistic identification can become expressed as incorporation: "The ego wants to incorporate this object into itself, and, in accordance with the oral or cannibalistic phase of libidinal development in which it is, it wants to do so by devouring it."[48] Because of the eye-mouth equation, the visual substitutes, or at least mediates, for the oral and allays some of its destructive potential ("eat-die"). The seeing-eating-shouting aggression, contained within the *EAT/DIE* diptych, embodies a defense against death. In doing so those paintings create verbal-visual statements that are like hybrid figurative language. *EAT/DIE*, as a synecdochic trope for his mother's (his own) errors and death, is an essentialized poem, one that does exactly what Harold Bloom (interpreting Freud) says that all poems do at bottom, defend against death: "If death ultimately represents the earlier state of things, then it also represents the earlier state of meaning, or pure anteriority; that is to say, repetition of the literal, or literal meaning. Death is therefore a kind of literal meaning, or from the standpoint of poetry, *literal meaning is a kind of death. Defenses can be said to trope against death, rather in the same sense that tropes can be said to defend against literal meaning*."[49] Whether or not Indiana was consciously aware of such meaning relations, it is clear that he had high ambitions regarding these simple panels. Their calculated monumentality and rhetoricity work to divert the personal meanings from which they were constructed. With *EAT/DIE* he said he intended to create visual words that recall the integral way in which words functioned in medieval mosaics, or, making an even more powerful comparison, he said, "I would like to feel that I had brought the word back to such a distance that it has almost the quality of, shall we say, one of the Ten Commandments."[50] Moses' commandments were not only carved in stone, they issued from the burning bush.

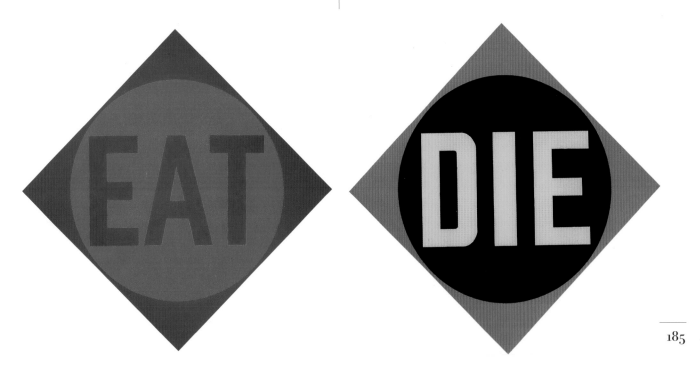

5.15 *Green Diamond EAT* and *Red Diamond DIE*,
diptych, 1963. O/c, two panels, each 85″ square.
Collection of Walker Art Center, Minneapolis;
gift of T. B. Walker Foundation, 1963.

Green Diamond EAT and *Red Diamond DIE* (1962; fig. 5.15) in the Walker Art Center, Minneapolis, vary the preceding formula in canvas shape and color, achieving an opposition of chromatic primaries with near-painful optical impact. In a review, Rosalind Krauss noted, "If the *Green Diamond Eat* has any power, it is in the 'easy' access to the sign itself, and the 'difficult' optical shimmer made by juxtaposing full-intensity red and green, a painterly manipulation which makes the color seem to exist independent of the sign – standing, indeed, out from the picture surface. Such power . . . lies in the ironies he can provoke with his peculiar transformation of mimesis into art."[51] Krauss's distinction between "easy" and "difficult" directs us again to the dual nature of Indiana's art. Her words remind us that other critics have pointed out the disparity between the product and its packaging: the artist and his mask, and the comparison of his images with apotropaiae or hex signs. As Krauss suggests, access for Indiana is always divided – the color catches our eyes and the words are easy enough to read, but on the other hand, as we have seen, the color combinations are sometimes jarring, and the words stand for, but do not inform us about, their intense and complex meanings.

The Eateria and The Dietary, both in mandala-plus-legend format, were also intended as a diptych, though these panels were ultimately separated (figs. 5.16 and 5.17). *The Eateria* is a red-blue-and-green work that combines *EAT* with a roulettelike

wheel of numbers stopping at eight (Carmen's number, phonetically identical to *ate*). The wheel's ring of *eats* invites recombination of the letters, most significantly to spell *teat* or *teate* (as a giver of milk, Mother is a kind of eateria). The artist specifically illustrated this arrangement in his working sketch of the painting (fig. 5.18). Similarly, *The Dietary* (black, white, red, and yellow), the "father" member of this pair, conflates a nutritional concept with the word *die* embedded within it.

Two other involvements with the eat/die theme should be noted. One has already been mentioned: late in 1963 Andy Warhol shot one of his earliest film portraits, entitled *EAT*, which involved a twenty-minute shot of Robert Indiana eating a mushroom (see fig. 4.23). Besides the connection of the fungus with atomic explo-

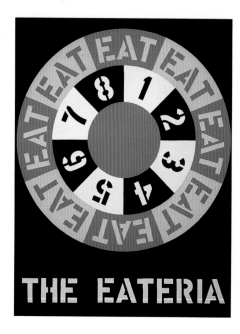

5.16 (LEFT) *The Eateria*, 1962. O/c, 60 x 48".
Hirshhorn Museum and Sculpture Garden,
Smithsonian Institution, Washington, D.C.
Gift of Joseph H. Hirshhorn, 1966
(photo by Lee Stalsworth).

5.17 (TOP RIGHT) "The Dietary," sketch of painting.
Journal-sketchbook 1961-62, 6 June [1962], artist's
collection.

5.18 (BOTTOM RIGHT) "TEATE" sketch of detail,
"The Eateria." Journal-sketchbook 1961-62,
6 May [1962]. Artist's collection.

sions (mushroom cloud), and the New York avant-garde (mushroom hunting was a popular pastime with John Cage and members of Fluxus), mushrooms are potentially poisonous food (eat/die). Mushrooms were also among Carmen's favorite foods, and Indiana told Carr of a personal memory involving her fearlessly cooking and eating mushrooms that young Robert had found, a strange harbinger of Carmen's last utterance ("Did you have something to eat?").[52]

In 1964 Indiana created an illuminated electric *EAT* for the New York World's Fair (fig. 5.19). The architect Philip Johnson invited Indiana to be one of ten artists (others included Warhol, Rosenquist, Rauschenberg, and Indiana's former mentor Kelly) to hang works around the exterior of his *Circarama*, part of the New York State Pavilion. Indiana devised a twenty-foot-high "sign" with intersecting *EAT*s (sharing the same *A*) forming a giant X, a figure of caution or warning as it appears in his work ("do not eat"). But the message was commonly misread within its context. It was taken literally, so much so that it had to be kept unlit after the first day, when fairgoers lined up looking for a restaurant. Johnson himself misread the big sign, calling it "banal, commanding, elevated vulgarity."[53] Clearly *EAT* represents more than Pop art elevating low life. In representing something it is not (a sign designating food), while hiding what it is (a work of art), the sign is a figure of irony. A six-foot *EAT Sign* done at the same time bears the word in electric lights within a circular frame. Both *EAT*s light up sequentially and flicker on and off, advertising the circularity of the verbal/oral-visual equation, via the timelessness of repetition.

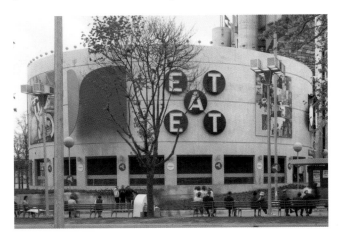

5.19 *EAT Sign*, 1964, flanked by works by Ellsworth Kelly (on left) and Robert Rauschenberg on the *Circarama*, New York State Pavilion, New York World's Fair 1964. Artist's collection (photo by Eric Pollitzer).

Dream Analysis

The representational and *EAT/DIE* works in Indiana's oeuvre directly reference childhood and origins. Here lies another dichotomy. His memories are focused within visual trimmings and patterns that make time stand still. But his messages are spoken in fragments from seats of absence, voids within pictures filled with signals of self-identity. Looking at the range of his sixties works, we see that the impressions of enigma and conflict between possible meanings confound the clarity of the works' optical issues and invade their facile surfaces. As he achieved personal success, Indiana may have felt an urgency to express some information about his past, to suggest the secret nature of the paintings (which the reviewers and journalists for the most part missed). So he produced the representational paintings on "family" themes and started writing the narratives to accompany his paintings. And when it must have seemed that the publicity he enjoyed as a Pop artist would certainly continue as he broke off from the herd – that he had captured an audience – Indiana displayed a certain boldness of disclosure, a stricter formal directness and reductiveness, and a tendency toward monumentalizing rhetoric, evident in the *EAT/DIE* of 1962, that would culminate in the *LOVE* of 1965-66.

Indiana's aspirations as a poet never departed, even though his writing of poetry had ceased in the late 1950s, as the herms and orb and gingko paintings occupied his creative energy. I have shown that Indiana's paintings function as poems that combine verbal and visual language, just as they are paintings that use words as well as images. But the matter goes further than this. As Krauss makes clear in her comment about them, the optical and formal achievement of Indiana's paintings is not simply another aspect or side of his work. In fact, color, shape, composition, and other formal elements are themselves all used, alongside words and numbers, as tropes or figuration – that is, in ways that are not simply literal – to make statements that are not narrative but conflicted, dynamic, and allusive. Even in the most formalist, verbally reductive compositions, literal meaning coexists with multiple figurative ones. For example, *EAT* is a nostalgic sign, a speech act, perhaps a command, possibly even a dare, but it is also Mother. Red-green is an intense clash of complementary colors, but it also suggests anxiety and indicates caution.

These chains of signification plumb Indiana's personal depths. They remind us of the power of figurative language or tropes, as Bloom says, to defend against death. Bloom also tells us what Freud always knew, that "psychoanalysis is a science of tropes. . . . A fantasy of defense is thus, in language, the recursive process that traditional rhetoric named a trope or 'turning,' or even a 'color.'" Lacan takes us one step further. He suggests that figurative language, or "signifying condensation" is present in both poetry and psychoanalysis. But the signification is never reducible to the thing symbolized. It is always reduced to another symbolic form. We can

untangle the chain of symbols, but we can never arrive at the original wrenching experience. Interpretation consists of finding the kernel of "non-sense" beyond the signifying chain.[54]

For example, Indiana's foundation paintings, the American Dream series, demonstrate the signifying processes that link the writing of poetry and the creation of dreams ("dream-work"). We have seen that, after *The American Dream #1*, Indiana rapidly created four more dream paintings in 1962-63. Numbers two through five (see figs. 4.24-27) rework the visual vocabulary of the first dream, but certain characteristics become increasingly consistent as the group progresses. They get larger – from seven feet high and wide, to twelve (number five), compared with number one's six by five feet. Indiana eliminates the brown of dream number one, and the second through fifth dreams are dominated by blacks, reds, and yellows – difficult and highly emotional colors in the artist's chromatic vocabulary.

Moreover, in comparison to number one's rectangular proportions and undulating background registers, the subsequent dreams are ritualistically regular – they are all axially symmetrical crosses or diamonds with internal crosses that create undertones of death and sacrifice. *The American Dream #2* is a diamond-shaped canvas with a somber black ground. Here the cross marked out by the placement of four circles within the diamond at the four points of the compass is repeated, with another cross in red within the top circle that contains the word *EAT* vertically and horizontally sharing the same *A*. Knowing what we do about this word and its relationship to Carmen and Indiana, the "EAT cross" here reads like a memorial. *The American Dream* numbers three and four are diamond arrangements of four smaller diamond canvases, each with a central circle, so that each of them also presents a cross-shaped arrangement. *The Demuth American Dream #5* forms a cross with five square panels.

Besides the recurrence of *EAT* in dream numbers two, four, and five, all the dreams contain multiple signifiers of Carmen and Earl, and of Indiana's childhood. There are the colors red and black, and roulette wheels, significantly numbered one through eight (Carmen's number), appear in dreams two and three. Dream number three repeats (from number one) the letters US (United States) and the numbers of the highways (U.S. routes 40, 37, 29, and 66) that the family ("us") traveled on.[55] Roulette and games of chance also recall family times in roadside cafes. Dream number one's TILT and TAKE ALL recur in dream number three, and number one's TILT/JILT recurs in number four. Stars or heroes – which parents become in the family romance – are indicated by circles of stars and the word JACK in dream number two, perhaps referencing JFK, still president when that canvas was painted – a hero and national father-figure. But heroism implies its opposite, lack of heroism or ignominiousness, certainly present in vernacular meanings of both jack and juke (dreams two and four) as we have seen. Heroism, like success in the American dream, is a game of chance.

189

Dreams numbers two through six appear as alarms or warnings ("beware-danger"). They quote the American system of roadside signage in their forms and formats: diamond signs that indicate changes in the roadway; the equal-armed cross symbolizing intersection; the X, motif of the circular railroad-crossing caution sign. Dream number three's red octagons mimic the familiar stop sign. Beware-danger stripes, also familiar from public signage, appear in dream number three and prominently in number four, *The Beware-Danger American Dream*. All signal potential dangers ahead.

The wheels of words and numbers and circles of stars that appear in dreams one through five suggest cyclical movement, a sense encouraged by the alternating dark-light handling of circling words and digits, as in the numbered wheels in dream numbers two and three, and the repeating ALL in dream number three. If we read across the crosses in the diamond paintings, their words make simple, alliterative repetitions: EAT-2 and JACK-JUKE, in dream number two, or JUKE-JACK / JILT-TILT / EAT-THE AMERICAN DREAM, in number four. They are the sort of sing-songy lines encountered in children's nonsense rhymes – or in Stein's verse ("Eating he heat eating he heat it eating"[56]). The parity and reciprocity of the words in Indiana's painting, and the circularity of their orbic enframements in four polar positions, create alternation and repetition – EAT-2-EAT and JUKE-JACK-JUKE – that implies an endless cycle and a perpetual present, comparable to the timelessness that Freud found characteristic of actual dreams.

The paintings also contain some unsettling optical illusions. For example, the number 3 in the center of the bottom circle in dream number three is colored to alternate with its background, a hexagon divided into red and black quarters. The resulting figure 3 appears fragmented and faceted and almost disappears like camouflage. In the same painting, the spaces between the octagons and the circles they inhabit are colored yellow, so these centers glow as though opening to a bright light, as if the painting imperfectly screens off another place or reality beyond. In dream number four the diagonal tops of the fours are positioned against parallel black/white "danger" stripes in a way that seems to disengage the figures from the ground so that they appear to hover in indefinite space. Finally, there are the voided centers, in all but dream five, amid the diamonds, crosses, circles, octagons, and circling words, stars, and numbers. Compositionally complex and dynamic fields of force, the paintings are empty at their cores.

The sixth dream, *USA 666* (fig. 5.20), is separated by time and consistency of detail from the others, and its autobiographical symbolism is rendered more explicit because it is the only one for which Indiana wrote a specific interpretation ("USA 666" in Appendix 2). Like the other dreams, however, it is conceived as a reference to highway signage in terms of what Indiana calls "road literature." *USA 666* exists in two versions: one red and green, the original colors of Phillips 66 (his father's company), plus blue ("for the sky"), and the other yellow and black, the colors

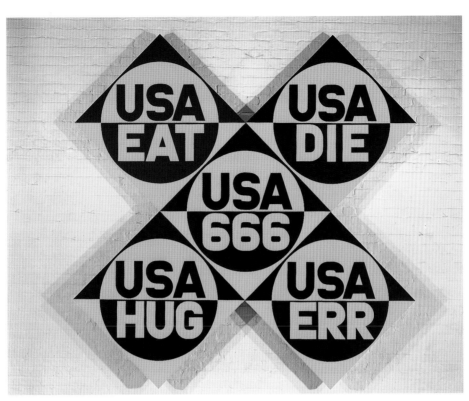

5.20 *USA 666*, 1966. O/c, five panels totaling
8' 6" square, yellow and black version.
Private collection.

of a yield sign and other cautionary road signs. Referred to by the artist as a "father painting," it was begun in 1965, and before it was completed in 1966, Indiana received the news of Earl's death.[57]

In the poemlike manner of the Mamaroneck paintings, each panel of *USA 666* has a bilevel message. In the center panel, *USA* (the place of the American dream) is paired with *666*, another reference to Earl (born in the sixth month, June), but also to Phillips 66 and to the great roadway west (Route 66) on which Earl disappeared when he left Robert and Carmen (see "USA 666," Appendix 2). But in the book of Revelations, triple-six is the numerological designation of Satan and the Beast of the Apocalypse. Four surrounding panels recite the cycle of sin, death, and redemption (EAT, HUG, ERR, DIE, or EAT, ERR, DIE, HUG), a series that builds up like Burma Shave signs, which the artist mentions in his written explanation as a pertinent childhood memory. Thus Indiana locates the metaphysical cycle of three-letter words on the highway of life. Moreover, the entire painting is organized like an X, the roadside signifier of railroad crossings ("stop – do not cross"). The black-and-yellow version is closest to railroad, yield, and other hexlike cautionary signs. The words seem here most like imperatives, perhaps like

"Father's" commands. Combined with elements of relentless repetition (USA:USA:USA etc.), danger, illocutionary force, and incantation intertwine.[58] Again it seems as if Indiana has employed one strong forebear to replace another – for "Father," Stein: her verbal repetition, her syllabic distinctness, her childlike rhythm and rhyme, and above all her insistence on presence. In the demotic idiom of roadside signage, Indiana enacts on Steinian verse a misreading that opens itself to be misread.

Like *The Demuth American Dream #5*, which also incorporates strong precursors, *USA 666* does not have the central void that we noted in the other dream paintings. Instead, the machinery of verbal and visual repetition form a kind of grid or screen. In Indiana's sixties work there is a dialectic of insistent presence and the absence that refers back to presence – between screens and holes, attracting faciality and repelling optical shimmer, speaking and seeing – that suggests the kernel of nonsense referred to before – that something that is incomprehensible and yet has the familiar air of the uncanny. It is what Swenson found in Indiana's work – to cite another of that critic's apt descriptions: "Indeed, a 'presence' always seems to stand near his paintings, modifying and enlarging the sense of sight, an ungraspable phantom."[59]

That resistant, unapproachable core of meaning is also represented in all the dreams by means of the tropes for life and death cycles, like the allusions to highways and road signs. The dream paintings are like Pop poetry of "highway culture," to use Lawrence Alloway's term for Indiana's painting.[60] But as restitutive, self-involved poetry, the words' meanings are fractured, shifting, and vastly overdetermined. They represent Indiana's own mobile childhood, the interminable moves and auto trips in cars more familiar than homes, driven by one or both parents. Such imagery of errantry calls up more universal mythical wanderers like Odysseus or blind Oedipus, or antiheroes like Ahab or Palinurus, or they simply evoke the journey of life, like the allegorical Ten Ages of Man. As linguistic markers of travel, the Dreams connect with their predecessors in Indiana's oeuvre, the constructions based upon classical herms – those "headstones" that bore inscriptions to be read by passers-by and evoked Hermes and his qualities but that also often served as grave markers. By extension, the Dreams, with their *vanitas* message and their mapping of life lived, connote the kin of autobiography, epitaphy. Indiana must have known at least one painting in the history of art that combined roadways and life's journeys, Nicolas Poussin's painting *Et in Arcadia Ego*. In it, travelers read a stone-carved roadside memento mori that speaks to the living and warns of "death ahead." William Wordsworth points out in the first of his *Essays on Epitaphs* that tomb writings were commonly found by the "way-sides" of the Greeks and Romans (Indiana's beloved classical culture).[61] As opposed to their English status as texts for graveyards, ancient epitaphs were another kind of "road literature."

Indiana himself has echoed the epitaphic character of some of his works, calling his Demuth Five paintings alternatively "commemoration" and "threnody."

Carr points out that the excerpts from Whitman and Melville in Indiana's 1961-62 paintings are from texts that have themes of death and rebirth. And the lines from *Song of Hiawatha* that appear in *The Calumet* are also epitaphy.[62] Indiana's 1980s-90s series "The Hartley Elegies," devoted to the American painter Marsden Hartley, rework Hartley's own postmortem symbolic portraits of a German officer (Karl von Freyberg).

Figures of death in Indiana's reports of his life reach a high point in the series of Indiana interviews with Carr conducted at Columbia University in 1965. These interviews, based on free-association technique, were designed as an exploration of the creative process using Freudian psychoanalytic dialogue. Thus Indiana was not a "subject," but he operated like one. The interviews were taped and transcribed, and so prominent is the subject of death in them that Carr, in his summary, speculates that Indiana's art is about the creation, repetition, and manipulation of screen memories (like the Phillips 66 pin on his father's uniform) that mask unknown traumatic childhood experiences, possibly involving the subject of death.[63] In particular, he felt that the mother and father stories, especially those involving eating and dying, may epitomize a "sense of the proximity of death" throughout Indiana's childhood. In the interviews the artist reported that his mother was very fearful and superstitious about death, especially death from cancer (of which she died). But other deaths abound. Already noted are the deaths of her first child and of one of Robert's earliest playmates, the spectacular family murder, and the prominence in his memory of John Dillinger's funeral. In addition, young Robert Clark had to attend numerous funerals of relatives, and Indiana related one vivid memory from when he was four or five, of accompanying his father to "view" the body of his deceased employer, James Henry Trimble, which Indiana remembered in connection with the elaborate interior of the Trimble mansion. Indiana reports that he became interested, as a child, in what he terms the "architecture of death" – funeral homes and cemeteries as well as ceremonies and rituals – and he reacted to the lack of these among relatives who were devout Christian Scientists. Clark, with his cousin Jack MacDonald (another possible reference for the Jacks of the American dream series), once entered an abandoned funeral parlor to look around. The artist also recalls having been interested in William Cullen Bryant's poem on the subject of death, "Thanatopsis," at some point in high school. Later, when planning the art student's ball in Chicago at the rented McCormick mansion, he developed the macabre theme of "Death of a Mansion," with allusions to the "grim reaper." Among his last paintings done in Chicago that won him the traveling fellowship was one of a New Orleans cemetery.[64]

Indiana relates several stories of being around graveyards. One was near the rural home where the Clarks moved when Robert nearly became tubercular, and its proximity kept his mother inside the house at night. Another was next to one of the schools Robert attended, and he and his friends played among the graves. As a stu-

dent at the Skowhegan School of Art in 1953, he toured old cemeteries in central Maine with the school's director, William Cummings.[65]

Moreover, Indiana reported two dreams in their entireties to Carr during the interviews, both involving death and funerals as well as another frequent theme from his narratives, auspicious dwellings. The first and most elaborate dream involves a long automobile trip with other people over a bleak, muddy landscape in the rain. The terrain was marked by large circular depressions that (in the course of the dream) reminded him of his own painting *The Calumet* (see fig. 4.14), painted some four years earlier.[66] The group arrived at a large house and passed through several empty rooms that overlooked a park filled with artists' studios. These were circular and arranged like the depressions in the muddy road. The group then went on to another, isolated house, where it was clear that someone – Indiana himself – had died. His father was there; he told his father where he wanted his work to go upon his death and indicated that his father was to have *The Calumet* (already owned by Brandeis University at the time), even though he felt that his father "wouldn't know what to do with the painting." It was "so that he would know that I hadn't forgotten him completely."[67]

The second dream, which followed the first by only a night or two, took place in another large, impressive environment, "like Notre Dame in Paris." Again he found himself with other, unidentified people, going from room to room, and suddenly in one room there was a casket, and he became aware that the occasion was being televised. In the casket was his cousin, Jack MacDonald from Bean Blossom (with whom he had visited the funeral parlor). The dream turned comical when his cousin smiled and "then popped right up out of his casket and [they all] ended up in a kind of party."[68]

Carr wrote that both dreams suggested a preparation for death, and that they also involved the exploration of some internal landscape, either a large house (which symbolizes the maternal body in a standard Freudian connection), or landscapes of circular markings that parallel the composition of virtually all of his paintings, though only *The Calumet* is actually a topic in one of the dreams. These circular markings are repeatedly described by the artist as being "depressions," very "orderly" and "regular"; in response, Carr noted in his summary of the interviews, "A typical obsessional way of keeping things under control, particularly castration anxiety, is through ordering."[69] But castration anxiety is a supposition – it stands for a traumatic experience of which we can only study the effects. What we really return to, in the image of Indiana's regular and circular "depressions," is the kernel of unknowable meaning – of the real (Lacan's term) or literal meaning troped by death (Bloom) – which forces the subject's articulation toward repetition.

In the course of discussing repetition in Freud, Lacan comes to the subjects of the gaze and the screen. The correlative of the picture is the screen – the screen does not create an optical space but does the reverse, blocks it, like a sign at the side

of the highway that blocks some of the view. The sign is not an object of our gaze; we are its object because it tells us about the position we are in. This is the way we "see" in dreams, Lacan says: things show themselves to us. We cannot see, in the sense of moving beyond what we are shown – we are led.[70]

Lacan used the scopic drive as a model for understanding in analysis: "There is something whose absence can always be observed in a picture. This is the central field. . . . In every picture, this central field cannot but be absent, and replaced by a hole – a reflection, in short, of the pupil behind which is situated the gaze." In looking, in the gaze, we are always involved in a play of light and opacity.[71] We block the light (one thinks of the effect of light shining behind forms in Indiana paintings like *Stavrosis* or *The American Dream #3*). As Krauss paraphrases Lacan, "To enter a picture [is] to be projected there, a cast shadow. . . . Light, which is everywhere, surrounds us, robbing us of our privileged position, since we can have no unified grasp of it. Omnipresent, it is a dazzle that we cannot locate, cannot fix. But it fixes us by casting us in a shadow. It is thus that, dispossessed and dispersed, we enter the picture. We are the obstacle – Lacan calls it the 'screen' – that, blocking the light, produces the shadow. We are thus a function of an optics that we will never master."[72] In such a manner Indiana's word paintings absorb our space as viewers by describing an unknowable kernel, a shadow that can only be made a trope by death. Indiana in his early and mid-sixties paintings hides his portrait faces/his own face, within hieratic displays of words and symbols that are like masks or screens that attract us. They are like the old story (Lacan, among many, tells it) involving the Greek artist Zeuxis, who paints a mural of grapes that fool the birds, which try to eat them. His rival Parrhasios paints simply a veil on the wall. Zeuxis asks what is behind it, unwittingly proving that Parrhasios fooled not the birds but Zeuxis. Another way to put this phenomenon is Bloom's gloss on Lacan concerning the drive: "'What one looks at is what cannot be seen.' Drive is ambiguous, a synecdoche for that aspect of every ego 'who, alternately, reveals himself and conceals himself by means of the pulsation of the unconscious.' Whatever Lacan intends here, I read him as interpreting the Freudian synecdoche as being at once the partial drive and its defensive vicissitudes. Drive therefore defends against its own incompleteness, its own need to look at what cannot be seen."[73]

As Gene Swenson pointed out, Indiana's masks or screens sometimes suggest the artist's presence but do not give his person away. And rather than simply making sense of the puzzle, Indiana's audience becomes embroiled in a screen effect, the property of certain ambiguous texts or images, like Rorschach cards or the Delphic oracle's dicta – an unpronounceable void that becomes a space in which we create our own figuration. Indiana's specular works, like Gertrude Stein's autobiography, engage the viewer in an ambiguous exchange. The shadow of artist in the canvas/mirror becomes itself a gaze, a gaze that lures us, and traps us – we enter the spectacle.

195

This is a tricky enterprise: constructed of cues from culture, the paintings' compulsive, repetitive, multiple referentiality is not strictly apparent to the uninformed spectator, who customarily sees only one or two Indiana works at a time. Wendy Steiner notes that in any portrait (or self-portrait), whether verbal or visual (she is speaking of Stein's literary portraits in particular), "unless the interpreter is acquainted with the subject beforehand, or is aware of the connection between the index and its referent, there is no way that the portrait can evoke its subject." But if it cannot evoke a specific subject, perhaps it can suggest a clustering of meaning. The question is, When the meaning is all autobiographical, as Indiana tells us is the case with his work, can we recognize its traces? Paul John Eakin finds the "I" in autobiography in a certain authenticity or "pain in the throat" of the utterer in the creation of narrative (at the "origin of the speaking being"). It is the magnetic charge in the screen, a particularly powerful illocutionary force that brings about a leap of comprehension, as in grasping a good trope or figure. "Readers in their turn reciprocate," Eakin notes, "for it is hard to undo the art of self-invention once it has been ably performed, hard to unhear the voice of presence in the text." This is the operation performed by Indiana's cool compositions that seem signifiably blank but are charged with potential reference. They direct us in an irreversible project, that, once it is grasped, cannot be undone. Eakin illustrates this project by citing the "irreversible solution to the picture puzzle" in the final lines of Vladimir Nabokov's autobiography, *Speak, Memory*: "something in a scrambled picture – Find What the Sailor Has Hidden – that the finder cannot unsee once it has been seen."[74]

6

LOVE

Between 1964 and 1966 Indiana developed a motif that is formalist and cool, yet signifies emotion: the imaged word *LOVE* (fig. 6.1). It was a watershed, an entirely new direction in the artist's work, and it became a motif that he has never abandoned. Formally, the *LOVE* paintings depart from his typical previous formats like the mandala-plus-legend and the diamonds and crosses of the successive American Dreams. Within a traditionally difficult canvas shape, the square, the four-letter word is divided into two pairs of two letters, arranged on two levels, exactly dividing the square into quarters. The letters fill the canvas from edge to edge. Word and image are equal, and figure and ground coextensive.[1]

 LOVE is partly rooted in love poems Indiana had written in the fifties and that he began again to write in the mid-sixties (see Appendix 1). His focus on the L-word was noted by critics like Lucy Lippard, who called Indiana an "out-and-out romantic." And yet the image is even more hard-edge and reductive than his earlier work. From the first, as we shall see, the four-square *LOVE* was conceived as a series, though not in the sense of the American Dream series or the Bridge series, in which the compositions are related but each is a variation. In design and composition *LOVE* always remains the same, but is repeated by the artist over and over again, varied in scale, color, material, or modular expansion and arrangement. In this sense *LOVE* is a visual construct, not confined to a particular materialization. Deceptively simple, it was originally addressed, like all Indiana's art, to both elite and popular viewing audiences, epitomizing his wish to be both "a people's painter" and a "painter's painter."[2] But *LOVE* functioned within its social context unlike any other Indiana work, in ways that have made it historically unique. This chapter examines the fit between, on the one hand, factors internal to the work and its presentation by Indiana and his agents, and, on the other, factors external to it, in the frayed cultural fabric of the late sixties – the fit that made *LOVE* America's "most plagiarized work of art."

6.1 *LOVE*, 1966. O/c, 72" square. Indianapolis
Museum of Art, James E. Roberts Fund.

Agape

Despite the connections between *LOVE* and Indiana's poetry, the artist never wrote any statements to accompany it, as he did for paintings like *Mother* and *Father*. The narratives and anecdotes he attaches to the work are short and confined to interviews, and in them he traces *LOVE* to his childhood. Love is something that Indiana says he always had from his adoptive parents, Earl and Carmen. It is a comment that seems to subsume its own denial, because satisfactory love is not indicated in the legends of uprootedness, frustration, and loss to which the narratives of other paintings testify. Studies of narcissistic disorders might be cited, such as *Prisoners of Childhood* by Alice Miller, who concludes that the subject who declares his parents' goodness is asserting his own wholeness and therefore a "masked view of himself."[3] But whatever the prognosis, and none is proposed here, Indiana's standard account of the "source" of *LOVE* – for him as a subject – is also a verbal mask, one that excludes his parents and suggests a void or lack: he first remembers seeing the word as written language in the Christian Science services and Sunday school classes he was taken to as a child, without his parents – the same place he said he became interested in the circle. He stared at the word imprinted on the church walls. As he told Barbaralee Diamonstein, most Christian Science churches "have no decoration whatsoever, no stained glass windows, no carvings, no paintings, and in fact, only one thing appears in a Christian Science church, and that's a small, very tasteful inscription, in gold usually, over the platform where the readers conduct the service. And that inscription is God is Love."[4]

Indiana's Edinburgh love poems from 1953, like "A Poem," were also planned in visual terms, at least as to their appearance on the page (Appendix 1). Designing and typesetting that poem for the pages in *Windfall* may have encouraged its somewhat graphic tendency: the metaphoric relations love/bucket and tears/fish are developed together in the bulk of the poem, while the last line, that delivers the "downward" conclusion ("*Either this . . . Or* – I drown"), visually breaks or falls below the verse line. The 1955 poem "When the Word Is Love" has a similar physical dimension. We recall that it describes the word as if it were the anatomical imprint of a verbal bludgeon. If such poems can be considered developments toward a visualized or even felt dimension of language, this continued in 1958 when he began a poem that would be published eleven years later as "Wherefore the Punctuation of the Heart."[5] In it Indiana greatly expands José Garcia Villa's percussive use of commas, deploying the illocutionary forces of colons, slashes, dashes, quotes, and question marks, as well as the disposition of letters in the word *love*. It is a calligrammatic survey of that word, ending with the four-square, two-letters-over-two form that verbally predicts the later word painting.

"Wherefore the Punctuation of the Heart" begins with a straight-lettered version of the word *love*, introduced as "that slim prim agapé." *Agape*, a Greek word

meaning platonic or brotherly love, associates the artist (as Robert Clark) with Dean James A. Pike – Clark's employer when that poem was begun – and this Christian (though Episcopalian) context refers us back to Clark's childhood encounter with the word-on-the-wall in Sunday school. At the cathedral, Clark served Pike, a former corporate lawyer and divorcee, just before Pike left to become bishop of California. Letters poured into the deanery from clergy and laity objecting to Pike's advancement. Such letters often cited I Timothy 3:2 that states a bishop must be blameless, and husband of one wife. (Ultimately, Pike had three.) Although Pike barely knew Clark, who worked directly under Canon West, it is the dean who stands out vividly in Indiana's memory. Pike had a charismatic, larger-than-life persona, even starring in a religious program on television, and possibly his discourses on love were part of what attracted Clark.[6]

Pike often employed Greek terms in his writings, just as Clark turned to the Greek word for crucifixion when he did *Stavrosis* about the same time (see fig. 2.13). Pike pointed out that Greek distinguishes three kinds of love: *eros* (sexual), *philia* (friendship), and *agapé*. Pike emphasized agape, finding its essence in the New Testament – for example, in Paul's First Epistle to the Corinthians – and used it to replace the King James Version's *charity* and the Revised Standard Version's *love*. Implied in the Greek word, however, is the Early Christian meaning of agape as a love feast, a Christian ritual meal held in connection with (or commemoration of) the Lord's Supper. Love in this Early Christian sense is an unselfish concept, a kind of spiritual cannibalizing (conjuring up *EAT/DIE*). It is a giving of the self up or outward, in imitation of God's love in its sacrificial aspect, as in 1 John 4:10-11, which Pike quoted: "In this is love (agape), not that we loved God but that he loved us and sent his Son to be the expiation for our sins. Beloved, if God so loved us, we also ought to love one another."[7] In agape the self is lost or transferred to a collective identity, and its quality pervades Indiana's *LOVE*.

A few years later, a newly renamed Robert Indiana referenced erotic love in the sculpture *Duncan's Column*, on which are stenciled words and place names around Coenties Slip (see fig. 3.1). Among these, "Love Pier" served as a hangout for young couples. About the same time (1961), the artist did the small canvas now called *Four Star Love*, which he exhibited as one of the verselike Mamaroneck paintings (see figs. 4.1 and 4.3). *Four Star Love*, like the others of that group, draws a poetic figure of comparison between upper and lower registers, perhaps suggesting a qualitative standard for love, like restaurant or hotel ratings, in which four stars is the highest. On the other hand, four is a danger or cautionary number, at least in the context of the American Dream paintings. *Four Star Love* belongs to the compositional ideas that began with *Stavrosis* and the orb paintings (see fig. 3.4) and culminated in *The American Dream #1* and *The Triumph of Tira* (see figs. 3.10 and 3.11), in which a cross can be read in the negative space between four stars, anthropomorphizing and sanctifying the arrangement. While Indiana's sequence of love poems and paintings

admit of erotic love, and may even mask specific sexual/homosexual allusions, a moralizing and cautionary tone prevails overall.

The word *love* did not reappear in Indiana's art until early 1964, when the fashion industrialist and art collector Larry Aldrich commissioned him to do a painting for Aldrich's new museum in Ridgefield, Connecticut. Aldrich had become aware of Indiana's work with the initial acquisition of *The American Dream #1* by the Museum of Modern Art. In 1963 Aldrich was on the acquisitions committee of the Whitney Museum of American Art and participated in its decision to purchase Indiana's *X5*. At some point Aldrich and Indiana met. Early in 1963 Aldrich began to renovate as a museum a building that had been erected in 1783 by two lieutenants in the Revolutionary War. Since 1929 the building had served as a Christian Science church, and Aldrich's renovations would obliterate religious inscriptions on the walls (fig. 6.2). Aldrich asked Indiana to do a painting for the new building, and the artist responded with *Love Is God* (fig. 6.3), which reverses the dictum that Mary Baker Eddy took over from the Bible, "God is Love," one of the inscriptions lost in the renovation.[8] *Love Is God*, a diamond painting in grisaille, is unusual in Indiana's work. It contains a small central mandala, circled in white gesso and containing the inscription in an anonymous sans serif stenciled letter style that departs from the florid Old English of the church's inscription. Around the central circle, filling the

6.2 Prerenovation photo of Aldrich Museum of Contemporary Art, Ridgefield, Connecticut, showing "God is Love" inscription on left foreground wall. © The Aldrich Museum of Contemporary Art (photo courtesy of the museum).

space between it and the canvas edges, are sixteen segments of gray shading from light gray to black, giving impressions of shadow and perspective depth, and of something like reflective metal, rare effects among Indiana's paintings.[9]

Obviously, "Love is God" calls to mind "God is love," implying a word cycle or mandala like Stein's "Rose is a rose is a rose." Moreover, *Love Is God* establishes an autobiographical cycle for Indiana. Retrospectively viewed through the coincidence and circumstances of the Aldrich commission, a prophecy appears to be fulfilled, one informed by Pike's agape but based in Indiana's childhood and the Sunday school classes he attended without Earl and Carmen.

6.3 *Love Is God*, 1964. O/c, 68" square. Private collection, Paris. © Robert Indiana-Morgan Arts Foundation/ARS, New York (photo courtesy of Simon Salama-Caro).

Father Painting

The transition from the Mamaroneck love painting and the *Love Is God* diamond to the square, two-letters-over-two image took place within complex circumstances at the end of 1964. At some point after his break-up with Ellsworth Kelly, Indiana did a painting called *FUCK* (with a tilted *U*), which he kept and never exhibited. According to his own account, when he showed it to Kelly, the latter was horrified (Kelly himself had used words in some playful collages, but never in a painting).[10] *Fuck* is a word that misreads the act of love. Similarly, the painting, together with Indiana's story about it, demonstrates a witty misreading of Kelly's own carefully wrought hard-edge abstractions that amounts to a renunciation of Kelly as an artistic mentor or "father."

FUCK was never exhibited, but it was a document of its time nonetheless. The word itself appeared in publicity surrounding the Berkeley Free Speech Movement (FSM), whose banner, bearing the disingenous acronym FUCK (for Freedom Under Clark Kerr, Berkeley's president), was reproduced nationwide in press coverage of the demonstrations of 1964-65. The word's political and rhetorical value was especially operative in the lesser-known successor to the FSM, the so-called Filthy Speech Movement, proponents of which appeared on the Berkeley scene early in 1965. This splinter group, like its predecessor, targeted, but in a more flamboyant way, linguistic hypocrisies among those in power. It was also rooted in an earlier beat culture trend, demonstrated by Ed Sanders in his underground magazine *FUCK YOU*, and by performers like Lenny Bruce and Taylor Mead (the latter a personal acquaintance of Indiana's), whose satire exposed America's double standard regarding the "F-word" and other sexual pejoratives. Linguistic satire signaled the new verbal awareness of the sixties, a time in which language as label and index of social difference was reexamined, and sometimes reinvented.[11]

By December of 1964 Indiana had experimented with the *FUCK* composition, creating a *FOUR* ("love is a 'four-letter word'") and a *LOVE* along similar lines. Significantly, the latter was not a painting — or gallery work at all — but a series of drawings that Indiana sent as Christmas cards to personal friends that year (fig. 6.4). Actually, these were *frottage* or rubbings, produced by running a pencil or conte crayon over paper with letter stencils arranged underneath, a technique that Indiana had begun doing in 1962. The earlier examples are mandala-plus-legend compositions like *The American Eat* now in the Rose Art Museum at Brandeis (fig. 6.5), based on Indiana's found American Hay Company stencil (see fig. 4.29). But he had already done some single-word rubbings, including the one related to love from his American Dream quartet of three-letter verbs: *HUG* (fig. 6.6). These works are contrapuntal to the hard-edged Indianas. As Rosalind Krauss wrote in *Art International*,

6.4 *LOVE*, 1964. Rubbing, colored pencil on paper, 8" square. Spencer Museum of Art, University of Kansas, Lawrence; Gene Swenson Collection 70.124.a.

6.5 *The American Eat*, 1962. Rubbing, pencil on paper, 24³⁄₄ x 18¹⁄₂". Collection of Rose Art Museum, Brandeis University, Waltham, Massachusetts; gift of the Friends of the Rose Art Museum Acquisition Society, 1964.

6.6 *HUG*, 1963. Stencil rubbing, conte crayon on paper, 9 x 3³⁄₄". Artist's collection (photo by Eric Pollitzer).

they return to "the abstract-expressionist surface full of the shadow and highlights of the emergent image." Rather than conveying mechanicalness and anonymity, she said, *The American Eat* "carries personal touch almost to the pitch of caress."[12]

This was certainly true of the 1964 *LOVE* rubbings. Around each letter, lines that define square sectors, the imprint of the stencils' outer edges add complexity and almost a faceted, cubist space (something that reemerges in the hard-edged Demuth Five paintings and in his later *Autoportraits*). The adjacent letters *LO* and *VE* appear to touch almost erotically – the bottom serif of the L seems to stroke the lower part of the O, which leans toward it in response; while the E's rigidly extended top serif continues into the opening of the V. Writers also have found countless sexual forms in the negative spaces of the imaged word, from phalluses and arrows to mouths, vaginas, and breasts. But in the rubbing, the evocativeness of the graphic is directed by the softly textured surface, which mitigates the hard lines and throws an irregular, seemingly fleeting highlight on each letter.

Like *Four Star Love*, *The American Dream #1*, and orb paintings like fig. 3.4, *LOVE* contains a compositional cross. The embedded cross common to all is only a little better hidden in the 1964 *LOVE*. The use of a classic, Roman letter style, all capitals, is not new in his work, but its unstenciled boldface is. Closest to Stanley Morison's Times Roman of 1932, a style that supposedly reflected modern journalism, Indiana's typeface is preeminently a *face*, bearing associations of presence and authority. Indiana adapted the style to the visual needs of the format and to negative/positive shapes of the design, and he emphasized, even exaggerated, the coved serifs that give the letters character.[13]

He told Barbaralee Diamonstein that the tilted O was a "very common typographical device." In some Roman faces (Old Roman or Shakespeare Medieval, for example, though not Times), the inside of the O has a backward tilt, and in any italics the whole letter leans forward. Elsewhere Indiana explained that he came across such examples frequently when he typeset poetry in Edinburgh. Over the years he has explained the O as "representing" everything from a cat's eye to an erect phallus. But more than anything else, it is the dynamic of the image, charging the printed word with the illocutionary force of the performative. Accentlike, the tilted O mimics the symbol for intonation in pronunciation or the placement of beat in the reading of poetry. By signaling the word's passage from speaker to receiver, it impersonates a subject and activates a command.[14]

The Christmas card drawings were probably done in different colored pencils exploring the motif through color variation. This idea was carried over in 1965, when the artist rendered the motif in his hard-edge style. But before being formally exhibited under the Indiana name, it was again, as it were, offered to others. Early in 1965 the Museum of Modern Art commissioned Indiana to provide a design for one of its Christmas cards. Indiana submitted several twelve-inch, hard-edged color variations in oil on canvas. The museum chose the most intense, rendered in high-

205

saturation, equal-value hues: red letters against a background of green and blue. It was among the most popular cards that the museum has ever offered. Later, Indiana told an interviewer that red, green, and blue were what he considered "the prime *LOVE* colors." He explained, "Most of my work is very autobiographical in one way or another. In the thirties, my father worked for Phillips 66, when all Phillips 66 gas stations were red and green: the pumps, the uniforms, the oil cans. . . . But when I was a kid, my mother used to drive my father to work in Indianapolis, and I would see, practically every day of my young life, a huge Phillips 66 sign. So it is the red and green of that sign against the blue Hoosier sky. The blue in the *LOVE* is cerulean. Therefore my *Love* is a homage to my father."[15] We have seen this color combination used for one version of his other "father painting," the sixth American Dream, *USA 666*, and the story of "Father's" colors told in his own statement for that painting (Appendix 2). The completion of the paintings *USA 666* and *Mother and Father* took place roughly alongside the development of *LOVE* – late in 1965. All of this was just before the news of Earl Clark's death on 19 December came to the artist on 30 December. It is a striking confluence of events, almost as if the artist had a premonition of his father's death. Earl had not even been ill; in the artist's account, he was eating breakfast when suddenly he "dropped dead," gruesomely heeding Carmen's scenario – "eat – die" (see "Mother and Father," Appendix 2). We also recall that, probably just after the MoMA card was put in its final form (as it had to be printed and ready well before December), Indiana told Arthur C. Carr of the dream about his own funeral, at which he gave *The Calumet* to his father. Also pertinent here is the artist's story of an earlier event, told to Carr in the same November sessions, when as a child he had accompanied Earl to view the body of Henry Trimble. In that account Indiana recalls being fascinated, not with the body, but with a large relief sculpture that hung above it. Indiana told Carr that it was the first piece of sculpture that he can remember ever noticing. In the same category of dominating images or screen memories was the Phillips 66 shield, "the most important sign of my life," he told Donald Goodall in 1977.[16] Moreover, Indiana said, Earl "wore a little badge commemorating the fact that he had worked for Phillips 66 for X number of years. And that was always in his lapel staring me in the face. I couldn't escape it." One conjures up an image of Robert staring at the badge and avoiding Earl's gaze.

Considering all the stories, as Carr concluded, a certain attitude can be detected, a difficulty created by some untold experience or repressed traumatic event (relating to his frustrating relationship with Earl and perhaps aggravated by awareness of an unknown father). Considered in this context, the strong red-green-and-blue *LOVE*, already an image with optical resonance and a sense of floating free of its gallery context, hovering in front of our eyes and confusing our perception of depth, becomes a signifier of unrecallable memory and unnamable experience. When a person has such experiences, Lacan says, the person's thoughts

circulate around a network of signifiers that never point back to the source: "And how is the network mapped? It is through the fact that one returns, one comes back, one keeps coming across the same path, it always overlaps and cross-checks itself in the same way; and [in Freud's] seventh chapter of *The Interpretation of Dreams* there is no other confirmation for one's *Gewissheit*, one's certainty, than this – 'Speak of chance, gentlemen, if you like. In my experience I have observed nothing arbitrary in this field, for it always meets up with itself, it cross-checks itself in such a way that it escapes chance.'"[17]

The ensuing events in the history of *LOVE* certainly suggest this betrayal of chance – the *Wiederkehr*, the function of the return ("that which has been repressed"), of which Freud and Lacan wrote. In any event, the MoMA Christmas card disseminated the image with the museum's copyright notice on the back. Thus, before the artist's definitive exhibition of *LOVE* paintings at the Stable Gallery in the spring of 1966 (the "*LOVE* Show"), the imaged word was twice delivered (1964 and 1965) to untold numbers of recipients via U.S. mail.

The exhibition took place amid rapid changes both at Eleanor Ward's gallery and in the New York art world. The cultural attachments of early sixties art, Pop above all, had been replaced by different issues. "The Responsive Eye," at the Museum of Modern Art the previous year, showcased something critics called Op art, with which the *LOVE* would be compared. At the same time as Indiana's Stable show, "Primary Structures," a major presentation of minimalism at the Jewish Museum, fairly dominated critical attention. Also the same spring, the Dwan Gallery exhibited words that were quite different from Indiana's – texts as conceptual art, as in Arakawa's labeled diagrams.[18] *LOVE* seemed to relate to all these critical categories without being part of any, a fact that affected the way Indiana's show was received.

At that time the Stable Gallery had passed its apogee. In the 1950s its annuals and brilliant one-man exhibitions like that of Cornell's boxes, which were individually lit in a darkened room (1956), had brought the gallery to the avant-garde forefront. Besides Indiana, Ward had given Rauschenberg, Twombly, Warhol, Marisol, and many other artists their starts. But by 1966 only Indiana hung on, out of intense loyalty, bucking the trend of the other artists to move on to newer galleries. In 1970 the Stable closed.[19]

The *LOVE* Show consisted of two categories of works. Most prominent were the *LOVE* paintings in different sizes and configurations: the four-panel *LOVE Wall*, for example, in which the imaged word, in different positions, creates a center of four radiating Os (aside from color, it is similar to the smaller *LOVE Rising (Black-and-White LOVE Wall)* reproduced here, fig. 6.7); and the *Imperial LOVE* diptych (fig. 6.8). A second room was devoted to *The Cardinal Numbers* (see fig. 4.46). Indiana recorded a father connection behind his use of numbers. Although the artist was always poor at mathematics, it was, along with music, one of Earl Clark's two memorable talents. (Earl's music was commemorated in the painting *Red Sails*.)[20] All

works in the 1966 exhibition were strikingly hued in red, blue, and/or green, the equal-toned complementaries of the MoMA *LOVE* card and the same vibrating tonalities, we have seen, that bear the mythical essence of "Father." The *LOVE* Show was altogether a "Father" exhibition, just as his show in 1964 had celebrated "Mother."

Reviews of the *LOVE* Show were few and short. Its flagrant brandishing of a word for intense emotion may have made some critics uncomfortable. Dore Ashton called the work "stately" and "reserved" but avoided any mention of love.[21] Lucy Lippard noted that "the letter forms, often turned upside down or backward, become abstract signs forming closely packed surface patterns. Only the warm glow refers obliquely to the subject matter. . . . The configurations [of the numbers 0-9]

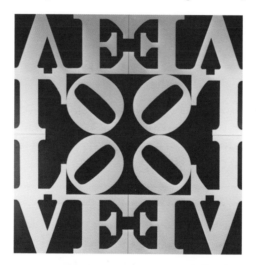

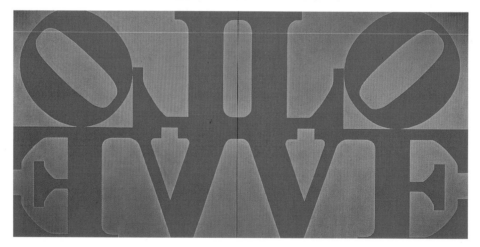

6.7 *LOVE Rising (Black-and-White Love Wall)*, 1968. A/l, four panels totaling 72" square. Museum Moderner Kunst Stiftung Ludwig Wien.

6.8 *Imperial LOVE*, diptych, 1966. O/c, two panels totaling 72 x 144". Private collection.

are not new, but I doubt if Indiana is concerned with formal advance so much as formal honesty and, perhaps, perfection. What distinguishes his work from the run-of-the-mill geometric abstraction is its strongly moral tinge and the application of such unemotional means to such a tenderly virtuous end."[22] Lippard's hint at the work's psychological complexity may have been lost on her 1966 readership, an art world that had moved away from subjective issues. In any event, her comments on Indiana were buried within a review that treated other artists, like Barnett Newman, at far greater length. In all, the *LOVE* Show was not a critical success.

Lost *LOVE*

William Katz, who knew Indiana during part of the germination of *LOVE*, recalls, "When he did the [*LOVE*] proposal for the Modern, . . . he did one in one color; one in black-and-white; one in two colors, blue-and-green; one in three colors, red-blue-and-green; one in four colors; and one in five colors. That's the way he works. And they chose of course the most vibrant one, which was the one in three colors . . . but he gave them the choice and in doing so he discovered this other kind of possibility for himself." The "other kind of possibility" was the expansion of the motif via his personal system of repetition and variation. Between 1965 and the end of 1966 his painting production shot up significantly for the first time since 1962, largely due to variations on *LOVE*.[23]

The motif appeared prominently on the poster for the Stable exhibition (fig. 6.9). In discussions with Ward and the printers, Posters Originals, the question of copyright arose, but apparently no one involved, including the artist at that point, knew the law. Then, just as now, even after copyright legislation was revised in 1978, notice had to appear, along with the artist's name and date, on any work construed to be published (that is, circulated in the public domain).[24] Printed without a properly affixed notice, the Stable posters circulated *LOVE* in just the manner that copyright law could not protect.

Indiana had argued against affixing notice, at least on the front, because he did not like the commercial look that such an attachment gave. Notice was a visual impediment, calling attention to itself within what he had taken pains to make an immediate, indivisible imaged word, like the mental exercise he suggested to Richard Brown Baker years before, in which the word and the idea are "inextricably locked in the mind." But omitting notice was a telling tactical error. In retrospect one can find indications that certain other reductivist artworks of the sixties were also in need of more specific legal protection. One such indication was the widespread appropriation of artistic motifs for high-priced commodities, as when Mondrian's characteristic rectilinear style and Bridget Riley's optical patterns showed up on trendy attire. In fact, these phenomena echoed *Vogue*'s use of Jackson

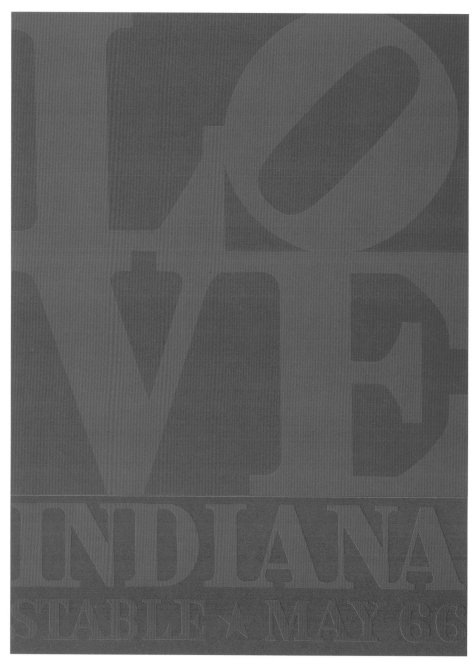

6.9 Poster for Robert Indiana's Stable Gallery
"*LOVE* Show," 1966. Artist's collection (photo by
Eric Pollitzer).

Pollock paintings as a backdrop for spring dresses a decade before – all part of a cycle observable since the nineteenth century, in which avant-garde art is repackaged for consumption by the culture industry.[25]

As Katz recalls, Indiana seemed to feel that because the role of the artist in any work of art was so primary, no one could really gain by not citing the artist in a reproduction. There would be no luster; no "aura" would transfer without the artist. Katz's use of the word *aura* suggests a bond between art and artist. That usage differs from the typical meaning of the term in recent art history, which connects *aura* with Walter Benjamin's use of the term in a number of writings, the best known of which is his 1936 essay, "The Work of Art in the Age of Mechanical Reproduction." In it Benjamin asserts that aura is a property of the unique work of art and is directly related to its authenticity and authority. The presence of aura signals a strict interrelation between the physical work and its context – its place and time. But as Harold Bloom has shown, in other Benjamin texts *aura* is given additional shades of meaning based on the Gnostic and Neoplatonist idea of the astral body; an aura can be an "invisible breath or emanation" or "a sensation or shock." In his essay on Baudelaire, Benjamin uses *aura* to bind the work, not so much to a place or ritual as to an author, a person, and to this sense of shock: "To perceive the aura of an object we look at means to invest it with the ability to look at us in return."[26] This aspect reminds us of Lacan's term *gaze*, which signals our fragmented condition, our central lack. Extrapolating beyond Benjamin, Bloom too connects aura with our fragmentation: it is both evidence of individuality and its exhalation or sublime loss, "a final defense of the soul against the shock or catastrophe of multiplicity."

With *LOVE* we have both optical shock (in the bold and loaded word and its intense colors) and multiplicity – a work with no real original, only a group of paintings, prototypes for the MoMA card commission. At the outset *LOVE* underwent two mechanical reproductions: the MoMA card and the posters. The posters advertised a gallery exhibition at which variations of paintings were hung. But the situation is still more complicated. The Stable exhibition also contained a *LOVE* sculpture, a twelve-inch solid aluminum piece that was actually one of an edition of six (signed and numbered by the artist), commissioned by Multiples, Inc. (fig. 6.10).[27] Multiples, founded by Marian Goodman, was an enterprise that was meant to translate the then-current taste for serial art and commodity technology into concepts for art publishing – beyond editioned prints, to banners, jewelry, domestic-scale sculpture, and the like. It was a step toward art industrialization, except that Goodman's projects were not manufactured but were designed by artists and carried out by crafts professionals. They ranged widely in price, virtually bridging the gap between masterpiece and merchandise. In 1966, in addition to the fairly expensive *LOVE* sculptures, Goodman commissioned a *LOVE* banner (in red-blue-and-green felt, signed and numbered) at a fraction of the cost.

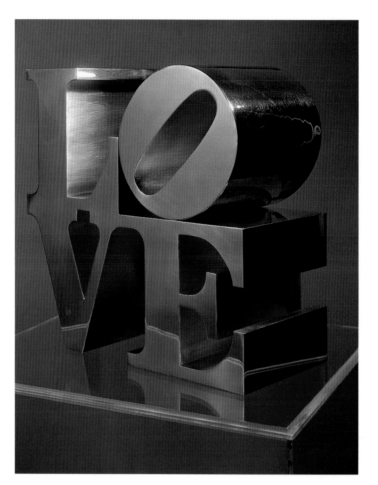

6.10 *LOVE*, 1966. Carved aluminum, 12 x 12 x 6″.
Artist's collection (photo by Eric Pollitzer).

Goodman and her lawyer urged that actual copyright registration be obtained through government application. Indiana filled out and sent in the standard form, but it was rejected because the law did not provide protection for a single word. Indiana realized only later that he should have disputed the ruling on grounds of creative enhancement. At the time, he was advised to patent the image as a trademark, an unsatisfactory solution that the artist rejected.[28] Indeed, even the suggestion that *LOVE* might be treated as a commercial logo was ominous.

In 1966 the word *love* was broadcast amid an expanding youth subculture that was attracting media attention. A feature article on "hippyism" in a 1967 issue of *Time* showed a young woman with the word brightly painted on her back (fig. 6.11). The Youth Movement – or youth culture, or the counterculture, or even hippyism – had sprung from the New Left and the spirit of civil rights and the Free Speech Movement at Berkeley, and was spreading among affluent, intellectual, and tuned-in students across America. Soon it was not just on campuses – it outgrew its

institutional confines and became contextless. Less than a year after Indiana's *LOVE* Show, the first formally designated "love-in" took place in Elysian Park in Los Angeles.[29] Newspapers here and abroad reported that four hundred hippies had gathered in an "emerald glen" to "spread love." In a matter of months not only "love-in" but "love beads," "love child," "love generation," and a host of related terms appeared in what seemed like a new utopian argot. Of course, it meant sex ("free love") and sexual revolution: sex as progressive, nonprejudicial, even transcendental activity. Making love on LSD was like making love with God, Timothy Leary told his *Playboy* interviewer in a widely read issue that appeared in September 1966. But the media process that dramatized the marginality, the difference, of this subculture, that offered it as entertainment and capitalized on it, simultaneously normalized and eradicated it. Its enunciations, for example, held forth from haute couture: Rudi Gernreich's "Love dress" (not Indiana's motif) premiered in the summer collections for 1966, about the same time the *LOVE* Show was hung at the Stable (fig. 6.12).[30]

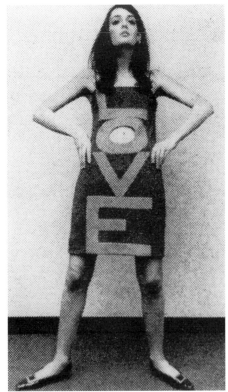

213

6.11 "Love bodypaint," photo by Lynn Pelham, *LIFE* magazine, © Time Inc. (photo courtesy of Time Life Syndication).

6.12 Rudi Gernreich, "Love Dress," (top center). *Newsweek*, 25 April 1966, 57.

In the mid-sixties, Indiana's paintings and sculpture, whatever their sources of inspiration, circulated within the institutionalized art world context and were processed in the art press under the rubric of Pop art. As we have seen, though, his work was unlike that of other Pop artists because of its lack of involvement with commodity culture. The depth of the mythological and poetic models that his images reference, and the way they invite application of psychoanalytical theory, are also rather un-Pop. But these aspects of his work were understood by few people at the time. Only a handful of printed interviews containing Indiana's life narratives circulated, and his statements on paintings were not published until 1969. Nonetheless, the work formally marked itself off. The enigmatic compositions with their iconic words call forth rhetorical conventions that are essentially intellectual, despite the "pop" status of "EAT," "JACK," and other of his labels.

The term used for the sort of cultural bricolage produced by the Pop artists in the mid-sixties was *camp* – a term already used for homosexual mannerisms in fifties theater.[31] From the French reflexive verb *se camper*, "to position oneself" or "to posture," Pop camp comprised mundane or vulgar objects turned into high art through the acquisition of a "virtual context" – like invisible quotation marks or a frame, perceptible to initiated beholders who participate in the subculture via the media. A gap is bridged. Sixties camp was specifically an arriviste position that momentarily unified and neutralized the "disaffected" and centralized marginality: beats, blacks, gays, and the new youth cultures alike. *LOVE*, appearing somewhat nostalgic, in its slightly corny oversized Roman lettering, the typeface of the *Times*, modeled the social gymnastics of camp. But in this role, rather than serving as an icon of unification borrowed from the art world – as a work of art made by an artist – *LOVE* became detached from that context. As Foucault would say, *LOVE*'s author function faded away, partly because its discourse ceased to be transgressive and rooted in difference (the act of an "owner"), and partly because (as we have seen) the legal aspects of ownership were already undermined.[32] *LOVE* became a mobile or vagrant sign, its authorship elided and dispersed, but it asserted an uncanny influence nonetheless.

Unlike the other Pop artists, who concentrated on subjects with specific contexts, supermarket or drugstore items, aspects of domestic interiors, or cartoons, for which the context is the newspaper itself, Indiana's imaged word refers to the world of signs – in particular, the signs of the highway and thus, allegorically, life's journey. *LOVE* (like Mother and Father) is inherently a traveler and addresses a culture of travelers, besides being a figure of Indiana's own roving childhood and experiences of serial homes. Its homelessness contributes to its hovering quality, how it seems free of supports and contingencies. It does not refer us to the viewing situation of art, the gallery wall, as Jasper Johns's paintings do. Philip Fisher shows us that with Johns's American flag (in *Flag* of 1955), the flag and painting are coextensive and the work asserts its existence on the museum wall. Its status as art is fur-

ther emphasized by its showy surface facture. On the other hand, as Cécile Whiting has shown, Pop art functioned in new, nonart contexts like window and supermarket displays – in fact Pop art could actually use commodity culture as its venue.[33] But Indiana's *LOVE* does not call forth those contexts, either, or any other specific ones; it is wedded in a protean way with the mind-set of the sixties. Unlike Johns's coextensive flag-and-painting, Indiana's word-and-painting does not function as an object with aura but rather like aura itself, in the sense suggested by Bloom of an "invisible breath or emanation . . . a breeze, but most of all a sensation of shock, the sort of illusion of a breeze that precedes the start of a nervous breakdown or disorder." Bloom deciphers the term *aura* (in Benjamin's writings on Baudelaire) as an ambivalent figure. In strong poetry, that is to say poetry that subsumes its own reversal, aura is "a figure of shock or catastrophe," the trace of the elided author. *LOVE* simulates this figure, this aura. It replays a trauma of authorship or origins that is clothed in strong "Father" colors that include the fighting complementaries, red and green. The word *love* itself is broken, literally split into two parts to create its four-square symmetry, reminding us of Indiana's earlier violent poem "When the Word Is Love." And the emphatic italic O enacts the "pain in the throat" of authentic utterance. But in multiplying the *LOVE* the shock is reversed, the violence is tamed, and the pain is repaired.

Indiana's use of mass-media graphics (in the form of typography), theme-and-variation series, and modular grids are all practices he shared with Warhol, his gallery mate at the Stable. Warhol, while perhaps not a strong precursor or mentor – someone Indiana might "misread" – was a significant rival, and their works operate as polar opposites, especially on the issue of authorship.

Warhol's signature on some of the silkscreen paintings produced at the famous Factory, as Andrew Ross reports, is like the infamous Disney industry signature that is attached to all manner of items that Walt Disney never signed. Warhol's florid early handwriting is not even entirely his own, but an imitation of his mother's, which his studio assistants later copied when they signed his name to pieces.[34] Yet even with no signature at all, Warhol's works seem indelibly stamped by an author, a personality responsible for choosing and contextualizing them. They *need* an author and so perfectly illustrate Foucault's "author function," a limiting of the possibilities of objects by attaching them to a name, and thus a means for their constraint. In this case the author (Warhol) recontextualizes the preexisting image of a soup can and renders it art in an endeavor related to the ready-made-designating activities of Marcel Duchamp (who might be considered, in Foucault's model, the founder of this mode of art-discursivity).

Furthermore, according to Foucault, the author function does not make claims as to the character and founding role of its "subject." Warhol's authorship was not called into question when he insisted to interviewers that there was nothing behind his words. His media self-promotion undermined any sense of a personal

core and flew in the face of the Abstract Expressionists' position that a conceptualized inner self truly authored one's art. Warhol parodied their position: "Some company recently was interested in buying my 'aura,'" Warhol wrote, "They didn't want my product. They kept saying, 'We want your aura.' . . . I think 'aura' is something that only somebody else can see, and they only see as much of it as they want to. It's all in the other person's eyes."[35] Warhol's media persona may have been inauthentic, but certainly it was efficient, and when the Campbell's soup can appeared on campy objects outside of the Warhol production, Warhol's name stayed with them.

LOVE functioned differently. In contradistinction to Warhol's silkscreen canvases sometimes produced by Factory drop-ins, Indiana's paintings are hand-crafted and so carefully designed that the artist's signature could go only on the back, to avoid detracting from the visual impact.[36] *LOVE* itself, as a personally distinctive formation of capitalized text, functions as a kind of monogram or signature – an authorship sign, where the sign is the only thing authored. Unlike Warhol's or Duchamp's framelike John Hancocks – signatures that are more context than text – Indiana's autographeme collapses the name and the work. It is uttered from personal experience and rendered with an investiture of labor, but these are again both denied, masked by the image's hard-edge quality and endless reproduction. This dual function of *LOVE* as both cathexis and repression is also reflected in the way Indiana loads his paintings (the *LOVE*s just like the Dreams) with autobiographical content without making that content widely accessible. The issuing of statements for a number of his paintings – notably excluding *LOVE* – may have been meant as reparation. The statements may even have been ultimately inspired by Warhol's far more dramatic and effective self-promotion – if not as a private, autobiographical, or even three-dimensional personality, at least as one vivid and provocative enough to ground his appropriative, campy brand of work. Indiana on the other hand, with his sparse, mythic-sounding personal stories that appeared only in hard-to-find catalogs and interviews, abjured the flagrant and held back the private. He failed to provide a Pop persona to enframe his work, another reason for its homelessness.

Worse still, with his curious repetitive acts, he effectively gave *LOVE* away. His own Christmas cards had already preempted his paintings, along with the ones he allowed MoMA to produce; then he issued the imaged word in multiple "fine art" editions. Similar occasions followed, as when he created *LOVE Rising (Black-and-White LOVE Wall)* in 1966 and then donated it to CORE. The notion of giving love away as a giving away of self is consonant with agape, and we remember that a cross lurks within the work, implied by the quarters into which the letters divide it. *LOVE*'s religious association was boosted in 1967, when John and Dominique de Menil commissioned the *LOVE Cross* for a projected Vatican "Oecumenical Pavilion" at the 1968 Hemisfair in San Antonio (fig. 6.13).[37] In so many ways, *LOVE*'s author signed, sealed, and delivered himself, not as owner and possessor, but as object. Impersonating *LOVE*, he offered himself to others.

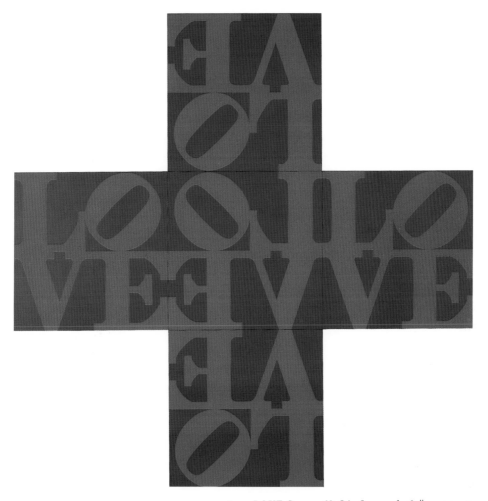

6.13 *LOVE Cross*, 1968. O/c, five panels, 60" square each, 15' overall. Menil Collection, Houston (photo by George Hixson, courtesy of the Menil Collection).

Critical discourse on authorship – discourse that primarily subverts the traditional sanctity of the notion, like Foucault's "What Is an Author?" and Roland Barthes's "Death of the Author" – roughly corresponds to Indiana's *LOVE* period, 1966 through 1973, though English translations did not appear until the late 1970s. Whether a signature testifies to a firm link between a subject/author entity and something that is signed (his work) was a debatable issue. In "Limited Inc abc" (only slightly later – 1977) Jacques Derrida points out that signature, as a constant repetition of something that has no original, cannot authenticate anything at all: "[My] signature is imitable in its essence."[38] The same could be said of Indiana's word as name as signature as sign. Participating in the kind of "capitalist" art system at large then, a system geared to persona and controlled by legislation, Indiana failed to protect the imaged word through either sufficient promotion of his persona or successful compliance with copyright law. *LOVE*, with its baggage of invisible pronouns (*I* love . . . love *you*) and so serving as a linguistic "shifter" – a term that changes meaning based on who is speaking – appeared late in 1966 and in the months and years following as a work of art that subsumed its own reversal. *LOVE* emitted its own desire and cried out to be possessed.

LOVE Power

Chronologically, the appearance of *LOVE* coincides with what Fredric Jameson has called "the 60s moment," defined as a brief period of perceived utopian possibilities that is ultimately eclipsed in universal industrialization. Todd Gitlin also found that within the youth culture at that time, two contradictory utopian visions prevailed side by side: a thread of old existentialist individualism and a new "idea of a social bond that could bring all hurt, yearning souls into sweet collectivity." The gentle hold of nostalgia helped maintain the belief in a classless society, a dream of liberal pluralism. Jameson locates this "moment" in late 1966 or early 1967, the beginning of a transition period that ends around 1973, coincidentally the year the *LOVE* postage stamp appeared and dealt the final blow to the imaged word as high art. But 1967, the first year *LOVE* disseminated widely, was, according to Jameson, the threshold of postmodernism proper, the moment the sign dissolved into the simulacrum.[39]

If there was such a moment, Indiana's imaged word helped mark it. The work tends to function as a screen or veil, as we have seen. In another analogy, it is an optical magnet like the one that Slavoj Žižek's points out in Patricia Highsmith's story "The Black House": a Lacanian *objet petit à*, "an empty form filled out by everyone's fantasy." In the late sixties *LOVE* as object of desire was appropriated by commodity culture touting countercultural values for profit. *LOVE*'s erotic connotations were usurped in the commodification of the sexual revolution. Moreover, its unmasculine lushness and bannerlike bearing could easily signify homosexual love and

burgeoning gay awareness in the time of the Stonewall riot. But despite the artist's political commitments, his speaking, as it were, as a critic of the American dream, he complained to interviewers that his motif did not turn up in countercultural enterprises. He suggests that he would not have minded if it had become left-wing graffiti or part or basis of a liberal political symbol. But (disappointingly) it did not.[40]

Indiana's own repetition of *LOVE*, his self-plagiarism, in a sense anticipated the commercial pirating of the image that simultaneously took place. Before *LOVE* Indiana had never shown any interest in seeing his work disseminated beyond the museum and gallery circuit and the art press. But in the late sixties and early seventies this self-styled "people's painter" participated in *LOVE*'s commodification. He engaged in numerous projects to produce the imaged word in various media, projects that reached well beyond Multiples Gallery to grassroots enterprises, trying to negotiate its replication between objet d'art and something like an emblem of liberal classlessness. In 1967 he authorized Joan Kron and Audrey Sable of the Beautiful Box and Bag Company of Philadelphia (the City of Brotherly Love) to use the motif on one hundred eighteen-karat gold rings, which sold for three hundred dollars each (fig. 6.14). He gave his consent, he said, because the rings were beautiful, creative objects. The same reasoning was behind a ten-foot square silk tapestry *LOVE* (1968), commissioned by Charles E. Slatkin Gallery. RCA Victor got Indiana's consent to reproduce his *Imperial LOVE* diptych on the album cover of the rather highbrow *Turangalîla-Symphonie* (1968), the composer Olivier Messiaen's orchestral love poems (fig. 6.15). At the same time, Indiana collaborated with a company called Mass Originals (owned by the collector Eugene Schwartz) to issue several thousand unsigned serigraphs at twenty-five dollars each – bringing *LOVE* within range of every wallet.[41]

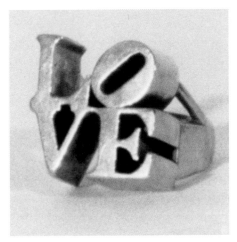

6.14 *LOVE Ring*, artist in association with the Beautiful Bag and Box Company, Philadelphia, 1968. 18K gold, 1" square. Artist's collection (photo by Tad Beck).

6.15 *Imperial LOVE*, diptych as album cover, 1968.
Oliver Messiaen, *Turangalila-Symphonie*,
Toronto Symphony, Seiji Ozawa, conductor,
New York, RCA Victor.

Legitimate replications floated on a sea of pirated ones. As early as 1966 another Philadelphia area company used *LOVE* in an unauthorized line of cheap cast aluminum paperweights, modeled directly on the Multiples sculptures (fig. 6.16). The paperweights were targeted for the new youth market and distributed to campus bookstores nationwide.[42] Other media appropriations matched *LOVE* with trivializing associations, as when the cast of *Hair* – the Broadway production that transformed counterculture into hit musical – posed for *After Dark* magazine with one of the unsigned *LOVE* prints (fig. 6.17).

Among the best known rip-offs is the jacket and promotional design for Erich Segal's 1970 novel *Love Story* (fig. 6.18). For this tragic romance about WASP and Italian-American students at Harvard, Segal set the American dream on campus, with sexuality and love as a substitute reward system that ultimately reflected a worldview in peril. The graphics for the book, designed by Anita Scott, featured the title in Roman letters against a red-green-and-blue background, just close enough to *LOVE* to capitalize on its popularity in an incontestable fashion and link it to the Segal story, while bypassing Robert Indiana.[43]

The turning point for *LOVE* – indexing the drift toward crisis in culture at large – came in the last years of the seventies, a period Todd Gitlin calls "a cyclone in a wind tunnel." One cataclysmic event followed another: assassinations of Martin Luther King, Jr., and Robert Kennedy, the trial of the Chicago Seven, the Black Panther shoot-outs, massacres at My Lai and Kent State, the Charles Manson murders, student revolts in Europe. Countercultural euphoria ignited in flashes of violence before burning out in a confusion of factionalism. Language hardened, and

6.16 Unauthorized *LOVE* paperweight, 1966.
Artist's collection (photo by Tad Beck).

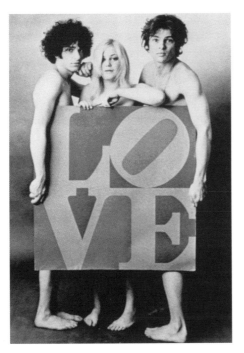

6.17 Members of the cast of *Hair* (Paul Jabara,
Suzannah Norstrand, Hiram Keller) with *LOVE*
print. *After Dark*, August 1966, 44.

6.18 Anita Scott, book jacket for Erich Segal,
Love Story. New York: Harper and Row, 1970.
Artist's collection (photo by Tad Beck).

"love" typically gave way to "power." In 1968 the *New York Times* announced the death of Pop art; the same year, Warhol was shot by Valerie Solanas. In 1969, the year of the Altamont music festival, where a fan was killed by Hell's Angels acting as security guards at a Rolling Stones concert, Bob Cenedella, who worked at the Museum of Modern Art, produced the image *SHIT* for Pandora Productions/Dadaposters (fig. 6.19).[44] LOVE/HATE was another popular variant around 1970, on matched items like cufflinks (to be articulated via body language) or written on opposite sides of mugs (fig. 6.20). Friends and fans sent dozens of unauthorized *LOVE* items over the years to the artist, who keeps a bizarre collection of rip-offs in the Star of Hope.

Eventually Indiana retained copyright lawyers in New York and registered some versions of *LOVE*. But it was too late. Pirated productions could be fought only case by case, through lengthy litigation, a process in which the artist would not participate. In 1974, after he refused to endorse Charles Revson's Ultima II perfume campaign plan to offer a cheap version of the *LOVE* ring, for which copyright was in force, the company proceeded anyway (fig. 6.21).[45]

Indiana himself demonstrated the image's easy adaptability, for example, when he helped create a *LOVE* hologram at the University of Michigan in Ann Arbor. Indiana's 1972 exhibition at Denise René Gallery (his first in six years, since the Stable had closed, but his second to feature *LOVE*) included a new six-foot red-and-blue polychrome aluminum *LOVE* (fig. 6.22) and a new serigraph, *LOVE: The Louisiana Purchase Variation*. If beyond the art world, in the mass culture, Indiana's identity had been severed from his image, within the art world the perception was that *LOVE* was making him a rich man. He had "sold out." John Canaday in the *New York Times* suggested that the artist do *MONEY* next.[46] But occasional reviewers had an inkling of what was happening. Richard Masheck wrote in *Artforum*, "It

6.19 Bob Cenedella for Pandora Productions/
Dadaposters, *SHIT* poster, 1969. Artist's collection
(photo by Tad Beck).

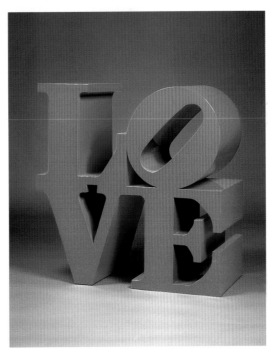

6.20 *LOVE/HATE* cufflinks. Advertisement for
Wallach's, *New York Times*, 11 February 1970.

6.21 Ultima II "*LOVE* Ring" with Lauren Hutton.
Advertisement for Bonwit Teller, 18-26 September
1974 (photo by Tad Beck).

6.22 *LOVE*, 1972. Polychrome aluminum, 36 x 36 x 18",
edition of six, artist's collection. © Robert Indiana-
Morgan Arts Foundation/ARS, New York
(photo by Prudence Cummings).

is ironical that although Indiana never became one of the superstars of Pop art, his *LOVE* works have remained in live currency longer than any other single works in the movement. It is even more ironical that the public popularity of the *LOVE* design in commercial circulation has sheathed it in commonness for connoisseurs."[47] And John Perreault for the *Village Voice* noted, "Although Indiana's 'love' predates the flower-power hoax, because his design came to permeate the ambiance, still present, of meaningless sentiment, it is impossible now to divorce the design, even in massive three-dimensional, two-color form, from the conditioned response of nostalgia for a media daydream, or justifiable contempt."[48] Or, as Indiana himself was quoted in an *Art News* article, "It's like committing murder, something done for the most personal reasons suddenly becomes notorious."[49]

In his own account, not only did he receive nothing from the exploitations, but they led to professional losses. Major museums, which had collected key examples of his work since 1961, stopped doing so. Only three unique (not editioned) *LOVE* works are in American public collections. The perception that Indiana created a moneymaker persisted for more than a decade. In a 1984 article in *Studies in Visual Communication*, David Kunzle misguidedly wrote that since introducing *LOVE*, Indiana had "thrived from its use in various media," and that "as late as 1972, this property, in immense enlargement, was serving . . . as proof that the market for love was bigger and richer than ever." Press like that can be debilitating, and rumors long persisted that an unfriendly art world was one reason that Indiana abandoned New York in 1978.[50]

Already by 1970 the urgency with which the artist regarded his work comes across in the extraordinary number of photographic portraits he posed for with it – not as artist working or in his studio (though these exist, too), but simply artist-with-*LOVE*, like a latter-day saint-with-attribute (figs. 6.23-24 and frontispiece). Starting around 1969 and culminating with his second *LOVE* exhibition in 1972, Indiana sought to repossess the work. Perreault noted of the twelve-foot Cor-ten steel *LOVE*, completed in 1970, "It seems that Indiana is willfully trying to reclaim his design and this, no matter how foolhardy, is admirable."[51] Indiana personally financed the fabrication of the work at Lippincott's and produced a documentary flier with photographs of himself and the metalworkers at the plant "making love" (fig. 6.25). From Connecticut the sculpture traveled an exhibition route to the new Indianapolis Museum of Art, which purchased it; then to Boston, where it was erected in the plaza of the new City Hall; and finally to New York's Central Park, before returning to Indiana in 1971.

The steel *LOVE* is language at giant scale. Even more than the other versions, this largest *LOVE* exudes its theological underpinnings and evokes American Edenic imagery, summoning the writings of Emerson and the paintings of Thomas Cole. Like a concrete metaphor of the pilgrim's manifest destiny, *LOVE* is the equivalent of a painting like Cole's *The Oxbow* (1836), in which Matthew Baigell

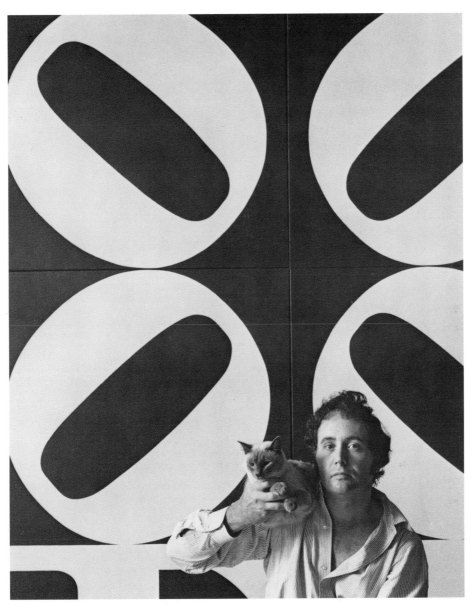

6.23 Indiana with *LOVE Wall*, 1969. Artist's collection
(photo by Hans Namuth).

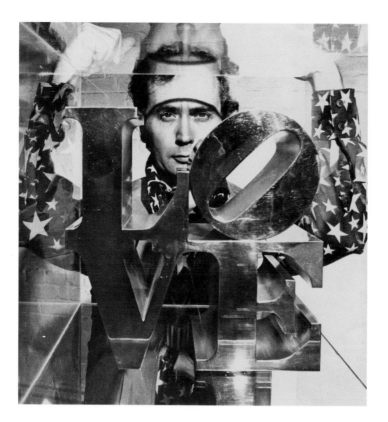

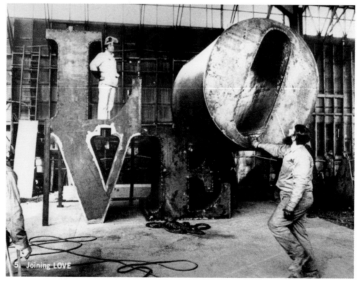

6.24 Indiana with 12″ *LOVE* sculpture, 1970.
Artist's collection (photo by Jack Mitchell).

6.25 *LOVE* in progress at Lippincott, Inc.,
North Haven, Connecticut. From *LOVE-O-Rama*,
mini-multiple by *ARTGallery* magazine,
October 1970 (photo by Tom Rummler).

has found the Hebrew letters spelling Noah (or, inverted, "the Almighty") in the face of the hillside beyond the river (fig. 6.26). In its late-sixties context, the big *LOVE* addressed the expanded field of sculpture, which spilled out of galleries to merge with architecture, landscape, and environment.[52] As a Word in the Wilderness, it addressed the American Sublime.

As the biggest *LOVE* journeyed from city to city, media followed and exploited it in a variety of situations, markets, and campaigns. Peter Plagens called it "a Frankenstein." In Boston, where it was part of an Institute of Contemporary Art exhibition of environmental sculpture, a candidate for political office is reported to have said that it was a symbol of left-wing hippie dissidence, and called for its removal.[53]

Its erection in Central Park was an art event, a performance that drew crowds despite a bitter November rain. A cheer went up when the titanic O was finally placed by a crane, completing the five-ton sentiment (fig. 6.27). Newspapers around the nation carried photos of it, and in Indianapolis a family named Love even re-created one on their front lawn as a mailbox. In 1978 Indiana created a sequel, a twelve-foot steel *AHAVA* for the Israel Museum (fig. 6.28). It was exhibited briefly in New York and – as if to complete a circle of events – it arrived in Jerusalem early in 1979, during Israeli-Egyptian peace talks and some sixteen years after the Rev. James Albert Pike had been found dead in the wilderness of Judea.[54]

227

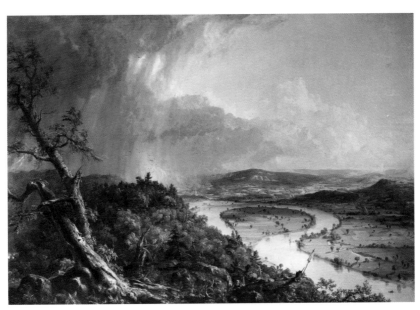

6.26 Thomas Cole, *View from Mount Holyoke, Northhampton, Massachusetts, After a Thunderstorm (The Oxbow)*, 1836. O/c, 51$^{1}/_{2}$ x 76". Metropolitan Museum of Art, New York; gift of Mrs. Russell Sage, 1908, 08.228 (photo © Metropolitan Museum of Art).

6.27　Erection of the 12' *LOVE* in Central Park,
Christmas, 1971 (photo by Steve Balkin).

6.28　*AHAVA*, 1978. Cor-Ten Steel, 12 x 12 x 6'.
Israel Museum, Jerusalem.

Self-Portraits and *LOVE* Letters

The mammoth sculpture was only one way that the artist responded to the diaspora of *LOVE*. Another was a triple series of symbolic self-portraits, based on the numbers 0 through 9, that counted ten of his years as an artist in New York (1960-69). Two series of ten paintings, one of forty-eight-inch-square canvases and one of twenty-four-inch ones, both entitled *Decade: Autoportraits*, were ready for his 1972 show at Denise René Gallery, where they were shown alongside that year's *LOVE*s. The third and largest set of seventy-two-inch-square canvases was painted between 1972 and 1977 (figs. 6.29-31).

The Autoportrait panels have the same square format as *LOVE*.[55] If hung with *LOVE* canvases of the same size, Autoportrait panels could be interspersed with them, though the artist has never done this. Formally they are opposites: the Autoportraits are faceted and complex, reversals of *LOVE*'s clarity and restraint. They summarize themes that run throughout Indiana's mature work and revolve around the central numeral 1 – the number of "oneself." They also recall *vision binoculaire* because they are mandalic compositions that, when hung as a line of ten or two lines of five, create frontal arrangements of orbs, the ocular stamp (in Indiana's oeuvre) of the poet's double sightedness. The series enact the processes of counting and repetition that defend the bulwark of identity. Moreover, in 1978 Indiana told an interviewer that the Autoportraits were the continuation of the series of *American Dreams*.[56]

6.29 *Decade: Autoportraits*, ca. 1971.
View of ten 48"-square panels. Artist's collection (photographer unknown).

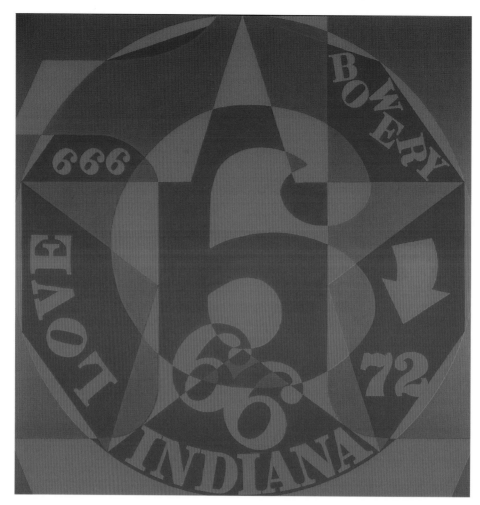

6.30 *Decade: Autoportraits: 1966*, 1972-77.
O/c, one of ten panels, each 72" square
(photo by Bruce C. Jones).

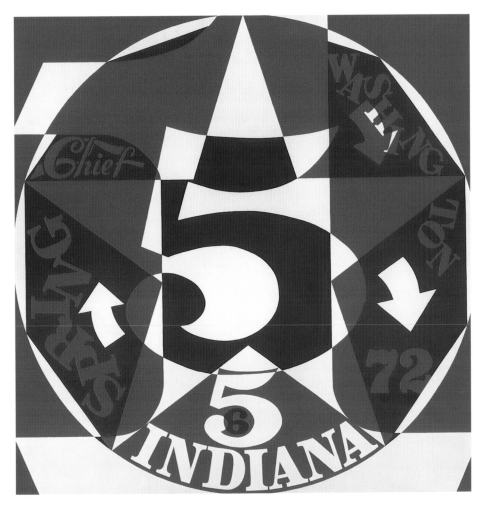

6.31 *Decade: Autoportraits: 1965, 1972-77.*
O/c, one of ten panels, each 72″ square.
Artist's collection. © Robert Indiana-
Morgan Arts Foundation/ARS, New York
(photo courtesy of Simon Salama-Caro).

In the middle-size series of forty-eight-inch paintings, each contains a decagon in a circle in a square, within all of which are superimposed the letters IND (for Indiana, a more straightforward signature than LOVE), a five-pointed star, and a numeral 1.[57] In each panel, within or intersecting with the hard-edged shapes created by the superimposed figures, are other symbols: smaller stars, circular arrows familiar from *Marine Works*, and 71, for the year the series was begun. Other words and numbers vary from painting to painting. Some are geographic records of the year in question ("Spring" for Spring Street, "Bowery," "The Slip," and so on); some are words from sixties paintings (for example, JUKE, JACK, EAT); and a few denote events in Indiana's life. In general, the palette of each Autoportrait follows that of a prominent Indiana painting from the year cited. For example, the seventy-two-inch 1966 Autoportrait, painted in 1972, commemorates the year of the Stable *LOVE* Show, so it is done in the *LOVE* ("Father") colors, high-intensity red-blue-green.

In each Autoportrait, figurative pronouncements (words, symbols, and numerals) representing the chosen year in the artist's life are updated with indicators of the year the Autoportrait painting was made, rendering interchangeable the early and the late. The decade of the seventies is superimposed on the sixties through certain references – the word "Washington" in the 1965 Autoportrait, for example, refers to Indiana's invitation there from President and Mrs. Johnson in 1965, but also obliquely to his visit to that city in 1975.[58]

LOVE and the Autoportraits are related serial compositions that exemplify the artist's fundamental impulse to make poems. Considered together, the two painting groups are analogous to the paired figures of metaphor and metalepsis (*askesis* and *apophrades*) in Harold Bloom's "Map of Misprision." These two dialectical figures commonly occur near the climax or conclusion of poems. Metaphor (whose psychoanalytical defense is sublimation) substitutes one term for another according to the dualism of inside/outside, a perspective that we can apply to *LOVE*, which has taken the place of the artist's name and identity. As a spoken word that performs direction, from artist to audience, *LOVE* is graphically demonstrated by the artist in fig. 6.24. Although metaphor is a popular trope, Bloom brands it a weak one from the viewpoint of poetry that must mark itself off from origins and influences. Metalepsis, though – with its related defenses, introjection and projection – is powerful, and furthermore, it sets itself against the forces of time and what Bloom calls belatedness. "Influence as a metaphor for reading is either a projection and distancing of the future and so an introjection of the past, by substituting late words for early words in previous tropes, or else more often a distancing and projection of the past and an introjection of the future, by substituting early words for late words in a precursor's tropes. Either way the present vanishes and the dead return, by a reversal, to be triumphed over by the living."[59] Arguably, both *LOVE* and the Autoportraits perform both functions – they substitute tropes for tropes and words for words, as in *LOVE*'s substitution for the artist's signature or self or name (a name

that is, after all, itself a trope for his geographical origins). In the Autoportraits, years of the artist's life (the self in time or on its journey) are represented by collections of words quoted from earlier paintings, poems, or life narratives. Again, we can discern the looming presence of Demuth's symbolic portraiture, particularly *I Saw the Figure Five in Gold*, which itself becomes figured into *Autoportrait #5*.[60]

The Autoportraits evoke such cubist portraits and poems because they render the self through the interpenetration of form and experience, and through words and numbers (just as Demuth's portrait of William Carlos Williams does). Indiana himself describes the Autoportraits as more essentially portraitlike than, for example, his Charles Demuth in the Figure Five series, which renders Demuth in terms of a single painting.[61] Presumably Indiana is also saying that his method of portraiture is stronger than Demuth's. All these examples seek to capture the experience of identity through time. As Bloom says, "Metalepsis leaps over the heads of other tropes and becomes a representation against time, sacrificing the present to an idealized past or hopeful future." My own invocation (or misprision) of Bloom, whose theories pertain to epic postromantic poetry as opposed to Pop art paintings, stretches the theory's boundaries. Yet the exercise is useful for conceptualizing the artistic enterprise that Indiana has been involved in, and his use of words and forms to figure forth meanings that are signifying chains capable of connecting the personal and the universal. Bloom recounts Quintilian's definition of *apophrades* as transumption, a taking across, and the presence of this type of allusion accounts for the tone of "conscious rhetoricity in Romantic and Post-Romantic poetry," which we also detect in Indiana's imaged utterances.[62] *LOVE* in Indiana's repetitions of it, and the serial Autoportraits in their confounding of markers of time, both struggle with influences, fathers, poets, and artists. In the Autoportraits Indiana has more graphically mapped his efforts to maintain coherency (the consistency of the circle, the star, and the number one) through the fragmentation (faceting) of chronological change (decagon, clockwise arrows), and the interface with Others.

In 1972, the year the first two Autoportraits series were completed and exhibited, the United States Postal Service approached Indiana about adapting his red-green-and-blue *LOVE* to a design for a postage stamp (fig. 6.32). Postal authorities acted on the suggestion of their Citizens Stamps Advisory Committee, eleven professionals in art, history, literature, graphics, and philately, who advised on the creation of some dozen commemorative stamps at that time issued annually.[63] The story made national news because, as a commemoration of an abstract emotion, the theme was a totally new direction for U.S. stamps and generated good publicity for the government agency. Postal authorities explained that *LOVE* gave them the opportunity to respond to thousands of requests they had had over the years for stamps appropriate for love letters, valentines, and wedding and shower invitations. The stamp was issued on Valentine's Day, 1973, with the ceremonial place of issue the "Love City," Philadelphia. The stamp was reissued in 1974, and 330 million were

233

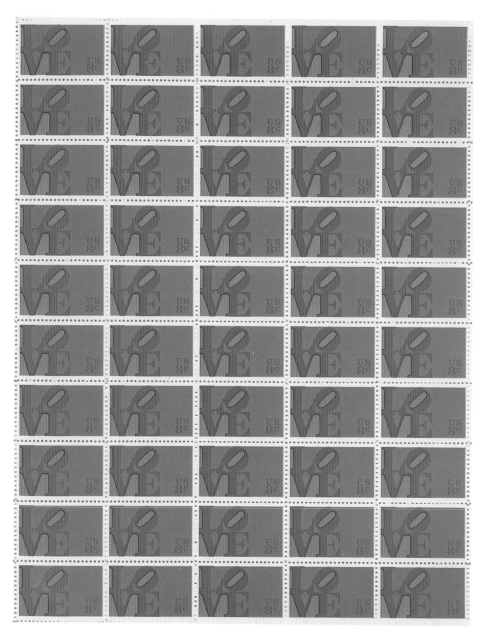

6.32 *LOVE Stamp*, commemorative eight-cent
postage stamp, 1973 and 1974. U.S. Postal Service
(photo courtesy Portland Museum of Art, Maine).

sold, more than any previous commemorative except for Christmas stamps. It initiated generations of "love" stamps – most in puerile designs featuring flowers, hearts, or puppy dogs – that continue today.

Adapted to the oblong commemorative format and mounted with "US 8c," the *LOVE* stamp officially usurped Indiana's American dream ideology and his visual voice. The artist had proudly responded to the postal service's request that he design the stamp, and he received a flat fee of one thousand dollars. He has referred to it as public editioned art, a vast "multiple"; as such, coincidentally, it evokes the first mailed *LOVE*s, the Christmas cards of 1964 and 1965. He has also pointed to America's lineage of "forgotten" artists – like the monumental sculptors Gutzon Borglum and Frédéric Bartholdi – a tradition in which public works eclipse artistic identity: "Everybody knows my *LOVE*," he told an interviewer in 1976, "but they don't have the slightest idea what I look like. I'm practically anonymous."[64] And it was not just the *LOVE*s that subsumed the presence of the artist but his other work as well – EAT/DIE motifs related to Indiana's turned up frequently in media and advertising. And in 1973, the year that *LOVE* appeared on domestic postage, Soviet art academy students Vitaly Komar and Alexander Melamid reproduced a fragment of an Indiana Confederacy Series painting out of a magazine they had obtained on the black market. They depicted it as a battle-torn antique, like a scrap of a rebel flag – a pastiched, parodic Pop act of insurrection in a socialist realist context (fig. 6.33).

In the late seventies, Indiana pursued his relentless variations of *LOVE*. In 1976 the Democratic National Committee commissioned a voter's registration poster, for which the artist turned *LOVE* into *VOTE*, "rewriting" his own earlier image and using its positive associations with youth, utopianism, and liberalism, plus the national and altruistic connotations of the stamp (fig. 6.34). The success of the poster in Jimmy Carter's presidential campaign brought Indiana twice to the White House and later occasioned a revision of the 1961 painting, *The President* (in serigraph) as a mandala-plus-legend portrait of Carter, the modified word-wheel reading, "An Honest Man Has Been President." But such efforts tended to make Indiana appear as a graphic designer, which is roughly the position he has been given in an art history that still sharply divides that practice from serious art.

In the 1980s, after a long and arduous transfer of his household and studios to Maine, Indiana undertook his most extensive series of intersecting portraiture based on the work of another early-twentieth-century homosexual poet and painter of symbolic portraits, Marsden Hartley. Hartley provides a link with the Demuth portraits through the legend that the poem on which Demuth's *I Saw the Figure Five in Gold* was based was written while William Carlos Williams was en route to Hartley's studio. Indiana based his visually opulent *Hartley Elegies* on the earlier artist's 1914 portrait series of a fallen German soldier, Karl von Freyberg, presumed to be Hartley's hoped-for lover (figs. 6.35-36). Indiana produced two matched but not identical series, one in oils, the other giant serigraphs. Some of each stay close to

235

236

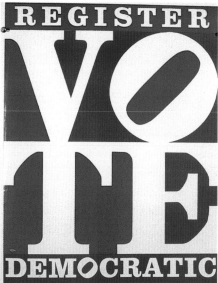

6.33 Komar and Melamid, *Post-Art No. 3 (Indiana)*,
1973. O/c, 42″ square. Courtesy the artists and
Ronald Feldman Fine Arts, New York
(photo by eeva-inkeri).

6.34 *VOTE*, poster for National Voter Registration
Program, Democratic National Committee, 1976.
Artist's collection (photo by Tad Beck).

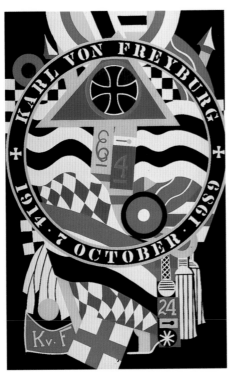
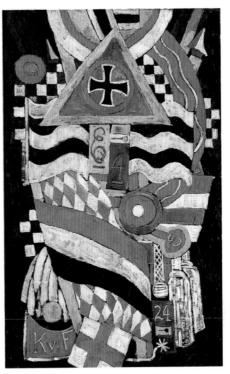

6.35 *KvFI: The Hartley Elegies: The Berlin Series,*
 1989-92. O/c, 77 x 51". Private collection
 (photographer unknown).

6.36 Marsden Hartley, *Portrait of a German Officer*, 1914.
 O/c, 68¹⁄₄ x 41³⁄₈". Metropolitan Museum of Art,
 New York. Alfred Stieglitz Collection, 1949 (49.70.42)
 (photo © 1986, Metropolitan Museum of Art).

the Hartley models while others edit them to become more "Indianas" – more iconic and symmetrical, with pronounced central mandalas. As with his earlier superimposed portraits/self-portraits, Indiana telescopes references to Hartley *(Der Amerikanische Maler)* and to von Freyberg with allusions to himself, to America, to Vinalhaven, and to historical events; one work, for example, includes *"Ich Bin Ein Berliner,"* from JFK's famous speech in the divided German city in 1963. The works are filled with references to wars and to the Cold War; one cites "The Wall," the notorious partition of the two Berlins, which, coincidentally, came down just as that painting was under way. Indiana's interpenetration with Hartley in the elegies is elaborate and expansive – there are dozens of wall-size "Hartley" paintings and prints that include diamond and tondo as well as portrait formats. The pitch is obsessive and sublime, and Indiana uses both the misunderstood painter/poet precursor and the dead German hero precursor to allegorize himself, the *LOVE* artist. They are his texts, his substitute mother and father, and he, in a grand reversal, substitutes himself for them.

Eternal *LOVE*

Jameson has described the sixties' quality of overextension as "an immense and inflationary issuing of credit; . . . an extraordinary printing up of ever more devalued signifiers."[65] In the aftermath of the sixties, *LOVE* was such a signifier, but not a completely devalued one. Granted, it has endured trivialization and criticism and has been virtually denied a position in art historical discourses since the late sixties. But its strength as a survivor lies exactly in its mobility and ability to absorb new meanings in the course of its own exploitation. From its artistic conception, as a poem-mask that pushes back fear of death or nonexistence, *LOVE* followed a path like the one described by Lacan of the stamping or imprinting effect of trauma *(Prägung)*: in the domain of the imaginary, during infancy, it "re-emerges in the course of the subject's progress into a symbolic world which is more and more organized." As time passes and the infant learns social rules and language, "something of the subject's becomes detached in the very symbolic world that he is engaged in integrating. . . . It will remain there, somewhere, spoken, if one can put it this way, by something the subject does not control."[66] *LOVE*, an artwork out of control, perhaps, today still maintains something of its imprint of trauma and desire; its chromatic intensity and assaultive commandment bear an aura – a shock – of recognition.

This is the phenomenon that best explains *LOVE*'s endurance. Upon it rely *LOVE*'s descendants, strong examples of word art since the seventies that more consciously and more critically explore the drama of subjectivity and its manipulation through seeing-reading. The speech of the symbolic order can be found in Jenny Holzer's LED boards and Barbara Kruger's pseudoadvertisements. In Kruger's works, like *"Untitled" (I am the real thing)* or *"Untitled" (You thrive on mistaken identity)* the "I" and "you" are shifters that slip from subject to object, public to private, artist to viewer (fig. 6.37). Among other works that substitute words for subjects is Bruce Nauman's lithograph *Use Me* (fig. 6.38), in which the message, written in bold capitals, is decipherable a second time scratched above the first in mirror-writing (as if it could be conveyed either way – from speaker to viewer or the opposite). A diagram of rectangles or columns, mirror-imaged *A* and *B* at bottom left in the print, supports the idea of identity graphed as interchangeable units. Nancy Dwyer has demonstrated the dominating power of words in her inflated polyurethane and nylon sculptures like *Big Ego*, and Christopher Wool's stark stenciled Pop song lyrics reveal to us a cultural prison with bars made of words (fig. 6.39). These works mimic, probably unwittingly, Indiana's *LOVE*, which attaches to them like a strong precursor in Harold Bloom's theory of poetry. It is not at all a matter of conscious stylistic influence, but rather of an image that, as Nabokov wrote, we cannot "unsee" once it has been seen.

Like contemporary bricolage ("the signified changes into the signifier and vice versa"[67]), *LOVE* frequently turns up as a symbol employed to invoke the libidinal

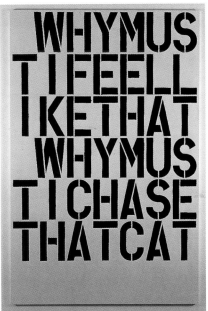

6.37 (BOTTOM LEFT) Barbara Kruger, *"Untitled"*
(You thrive on mistaken identity), 1981.
Photograph, 60 x 40". Courtesy Mary Boone
Gallery, New York.

6.38 (TOP) Bruce Nauman, *Use Me*, 1988. Lithograph.
Collection of Dean Velentgas, Portland, Maine.
© 1999, Bruce Nauman/Artists Rights Society
(ARS), New York.

6.39 (BOTTOM RIGHT) Christopher Wool, *Why?* 1990.
Enamel on aluminum, 108 x 72". Artist's
collection, courtesy of Christopher Wool and
Luhring Augustine Gallery, New York.

or merely "lost" character of the sixties, as in Glenn O'Brien's unabashed publication of Indiana's image in an article on condom advertising in a 1987 issue of *Artforum*, and a 1991 Stuart Leeds cartoon in the *New Yorker* (fig. 6.40), to cite just two from among countless possible examples. With the awareness of AIDS in the eighties – a syndrome that itself acts like a signifier, in the puritanical view of disease as just reward for the social ills of an earlier decade, of the "sixties moment" – a specific group of revisionary *LOVE* artworks issued forth, pairing LOVE (rather than EAT) and death. Among these, what Jameson would term "postmodernist 'nostalgia' art language," are Jiri Georg Dokoupil's *LOVE (for JK and RI)* (1986), and Marlene McCarty's *Love, AIDS, Riot* (1990), the latter an ironic and undoubtedly unwitting variant of Indiana's original *FUCK* (figs. 6.41-42). McCarty's work itself responds to the best-known *LOVE* appropriations of the eighties, those by

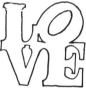

6.40 Stuart Leeds cartoon, *New Yorker*, 4 February 1991, 24. © The New Yorker Collection, 1991, Stuart Leeds from Cartoonbank.com. All rights reserved.

6.41 Jiri Georg Dokoupil, *LOVE (for JK and RI)*, 1986. O/c. Collection of Cornelia Lauf and Joseph Kosuth, New York (photo courtesy of Cornelia Lauf).

6.42 Marlene McCarty, *Love, AIDS, Riot (Study 2)*, 1990. Heat transfer on canvas, 24" square. Collection of Richard Prince (photo courtesy of Marlene McCarty).

AIDS-related groups: General Idea's *AIDS* and Gran Fury's *RIOT*, which also commemorated New York's Stonewall riots ten years before (figs. 6.43-44). Through their appropriations, both represent the fate of Indiana's *LOVE* and the cultural climate that precipitated it. *RIOT* was a silkscreen crack-and-peel sticker, but General Idea started, like Indiana, with *AIDS* paintings, then varied them in terms of color scheme, and recycled the design in sundry media, including an edition of stamps, silkscreened wallpaper (more reminiscent of Warhol than Indiana), and "commercial" posters distributed (in 1987) in subways and on street corners of New York and San Francisco.[68] Even more recently, *AIDS* itself has been appropriated and scrambled to become *SIDA*, the work of the French artist Aurèle and Information Antécédent Comportement (IAC). Aurèle uses General Idea (and Indiana) as unwitting collaborators, as Indiana has used Hartley and Demuth (fig. 6.45).

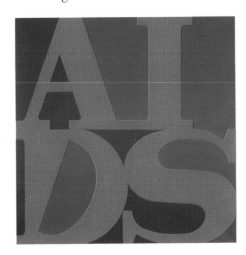

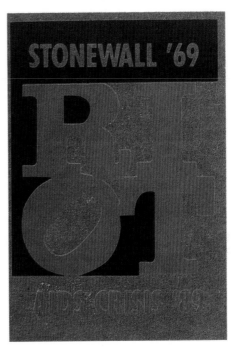

6.43 General Idea, *AIDS (Cadmium Red Light)*, 1988. A/c, 24" square. Private collection. Courtesy of General Idea.

6.44 Gran Fury, *RIOT*, 1989. Silkscreen crack-and-peel sticker.

6.45 Aurèle, SIDA postcard, *Catherine Deneuve*, 1991.
Poster on paper mounted on canvas,
97 x 1230 cm. (photo by Sergwe Arnal, IAC and
Flammarion 4, Paris).

Appropriations of *LOVE* have mounted up like ex-votos at the shrine of a good cult statue. *LOVE* is a big-brotherly image offering faceless comfort to a decentered, technologized culture, in which identity is reckoned through language and media. (Already in 1914 Gertrude Stein had warned: "Act so that there is no use in a centre.") In the sixties, individual selfhood gave way to collective identities, and an illusion died. *LOVE*, because it transumes or crosses, as Bloom writes of crisis poetry, "between experiential loss and rhetorical gain," attached itself to the cusp of that transition and remains its relic.[69] A few years ago, when I published a call for examples of recycled *LOVE*s, the overwhelming response brought no commercial renditions but rather intimate or homemade ones – *LOVE* used as a theme for a wedding or patterned into a hooked rug, somehow recathected into the realm of the personal. The power of *LOVE* may have been aided by its fit with the social context. But the notorious checkered past of that imaged word is due ultimately to our attraction (and sometimes revulsion) to images that draw us into the shadows of ourselves. *LOVE* remains an aura or emanation of self-remembrance: an upright, speaking subject, an Apollonian imaged voice.

Robert Indiana's articulation – his visualization – of the agony of fragmentation provides the significant interpretive context for the artist's works, works (*LOVE* in particular) that have behaved so uniquely in the history of art. Under-

standing Indiana's work contributes less to the topos of Pop art than it does to our ability to think about the borders between seeing and reading, the nexus of perceptual impact and language. His paintings affect us, when they do at all, not simply because they are *like* poems but because Indiana has used them *as* poems, and this use has left its mark on them, too. As poems – strong revisionist deployments of language, language born of catastrophe at the origin of consciousness – his paintings make visual tropes of catastrophe's aftershocks. Indiana's poem paintings are tools that use layers of substitution – bits and pieces of mothers and fathers and heroes, fragmented by language and reconstituted through verbal-visual figuration – to defend against the unutterable. And the artist does what Bloom says poets do: "The poet writes to usurp. Usurp what? A place, a stance, a fullness, an illusion of identification or possession; something we can call our own or even ourselves."[70]

Appendix 1
Poems by Robert Indiana

October

By Robert E. Clark

st printed in *The Arsenal*
nnon, 24 October 1945.

October
is in the wind,
and the wind
has a Midian finger;
for the brown leaves
are gilt leaves,
and the hills are piles of gold.

October
is in my heart,
and my heart
is so yearning to linger
in autumn hills
those autumn hills
and to count my treasure there.

August Is Memory
or
Epitaph for Carmen
By Robert Clark

 August
Is bittersweet memory.

Hot month:
 Death reeks
 As it will reek
 In an Indiana autumn.
Pain,
 Ending in
 Fetid orgasm,
 Helpless witness I.
Odour
 Of August
 And of death &
 the last gasped word.

 August
Is the stained crumpled
Sheets & the rainless day
 I saw
 Slipped in
 In proper custom:
 The sun-baked,
 Her native soil,
 Our common coil:
 (NE plot No 16 –
This is the receipt for
two grave sites. J. Aberdeen)
That pain wracked memory,
 Disease ridden
 Labour driven,
 Jealousy sucked.
Memory
 Of love
 German vitality,
 Gun-clicking hatred.

Carmen,
 The sad musician laments.
Carmen,
 The gay mortician
 undertakes

 It Is All Over.
The operation was clean cut.
The floral tributes *were*
Fresh for August.
There was absolutely
No inconvenience to
Those concerned.
Every pain
 Was spared
 Family,
 Friends &
 Relatives.
A pretty cemetery – pity
The highway is so near.

Red mottled granite
Would remember her best.
I think the metal marker can do.
Blue-serge sorrow
Is the proper vest to wear.
I think I am glad it is over.
 I love the sad musician!
 I love the gay mortician!

 August brought You.
 August takes You.
 Heat becomes You.
 Take the hot grave well,
 Carmen.

August is Memory
 Laid in Elizabethtown 1949
 Written at Edinburgh, 1953

My First Spring in Scotland
For Alison Balfour
By Robert Clark

This was my first spring
Broke on the red cliffs vivid in the pale sun,
Strong under the spread of pine
That succour gives a fragile flower, the snowdrop,
Yet embraced in a godmother's chill arms –
Harbinger too soon,
Harbinger too fair,
Lost in the whiteness of a reluctant season,
Malingering the glen in wintry quiet,
Breathing crisp the frosted air.

Sky was a claiksome
Whir of north-hurtling, highland-hieing geese.
Wild etch against the blue,
That feather-carries the warmth of a tropic sun
To moult it welcome on a wanting land.
A feather swirls,
A feather falls
To startle the pheasant copper-quiet in the grass,
Migrant kin returned and bramble-nesting,
Patient waiting the first shell-knock.

Spring was announced.
Still the ice-gurgling burn rattled winter,
Cold to fingers green in the sun.
She said them to me, my Ali, and commended me
To bell them on plaintive to the wood,
Restive as I,
Anxious as I
To throw arms to the sky and feel the bubbling sap
Surge hot to the very fingertips and
Singe the fevered flight of geese!

Spring was a window
Wide of clouds scraping large the distant law,
Deep in a vast hollow of sky
That throbs to the rub of restless boughs,
Giddy in the warm loving wind –
Kisses me to life,
Kisses me to love,
Dizzy on the Green Walk of moss-bussed beeches,
Reeling down the green path of spring,
Drinking drunk the pith of spring.

There was the bluebell
Shy in the garlic breath of the white-starred ramson,
Rank in lush clustered galaxies
That season the dingle with a salad scent,
Pungent and delicious to all senses at once –
Inviting the feast,
Inviting the gourmet,
Hungry for the sea-scented lungwort, oyster-
Tasted aperitif of primavera's herbal,
Spread in sating green profusion.

Bright was the porcelain
Rich in the clitter-clatter house that harboured me,
Glad in my first Scot's spring
That I laughed to with Lily, the tawny-coloured cat,
Blessing spring with hybrid new meows –
Mewing their birth and love,
Mewing their love and birth,
While caressing rough-tongued the kitteny spring,
Swathed in furry greenness and christened *Joy*,
Called *Happiness* and *Love*.

1954

Fractured Crucifix
For the Gentle Unbeliever

By Robert Clark

First published in *Windfall*,
June 1954.

A fractured crucifix
 bleeds against the sky.

Black crumbling stone
 is the raw wound that
 festers in the city's
 acrid air:
The treacherous pollution
 that soils the ikon
 that spoils the idol
 conceived immaculate
 but in vulnerable stone
 reincarnate.

A splint of steel
 ramifies the enfeebled figure,
 rotting in the
 hostile industrial atmosphere,
 whereon
 workmen travail to revivify.

Indifferent,
They whose rough hands
 soothe the ailing rock
 restore the frail Shepherd
 of an ancient ingrate flock.
They chink the cracks,
They mend the scars,
They scrape off pigeon dung
 that obscures the irony
 that obliterates the agony.

They bolster the sagging cross –
 in dangerous intercourse
 with the lethal respiration
 of the mechanized
Herd –
 superficially recognized
 As the Meek.

A Poem

By Robert Clark

First published in *Windfall*,
June 1954.

Love
is a bucket
that I wear on my head.
When it fills with tears,
My thoughts,
finny and agile,
swim like hungry fish
thru the seaweed algae
of my hair,
nibbling
the dandruff, precious
for its propinquity
to me;
tripling
themselves rapacious
on self-pity, pity
for me.
 – *Either this*

when the love I bear
is a pail of tears
Or –

 I drown.

When the Word Is Love

By Robert Clark

Dent the head
With the word.
See the lettered scar
On the skull.
On the bone
(In the beginning)
The straight line,
Wherefrom the rounding
Circle is begat,
But on our tongues
Never sat.
Yet see the jutting
Diags do –
Ascendency inversed –
And in the final due,
Lo: the single stroke
Rampant three-pronged
Trinity into infinity.

1955

Wherefore the Punctuation
of the Heart

By Robert Indiana

First published in limited folio
edition *TRILOVE* (New York:
Bouwerie Editions, 1969).

Wherefore the punctuation of the heart

When that slim prim agapé

LOVE

Erred into

L,O,V,E,

Encomma'd in uncertainty

Is neither

L;O;V;E;

Haltered in some Philistine design;

Nor

L:O:V:E:

Encumbered in even deeper discelebration:

Let not

L/O/V/E/

Staggered stumble unrequitedly/

Quite not

L-O-V-E-

Shackled in measured irony –

Should not be

(L)(O)(V)(E)

(Buttressed incarceration)

But most not

L.O.V.E.

Hated anagram of death.

Instead quoth

"L"O"V"E"

Not "nevermore," for "evermore"

Or

L?O?V?E?

In quest, not question?

Rise bright phoenixwise
 E
 V
 O
 L
 Ecstatic
 Erect
 Erotic
 Having dove (sic)
 L
 O
 V
 E
 To emerge purged.

 Let shout exult
 L!O!V!E!
 From every glyph!
 Yea increase
 L&O&V&E&
 Amply companioned
 To be
 Emblossomed
 L*O*V*E*
 In an asterism of erosia
 To make
 L O
 V E
 Architected in eternal form.
 1958-69

Appendix 2
Artist's Statements

Coenties Slip

Some years ago – it was in the spring of 1956, the last week of June precisely – having little or no money in my purse, and no particular interest in the wave of abstract expressionism that had inundated the middle part of Manhattan, I came to the tip end of the island where the hard edge of the city confronts the watery part.

There in that fringe of derelict warehouses that have stood since the Fire of 1835, facing the harbor between Whitehall and Corlears Hook, I rented a top-floor on Coenties Slip. Out of necessity it was a cheap accommodation and it was necessary to put in the windows myself before it was habitable, but there were six of them and they overlooked the East River, Brooklyn Heights, the abandoned piers 5, 6, 7 and 8, the sycamores (as Hoosier as a tree can be) and ginkgoes of the small park called Jeanette, and the far side of the Brooklyn Bridge, through whose antique cables the sun rises each morning, while at night the Titanic memorial lighthouse of the nearby seamen's hostel illuminates the skylights of my studio whether the moon shines or not.

Coenties, of the dozen or so slips of Manhattan, is the oldest, largest and busiest of the lot, and the last to be filled in (circa 1880), all of which are relics of the wooden ship days of sail and mast. Its origin goes back directly to the Dutch days of Nieuw Amsterdam and a landowner named Coenach Ten Eyck. (The good Yankee slaver *Rebecca* may well have taken on provision here and the *Great Eastern* that Whitman celebrated in *Year of Meteors*, as I did myself recelebrate, certainly did steam and sail past the Slip.) Cartographically it describes a Y – a funnel drawing in the commerce of the port in its day, sadly now paved over with asphalt and granite brick, through which poke the fifteen ginkgoes, whose leaf form doubled provides the motif of *The Sweet Mystery* – but a Y rounded out so as to describe a partial circle. This from the windows of 31 and now from the neighboring 25 (since the demolition of the first in 1957), both buildings by coincidence once the *Marine Works*, ship chandlers at the turn of the century.

Also, from my windows, if one looks landward instead of seaward, there is that solid cliff of stone that Wall Street makes, meeting the sky as sharply as the piers to the water, all lines of demarcation crisp and sure. Here this heady confluence of all elements, the rock, the river, the sky and the fire of ship and commerce causes a natural magnetism that has drawn a dozen artists since to the Slip.

It is 25 which is emblazoned with signs of words over its entire facade that paradoxically became a daily confrontation with the format my work has assumed. Not only this, but every ship that passed on the river, every tug, every barge, every railroad car on every flatboat, every truck that passes below – on Slip, on South, on

Robert Indiana, first published in *Richard Stankiewicz; Robert Indiana* (Minneapolis: Walker Art Center, 1963).

Front, on Water and on Pearl Streets – and every helicopter that now lands at the heliport a stone's throw from my building – for progress pushes its way onto the obsolete waterfront, as sure to go as the artists collected by its rotting piers – carries those marks and legends that have set the style of my painting. The commercial brass stencils found in the deserted lofts – of numbers, of sail names, of the names of 19th century companies *(The American Gas Works)* became matrix and substance for my painting and drawing. So then did all things weave together.

Eat

First published in *KunstLicht* (Eindhoven: Stedelijk van Abbemuseum, 1966).

Signs loomed large throughout my whole life. First there was the huge round Phillips 66 sign that rose high above the flat skyline of my hometown. I saw it and felt it every year of my youth there for it happened to stand, perched on two girders, on the very route that my father took to work each day for many years. It also just happened that he worked for the very company that it announced red and green against the blue sky. His sign; my sign. And it was about the highest thing (in my imagination) in town save the spectacularly ugly war monument that dominates the center of Indianapolis, surrounded as it is by a circular street called the "Circle," the city being elaborately laid in freshly hewn forests according to a European plan.

Not long after came EAT signs. Ubiquitous in that part of America they signal all the roadside diners (no DINE signs) that were originally old converted railway cars, taken off their wheels and mounted on blocks amid zinnias and petunias when the motor bus displaced the railroad in the '30s, and the cheap cafes (rivaled by CAFE signs). Some of the latter were operated with strict "homecooking" by my mother when she had to support herself and her son during the Depression when Father disappeared behind the gasoline sign (66) in a westerly direction, leaving home and family for other signs. The son, burning to be an artist from the age of six, painted the window signs of those establishments. It was fitting that the very last word that she uttered to him at her death was "eat."

Then, some years later, amid the lighted splendors of Times Square and the millions of signs in New York, a few of which covered the front of my studio building in the old Dutch section of Manhattan, came the architect Philip Johnson and the New York World's Fair and his commission to do a work for his New York State Pavilion there – along with friends and neighbors, Kelly, Rosenquist, Rauschenberg – on the side of a circular building, part of the tallest and most prominent complex in the exposition. A black EAT came to mind and in order to elevate it to the spirit of the occasion it became an electric EAT, flashing its imperative with real energy. Too much so for the Fair officials who turned it off the very first day it was lit, and there it hung for two summers viewed by millions of people, but emasculated and tame. Too many had reacted, that first day, to the imperative.

The Sweet Mystery

First published in *Robert Indiana* (Philadelphia: Institute of Contemporary Art, University of Pennsylvania, in collaboration with the Marion Koogler McNay Art Institute, San Antonio, and the Herron Museum of Art, Indianapolis, 1968).

The Sweet Mystery came from these things:

1 My first I Ching reading: this occurred early on Coenties Slip with Ellsworth Kelly and his newly arrived friend from Paris days, the Kentuckian Jack Youngerman, in his first loft on the waterfront which, curiously, was the site of a Chinese laundry at the time of my birth.

2 Yin and Yang: a wish to invest them with a new form.

3 The gingko leaf: the new form though of prehistoric Oriental botanic origin, not of a tree, but a fern, which – in the not humid enough climate of New York – unable to have normal prehistoric sex, the female specimen throws off a foul-smelling seed as if in anguished protest (sour/sweet Mystery with Chatham Square and Chinatown the next El stop away from Hanover Square when the Slip was transversed by the famous snake-curve of the recently vanished Third Avenue Elevated downtown).

4 One year of painting: various mutations of the doubled ginkgo leaf shape – my Yin and Yang – but very Westernly and dangerously in oil on paper, a medium claiming no permanency . . . perhaps thinking of my self as a tree casting off leaves at autumn.

5 The cycle: from Spring's Permanent Green Light to Fall's golden leaves on the blue-black asphalt of Jeanette Park, even up to my own stoop next to the Rincón de España downstairs where a handsome, dark-eyed barmaid named Carmen – like my "Mother" worked those eight years I lived above and sent Spanish music welling up the hoist shaft – but never the "Habañera."

6 Yellow: my color, particularly in its darkened aspects, the browns and earths (my "Father"'s last property in Indiana was on Greasy Creek in Brown County).

7 "Vision binoculaire": a phrase from Cyril Connolly's *The Unquiet Grave*, a book I was reading at the time with a friend who, ironically, was destined to commit suicide later while living at 3-5, since the book is fixed on the character of Palinurus.

8 *The Sweet Mystery*: life and death. The hereness and nonhereness.

9 The words: among my first cautious uses of them on canvas, here muted and restrained.

10 *THE SWEET MYSTERY*: song breaking through the darkness.

Yield

Arrogant admonition of the American highway, by far the most provocative of all road signs, emblazoned too on that unexpected shape: the descending triangle. Wildly indecorous for a humorless Highway Department that never follows "Soft Shoulders" with "Supple Hips." However, Yield – as humble injunction – appropriate and pressing for the whole troubled world. So when Bertrand Russell's plea for worldwide support for his peace program went out a few years ago I responded with my first *Yield Brother*, transforming certain of the cartographic forms that I had used to describe early Manhattan streets mentioned in "Moby Dick" in the *Melville Triptych* into his "ban the bomb" symbol, four times over – visual catechism, so to speak. Ironically enough when it was presented there in a benefit exhibition at Woburn Abbey, it found no takers in swinging, with-it England, drawing the non-reaction instead that one might expect from her old Puritannic Majesty's realm, and was returned to America for sale here. Perhaps there has been too much yielding for the British; in Stand-Firm-America there is more need. That the countryside is peppered with "Yield" signs hasn't affected the national conscience much – particularly in our least yielding region entrenched as it is in the doctrine of White Supremacy. Against the recalcitrance of the South I have aimed the salt of the Confederacy Series, *Florida* in this exhibition, but *Mississippi* too, and *Alabama* and *Louisiana* and eventually I mean to encompass all 13 of the Secessionist States whose citizens were willing to die for the perpetuation of human slavery, indicted here with "JUST AS IN THE ANATOMY OF MAN EVERY NATION MUST HAVE ITS HIND PART."

First published in *Robert Indiana* (Philadelphia: Institute of Contemporary Art, University of Pennsylvania, in collaboration with the Marion Koogler McNay Art Institute, San Antonio, and the Herron Museum of Art, Indianapolis, 1968).

The Demuth American Dream No. 5

First published in *Robert Indiana* (Philadelphia: Institute of Contemporary Art, University of Pennsylvania, in collaboration with the Marion Koogler McNay Art Institute, San Antonio, and the Herron Museum of Art, Indianapolis, 1968).

I Saw the Figure 5 in Gold by Charles Henry Demuth is my favorite American painting in New York City's Metropolitan Museum. *The Demuth American Dream No. 5*, the central painting of the five in my "Fifth Dream" suite, is in homage to Demuth and in direct reference to the same painting which his own object of acclamation, the American poet William Carlos Williams, thought one of his best works.

For in 1928, the year of my birth, Demuth painted his "picture" inspired by his friend's poem "The Great Figure." It was on a hot summer day in New York early in this century that William Carlos Williams, on his way to visit the studio of another American artist of the time, Marsden Hartley, on Fifteenth Street that he heard "a great clatter of bells and the roar of a fire engine passing the end of the street down Ninth Avenue." He turned just in time to see a golden figure 5 on a red background flash by. He was so impressed that he took out a piece of paper from his pocket and wrote the following poem on the spot: Among the rain / and lights / I saw the figure 5 / in gold / on a red / firetruck / moving / tense / unheeded / to gong clangs / siren howls / and wheels rumbling / through the dark city.

I did my painting in 1963, which when subtracted by 1928 leaves 35 – a number suggested by the succession of three fives (5 5 5) describing the sudden progression of the firetruck in the poet's experience. In 1935 Demuth died, either from an overdose or an underdose of insulin (he suffered for years from diabetes) according to Doctor Williams, the pediatrician-poet who birthed thousands of babies as well as hundreds of poems, and then in 1963 the venerable doctor died, completing the unpremeditated circle of numerical coincidence woven within the "Fifth Dream."

For the major painting of the "Dream" I chose the cruciform, a polyptych of unusual form in the history of painting if not sculpture – the obvious exception to this of course being Cimabue's *Crucifix*, so recently nearly destroyed – by the use of which I meant to set this particular painting most apart from all others given that its theme and internal form is in direct dialogue with the original inspiration. The head, the arms, the foot, or less particularly the surrounding members echo and reinforce Demuth's composition though somewhat simplified to fit the nature of my own work, stripped as it is of the allusions to a cubist cityscape.

USA 666

USA 666 actually comes from multiple sources: the single six of my father's birth month, June; the Philips 66 sign of the gasoline company he worked for – the one sign that loomed largest in my life casting its shadow across the very route that my father took daily to and from his work and standing high in a blue sky, red and green as the company colors were at the time but changed upon the death of the founder of the company. (Which three colors make up half of the "Sixth Dream" series, as they are also predominant in the "LOVE" series for they are the most charged colors of my palette bringing an optical, near electric quality to my work.) It also conjures up Route 66, the highway west for Kerouac and other Americans for whom "Go West" is a common imperative, whereas for a common cold it is "Use 666," the patent medicine that is the final referent and which on small metal plates affixed to farmers' fences – black and yellow – dotted the pastures and fields like black-eyed susans in perennial bloom, alternating with the even more ubiquitous Burma-Shave advertisements that brought elementary poetry as well to the farms and byways. In perhaps lesser profusion over the countryside bloomed the EAT signs that signalled the roadside diners that were usually originally converted railway cars of a now disappeared electric interurban complex taken off their wheels and mounted on cement blocks when the motorbus ruined and put that system out of business in the thirties. In similar cheap cafes my Mother supported herself and son by offering "home-cooked" meals for 25 cents when Father disappeared behind the big 66 sign in a westerly direction out Route 66.

Published in *Robert Indiana* (Philadelphia: Institute of Contemporary Art, University of Pennsylvania, in collaboration with the Marion Koogler McNay Art Institute, San Antonio, and the Herron Museum of Art, Indianapolis, 1968).

Mother and Father

Some painters have painted their mothers; some painters have painted their fathers. A very few are known to have committed both to canvas and fewer still to have fixed them in the same work. MOTHER and FATHER is a single work, a diptych in homage, and respect too, to two people conspicuously crucial to my life and my becoming an artist, for − contrary to the customs of the time − I was half-encouraged toward this unthinkable occupation. Otherwise they were immensely unimportant in their world, leaving no other mark. Born at the end of the nineteenth century they helped to dissolve that era's social solidity. They were definitely the "lost generation." They were lost and they got there fast on wheels.

My mother's name was Carmen. Though warm and vibrant she was not Latin, but was so named because it was her father's favorite opera. An insurance salesman when that breed criss-crossed North America by rail (HIGHBALL ON THE RED-BALL MANIFEST) and were away from home long intervals spending nights (USA FUN) in countless hotels and going to vaudeville palaces or opera houses − according to their likes. He preferred Bizet. Her mother died of *dementia melancholia* while he was on the road (USA DIE) and he took another wife who was shot to death because she was so mean. My mother's darkest hour came at the trial when the defense declined her testimony in behalf of her step-mother's murderess, a dark-haired ball-o'-fire named Ruby (THE RUBY RED YIELD). Before the death of rail passenger service whenever I traveled to Chicago from New York I took the Twentieth Century Limited and always thought of this grandfather, as well as of my paternal counterpart who used to drive trains for the Pennsylvania Railroad (THE BIG FOUR). Each morning on one of those trips I would wake up in South Bend, Indiana, where the notorious event took place in '38 and mull over it eating breakfast (USA EAT) all the way to Chicago (THE SECOND AMERICAN DREAM). My mother never saw "Carmen" and probably would not have even liked it, but she did know and admire Theda Bara, styled herself into a "vamp," and wore her fancy cape seductively. She employed marcelling irons and finger-curled her bangs with spit. She applied mascara with a mean thin brush. She went through three husbands, but "Father" lasted longest. For 21 years she worshipped the ground he walked on (her words). She wouldn't permit an ordinary laundry to do his shirts. She held him all through the Depression with her cooking (EAT), but finally drove him to distraction with her gypsy-like obsession to keep domestically on the move (USA ERR). All in all they called it "home" in over fifty different bungalows − as modest habitations were wont to be called in the Midwest − and I personally lived in 21 of these before I found stability in the U.S. Army at the age of 17. They were the swingers of their

times and loved their newly found four-wheeled mobility. She had her car and he his, Crash or no Crash! With roadmap in hand they devoured the American land-scape (THE GREAT AMERICAN DREAM). This went on, trip after trip, Sunday drive after Sunday drive, evening spin after evening spin, for those 21 gasoline-gorg-ing years. Then one sunny Fourth-of-July weekend "Father" packed his duds and fishing gear and took off with a new-found auto-mate. "Mother" loaded the family revolver (which he had left behind) and went scouring the Hoosier countryside for him in her car with the '38 in her lap. She was going to shoot them both if she could find them together. He had added insult to injury by confiscating her fishing rod for his new love.

My father's name was Earl and he was as colorless as his name and the grays I have used to depict him, but *he* thought himself a chip off the new American block, a real patriot who wanted to make the world "safe for democracy" in '18 but never got closer to France than Louisville (Kentucky). He wanted the big house on the hill, geared himself to make it – he was American Dreamer No. 1 (THE AMERICAN DREAM). The Numbers 37, 29, 40 and 66 in it are the highways that he traveled in his quest – a Lindbergh of the plains who never quite made it. He loved all three of his wives, but with Carmen he flew highest. My mother was middle wife and he was in his prime. He wooed her on wheels and she was crazy for it. Then she became fat and middle-aged and he ditched her for a new model; obsolescence Yankee-style: new wives, new cars, new art (regularly).

MOTHER AND FATHER is part and parcel of my AMERICAN DREAM, the first major Pop painting acquired by an American museum (1961) that grew into a large series of paintings still in progress. The first, acquired by the Modern, and the third, by a Dutch museum, were couched in the jargon of the pin ball and slot machines, two of my mother and father's favorite devices, second only to the very keystone of their happiness and dream – the chugging chariot carrying them on to ever greener pastures and redder passions, the arm-breaking magic carpet of escape from the confines of family (large), neighbors (encircling), and the small town (imprisonment). It was Mr. Ford's answer to a national dilemma that liberated one generation, killed off half another, and put amorality on the road and Detroit on the map. Here beside their Model-T they are stopped momentarily (forever) in their endless pursuit of distraction from any meaningful aspects of life – now ended for "Mother" in that same Indiana loam she stands on; in fact, in a country cemetery very similar to the wintry landscape here, but the rutted road has been paved over many times and become a busy highway dominated by the smell of exhaust rather

This is a slightly different, and longer, version of the statement published under the same title in *Robert Indiana* (Philadelphia: Institute of Contemporary Art, University of Pennsylvania, in collaboration with the Marion Koogler McNay Art Institute, San Antonio, and the Herron Museum of Art, Indianapolis, 1968).

than myrtle. Ended, too, for "Father" who went on traveling to both ends of the American rainbow – California for a few years and finally to Florida where, Eureka! having solved the revolving house problem with a mobile home (castle-on-wheels), while eating breakfast one morning he toppled over and died (EAT/DIE). Somewhere in the middle was Indiana, a state that produced more automobiles (247 makes) than painters (until my generation) but lots of farmers, Republicans, Ku Klux Klanners, John Birchers and John Dillinger – the cream of the crop whose hometown was where I attended first grade and suffered my first art theft (Chicago second, New York third, Berlin fourth).

Sealed in time here they stand fixed on this lonely dirt road frozen hard in midwinter, according to the license plate about nine months before my birth. My father considered himself as hard as hickory as well as a bit of a dandy, properly arranging his overcoat for my mother's Kodak. She reveled for him in her very store-bought attirement and a burst of warm sunshine. Beyond them a hand-split rail fence (it was Lincoln as well as Dillinger territory) encloses a stand of hickory. They were young and flush and happy with their Tin-Lizzie – surely as proud of her as they would have been were she a Hoosier Dusenberg. They are totally unaware of the sad trip ahead.

The Metamorphosis of
Norma Jean Mortenson

The rise and fall of the Flesh Cult in Hollywood, the birth and demise of one more celluloid goddess only pall in an enormous way, having gone through the gamut in the '30's when going to the movies was substitute for a baby sitter, but Marilyn Monroe was a cut above the ordinary and made the tired old money-making ritual worthwhile again – almost. It was probably her pathetically human, incredibly vulnerable image she exposed on the consciousness of America and the Americanized world. Jean Harlow might have received similar homage in her day if certain artists had been born a generation earlier. Or the Hoosier Carol Lombard whose tragic death during the Second World War – setting off from Indianapolis after a bond rally – affected me more personally, but her death didn't really become Americana, the Dream. The little California orphan girl whose every dream was fulfilled did win her legend and became the terminal symbol of the Lotus Land the world grew weary of. An irony indeed that her role in "Misfits" was not only her final appearance on the screen, but the vehicle of farewell for her costars Clark Gable and Montgomery Clift as well. The last film for all three. Six divided by two. '26 the year of her birth; '62 the year of her death. At two baby Norma Jean was almost suffocated by a hysterical neighbor; at six a member of one of her 12 (6 x 2) foster families tried to rape her. In '52 (26+26) when she was 26, her most cherished ambition of all was realized when she starred in a dramatic role and, in the first week at the Manhattan box office, the film grossed $26,000. Death came by her hand on the sixth day of August, the eighth month (6+2 for the last time). This odd run of numerical coincidences only buttressed my fascination with the subject once I had become intrigued by the metamorphosis of her name itself.

From the letters of her original name someone drew – almost anagrammatically – those of her fame. Three were added; three were subtracted. Six again. In gray. Encircled by the telephone dial-like ring of her destiny and death (it was this instrument she was clutching) Marilyn is posed – in the cosmetic colors of her much-vaunted femininity – against the golden star of her dreams though its tips, however, point to the letters I MOON. Her stylized image comes, of course, from the famous nude calendar "Golden Dreams," which, upon finding by chance in a Greenwich Village shop called "The Tunnel of Love," I turned over and discovered that our last Goddess of Love had been printed in Indiana.

First published in *Robert Indiana* (Philadelphia: Institute of Contemporary Art, University of Pennsylvania, in collaboration with the Marion Koogler McNay Art Institute, San Antonio, and the Herron Museum of Art, Indianapolis, 1968).

Formats of Major Indiana Paintings

1960-73

Portrait rectangles
60 x 48 or 50"

Ballyhoo
The President
American Reaping Co.
God is a Lily of the Valley (2 versions)
Corlear's Hook, Coenties Slip, Whitehall
(*Melville Triptych*)
Coenties Slip
The Rebecca
Yield Brother
The Eateria
American Stock Co.
The Figure Five
Highball on the Redball Manifest
Numbers (10 paintings)
The Cardinal Numbers (10 paintings)
To the Bridge
Leaves
Terre Haute #2
Oranges
The Dietary

Portrait rectangles
70 or 72 x 60"

The Sweet Mystery

The American Dream #1

The Triumph of Tira

Melville

EAT/DIE

Mother and *Father*

Alabama

Florida

Mississippi

Louisiana

Parrot

Squares

Zero

Four

LOVE (more than 20 versions)

ART

Decade: Autoportraits
 (3 series of 10 each)

Exploding Numbers

Tondos

Jesus Saves

Six

LOVE (destroyed)

Diamonds

Black Diamond American Dream #2

Red Diamond American Dream #3

Green Diamond EAT and
 Red Diamond DIE

The Big Four

Four Sixes

Beware-Danger American Dream #4

The Demuth Five

The Small Demuth Diamond Five

Yield Brother #2

Four Numbers Summing 30

The Bridge (The Brooklyn Bridge)

Fire Bridge

Love Is God

The Metamorphosis of Norma Jean
 Mortenson

One Indiana Square

X's

X5

USA 666 (2 versions)

Crosses

Demuth American Dream #5

LOVE Cross

Notes

Introduction

1 "People," *Time*, 3 December 1971, 37.

2 Max Kozloff, "'Pop' Culture, Metaphysical Disgust, and the New Vulgarians," *Art International* 6 (March 1962): 35.

3 An important Pop art symposium was held at the Museum of Modern Art; see Peter Selz, et al., "A Symposium on Pop Art," *Arts Magazine*, April 1963, 36-44. For more on the art/not art debate, see Carol Anne Mahsun, *Pop Art and the Critics* (Ann Arbor: U.M.I. Research Press, 1987). Among the first definitive Pop art surveys are Mario Amaya, *Pop Art . . . and After* (New York: Viking, 1966); Lucy Lippard's *Pop Art*, with contributions by Lawrence Alloway, Nancy Marmer, and Nicolas Calas (New York: Praeger, 1965); and John Rublowsky's *Pop Art* (New York: Basic, 1965).

4 See Sam Hunter and John Jacobus, *Modern Art*, 3d ed. (Englewood Cliffs, N.J.: Prentice-Hall, 1992), 305; Irving Sandler, *American Art of the 1960s* (New York: Harper and Row, 1988), 136, 156; and Jonathan Fineberg, *Art Since 1940: Strategies of Being* (Englewood Cliffs, N.J.: Prentice-Hall, 1995), 264.

5 Lippard, *Pop Art*, 69, 122; Nicola Calas and Elena Calas, *Icons and Images of the Sixties* (New York: Dutton, 1971), 139-48; and Amaya, *Pop Art*, 80.

6 Alfred H. Barr, Jr., "Comments by Alfred H. Barr, Jr., Director of Museum Collections; Recent acquisitions: Painting and Sculpture, December 19-February 25, 1962," press release, Museum of Modern Art Archives.

7 Robert L. Tobin, "Robert Indiana," in *Robert Indiana* (Austin: University Art Museum, University of Texas at Austin, 1977), 18.

8 Amaya, *Pop Art*, 80. Gene R. Swenson, "Robert Indiana," *Art News* 63 (Summer 1964): 13.

9 Gene R. Swenson, "The New American Sign Painters," *Art News* 61 (September 1962): 46.

10 See, for example, Richard Kostelanetz, "Words and Images Artfully Intertwined," *Art International*, 14, no. 7 (1970): 44-56; and Richard Kostelanetz, *Imaged Words and Worded Images* (New York: Outerbridge and Dienstfry, 1970).

11 Fred Orton, *Figuring Jasper Johns* (Cambridge: Harvard University Press, 1994), 14.

1
The Making of Autobiography (Robert Clark)

1 Michael Baxandall, *Patterns of Intention: On the Historical Explanation of Pictures* (New Haven: Yale University Press, 1985), 42.

2 Quotations are from Marius Péladeau, "'Love' on a Maine Island," *Historic Preservation*, February 1986, 13; and John Loring, "*Architectural Digest* Visits Robert Indiana," *Architectural Digest*, November 1978, 120.

3 Richard Brown Baker, "Taped Interview with Robert Indiana (September-November 1963)," transcript (Robert Indiana Collection, Archives of American Art, Smithsonian Institution, Washington, D.C.), 17.

4 The point is made by Thomas Crow in "The Children's Hour," *Artforum* 30 (December 1991): 84-88, but it was also made earlier by Allan Kaprow in "Pop Art: Past, Present, and Future," *Malahat Review*, July 1967, 56.

5 Major unpublished interviews are (1) with Richard Brown Baker in 1963 ("Taped Inter-

view"); and (2) with Dr. Arthur C. Carr for a study on the psychological aspects of creativity in 1965 (transcript entitled "The Reminiscence of Robert Indiana" is in the Oral History Research Office, Columbia University). Major published interviews are (1) with Donald Goodall, director of the University of Texas Art Museum, in *Robert Indiana* (Austin: University Art Museum, University of Texas at Austin, 1977); (2) with Barbaralee Diamonstein for a course at the New School for Social Research in 1978 and published in Diamonstein, *Inside New York's Art World* (New York: Rizzoli 1979). Indiana's "Autochronology" appears in John W. McCoubrey, *Robert Indiana: An Introduction* (Philadelphia: Institute of Contemporary Art of the University of Pennsylvania; San Antonio: Marion Koogler McNay Art Institute; and Indianapolis: Herron Museum of Art, 1968). It has been updated in 1977 in the University of Texas catalog cited above; in the catalog, *Robert Indiana: Early Sculpture, 1960-62* (London: Salama-Caro Gallery, 1991); and in *Robert Indiana: Rétrospective 1958-1998* (Nice: Musée d'art moderne et d'art contemporain, 1998).

6 Robert Indiana, interview, Vinalhaven, 5 October 1990. The house later became a Catholic girls' school.

7 "1929," in "Autochronology."

8 Robert Indiana, interviews, Vinalhaven, 26 July and 5 October 1990; Robert Indiana and William Katz, "Twenty-One Houses," album, Robert Indiana, personal archives, Vinalhaven. The project makes an autobiographical contrast to some similar but impersonal publications that came to pass in the sixties, like Ed Ruscha's *Some Los Angeles Apartments* (Los Angeles: Edward Ruscha, 1965).

9 Baker, "Taped Interview," 18.

10 It is "Coffin" in the Baker interview and part of the Carr interviews: Baker, "Taped Interview," 18; Carr, "Reminiscences," 23-24.

11 Indiana, interview, Vinalhaven, 26 July 1990.

12 Indiana, interviews, Vinalhaven, 26 July 1990, 5 October 1990. See the following items in *Life*: 23 November 1936, 28-31; 14 December 1936, 24-27; 28 December 1936, 44-49; 11 March 1940, 70-71.

13 The monument was designed by the German architect Bruno Schmitz and built in 1887-1901 with sculpture by Rudolf Schwarz. Robert Indiana's comment is from interview, Vinalhaven, 5 October 1990.

14 Baker, "Taped Interview," 21.

15 *Arsenal Cannon*, 29 November, 4 October, 24 October 1945.

16 Indiana, interview, Vinalhaven, 10 August 1996; Baker, "Taped Interview," 50, 68-69, 75, 87.

17 Baker, "Taped Interview," 68-69, 75, 87. Also during the service he was posted for a few months at Rome, New York, where he spent off-duty hours in classes at the Utica branch of Syracuse University. He studied Russian there and took an art class at Munson-Williams-Proctor Institute under Oscar Weissbuch, a devotee of the abstract painter Hans Hoffman.

18 Carr, "Reminiscences," 7; Robert L. Tobin, telephone interview, February 1991; Indiana, interview, Vinalhaven, 5 May 1992. The cryptic reference is in the documentary film *Robert Indiana, Portrait*, directed by John Huszar, with David Baily, narrator, music by Virgil Thomson, Huszar Productions, 1973. Indiana told me that Carmen believed that telling children early about their adoption was the best thing to do (interview, Vinalhaven, 4 May 1992).

19 William Katz, interview, New York, 12 February 1990.

20 Carr, "Reminiscences," 8.

21 Arthur C. Carr, "Indiana – The Artist," typescript (Arthur C. Carr Papers, Rare Book and Manuscript Library, Butler Library, Columbia University, New York), 17; Carr, "Reminiscences," 9.

22 Earl Clark, Christmas card to Robert Clark, 16 December 1963, Robert Indiana personal archives, Vinalhaven.

23 Indiana told me that this was an approximate number – he is not sure exactly how many homes there were, though twenty-one is probably close (interview, Vinalhaven, 31 August 1992). Coincidentally, Earl and Carmen were married for exactly twenty-one years.

24 Carr, "Reminiscences," 9.

25 Interview, Vinalhaven, 28 August 1990.

26 Interview, Vinalhaven, 19 July 1990.

27 Tobin, "Robert Indiana," *Robert Indiana*, 17.

28 Vera Berdich, telephone interview, August 1986.

29 Walt Whitman, *Leaves of Grass*, ed. Harold W. Blodgett and Sculley Bradley (New York: Norton, 1965 [1855-92]), 246.

30 Interviews, 26 July 1990, 5 May 1992. Blackshear was a combination artist/art historian and drew the diagrams in Gardner's early editions. See Helen Gardner, *Art Through the Ages: An Introduction to Its History and Significance*, 3d edition (New York: Harcourt, Brace and Company, 1948) – the edition Clark would have used in Blackshear's class; Baker, "Taped Interview," 93.

31 Baker, "Taped Interview," 104.

32 Baker, "Taped Interview," 100. Indiana told Baker that it was at Northwestern, but gallery archives at the Evanston university show no record of such an exhibition.

33 Robert Indiana, "The Route to the Mother of Us All," typescript, Robert Indiana personal archives, Vinalhaven; Robert Indiana, notes to a draft of this chapter, 31 August 1992; Richard Bridgman, *Gertrude Stein in Pieces* (New York: Oxford University Press, 1970), 176-87.

34 Baker, "Taped Interview," 124.

35 Baker, "Taped Interview." 136-37. Clark's first choice was the University of London, but it had filled its quota.

36 Baker, "Taped Interview," 43, 154.

37 Indiana, interview, Vinalhaven, 5 October 1990.

38 Baker, "Taped Interview," 100, 162; Michael Leja, *Reframing Abstract Expressionism: Subjectivity and Painting in the 1940s* (New Haven: Yale University Press, 1993), 113.

39 Indiana, interviews, Vinalhaven, 15 January 1990, 19 July 1990.

40 "José Garcia Villa," *Contemporary Authors* (1977); José Garcia Villa, *Have Come, Am Here* (New York: Viking, 1942). Villa's brother-in-law, Thomas Messer, later became director of the Guggenheim Museum.

41 Indiana also referenced authors who were not gay, like Henry Wadsworth Longfellow. Beyond a handful of explicit connections, it is difficult to determine in what specific ways his homosexuality influenced his art. But see also Michael Plante, "Truth, Friendship, and Love: Sexuality and Tradition in Robert Indiana's Hartley Elegies," in Patricia McDonnell, ed.,

Dictated by Life: Marsden Hartley and Robert Indiana (Minneapolis: Frederick R. Weisman Art Museum, University of Minnesota, 1995). A different approach to Indiana's gay life in Maine is given by the late Paul Taylor, "*LOVE* Story," *Connoisseur* (August 1991):46-51, 94-97.

42 Ernst Kris and Otto Kurz, *Legend, Myth, and Magic in the Image of the Artist: A Historical Experiment* (New Haven: Yale University Press, 1979), 17. This book was based on investigations and findings previously published in German (*Die Legende von Künstler: Ein historicher Versuch* [Vienna: Krystall Verlag, 1934]). Also see Ernst Kris, "The Image of the Artist: A Psychological Study of the Role of Tradition in Ancient Biographies," in *Psychoanalytic Explorations in Art* (New York: International Universities Press, 1952), 64-86.

43 Kris and Kurz, *Legend, Myth, and Magic*, 33-35; Kris, "Image of the Artist," 69-71. Kris draws upon Otto Rank, *Myth of the Birth of the Hero*, Nervous and Mental Disease Monographs 18 (New York: 1913).

44 Phyllis Greenacre, "The Family Romance of the Artist," in *Emotional Growth: Psychoanalytic Studies of the Gifted and a Great Variety of Other Individuals* (New York: International Universities Press, 1971), 2: 522-25. Greenacre found a similar myth pattern in accounts of the lives of her sample group: Thomas Chatterton, Sir Henry Morton Stanley, Gogol, Rilke, and St. Francis of Assisi, all of whom suffered from unsatisfactory childhoods and father images. The need for expansive personal myth resulted for some, like Rilke and St. Francis, in a degree of identification with the family of God, and of themselves as parallel Christs. But all underwent a change of name associated with some sense of rebirth (Chatterton, for example, wrote as a medieval monk named Rowley; orphaned Stanley, born John Rowlands, took the name of the first kind adult who took him in; St. Francis was born Giovanni di Bernardone to a wicked father whom he renounced; and Rilke changed his name from René as he matured as a writer, under the influence of an elder friend). Alongside their acts of self-enhancement, a tendency toward self-denial and sacrifice in the interest of transcendence or altruism emerges in Greenacre's accounts.

45 The statement here is paraphrased from his interview in Diamonstein, *Inside New York's Art World*, 156; Catherine M. Soussloff, *The Absolute Artist: The Historiography of a Concept* (Minneapolis: University of Minnesota Press, 1997), 152.

46 Soussloff, *Absolute Artist*, 154-55.

47 Jacques Lacan, *Séminaire II* (1978), quoted in Shoshana Felman, *Jacques Lacan and the Adventure of Insight: Psychoanalysis in Contemporary Culture* (Cambridge: Harvard University Press, 1987), 129.

48 Carr, "Reminiscences," 141.

49 Quoted in Diamonstein, *Inside New York's Art World*, 156. Picasso, christened Pablo Ruiz y Picasso, has commented on his decision to use only his mother's name; Pierre Cabanne, *Pablo Picasso: His Life and Times*, trans. Harold J. Salemson (New York: Morrow, 1977), 38.

50 Felman, *Jacques Lacan*, 134.

2
Constructing Robert Indiana

1 See Stephanie Barron, "Giving Art History the Slip," *Art in America* (March-April 1974): 80-84; *Nine Artists/Coenties Slip* (New York: Whitney Museum of American Art Downtown Branch, 1974); and Mildred Glimcher, *Indiana, Kelly, Martin, Rosenquist, Youngerman at Coenties Slip* (New York: Pace Gallery, 1993).

2 For example, at Wall and South Streets, once Murray's Wharf, another plaque announces the landing point in 1789 of George Washington on his way to his inauguration in Federal Hall. Indiana best recalls a plaque on Pearl between John and Fulton Streets, marking where Thomas Alva Edison set up the first plant generating electricity in Manhattan. Edison, the artist notes, once worked at the Union Depot in Indianapolis, where he himself had been employed (Indiana, interview, New York, 13 May 1991).

3 Like 61 Whitehall Street; see *New York City Guide*, American Guide Series (New York: Random House, 1939), 81.

4 See Theodore Prudon and Timothy Burditt, "The Coenties Slip Buildings," Historic Structures Report prepared by the Ehrenkrantz Group for New York Landmarks Conservancy, 30 June 1979.

5 Barron, "Giving Art History the Slip," 80-81.

6 Dore Ashton, *The New York School: A Cultural Reckoning* (New York: Viking, 1972), 198.

7 Indiana, interview and tour of Coenties Slip, 13 May 1991; Agnes Martin, telephone interview, 15 April 1991. Indiana was a capable carpenter and handyman, she says, who helped artists, including Kelly and Tawney, renovate their loft spaces. In addition, he did considerable work on his own space at 31 and (after that building was scheduled to be torn down) at 25, where he remained for eight years.

8 This phenomenon was first noticed by Barron, "Giving Art History the Slip," 80-84. Several of the examples I have given were exhibited in the Whitney Downtown Branch exhibition in 1974; see *Nine Artists/Coenties Slip*.

9 Harold Bloom, *A Map of Misreading* (New York: Oxford University Press, 1975), 13.

10 Bloom, *Map of Misreading*, 18-19.

11 It is easy to imagine how Clark may have been fascinated with Eliot's much-quoted dictum from his essay, "The Metaphysical Poets": "The poet must become more and more comprehensive, more allusive, more indirect, in order to force, to dislocate if necessary, language into his meaning." T. S. Eliot, *Selected Essays* (London: Faber and Faber, 1951 [1932]), 289.

12 José Garcia Villa, *Have Come, Am Here* (New York: Viking, 1942), 20.

13 "When the Word Is Love" also shows some affinity with the work of E. E. Cummings, which Clark was reading at the time.

14 Ernst Kris and Otto Kurz, *Legend, Myth, and Magic in the Image of the Artist: A Historical Experiment* (New Haven: Yale University Press, 1979), 20-21.

15 Arthur C. Carr, "Indiana – The Artist," typescript (Arthur C. Carr Papers, Rare Book and Manuscript Library, Butler Library, Columbia University, New York), 10; Indiana, notes to a draft of this chapter, 31 August 1992.

16 Richard Brown Baker, "Taped Interview with Robert Indiana (September-November 1963)," transcript (Robert Indiana Collection, Archives of American Art, Smithsonian Institution, Washington, D.C.), 100. In Edinburgh in 1954, Clark did no painting, only some figure drawing (Baker, "Taped Interview," 149). Touring Italy that spring, he met a London artist named Milein Cosman, with whom he traveled to Paestum. Later, in London, she located a room for him in a Hampstead apartment. There Clark made an easel and began to paint.

17 Indiana, interview, Vinalhaven, 17 May 1991. He must have seen some of Bacon's portraits and Pope Innocent paintings, and perhaps *Three Figures at the Base of a Crucifixion* (1944) at the Tate Gallery. For Bacon on homosexuality in relation to his art, see his interview with Miriam Gross, "Bringing Home the Bacon," *Observer*, 30 November 1980, 31.

18 Robert Indiana, "1955," in "Autochronology," *Robert Indiana* (Austin: University Art Museum, University of Texas at Austin, 1977).

19 Indiana, interview, Vinalhaven, 7 October 1990; Indiana, letter to author, 24 November 1990; Baker, "Taped Interview," 173.

20 Indiana, "1957," in "Autochronology"; Robert Indiana, journal-sketchbook 1959/60, artist's collection, Vinalhaven, Maine. Beginning in 1958 and continuing for several years, Indiana kept his daily journals in large bound folios, in which he combined records of daily activities with notes and sketches for his works. The folios for 1959/60 and 1961/62 combine, on each page, records for both years in each case. Entries in which the artist experienced fears of showing his influences occur throughout the entries for the 1959/60 volume.

21 Baker, "Taped Interview," 173-74.

22 Curvilinear shapes first appeared in sketches and studies, however, while Kelly was still in Paris, as Diane Upright points out in her *Ellsworth Kelly: Works on Paper* (New York: Abrams; Fort Worth: Fort Worth Art Museum, 1987), 19.

23 See Upright, *Ellsworth Kelly*, 194, 200, and plates 83, 84, 134. These plant forms of the fifties and sixties can be contrasted with earlier examples of Kelly plant compositions from Paris, which are much more Matisse-like in appearance, such as the oil-on-wood *Plant II* of 1949, illustrated in Upright, *Ellsworth Kelly*, 8.

24 See Indiana, "1957," in "Autochronology"; see also Baker, "Taped Interview," 175, 177. This dating differs from that of Virginia Mecklenburg, *Wood Works: Constructions by Robert Indiana* (Washington, D.C.: National Museum of American Art-Smithsonian Institution Press, 1984), 13, who does not seem to have taken these sources into account.

25 See Upright, *Ellsworth Kelly*, 9-10.

26 Baker, "Taped Interview," 177. Many of the gingko leaf paintings were done on paper and have since been destroyed (175).

27 In Indiana's journal-sketchbook of 1959-60, on 28 January [1959] he noted "last day at the cathedral" in his journal.

28 Norman Laliberte and Edward N. West, *The History of the Cross* (New York: Macmillan, 1960).

29 Interesting in light of Clark's change of name and later use of words in his "signature style" is an article that Pike had published years before, as a corporate lawyer, entitled "Personal Names as Trade Symbols," *Missouri Law Review*, 3.2 (April 1938): 93-119.

30 The offer came from Harold Rubin and Robert Kayser's Parma Gallery. Indiana, "1958," in "Autochronology"; see also Baker, "Taped Interview," 185.

31 Indiana, interview, Vinalhaven, 27 July 1990. Any formal connection is ruled out, however,

both by appearances and themes of the two works – Grünewald's *Crucifixion*, in the Musée d'Unterlinden, and the others noted in this paragraph are traditional crucifixions scenes with saints, not Christ flanked by thieves.

32 Picasso's *Crucifixion* and sketches for it are in the Musée Picasso, which Clark had visited. His friend David Phillips in London was a Picasso enthusiast. Indiana himself is no slouch on the subject and did a word-portrait of Picasso in 1974. But though inspired by "great" crucifixions, the artist does not recall a specific Picasso (or any other artist's crucifixion) in relation to his mural (telephone interview, 11 June 1991). The Christ flanked by the two thieves type is noted only in passing by Laliberte and West in *The History of the Cross*, 10. As an interpretation of the scene stressing the historical fact of Christ's punishment as a criminal and outsider, *Stavrosis* is thus related to Clark's Skowhegan fresco of Pilate and Judas.

33 The connection between the avocado seed and "Arp's Birth of a Rock" is made in several places in the 1959-60 journal-sketchbook; see, for example, the entry for 28 January 1959. I find no such work by Arp, although ovals and egg-shapes are ubiquitous in his work. On view in the MoMA Arp exhibition and illustrated in several reviews of it were "newborn" stone forms: *Stone Formed by Human Hand* (1937-38) and *Human Concretion* (1935). See Dore Ashton, "Art," *Art and Architecture*, December 1958, 8; and William Rubin, "Month in Review," *Arts Magazine*, November 1958, 49-51.

34 This reading is based on artist's comments delivered in telephone interview, 13 June 1991. The artist grew these plants in his loft.

35 Richard Rambuss, "Homodevotion," in *Cruising the Performative: Interventions into the Repre-* *sentation of Ethnicity, Nationality, and Sexuality*, ed. Sue-Ellen Case, Philip Brett, and Susan Leigh Foster (Bloomington: Indiana University Press, 1995), 78.

36 See E. C. Goossen, *Ellsworth Kelly* (New York: Museum of Modern Art, 1973), 57, 112.

37 The artist has cited his botany course at the University of Edinburgh as pertinent to the genealogy of *Stavrosis* (Indiana, interview, Vinalhaven, 27 July 1990). Kelly was only five years older than Clark but much more experienced as a professional artist.

38 Indiana, journal-sketchbook 1959-60, 8 January [1969], 24 January [1969]. "Sugaï" is probably Kumi Sugaï, a Japanese painter who showed at Samuel Kootz gallery in April, examples of whose work may have been on view or in reproduction earlier. Many of Sugaï's works, like Arp's, and Youngerman's *Naxos*, contain egglike forms. The "New Images of Man" show opened late in 1959. In his journal-sketchbook for 4 March 1960, Indiana notes having received the catalog.

39 John W. McCoubrey, *Robert Indiana: An Introduction* (Philadelphia: Institute of Contemporary Art, University of Pennsylvania, 1968), 9; Indiana, journal-sketchbook, [14 or 16] April [1959?], 181. The four orbs around the doubled avocado seed, at the far right in the mural, symbolize the four gospels (Indiana, telephone interview, 11 June 1991).

40 According to the artist, the term *state* was intended to mean something like "stage," in the sense of a stage of development, and is thus related to the use of the term in printmaking. Used in this way, the individual orb paintings become parts of a larger process or series to which they must be related.

41 Indiana, interview, Vinalhaven, 27 July 1990; Carr, "Indiana," 16-17. To Diamonstein, he said that as a child he learned that the circle symbolized eternal life; Diamonstein, "Robert Indiana," *Inside New York's Art World* (New York: Rizzoli, 1979), 161.

42 For rows of circles, see journal-sketchbook 1959-60, 10 January [1959], 31; [13?] January [1959], 34. Indiana's reaction to first seeing Martin's "circle" paintings is recorded in his journal-sketchbook 1959-60, 12 February [1959], 73. For illustrated examples of Martin's paintings, see Barbara Haskell, *Agnes Martin* (New York: Whitney Museum, 1992).

43 Indiana, journal-sketchbook 1959-60, 16 April [1959], 181. Indiana probably visited Newman's studio the following year; journal-sketchbook 1959-60, 18 July [1960], 273.

44 Indiana, journal-sketchbook 1959-60, 22 April [1959], 215. At French's he would have seen several of Louis's 1954 and 1958 edge-to-edge veils, and at least one with the poured pigment occupying the center of the canvas *(Terrain of Joy)*. See Diane Upright, *Morris Louis: The Complete Paintings* (New York: Abrams, 1985), 61-62 and cat. no. 66.

45 Barnett Newman, "The First Man Was an Artist," *Tiger's Eye*, October 1947, 59-60; journal-sketchbook 1959-60, 22 April [1959], 215.

46 He also taught a seminar at the Minneapolis School of Art in 1962, in connection with his exhibition (with Richard Stankiewicz) at the Walker Art Gallery. Baker, "Taped Interview," 202; Indiana, journal-sketchbook 1959-60, 11 February [1960]; Indiana, telephone interview, 11 June 1991.

There was also a wood-and-nail *Hedgehog*, sketched in January 1960. The *Pumpkin* construction shown in Mecklenburg (*Wood Works*, 18, ill. 19) is a piece resembling the products of Mister Potato Head games popular in the late fifties; it is later and was done privately for a friend's daughter (Indiana, telephone interview, 11 June 1991).

3 Indiana, "1959," in "Autochronology"; Indiana, telephone interview, 11 June 1991.

9 Indiana, journal-sketchbook 1959-60, 15 January [1960], 38.

0 In Edith Sitwell, "American Writing To-Day: Its Independence and Vigour," *Times Literary Supplement*, 17 September 1954, i. In the article Sitwell says that Villa's poem, which she reprints in full (including the closing ellipsis), is otherwise unpublished. The reference was provided by the artist in interview, Vinalhaven, 1 September 1992.

1 Indiana, interview, Vinalhaven, 27 July 1990; Bloom, *Map of Misreading*, 173. See also Bloom, *The Anxiety of Influence: A Theory of Poetry* (London: Oxford, 1973), 8.

2 Baker, "Taped Interview," 186; Indiana says that he cannot recall the name of the chain; Paul Taylor, "*LOVE* Story," *Connoisseur* (August 1991): 94.

3 Indiana, journal-sketchbook, 1959-60, 15 January [1959?], 38.

4 Indiana, journal-sketchbook 1959-60, 15-16 January [1959], 39. Indiana records that he first saw Bergman's film that Friday with a friend and that afterward the two discussed it at a cafe. A notation in his journal-sketchbook 1961-62,

for 10 April [1962], 100, says that the *J* existed previously in pencil.

55 Indiana, journal-sketchbook 1959-60, [no date], 43. This may have been planned as a wall piece and then (because of numbers painted on the back), made into a freestanding construction – the artist is not entirely sure (telephone interview, 11 June 1991).

56 Indiana, journal-sketchbook 1959-60, 18 November [1959].

57 There is a kind of chain of increasingly symbolized and abstracted anthropomorphism running from the *Stavrosis* (which is a "figurative" and "anthropomorphic" work), to the orb paintings that came out of it, and then to the constructions that utilized clusters of orbs, especially the herms. Connolly is mentioned in the artist's notes for *The Sweet Mystery*, Appendix 2. There Indiana connects Palinurus with a friend, who had killed himself shortly before.

58 Cyril Connolly, *The Unquiet Grave: A Word Cycle by Palinurus* (New York: Harper and Brothers, 1945), 146.

59 "Cyril Connolly," *Current Biography*, 1947; Anne Fremantle, "Horizon's Editor," *Commonweal*, 26 July 1946, 387.

60 Connolly, *Unquiet Grave*, 120.

61 W. H. Auden, *The Collected Poetry of W. H. Auden* (New York: Random House, 1945), 290.

62 In the history of self-portraiture this idea is explored by Wendy Stedman Sheard in "Giorgione's Portrait Inventions, c. 1500: Transfixing the Viewer," in *Reconsidering the Renaissance*, Medieval and Early Renaissance Study 93, Mario A. Di Cesare, ed. (Binghamton: Center for Medieval and Early Renaissance Studies, 1992), 141-71.

63 See Jacques Lacan, "The Mirror Stage as Formative of the Function of the I As Revealed in Psychoanalytic Experience," in *Écrits: A Selection*, trans. Alan Sheridan (New York: W. W. Norton, 1977), 2.

64 William Katz, interview, New York City, 12 February 1990.

65 Diamonstein, *Inside New York's Art World*, 157.

66 McCoubrey, *Robert Indiana*, 12. The artist noted one colleague on the slip: "[Mark] di Suvero, who harvested the same fertile demolition sites as Indiana" (notes to a draft of this chapter, 31 August 1992).

67 William Seitz, *The Art of Assemblage* (New York: Museum of Modern Art, 1961), 83-84.

68 Indiana, "1961," in "Autochronology."

69 See Martin Dibner in William A. Farnsworth Library and Art Museum, *Indiana's Indianas* (Rockland: Farnsworth Art Museum, 1982), 5; Carl J. Weinhardt, Jr., in *Robert Indiana* (New York: Abrams, 1990), has likened the herms to "personages in a wax museum sharing an . . . unknown ancestry" (61). Indiana, telephone interview, 11 June 1991.

70 Indiana, telephone interview, 11 June 1991, and interview, Vinalhaven, 1 September 1992. Indiana also remembers a particular giant herm from Roman Egypt, which I have not been able to identify in the Ashmolean listings.

71 Diamonstein, *Inside New York's Art World*, 157.

72 Sources for this account are traced in Walter Burkert, *Homo Necans: The Anthropology of Ancient Greek Sacrificial Ritual and Myth*, trans. Peter Bing (Berkeley: University of California Press, 1983), 165.

73 H. J. Rose, *Primitive Culture in Greece* (New York: George H. Doran, [1925]), 72. For the idea that herms are vestiges of preclassical religion see George Hersey, *The Lost Meaning of Classical Architecture* (Cambridge: MIT Press, 1988); Burkert, *Homo Necans*, 164-65. Also see Karl Kerényi, *Hermes, Guide of Souls: The Mythologem of the Masculine Source of Life* (Dallas: Spring, 1986), 66, 78; and "Herms," *Oxford English Dictionary*, 1989 ed. About the headlessness of Indiana's herms, Mecklenburg also mentions his need to appear different from Marisol, who was doing square wood sculptures topped by portrait heads at this time (*Wood Works*, 43).

74 Kerényi, *Hermes*, 12-14.

75 Kerényi, *Hermes*, 82-84, 86-87.

76 Kerényi, *Hermes*, 88.

77 Weinhardt, *Robert Indiana*, 51; Carr, "Indiana," 2; Appendix 2.

78 Information on *GE* obtained from Indiana, telephone interview, 11 June 1991. *GE* and *Zeus* appear in Indiana, journal-sketchbook 1959-60, 22 September [1960], 467.

79 Mecklenburg says *Soul* "emerged after Indiana had read a philosophical paper describing the soul in terms of a photographic plate that collects impressions" (*Wood Works*, 38). Thus *Soul*, equaling an identity, is a tabula rasa. Indiana says he cannot remember the paper, but it was part of his research for an essay on the soul for his course in social philosophy at the University of Edinburgh (Indiana, telephone interview, 11 June 1991). But the herm *Soul* could also qualify as a critique of the abstract expressionists' rhetoric of the internal core of metaphysical self-identity.

80 Indiana, telephone interview, 11 June 1991. *Sun and Moon* invites comparisons with neighbor Agnes Martin's wood and metal constructions done about the same time (for example, *Burning Tree*; see fig. 2.3, which is also a crown of thorns). Martin, telephone interview, 15 April 1991.

81 Laliberte and West, *History of the Cross*, 30.

82 Donald B. Goodall, Introduction, *Robert Indiana* (Austin: University Art Museum, University of Texas at Austin, 1977), 41.

83 Moira Roth, "The Aesthetic of Indifference," *Artforum* 16 (November 1977): 46-53; Indiana, journal-sketchbook 1959-60, 13 February [1960]. Indiana's friend and neighbor, Rolf Nelson, later owner of the Rolf Nelson Gallery in Los Angeles, at that time worked for Jackson and organized the shows. The second one in the fall included Indiana's herm *GE*.

84 Properly, Cedar Tavern, a hangout for abstract expressionists. Indiana, journal-sketchbook 1961-62, 28 April [1962], 118. He has also said that this herm is named for Alfred H. Barr, Jr. (interview, Vinalhaven, 27 July 1990). In this connection, it commemorates the purchase of the *American Dream* (see Chapter 3) and also moves toward symbolic portraiture.

85 Kenneth E. Silver cites Johns's *5* as a reference to homosexual artist Charles Demuth's painting *I Saw the Figure Five in Gold*. Silver, "Modes of Disclosure: The Construction of Gay Identity and the Rise of Pop Art," in *Hand-Painted Pop: American Art in Transition, 1955-62*, ed. Russell Ferguson (Los Angeles: Museum of Contemporary Art with Rizzoli International, New York, 1993), 186.

86 Indiana, quoted in Carr, "Indiana," 4. One association for the number four, for Indiana, is the allegorical theme the Ten Ages of Man, in which the fourth stage is adolescence, "the most dangerous time of life" (interview, Vinalhaven, 13 November 1991).

87 Indiana, journal-sketchbook 1959-60, 1 September [1960], 457.

88 Indiana, journal-sketchbook 1960-61, 26 June [1961], 177. *Ahab* is noted as renamed, preexisting as *Agnes* [Martin].

89 Jacques Lacan, *The Seminar of Jacques Lacan* book 1, *Freud's Papers on Technique, 1953-54*, ed. Jacques-Alain Miller, trans. John Forrester (New York: Norton, 1991), 81-82. Baker, "Taped Interview," 186.

90 Harold Bloom, *Agon: Towards a Theory of Revisionism*, (New York: Oxford University Press, 1982), 36.

3
Dreaming "American Dreams"

1 Quotations are from Mary Trasko, "The Most American Painter: Robert Indiana," *Indiana Alumni Magazine*, July 1980, 8; and Richard Brown Baker, "Taped Interview with Robert Indiana (September-November 1963)," transcript (Robert Indiana Collection, Archives of American Art, Smithsonian Institution, Washington, D.C.), 179. The artist also told Baker that he did not seek a gallery during 1960 and early 1961 (179). Indiana's journals indicate, however, that he was already preparing a portfolio of photographs of his work in March 1960 and the following April he discussed his work with a Ms. Dewitter of French and Company, to whom he sent photographs in July. Robert Indiana, journal-sketchbook 1959-60, 19 March, 22 April, and 13 July [1960], 156, 215, 271. In

November, Martha Jackson visited his studio preliminary to the first "New Forms, New Media" show; journal-sketchbook 1959-60, 14 November [1960], 464.

Baker, "Taped Interview," 190-91. Ward had spotted a piece by Indiana hanging in the Museum of Modern Art penthouse. She was informed by Campbell Wylly, then selections adviser for MoMA's art lending service, that the artist was not committed to a gallery, and she offered Indiana a solo show in fall 1962. In the meantime, Indiana was invited by Allan Stone to show at his new gallery much sooner, but in a two-man show with James Rosenquist. Both artists declined the offer. Accepting Ward's invitation meant that Indiana had to wait several months, even though new paintings were finished and ready to hang (Baker, "Taped Interview," 190; Judith Goldman, *James Rosenquist* (New York: Viking, 1985), 29.

Baker, "Taped Interview," 183.

Baker, "Taped Interview," 183. The rest were finished in 1963-64 in all white (gesso) lettering. Indiana said that many columns were unfinished because they were intended to have wheels and bases, but they were exhibited without them in his second Stable show (1964) and remained that way for decades.

Journal-sketchbook 1959-60, 17 October [1960], 473. The column is named for Duncan Youngerman; Orange was Ellsworth Kelly's dog, a sort of community mascot; J. is unknown [Jack?]. The inscription continues in red letters: Delphine, Big Red, 60, Ironhorse; and in white: Ells Pier [Ellsworth's pier], New York, U.S. Indiana.

Journal-sketchbook 1959-60, 12 February and 2-3 March [1960], 139; "King Offers Wealth to Rebuild Agadir," *New York Times*, 2 March 1960.

7 Journal-sketchbook 1959-60, 3 March [1960], 139; Robert Indiana, interview, Vinalhaven, 13 November 1991.

8 When MoMA purchased the painting in 1961, it was registered "untitled," but its subject was "The American Dream," and it probably acquired this title shortly after. In 1963, following Dorothy Miller's suggestion, Indiana agreed to formally name the painting *The American Dream #1*, distinguishing it from other paintings in the series that was then under way.

9 Journal-sketchbook 1959-60, 14 July [1960], 271.

10 Walt Whitman, *Leaves of Grass*, ed. Harold W. Blodgett and Sculley Bradley (New York: Norton, 1965 [1855-92]), 5-8. Indiana no doubt felt the last two verses of "Eidólons" to be particularly relevant to his work:

> Thy body permanent,
> The body lurking there within thy body,
> The only purport of the form thou art, the real I myself,
> An image, an eidólon.
>
> Thy very songs not in thy songs,
> No special strains to sing, none for itself,
> But from the whole resulting, rising at last and floating,
> Around full-orb'd eidólon.

11 In 1982 Indiana stated that the amount of black used in these early paintings was due to the fact that he was depressed when he arrived in New York. See William A. Farnsworth Library and Art Museum, *Indiana's Indianas* (Rockland: Farnsworth Library and Art Museum, 1982), 5.

12 Moira Roth, "The Aesthetic of Indifference," *Artforum* 16 (November 1977): 46-53; Jonathan Katz, "Culture and Subculture: On the Social

Utility of Queer Artists in Cold War American Art," paper delivered at the Annual Meeting of the College Art Association, New York, 1991.

13 Indiana, interview, Vinalhaven, 13 November 1991. After exhibition at the Anderson Gallery, the canvas was crushed by a construction in the move back to the studio. It was repaired as the present abbreviated version, commemorating (by Indiana's characteristic concept of significant coincidence) Kennedy's similarly abridged term of office.

14 See Edward Trapunski, *Special When Lit: A Visual and Anecdotal History of Pinball* (Garden City, N.Y.: Doubleday, 1979), 9-10. Indiana has also connected both the dominant yellow (of the orbs in *Ballyhoo*) and the implicit number four (four-part division of both canvases) with caution and danger (thus alternatives to the diagonal danger stripes in other paintings of the group).

15 Baker "Taped Interview," 177; Indiana, interview, Vinalhaven, 13 November 1991; Elizabeth W. Bruss, *Autobiographical Acts: The Changing Nature of A Literary Genre* (Baltimore: Johns Hopkins University Press, 1976), 23. The statement about the meaning of *Terre Haute* was made in an interview with Donald Goodall, "Conversations with Robert Indiana," in *Robert Indiana* (Austin: University Art Museum, University of Texas at Austin, 1977), 30. There, Indiana said that *Terre Haute* was one of his least autobiographical paintings, however, because he had actually never lived in that coal mining and banking center of his midwestern state. It should be noted that explanations of his paintings vary over the years due to changing concerns and situations – and, sometimes, interviewers' personalities – but this inconsistency only underscores the complex nature of the associations.

16 "Terre Haute is where the Wabash River crosses U.S. 40, and U.S. 40 used to be the road that crossed America"; Indiana, interview, Vinalhaven, 13 November 1991.

17 The final scheme was probably arrived at in 1961, when it was exhibited, but in 1962 some of the forms and colors were still being adjusted – the relatively long completion time is characteristic of Indiana's work from this time forward and makes the chronology of his completed works diverge somewhat from the actual progression of his ideas. See journal-sketchbook 1961-62, 10 May [1962], 130.

18 Baker, "Taped Interview," 178.

19 The artist's name was Fred Muhlman. Indiana, interview, Vinalhaven, 13 November 1991. The verse in the painting suggests Herbert's popular operetta, Naughty Marietta (1910), and the first line of the song is "Ah, sweet mystery of life at last I found you." In the last line, the mystery turns out to be "Love and love alone . . . " Indiana, interview, Vinalhaven, 5 August 1996.

20 Journal-sketchbook 1959-60, 1 November [1960], 479; also entry for 15 July [1960]. The artist was still adding coats of color to the canvas in the summer of 1962 – that is, after its first exhibition. See journal-sketchbook 1961-62, 6 June [1962], 157; and 30 August [1962], 242.

21 Journal-sketchbook 1959-60, 2 November [1960], 479.

22 Indiana, interviews, Vinalhaven, 7 October 1990, 13 November 1991.

23 Mae West, Goodness Had Nothing to Do with It (New York: Manor, 1976), 165. Her plays had incurred even more severe censorship. Her play

about homosexuality entitled The Drag (like Sex, also written in 1926 and under the pseudonym Jane Mast) opened only off Broadway and briefly, due to its content. West even served a jail sentence for Sex, for "corrupting the morals of youth, or others." See Jon Tuska, The Films of Mae West (Secaucus, N.J.: Citadel, 1973), 31-36.

24 See Pamela Robertson, "The Kinda Comedy Where They Imitate Me," Guilty Pleasures: Feminist Camp from Mae West to Madonna (Durham, N.C.: Duke University Press, 1996), chapter 1.

25 Indiana interview, Vinalhaven, 9 August 1996.

26 Journal-sketchbook 1959-60, 15 July [1960], 272; 30 October [1960], 477.

27 See S[idney] T[illem], "William Ronald," Arts Magazine 35 (November 1960): 58-59; Indiana, journal-sketchbook 1959-60, 1 November [1960], 478.

28 Baker, "Taped Interview," 187-88.

29 Gene Swenson, "Reviews and Previews: New Names This Month," Art News 60 (May 1961): 20.

30 Harold Bloom, Agon: Towards a Theory of Revisionism (New York: Oxford University Press, 1982), 94-95.

31 The Museum of Modern Art, New York, Department of Painting and Sculpture: Robert Indiana, The American Dream, I, Collection File [Artist's Questionnaire, December 11, 1961].

32 See, for example, Roger C. Sharpe, Pinball! (New York: Dutton, 1977); Trapunski, Special When Lit. The artist has noted that pinball was also a fascination of his own (Indiana, handwritten notes to author's draft, 31 August 1992).

33 The Museum of Modern Art, New York, Department of Painting and Sculpture: Robert Indiana Collection File [Artist's Questionnaire].

34 Goodall, "Conversations with Robert Indiana," 2

35 Indiana, interview, Vinalhaven, 13 January 19 Virginia Mecklenburg says that Indiana's paint ing related directly to the play "written by his friend Edward Albee." Mecklenburg, Wood Wor Constructions by Robert Indiana (Washington, D.C: National Museum of American Art, Smith sonian Institution, 1984), 31. I find no substan ation for this suggestion of friendship, and the artist himself has stated otherwise (interview, Vinalhaven, 27 July 1990).

36 Even the opening night review by Howard Taubman in the New York Times pointed out about the Young Man: "Evidently this figure is full of private meaning for Mr. Albee" (25 January 1961).

37 Goodall, "Conversations with Robert Indiana," 2

38 Edward Albee, Preface, The American Dream: A Play by Edward Albee (New York: Coward-McCann, 1961), 8. Albee signed his preface 24 May 1961, at which time Indiana's painting wa first being exhibited.

39 Indiana, interview, Vinalhaven, 3 August 1996

40 Charles S. Krohn and Julian N. Wasserman, "An Interview with Edward Albee," in Edward Albee: An Interview and Essays, ed. Wasserma (Houston: University of St. Thomas, Lee Lectu Series, 1983), 19; Julian N. Wasserman, "'The Pitfalls of Drama': The Idea of Language in th Plays of Edward Albee," in Wasserman, Edwar Albee, 41.

41 Indiana, interview, Vinalhaven, 3 August 1996. Albee, American Dream, 37; Richard E. Amache Edward Albee (New York: Twayne, 1969), 37, who also cites William Flanagan, "Albee in the Village," New York Herald Tribune, 27 Octobe 1963.

2 Coincidentally, West's swan song, when she was in her seventies, was a role in a film about a female impersonator, in the screen version of Gore Vidal's *Myra Breckinridge* (1970). Notably, as a champion of homosexuals all her life, West in the fifties was a heroine of the gay culture, especially in New York. For her one-liners, see Tuska, *Films of Mae West*, 84.

3 The quotations are from, respectively, *Night After Night*, *She Done Him Wrong*, and *I'm No Angel*.

4 Camille Paglia, *Sexual Personae: Art and Decadence from Nefertiti to Emily Dickinson* (New Haven: Yale University Press, 1990), 539. Recall that Wilde, and this play in particular, were important for Indiana.

5 Farnsworth Library and Art Museum, *Indiana's Indianas*, 5.

6 As in Tocqueville's discussion of individualism and self-improvement in *Democracy in America*, ed. Phillips Bradley (New York: Vintage, 1945 [1835]), 2: 258.

7 G. Thomas Couser, *Altered Egos: Authority in American Autobiography* (New York: Oxford University Press, 1989), 47. Franklin's *Autobiography* was certainly influential: in 1828, when young Thomas Mellon read it, he abandoned the idea of farming; later he founded a banking dynasty.

8 See Irvin G. Wyllie, *The Self-Made Man in America: The Myth of Rags to Riches* (New York: Free Press, 1966 [1954]); Charles R. Hearn, *The American Dream in the Great Depression* (Westport, Conn.: Greenwood, 1977), 8.

9 Wyllie, *Self-Made Man*, 10-19. Richard Amacher's popular monograph, *Edward Albee*, begins, "The life of Edward Albee reads like a Horatio Alger story."

50 See James Truslow Adams, *The Epic of America* (Boston: Little, Brown, 1931), 405; Anthony Brandt, "The American Dream," *American Heritage* 32 (April-May 1981): 24-25; Meriam-Webster Language Research Service, letter to author, 10 September 1991.

51 Indiana, interview, Vinalhaven, 4 August 1996; Hearn, *American Dream*, chapter 4.

52 Hearn, *American Dream*, 111-12.

53 Meriam-Webster Language Research Service, letter to author, 10 September 1991.

54 Archibald MacLeish, "The National Purpose," *New York Times*, 30 May 1960.

55 Among those taking on Indiana's and Albee's title is Raymond Saunders, with his *American Dream* collage of 1968 in the collection of Mount Holyoke College.

56 Sidney Tillim, "Month in Review," *Arts Magazine* 36 (February 1962): 34.

57 Tillim compared Indiana's MoMA statement to that of the prodigal's return (to the "old" American Dream), "concealed in the radical but pat language of protest" (34); he called the painting itself a "work that does not transcend its own rationalizations" (35), "a smart-alecky ode to a pinball machine" (37).

58 Max Kozloff, "New York Letter," *Art International* 6 (March 1962): 57-65.

59 For a complete history of the emergence and critical reception of Pop art in America, see Steven Henry Madoff, ed., *Pop Art: A Critical History* (Berkeley: University of California Press, 1997); Carol Anne Mahsun, *Pop Art and the Critics* (Ann Arbor: UMI Research Press, 1987); and Cécile Whiting, *A Taste for Pop: Pop Art, Gender, and Consumer Culture* (New York: Cambridge University Press, 1997). Also helpful

are the chapters on Pop art in Barbara Haskell, *Blam! The Explosion of Pop, Minimalism, and Performance, 1958-1964* (New York: Whitney Museum of American Art, 1984); and Irving Sandler, *American Art of the 1960s* (New York: Harper and Row, 1988).

60 Gene Swenson, "The New American Sign Painters," *Art News* 61 (September 1962): 45-47, 61-62; review of Indiana's Stable show by Emily Genauer, "One for the Road Signs," *New York Herald Tribune*, 21 October 1962. There were precedents for this device. Rauschenburg had used road signs in his assemblages (like *Black Market*, 1961, the permanent part of which contains a one-way sign). And before that, in March 1954 (when Indiana was in Scotland) MoMA presented an exhibition entitled "Signs in the Street," containing actual signs and photographs of them. Alloway cited interest in signs as part of the move toward abstraction characteristic of second-phase Pop art in England, though few British artists seemed to be interested in signs per se. See Lawrence Alloway, "The Development of British Pop," in Lucy Lippard, *Pop Art* (New York: Praeger, 1966), 47.

61 Peter Selz et al., "A Symposium on Pop Art," *Arts Magazine* 37 (April 1963): 40.

62 Mahsun, "Audience Participation as Liberating Praxis," in *Pop Art and the Critics*, 81-82.

63 Allan Kaprow, "Pop Art: Past, Present, and Future," *Malahat Review*, July 1967, 56, 61.

64 Max Kozloff, "American Painting During the Cold War," *Artforum* 11 (May 1973): 52. Indiana's *French Atomic Bomb*, his first herm exhibited at Martha Jackson's, was labeled "Untitled" in the show – its real title was thought to be too agitative.

65 Kaprow, "Pop Art," 63.

66 Gene Swenson, "What Is Pop Art?" *Art News*
62 (November 1963): 24-27, 60-64; and 62
(February 1964): 40-43, 62-66. Of the group,
these two artists also had in common their
admissions that their work is autobiographic.
See Warhol's comment relating to the source of
the Campbell's Soup image, in his own lunches:
"someone said my life has dominated me. I
liked that idea." For Warhol as autobiographic
artist, see Pat Smith, "Art in Extremis: Andy
Warhol and His Art," Ph.D. diss., Northwestern
University, 1982, 229-38.

67 Indiana, interview, Vinalhaven, 28 August 1989.
The long tradition of pattern poetry is examined
most closely perhaps by Dick Higgins in *Pattern
Poetry: Guide to an Unknown Literature*
(Albany: State University of New York Press,
1987). Higgins prefers to use the term for pre-
twentieth-century forms, since related modern
labels (concrete poetry, *poesia visiva*, *parole in
libertà*, and so on) are so abundant and well-
defined (3). He provides a broadly applicable
rule, however, for distinguishing pattern poetry
of any period from shaped prose: its affinity
with music (206). In his statement on the paint-
ing *The Sweet Mystery*, Indiana makes clear his
own association between his word/symbol com-
positions and music (Appendix 2). See also
Johanna Drucker, *Figuring the Word: Essays on
Books, Writing, and Visual Poetics* (New York:
Granary, 1998).

68 Except *Ballyhoo*, in which purple is added.

69 John Coplans, *Serial Imagery* (New York:
New York Graphic Society in Association with
Pasadena Art Museum, 1968), 7-20.

70 Benjamin's essay is in *Illuminations*, ed. Hannah
Arendt, trans. Harry Zohn (New York: Schocken,
1969 [1936]); Swenson, "What Is Pop Art?" 26.

71 Or publicity and death, a topic discussed by
Jonathan Flatley in "Warhol Gives Good Face:
Publicity and the Politics of Prosopopoeia," *Pop
Out: Queer Warhol*, ed. Jennifer Doyle et al.
(Durham, N.C.: Duke University Press, 1996),
101-34. For Freud on repetition see *Beyond the
Pleasure Principle* (1920), in James Strachey,
trans., *The Standard Edition of the Complete
Psychological Works of Sigmund Freud*, 18 (Lon-
don: Hogarth, 1955), 14-17, 29-36.

72 Jacques Lacan, "Function and Field of Speech
and Language," in *Écrits: A Selection*, trans.
Alan Sheridan (New York: Norton 1977), 102-4.

73 Harold Bloom, *A Map of Misreading* (New York:
Oxford University Press, 1975), 59.

74 Bloom, *Agon*, 98.

75 Gertrude Stein, *The Making of Americans:
Being a History of a Family's Progress* (1925;
New York: Harcourt, Brace, 1934).

76 Gertrude Stein, *Lectures in America* (Boston:
Beacon, 1985 [1935]), 167-77. Wendy Steiner
discusses the influence of photography and cin-
ema, mechanical reproduction techniques, and
public images on both Stein and Pop artists
Warhol and Lichtenstein in an introduction to
the edition, xiii.

77 Norman N. Holland, *The Dynamics of Literary
Response* (New York: Columbia University Press,
1968), 145-48. See also Gilbert J. Rose, *The
Power of Form: A Psychoanalytic Approach to
Aesthetic Form*, Psychological Issues Monograph
49 (New York: International Universities Press,
1980), 8-9, 140-43.

4
"Verbal-Visual"

1 It was a two-man show with Robert Natkin
(a former SAIC classmate of Indiana's), arranged
by Ruth Kaufman at the Stubbing and
Greenfield Gallery, 132 Mamaroneck Avenue,
24 March-14 April 1962. The exhibition is not
mentioned in the exhibition list of Peter Fuller
monograph *Robert Natkin* (New York: Abrams
1981). It is verified, however, by many notes in
Indiana's journal-sketchbooks. The paintings
were square or near-square portrait (vertical)
rectangles, averaging between 8 by 10 inches
and 12 by 12. The whereabouts of some of these
paintings is unknown.

2 Gertrude Stein, *Everybody's Autobiography*
(New York: Random House, 1937), 113-14.
William Katz, "Polychrome Polygonals: Robert
Indiana's New American Geometry," in *Robert
Indiana* (Austin: University Art Museum,
University of Texas at Austin, 1977), 20. A few
of the small paintings were not word-abstrac-
tions but rather words for concrete things or
names: *DICK*, for example, was a canvas with
a five-pointed star above this nickname for a
friend of Indiana's, the British painter Richard
Smith. It might be construed as a single-word
portrait. Other paintings included *GOG, LIP*
and *BANG* (1961), and *PET* (1962). Indiana,
work records, Star of Hope, Vinalhaven.

3 Sigmund Freud, *The Interpretation of Dreams*,
in James Strachey, trans., *The Standard Edition
of the Complete Psychological Works of Sigmund
Freud*, 4 and 5 (London: Hogarth, 1953). In his
chapter on dream-work, Freud discusses these
two primary psychic processes. He describes
condensation as the representation of many

ideas and feelings in a reductive or single form or symbol and *displacement* as the transference of meaning from a directly associated, highly charged form to a form or symbol not intensely charged. André Breton quoted in Judi Freeman, *The Dada and Surrealist Word-Image* (Los Angeles: Los Angeles County Museum of Art; Cambridge: MIT Press, 1989), 38.

On Magritte see Martha Wolfenstein, "The Image of the Lost Parent," *The Psychoanalytic Study of the Child* 28 (1973): 433-56; Ellen Handler Spitz, *Museums of the Mind: Magritte's Labyrinth and Other Essays in the Arts* (New Haven: Yale University Press, 1994), 47. See also William G. Niederland, "Clinical Aspects of Creativity," *American Imago* 25, no. 1-2 (1967): 9-10. Indiana was adopted so early that one might question whether he experienced any sense of maternal loss. Niederland's article, however, really zeros in on the potential of childhood injury or illness to influence creativity – Robert Clark's early bout with lung disease may be relevant here.

The Magritte influence was via Janis's exhibition "Les Mots et les choses" in 1954. See Roberta Bernstein, *Jasper Johns' Paintings and Sculptures, 1954-74: The Changing Focus of the Eye* (Ann Arbor: UMI Research Press, 1985), 3, 38-39, 60-68; Ronald Paulson, *Figure and Abstraction in Contemporary Painting* (New Brunswick, N.J.: Rutgers University Press, 1990), 232-35; Fred Orton, *Figuring Jasper Johns* (Cambridge: Harvard University Press, 1994), 83-86. In *Making and Effacing Art: Modern American Art in a Culture of Museums* (New York: Oxford University Press, 1991), 69-85, Philip Fisher discusses the rivalry between the paint and the word in holding viewer attention.

6 Fisher, *Making and Effacing Art*, 74; Roland Barthes, "That Old Thing, Art . . .," in *The Responsibility of Forms: Critical Essays on Music, Art, and Representation*, trans. Richard Howard (New York: Hill and Wang, 1985), 203.

7 I use the term in the sense discussed by Roman Jakobson in his "Closing Statement: Linguistics and Poetics," in *Semiotics: An Introductory Anthology*, ed. Robert E. Innis (Bloomington: Indiana University Press, 1985), 164-65.

8 Charles Peirce, "Logic as Semiotic: The Theory of Signs," in *The Philosophy of Peirce: Selected Writings*, ed. J. Buchler (London: Routledge and Kegan Paul, 1940), 98-119. See also Norman Bryson, *Vision and Painting: The Logic of the Gaze* (New Haven: Yale University Press, 1983), 52.

9 The subject-viewer distance has a strong psychological parallel in the period between infancy and childhood. Gilbert Rose states, "The ongoing interplay between an artwork and viewer is like the balancing of closeness with distance, the child's 'shadowing' and darting away from mother characteristic of the rapprochement subphase"; see "Some Aspects of Aesthetics in the Light of the Rapprochement Subphase," in *Rapprochement: The Critical Subphase of Separation-Individuation*, ed. Ruth F. Lax, Sheldon Bach, and J. Alexis Burland (New York: Jason Aronson, 1980), 354. For other references see Ellen Handler Spitz, *Art and Psyche: A Study in Psychoanalysis and Aesthetics* (New Haven: Yale University Press, 1985), 18, 23.

10 Among events he recorded seeing was Jim Dine's *Car Crash* at the Reuben Gallery (Robert Indiana, journal-sketchbook 1959-60, 1 November [1960], 478). Indiana can clearly be seen in the audience, in photographs of that performance, as in Barbara Haskell, *Blam! The Explosion of Pop, Minimalism, and Performance, 1958-1964* (New York: Whitney Museum of American Art in association with Norton, 1984), fig. 41.

11 Indiana has stated that the *Melville Triptych* plus *Ahab* was his "first *conscious* application of the idea to pair herms and paintings" (interview, Vinalhaven, 27 July 1990). Again, speaking at the National Museum of American Art, Smithsonian Institution, on the occasion of his construction exhibition there (and the installation of the herm *Five*, 1983, with the painting *The Figure Five*, 1963), he said that at one time he planned that each painting, or at least many of them, would have a herm or sculptural companion (taped lecture dated 3 May 1984, Robert Indiana collection, Archives of American Art, Smithsonian Institution). The ensemble *Ahab* and *The Melville Triptych* was shown in the early 1970s at the Denise René Gallery and published as an illustration in Schleswig-Holsteinischen Landesmuseum, *Illustrationen zu Melville's Moby-Dick* (Schleswig: Schleswig-Holsteinischen Landesmuseum, 1976), 187.

12 Indiana, interview, Vinalhaven, 27 July 1990. Not surprisingly, beginning in the early to mid-sixties, psychologists began to explore the two-way nature of the aesthetic experience, requiring an active process on the part of the audience as cocreator, or the acceptance of unplanned aspects in the work on the part of the artist. See, for example, Joanna Field (pseudonym for Marion Milner), *On Not Being Able to Paint*, New Library of Psychoanalysis, no. 3 (Los Angeles: Jeremy P. Tarcher, 1957); Marion Milner, "Winnicott and the Two-Way Journey (1972)," in *The Suppressed Madness of Sane*

Men: Forty-Four Years of Exploring Psycho-analysis (New York: Tavestock, 1987), 246-52. See also Rose, "Some Aspects," 356.

13 In particular see Jakobson's "Closing Statement." See also J. L. Austin, *How to Do Things with Words* (New York: Oxford University Press, 1962), and John R. Searle, *Speech Acts: An Essay in the Philosophy of Language* (Cambridge: Cambridge University Press, 1969).

14 A third category, harder to pin down, comprises perlocutionary acts, statements that actually demonstrate an accomplishment of action in the saying: for example, "I persuaded him to go away." Illocutionary force arises from the will of the speaker and is normally transmitted through a variety of devices such as word order, stress, intonation or punctuation, accompaniments and circumstances of an utterance (including visual signs), and so on (Searle, *Speech Acts*, 30). It would seem that illocutionary force would have to have a psychological wellspring. In one place, however Searle speaks of "force" as a metaphor (70). Austin never really defines the term.

15 See Richard Brown Baker, "Taped Interview with Robert Indiana (October-November 1963)," transcript (Robert Indiana Collection, Archives of American Art, Smithsonian Institution, Washington, D.C.), 30.

16 Baker may have been referring, for example, to Johns's *Tango* (1955), which plays music.

17 Baker, "Taped Interview," 29-31. It is interesting to note in this connection (though any influence would be impossible to prove) that Jasper Johns said that his initial idea for *Target with Plaster Casts* was that the body casts would somehow be movable parts behind the target and would emit sound (see, for example, his interview with Emile de Antonio in the film *Painters Painting*, 1972).

18 Journal-sketchbook 1959-60, 16 May [1960].

19 See editors' notes to "Year of Meteors," in Walt Whitman, *Leaves of Grass*, ed. Harold W. Blodgett and Sculley Bradley (New York: Norton, 1965), 238-39.

20 The importance of quotation marks, especially to evoke a figurative mood, is pointed out in Dan Sperber, *Rethinking Symbolism*, trans. Alice L. Morton (New York: Cambridge University Press, 1974), 104-13. However, Sperber distinguishes between figures and expressions of true belief (following Jakobson and Tzvetan Todorov), because figures emphasize language itself more than the thought behind it. I use Sperber's ideas about quotation marks but disagree with his restriction of figurative language.

21 Quentin Anderson, *The Imperial Self: An Essay in American Literary and Cultural History* (New York: Alfred A. Knopf, 1971). The quotation is from pages 15-16. The phrase from *Hiawatha* in *Calumet* is, properly speaking, history and thus descriptive, not illocutionary, but it could enter that category under speech act theory by means of its context – that is, that the Indian leader was telling his story in order to have a strong effect on his people. Moreover, the phrase from *Year of Meteors* possesses additional emotive and sexually evocative force.

22 Indiana made up the verse in the second painting: "He is a blossom / He is a root / He is a stamen / He is a pistil."

23 The note reads: "cat pissed on catalogue of Arensberg collection that I have from Chicago days (1949 – May 1st, great show at the art institute, in fact it began the month I enrolled in its school) and [I] noted that the Brancusi 'Torso of a Young Man,' besides other things, is directly

parallel to my 'Coenties Slip' form." The diagram below this is labeled, "Brancusi's Terminals" (journal-sketchbook 1961-62, 8 June [1962], 159). The catalog is *Twentieth-Century Art from the Louise and Walter Arensberg Collection* (Chicago: Art Institute of Chicago, 1949), and the reference is to fig. 17.

24 This is a phrase that occurs throughout her work as in *The Geographical History of America: Or the Relation of Nature to the Human Mind* (New York: Random House, 1936), 146; see also Allegra Stewart, *Gertrude Stein and the Present* (Cambridge: Harvard University Press, 1967), chapter 2.

25 Gertrude Stein writes in *The Making of Americans*: "Loving repeating is one way of being." The kaleidoscope reference is from *The Autobiography of Alice B. Toklas*: "But to return to the beginning of my life in Paris. It was based upon the rue de Fleurus and the Saturday evenings and it was like a kaleidoscope slowly turning." Both in *Selected Writings of Gertrude Stein*, ed. Carl Van Vechten (New York: Vintage, 1990), 84, 264.

26 In his analysis of one of Indiana's dreams in which *The Calumet* appeared, Arthur C. Carr suggested that "Calumet," which means peace pipe, and Pukwana, brotherhood, may be (homo)sexual references that represent "denial of the wish to fuse with the mother-figure." Carr, "Indiana – The Artist," typescript (Arthur C. Carr Papers, Rare Book and Manuscript Library, Butler Library, Columbia University, New York), 17.

27 Gene Swenson, "Robert Indiana," *Art News* 61 (October 1962): 14; the critic who gave the painting highest rating is Michael Fried, "New York Letter," *Art International* 6, no. 9 (November 1962): 55.

Journal-sketchbook, 10 January [1962], 10. There were at least Red, Green, and Brown County paintings at one point. In fact, the state has no Red County, only Greene, Orange, and Brown Counties. The artist says that the series grew as much from his desire for color variations as to commemorate Indiana places (interview, Vinalhaven, 14 November 1991). Brown County was the location of the state's art colony and a branch of Clark's family, so it had specific importance in the artist's autobiography. The painting connected with that county was done in raw sienna in 1960; its whereabouts are unknown.

Lawrence Alloway, "Notes in Five New York Painters," *Buffalo Fine Arts Academy and Albright-Knox Art Gallery, Gallery Notes* (Autumn 1963): 16.

See José Garcia Villa, *Selected Poems and New*, introduction by Dame Edith Sitwell (New York: McDowell, Obolensky, 1958). The central comma even suggests the third eye that Villa sometimes painted between his own. Indiana, work records, Star of Hope, Vinalhaven.

Herman Melville, *Moby Dick: Or, The White Whale* (New York: New American Library, 1961), 479.

2 The number was arrived at from Indiana's work records, Star of Hope, Vinalhaven. After his Stable premiere in 1962 his production of constructions halted and he concentrated on painting.

3 Dorothy Miller selected Indiana's work before that of most of the other artists on her visit to the Coenties Slip studio on 4 April 1962 (jour-nal-sketchbook 1961-62, 4 April [1962], 97). Indiana was also included in the "Formalists" exhibition at the Washington Gallery of Modern Art, 1963. Gene Baro, "Gathering of Americans," *Arts Magazine*, September 1963, 31. Fried, "New York Letter," 55. Indiana's major museum show of the period, a two-man with "junk" sculptor Richard Stankiewicz at Minneapolis's Walker Art Museum in fall 1963, did nothing to clarify Indiana's position within an increasingly category-driven critical field.

34 Indiana, telephone interview, February 1992; Ninette Lyon, *Vogue*, March 1965, 184-86. Indiana relates that the theme, "Eat," was his idea but agreed upon by the two men (and of course serves as a filmic portrait of Indiana by Warhol). The day of the shoot, Indiana had assembled a full table inspired by the popular film *Tom Jones* (1962), which he had just seen. Warhol, however, selected just one mushroom, saying, "Make it last" (Indiana, telephone interview, February 1992). Gerard Malanga, telephone interview, 10 February 1992, and Indiana interview, Vinalhaven, August 1996.

35 Indiana, interview, Vinalhaven, 28 August 1991. In the statement "Mother and Father," Appendix 2, the *Black Diamond American Dream #2* has a connection with Carmen's trip to the Chicago trial of her half-sister Ruby, who murdered Carmen's stepmother. Of course, red in that painting, or in the #3, could allude to the "color" names of Carmen (carmine) and/or Ruby.

36 For *juke* see *Oxford English Dictionary*, 1989 ed. The artist said that he came across this aspect of the word while reading Tennessee Williams, but the specific reference remains unknown; for *jack* see Paul Beale, *A Concise Dictionary of Slang and Unconventional English*, from Eric Partridge, *A Dictionary of Slang and Unconventional Eng-lish* (New York: Macmillan, 1989), 234-35. Indiana, interviews, Vinalhaven, 4 May 1992, 9 August 1996.

37 According to Indiana, properly speaking all five Demuth Five paintings *are* the "Fifth Dream," making the Dreams a complex series that intersects and combines with additional series. Six "Sixth Dream" paintings were also planned, but only two were completed. Indiana, interview, Vinalhaven, 5 May 1992.

38 Mario Amaya, *Pop Art . . . and After* (New York: Viking, 1965), 79.

39 Harold Bloom, *Agon: Towards a Theory of Revisionism* (New York: Oxford University Press, 1982), 184.

40 Emily Genauer: "[Indiana's work] manages to be almost romantic . . . in the way that heraldry can be romantic, with each word or shape summoning poetic associations" ("One for the Road Signs," *New York Herald Tribune*, 21 October 1962). A few exceptional mandala paintings have no bottom legend, and the great circle is positioned midway or lower in the slightly vertical canvas (for example, *Highball on the Redball Manifest* and *The American Gas Works*).

41 Most of them are gothic-style, but some of them are roman type.

42 "[My] literary paintings are not removed from the American dream," he has commented, "and each of our writers had his own dream." Indiana, interview, Vinalhaven, 28 August 1989.

43 Virginia Mecklenburg, *Wood Works: Constructions by Robert Indiana* (Washington, D.C: National Museum of American Art, Smithsonian Institution Press, 1984), 29. The quotation is from

Richard Stankiewicz; Robert Indiana (Minneapolis: Walker Art Center, 1963); see Appendix 2. Melville's novel begins: "Call me Ishmael. Some years ago – never mind how long precisely – having little or no money in my purse, and nothing particular to interest me on shore, I thought I would sail about a little and see the watery part of the world."

44 William Carlos Williams, *The Collected Earlier Poems of William Carlos Williams* (Norfolk, Conn.: New Directions, 1951 [1938]), 230.

45 A fourth Brooklyn Bridge canvas in the artist's possession has never been completed. Indiana, interview, August 1996. Stella's painting, like Demuth's, is in the Metropolitan Museum of Art. The year before, 1963, Johns also did a painting that referred to the same poet, *Periscope (Hart Crane).* The reference to a periscope is taken from a passage in Crane's "Cape Hatteras." Another Johns work, *Diver,* of 1962, is a reference to Crane's suicide, when the poet vaulted off the deck of a steamship on the way home from Mexico. One further note: because Kelly also did a series of Brooklyn Bridge paintings, Indiana's Bridge paintings in this sense are (again) "corrected Kellys."

46 Hart Crane, *The Bridge, The Poems of Hart Crane,* ed. Marc Simon (New York: Liveright, 1986), 43-44. The lines do not form a connected passage in the poem but come from different parts of it. The artist has said that they were lines chosen to fit a certain space (interview, August 1996). In the first line (top panel) Indiana edited Crane by writing "thy arms" in place of the latter's "thine" (pointed out to me by Professor Laurence Goldstein), possibly an adjustment for visual reasons. It is easy to believe that these lines of Crane's embodied the crux of Indiana's own feelings toward the bridge.

47 Indiana, quoted in *Art in Progress: The Visual Development of a Painting* (New York: Finch College Museum of Art, 1975), n.p.

48 Katz, "Polychrome Polygonals," 20.

49 Robert Indiana, telephone interview, 20 February 1992.

50 All information about his involvement with *The Rebecca* furnished by Indiana in telephone interview, 20 February 1992, and Baker, "Taped Interview," 28. Indiana says he first read about the *Rebecca* in *American Heritage* magazine, probably the article by J. C. Furnas, "Patrolling the Middle Passage," *American Heritage: The Magazine of History* 9, no. 6 (October 1958): 4-9, 101-2.

51 Gene Swenson, "Robert Indiana," *Art News* 61 (October 1962): 14.

52 Gene Swenson, "The Horizons of Robert Indiana," *Art News* 65 (May 1966): 60. In 1981, of course, Ronald Reagan became the first divorcé to enter the oval office. Comments about *The President* are made in Carr, "Indiana," 38. In fact, not only was Earl Clark divorced before marrying Carmen, but he divorced her during Indiana's childhood and married yet a third time.

53 Baker, "Taped Interview," 3; Joan Adams Mondale, *Politics in Art* (Minneapolis: Lerner, 1972), 71.

54 Norman Laliberte and Edward N. West, *The History of the Cross* (New York: Macmillan, 1960), 60; Rudolf Koch, *The Book of Signs,* trans. Dyvyan Holland (New York: Dover, 1955 [1930]), 16 – this is the particular symbol reference that Indiana owned and consulted (Baker, "Taped

Interview," 5). He told Baker, "By adopting the Biblical language of Yield Brother, . . . I bring this up to a question of Christian ethics."

55 Baker, "Taped Interview," 3, and Indiana, interview, Vinalhaven, 5 November 1992. North is a phallic position of the compass. In Indiana's Work Records (Star of Hope, Vinalhaven), *Yield Brother #2* is listed as "Dedicated to the President," although the exact connection with Kennedy, or to his assassination that year, is unknown.

56 Blue-green-and-orange *Yield* number two and yellow-and-black number three are single diamond canvases; red-and-yellow number four is a grouping of four small diamond canvases. Later (1966) Indiana did a series of small "Yield Brother" portraits, which combine the mandala formula and Polaris sign with names of acquaintances like Virgil Thomson, whose musical portrait of Indiana *(Edges)* was composed the same year. All these paintings were given as gifts to their subjects, foreshadowing his "giving away" of *LOVE* (see Chapter 6).

57 According to his own report in a 17 November 1965 interview with Carr, Indiana worked on maps of Alaska for defense projects while he was in the air force ("The Reminiscences of Robert Indiana," transcript, Oral History Research Office, Columbia University, New York). Of course, Jasper Johns also produced paintings based on complete U.S. maps in the sixties. Again, for Johns the map is another preexisting flat object and a vehicle for ideas about scale and measurement in the worlds of reality and painting. It is nonideologic, impersonal, and neutral, and thus the opposite of Indiana's state shapes in the Confederacy series. In Indiana's account, an old roadmap dictated the unusual pink color of the target state in all four

paintings of the series. That color, however, in conjunction with the association of "hind part," has its own visual logic (Indiana, interview, Vinalhaven, 13 November 1991).

8 Sidra Stich, *Made in USA: An Americanization in Modern Art* (Berkeley: University of California Press, 1987), 191; see also Dean Sobel's discussion of *Alabama* in "Words as Socio-Political Commentary," *Word as Image* (Milwaukee: Milwaukee Art Museum, 1990), 130. Indiana has often mentioned Burma-Shave ads as a kind of popular poetry, as in the statement, "USA 666" (see Appendix 2). See also Frank Rowsome, Jr., *The Verse by the Side of the Road: The Story of the Burma-Shave Signs and Jingles* (Brattleboro: Stephen Greene, 1965).

9 Indiana acknowledges this connection in Barbaralee Diamonstein, *Inside New York's Art World* (New York: Rizzoli, 1979), 21-23.

10 Indiana quotation is from Donald Goodall, "Conversations with Robert Indiana," in *Robert Indiana*, 40. The print was a gift to Indiana from Matt Wysocki of the Hopkins Center, Dartmouth University, in 1969, when Indiana was a summer visiting artist there. But the artist says that he had seen versions of it long before. The "Ten Ages of Man," associated with the metaphor of the "steps of life" is the latest variant of the "ages of man" theme to appear in art – in the sixteenth century. Such allegories, of course, personify numbers. And in "ten steps," the figures customarily occupy places on a bridge (a coincidental connection to Indiana's Bridge series). See Elizabeth Sears, *The Ages of Man: Medieval Interpretations of the Life Cycle* (Princeton: Princeton University Press, 1986).

61 Gertrude Stein, "Poetry and Grammar," *Lectures in America* (Boston: Beacon, 1985 [1935]), 227, quoted by Wendy Steiner, *Exact Resemblance to Exact Resemblance: The Literary Portraiture of Gertrude Stein* (New Haven: Yale University Press, 1978), 179.

62 Sigmund Freud, *Jokes and Their Relation to the Unconscious* (1905), SE 8 (1960), 128. See also *Beyond the Pleasure Principle* in SE 18 (1961 [1955]): 35.

63 Stein, *Everybody's Autobiography*, quoted in Steiner, *Exact Resemblance*, 180.

64 Gertrude Stein, *Alphabets and Birthdays* (New Haven: Yale University Press, 1957); quoted phrase is from p. 132. Journal-sketchbook 1959-60, 19 March [1959], 56.

65 Katz, "Polychrome Polygonals," 20.

66 Carr, "Reminiscences," 4. See also Indiana's *Stele with Four Orbs*. Four has other ancient meanings – in the Renaissance, for example, the Neoplatonist Marsilio Ficino helped popularize the notion that all even numbers are female and odd numbers male; George L. Hersey, *Pythagorean Palaces: Magic and Architecture in the Renaissance* (Ithaca, N.Y.: Cornell University Press, 1976). In contrast to the notion that four is unlucky, Carl Jung, in *Man and His Symbols*, gives it the status of most perfect number. Also, four is Hermes' number (see Chapter 2).

67 D[onald] J[udd], "In the Galleries," *Arts Magazine*, September 1964, 61. In his Indiana review, Judd said he most liked the small flourescent *EAT Sign* that lit letter by letter and flashed on and off.

68 As in his 1966 four-box wall pieces of galvanized iron with top connecting strips of aluminum, painted blue or some other color. See for comparison John Coplans, *Donald Judd*

(Pasadena, Calif.: Pasadena Art Museum, 1967), plate 15.

69 Robert Morris used quadratic sections in works like his gray fiberglass *Untitled* of 1965, a quartered trapezoid, or his four mirror-sided boxes shown at the Green Gallery in 1965.

70 Mel Bochner, "The Serial Attitude," *Artforum*, December 1967, 28-33. John Coplans differed from Bochner's program only in details; *Serial Imagery* (Pasadena, Calif.: Pasadena Art Museum and New York: New York Graphic Society, 1968). See also Dore Ashton's "The 'Anti-Compositional Attitude' in Sculpture," *Studio International* 172 (July 1966): 44-47, in which Indiana's number and *LOVE* paintings, exhibited at the Stable gallery that season, were discussed broadly with minimalism (as was the work of some other artists like George Sugerman and Louise Nevelson). Indiana's paintings, Ashton wrote, "are experiments in equilibrium of shape, colour, drawing brought as closely together as possible"; Indiana, interview, Vinalhaven, 9 August 1996.

71 Robert Hobbs, *Robert Smithson: Sculpture* (Ithaca, N.Y.: Cornell University Press, 1981), 69; Robert W. McCoubrey, *Robert Indiana* (Philadelphia: Institute of Contemporary Art, University of Pennsylvania, 1968), 32.

72 Goodall, "Conversations with Robert Indiana," 40.

73 Robert Indiana and Robert Creeley, *Numbers* (Stuttgart: Edition Domberger; Düsseldorf: Galerie Schmela, 1968). Indiana also designed the calendar-modeled cover for Robert Creeley's *A Daybook* (New York: Scribner's, 1972).

74 Creeley's comments on Indiana were obtained in telephone interview, 31 July 1990, and letter to the author, 30 July 1990, in which the poet excerpted from a proposed nomination speech to the American Academy of Arts and Letters.

75 Walt Whitman, "As Adam Early in the Morning," quoted in Bloom, *Agon*, 185-86.

76 Gene R. Swenson, "Robert Indiana," *Art News* 64 (Summer 1964): 13.

77 Freud, "The 'Uncanny'" (1919), *SE* 17 (1955), 220, 245.

5
Sign, Screen, and Epitaph

1 Phyllis Tuchman, "Pop! Interviews with George Segal, Andy Warhol, Roy Lichtenstein, James Rosenquist, and Robert Indiana," *Art News* 73, no. 5 (May 1974): 29.

2 Michael Fried, "New York Letter," *Art International* 6, no. 9 (November 1962): 55.

3 Clement Greenberg, postcard to author, 2 October 1991.

4 Aldo Pellegrini, *New Tendencies in Art* (New York: Crown, 1966), 236.

5 Michael Newman, in "Rauschenberg Re-Evaluated," *Art Monthly* 47 (June 1981), 7-10, exemplifies the use of the hard-edge analogy and cites Mary Douglas, *Purity and Danger: An Analysis of Concepts of Pollution and Taboo* (New York: Praeger, 1966).

6 Arthur C. Carr, "Indiana – The Artist," typescript (Arthur C. Carr Papers, Rare Book and Manuscript Library, Butler Library, Columbia University, New York), 24.

7 Carr, "Indiana," 43.

8 Very occasionally, as with the designs for *The Mother of Us All*, Indiana makes a preliminary sketch or cut-paper mock-up. Indiana, interview, Vinalhaven, 5 May 1992. See also Carl J. Weinhardt, Jr., *Robert Indiana* (New York: Abrams, 1990), 174-81.

9 Indiana in Donald B. Goodall, "Conversations with Robert Indiana," *Robert Indiana* (Austin: University Art Museum, University of Texas at Austin, 1977), 27.

10 Indiana, telephone interview, 20 February 1992. Agnes Martin, during the early Coenties Slip period, also settled on a format "just off square" and may have provided an encouragement; see Whitney Museum of American Art Downtown Branch, *Nine Artists: Coenties Slip* (New York: Whitney Museum of American Art, 1974); and Lizzie Borden, "Agnes Martin: Early Work," *Artforum* 11, no. 8 (April 1973): 42-43.

11 Ernst Gombrich, *The Sense of Order: A Study in the Psychology of Decorative Art* (Ithaca, N.Y.: Cornell University Press, 1979), 155; see also 169-70.

12 Rudolph Arnheim, *The Power of the Center: A Study of Composition in the Visual Arts*, new version (Berkeley: University of California Press, 1988). Peter C. Dodwell, "Local and Global Factors in Figural Synthesis," and William C. Hoffman, "Figural Synthesis by Vectorfields: Geometric Neuropsychology," in *Figural Synthesis*, ed. Peter C. Dodwell and Terry Caelli (Hilldale, N.J.: Erlbaum, 1984), 219-82.

13 Arnheim, *The Power of the Center*, 36-37.

14 Indiana, quoted in Carr, "Indiana," 16. Recall that as a child Indiana attended Christian Science church. The church's founder, Mary Baker Eddy, in accordance with traditional beliefs in diverse cultures that circles are associated with eternity or eternal life, opposes the circle with the straight line, with which she symbolizes human life with beginning and end. See Eddy, *Science and Health with Key to the Scriptures* (Boston: First Church of Christ Scientist, 1971 [1875]), 282, lines 3-5; and Aniela Jaffé, "Symbolism in the Visual Arts," in Carl G. Jung et al, *Man and His Symbols*, ed. Carl G. Jung and M. L. von Franz (New York: Doubleday, 1964).

15 Donald Kuspit, "Concerning the Spiritual in Contemporary Art," in Los Angeles County Museum of Art, *The Spiritual in Art: Abstract Painting 1890-1985* (Los Angeles: AMA, 1985) 319-21. Both Jensen and Indiana did works about the Russian Yuri Gagarin, the first astronaut to orbit *(circle)* the earth: Jenson's *A Film Ringed the Earth* and Indiana's *Le Premier homme* (both 1961). Emily Wasserman surveyed the late 1960s trend of circular art in "Centering" *Arts Magazine* 47, no. 2 (November 1972): 44-46.

16 For Mondrian's diamond or lozenge-shaped canvases as implicit crosses, see Eric Saxon, "On Mondrian's Diamonds," *Artforum* 18, no. 4 (December 1979): 40-45. In Indiana's oeuvre, crosses are often embedded in square-format compositions, as well as in diamonds.

17 Indiana, interview, Vinalhaven, 5 May 1992; Norman Bryson, *Vision and Painting: The Logic of the Gaze* (New Haven: Yale University Press, 1983), 164.

18 Indiana, interview, Vinalhaven, 27 July 1990.

19 Gene Swenson, "Robert Indiana," *Art News* 63 (Summer 1964): 13.

0 *Minimal schema* is Bryson's term for the minimum requirements for recognition (Bryson, *Vision and Painting*, 58). For the three-month-old's facial recognition, see René Spitz, *The First Year of Life: A Psychoanalytic Study of Normal and Deviant Development of Object Relations* (New York: International Universities Press, 1965), discussed in Norman Holland, *The I* (New Haven: Yale University Press, 1985), 132. See also R. L. Gregory, *Eye and Brain: The Psychology of Seeing*, 2d ed. (New York: McGraw Hill, 1973), 200-201. William T. Powers has focused his research on minimal configurations and how they are recognized; see his *Behavior: The Control of Perception* (Chicago: Aldine, 1973); and Holland, *The I*, 130-33, 181. For Heinz Kohut's position, see *Self Psychology and the Humanities: Reflections on a New Psychoanalytic Approach*, ed. Charles B. Strozier (New York: Norton, 1985), 115. For relevant passages in Lacan, see "The Topic of the Imaginary," in *The Seminar of Jacques Lacan*, Book 1, *Freud's Papers on Technique, 1953-54*, ed. Jacques-Alain Miller, trans. John Forrester (New York: Norton, 1991); also, "The Mirror Stage as Formative of the Function of the I as Revealed in Psychoanalytic Experience," in *Écrits: A Selection*, trans. Alan Sheridan (New York: Norton, 1977).

1 André Grabar, "The Portrait," in *Christian Iconography: A Study of Its Origins* (Princeton: Princeton University Press, 1968), 60-86; and Bryson, *Vision and Painting*, 96. A good example is the style of circular-enframed portraits called *imagines clipeatae*, or "shield images," of Late Roman and Early Christian periods.

2 Bryson, *Vision and Painting*, 98.

3 Edwyn Bevan, *Holy Images: An Inquiry into Idolatry and Image-Worship in Ancient Paganism and in Christianity* (London: Allen and Unwin, 1940, rpt. 1979), 174. This is the opposite of what David Freedberg describes as the attraction of religious images that seem to gaze at us, like Hans Sebald Beham's *Head of Christ Crowned with Thorns*, the source of which Freedberg contends is its apparent realism. See Freedberg, *The Power of Images: Studies in the History and Theory of Response* (Chicago: University of Chicago Press, 1989), 220.

24 Gilles Deleuze and Félix Guattari, *A Thousand Plateaus: Capitalism and Schizophrenia* (Minneapolis: University of Minnesota Press, 1987), 167-91.

25 This was true until recently, when Indiana allowed many of the key works discussed here to travel to Nice, France, for his 1998 retrospective. The charmlike quality of the portrait for Leonardo is suggested in Camille Paglia, *Sexual Personae: Art and Decadence from Nefertiti to Emily Dickenson* (New Haven: Yale University Press, 1990), 49. With Indiana's work, as with the *Mona Lisa*, some viewers and critics (like Swenson, for Indiana) seem to respond to the fixating quality of the work; others are less sensitive to it.

26 Lawrence Alloway, "Notes on Five New York Painters," *Buffalo Fine Arts Academy and Albright-Knox Art Gallery, Gallery Notes* 24, no. 2 (Autumn 1963): 16. Alloway waffles somewhat about the implications of his own words.

27 While the express use and potency of such signs in America is in doubt, they retain their appeal in eastern Europe. See Thomas Edmund Graves, "The Pennsylvania German Hex Sign: A Study in Folk Process", Ph.D. diss., University of Pennsylvania, 1984.

28 Freedberg, *Power of Images*, 130-32.

29 Géza Róheim, *Spiegelzauber* (Leipzig: Internationaler Psychoanalytischer Verlag, 1919).

30 Harold Bloom, *A Map of Misreading* (New York: Oxford University Press), 70-75.

31 Bloom, *Map of Misreading*, 70.

32 Iconic and hypoiconic representation, as in Charles Sanders Peirce, "The Icon, Index, and Symbol," *Collected Papers of Charles Sanders Peirce*, ed. Charles Hartshorne and Paul Weiss, vol. 2 (Cambridge: Harvard University Press, 1932), 156-60. Indiana's practice of writing down his narratives seems to have begun with the very extensive taped interview with Richard Brown Baker: "Taped Interview with Robert Indiana (September-November 1963)," transcript (Robert Indiana Collection, Archives of American Art, Smithsonian Institution, Washington, D.C.).

33 Information on *Red Sails* obtained from Indiana, telephone interview, 20 February 1992. But see also Baker interview as in note 32.

34 Arthur C. Carr, "The Reminiscences of Robert Indiana" (Oral History Research Office, Columbia University), 137; and Indiana, interview, Vinalhaven, 30 August 1989.

35 The convention recurs in the history of art, as with Delacroix's *Liberty Leading the People*; for a discussion of it, see Camille Paglia, *Sexual Personae*, 77-78. The single bare breast specifically occurs in Indiana's etching *Mother of Exiles* (1986, published by the Vinalhaven Press), where it is an editing of the garb of the Statue of Liberty. The connection between his depiction of Liberty and the convention for Amazons was made by the artist in interview, Vinalhaven, 6 July 1986.

36 The term first appears in Freud's "The Dynamics of Transference" (1912), in which he calls it a "stereotype" and credits the term to Carl Jung, who drew it from Carl Spitteler's novel *The Imago*, about a man with real and imaginary lovers, both sharing the same face; see James Strachey, trans., *The Standard Edition of the Complete Psychological Works of Sigmund Freud*, 12 (London: Hogarth, 1960), 100. In "The Economic Problem of Masochism" (1936) Freud describes the phenomenon: "The course of childhood development leads to an ever-increasing detachment from parents, and their personal significance for the super-ego recedes into the background. To the imagos [*sic*] they leave behind there are then linked the influences of teachers and authorities, self-chosen models and publicly recognized heroes, whose figures need no longer be introjected by an ego which has become more resistant. The last figure in the series that began with the parents is the dark power of Destiny which only the fewest of us are able to look upon as impersonal" (*SE* 6 [1961], 168). *The Psychiatric Dictionary*, 7th ed. (New York: Oxford University Press, 1966), 351, defines *Imago* as an "image or likeness of someone constructed in the unconscious and remaining therein. The commonest imagos are those of the parents and those who stand for the parents." In classical Rome the Latin word meant a wax portrait mask placed on a corpse displayed in the forum.

37 Gene Swenson, "Robert Indiana," 13.

38 Lacan, "The Eye and the Gaze," *The Four Fundamental Concepts of Psycho-Analysis*, ed. Jacques-Alain Miller, trans., Alan Sheridan (London: Norton, 1981), 69-70.

39 Some information was drawn from William Katz, "A Mother Is a Mother," *Arts Magazine* 41, no. 3 (December 1966-January 1967): 46-48. Thomson and Stein collaborated on "The Mother of Us All" in 1945-46. See also Anson B. Cutts, "Minneapolis," *Opera News* (March 1967): 32-33; Joan Downs, "An American Momma," *Time*, 23 August 1976, 37; Martin Dulman, "Independent Spirit," *Opera News* (July 1976): 16-18; Shirley Fleming, "Music Notes: Thomson's Opera, Indiana's Painting at Santa Fe," *New York Times*, 18 July 1976; and William Peterson, "Robert Indiana," *Artspace* (Fall 1976): 4-9. Indiana did a second version of the same designs for the Santa Fe Opera Company's production of the work in 1976. The designs for the two productions were similar, though much more extensive for Santa Fe. Another heroine in the opera is named Indiana Eliot. Indiana also did a design for the figure of "Gertrude S." In his designs, all of Stein's characters wear words: their proper names, spelled out on shoulder-to-waist sashes.

40 It was done in time to be exhibited in a theme show, "Homage to Marilyn Monroe," devoted to the movie star at Sidney Janis Gallery in 1967; see Dore Ashton, "New York," *Studio International* 175 (February 1968): 92-94.

41 *Parrot* was exhibited in a theme show devoted to these birds (perhaps another rationale for the painting's existence), "Pollymorphous Images" at the Cordier Ekstrom Gallery in 1968. Ashton, "New York," 94.

42 As in Wendy Steadman Sheard, "Giorgione's Portrait Inventions c. 1500: Transfixing the Viewer," in *Reconsidering the Renaissance*, ed. Mario A. Di Cesare, Medieval and Early Renaissance Study 93 (Binghamton: Center for Medieval and Early Renaissance Studies, 1992), 141-76, especially p. 168 and n. 66. Sheard argues that befo[re] Giorgione, "'the look out of the picture' . . . alluded to a look from beyond the grave" – tha[t] is, it was a convention for funerary portraiture. This also has application to Indiana's "binocula[r] portrait schematic as a memento mori.

43 Artist's explanation obtained in telephone inte[r]view, 13 April 1992. The fixed or focused stare (during which patients became "oblivious of their surroundings"), as characterizing the loo[k] into mirrors of patients with narcissistic disorders, is discussed in Paula Elkisch, "The Psych[o]logical Significance of the Mirror," *Journal of the American Psychoanalytic Association* 5 (195[7]: 235-44. Further, spectrophobia, the hysterical fear of catching sight of oneself in a mirror, wa[s] thought by Ferenczi to be a problem of identit[y]; see Sándor Ferenczi, *Further Contributions to the Theory and Practice of Psychoanalysis*, trans. Jane Suttie et al. (London: Hogarth, 1951). Otto Fenichel points out that libidinal looking takes the form of the fixed gaze and is connected with identification; see Fenichel, "The Scoptophilic Instinct and Identification" (1935), in *The Collected Papers of Otto Feniche[l]* 1st series (New York: Norton, 1953), 379.

44 The eat/die trauma may even extend to the artist's predecessor and sibling, Carmen's first child, who died not eating but coughing. See Carr, "Indiana," 5, 10-11; and Carr, "Reminiscences," 50, 112-13.

45 John K. Sherman, "Metal Sculpture, 'Pop' Art Compete," *Minneapolis Sunday Tribune*, 27 October 1963.

46 Indiana reported that, long after this diptych was painted, no collector expressed interest in owning it: ("it would take courage" he has said[)

although this statement is hard to evaluate because the artist himself clearly does not wish to part with it. It is interesting that in 1990 Indiana made a version of the diptych as a pair of serigraphs. It was on the occasion of a dinner that his friend, William Katz, gave in the artist's honor at the restaurant, Chanterelle, in New York, and the red *EAT* bore a hand-written menu on the back. The black *DIE* was not employed.

Carr, "Reminiscences," 141-145.

Freud, *SE* 14, 249. On the visual substituting for the verbal, see also Ellen Handler Spitz, *Museums of the Mind: Magritte's Labyrinth and Other Essays in the Arts* (New Haven: Yale University Press, 1994), 48.

Bloom, *Map of Misreading*, 91.

Carr, "Reminiscences," 121-22.

Rosalind Krauss, "Boston Letter," *Art International* 8, no. 1 (February 1964), 32.

Indiana, quoted in Carr, "Indiana," 11-12. Mushroom eating can also be a phallic and sexual image.

Philip Johnson, "Young Artists at the Fair and at Lincoln Center," *Art in America* 52, no. 4 (August 1964): 112. While Indiana's work was too "real," Warhol's, mounted on the same building, was too fraudulent: his *Ten Most Wanted Men* had to be painted out.

Bloom, *Agon*, 93; Lacan, "From Interpretation to Transference," *Four Fundamental Concepts*, 247.

This is almost also a sequence of American bomber designations in the Second World War: B-41 (not 40); B-37; B-29; and B-66. Clearly, Indiana had ample opportunity to observe military aircraft and insignia during Army Air Corps days. See Indiana's answers to the MoMA ques-

tionnaire and his reference to the "raiment of the American soldier," Chapter 3.

56 Gertrude Stein, "Eating," *Tender Buttons*, in *Selected Writings of Gertrude Stein*, ed. Carl Van Vechten (New York: Random House, 1990), 494. See also E. E. Cummings's use of such phrases – for example, the repetitive line "Sun, moon, stars, rain" in his poem 29 ("any-one lived in a pretty how town"), *50 Poems* (New York: Duell, Sloan, and Pearce, 1940). We recall that Indiana met Cummings in 1955.

57 Indiana in Goodall, "Conversations with Robert Indiana," 33, 40; Indiana, interview, Vinalhaven, 9 August 1996. Indiana has since completed *The Seventh American Dream* (1998), a 204 x 204-inch diamond assembled from four smaller panels. On blue fields, each panel contains a red 7 on a cerulean heptagon superimposed on an orange field within a red-white-and-blue mandala. They are inscribed (in part) "Grace," "Isadora," "Josephine," "Indiana" – including himself in the company of three American women (Grace Kelly, Isadora Duncan, and Josephine Baker) who came to live and die in Europe. The painting is strongly related to Indiana's polygon paintings, and his association in the seventh dream with great (but misunderstood) American women is adjunct to the closely knit themes of the other dreams. Thirty-two years elapsed between *USA 666* and the seventh dream.

58 The element of repetition and perhaps also the threat of death sometimes associated with eating mushrooms are further factors in the 1963-64 film *Eat*, Warhol's portrait of Indiana. See Donna Gustafson, "Food and Death: *Vanitas* in Pop Art," *Arts Magazine* 60, no. 6 (February 1986): 90-93.

59 Gene Swenson, "The Horizons of Robert Indiana," *Art News* (May 1966): 62.

60 "Highway Culture: Man at the Wheel" was the title of an article by Lawrence Alloway that featured Robert Indiana's *USA 666* along with works by Allan D'Arcangelo, Tom Wesselmann, and others; see *Arts Magazine* 41, no. 4 (February 1967): 28-33.

61 William Wordsworth, *The Prose Works of William Wordsworth*, ed. W. J. B. Owen and Jane Worthington Smyser (Oxford: Clarendon, 1974), 2: 53; the idea (like many in the *Essays*) is taken from John Weever's discourse on funeral monuments in his *Ancient Funerall Monuments within the United Monarchie of Great Britaine, Ireland, and the Islands adjacent . . .* (London: 1631).

62 Comment on Demuth Five paintings in Weinhardt, *Robert Indiana*, 108; Carr's comments are in "Indiana," 12-13; the end of Longfellow's introduction, just before the first section from which Indiana took his lines, reads:

Ye, who sometimes, in your rambles
Through the green lanes of the country,
· · · · · · · · · · ·
Pause by some neglected graveyard,
For a while to muse, and ponder
On a half-effaced inscription,
· · · · · · · · · · ·
Of the Here and the Hereafter; –
Stay and read this rude inscription,
Read this Song of Hiawatha!

See Henry Wadsworth Longfellow, *Poems of Henry Wadsworth Longfellow* (Secaucus, N.J.: Castle, n.d.), 168.

63 The theory that psychoanalytic technique could be used on normal groups or populations to explore social behavior was developed by

Herbert Hendin and applied by Hendin and Willard Gaylin in interviews with a population of student nurses. See Hendin, Gaylin, and Carr, *Psychoanalysis and Social Research: The Study of the Non-Patient* (Garden City, N.Y.: Doubleday, 1965). The interviews between Carr and Indiana took place in November 1965, and the transcripts have been cited as "Reminiscences." Carr's summarizing narrative has also been cited ("Indiana"). Carr's comments in this paragraph are found in that document, p. 15. For symbols as screen memories, see Sigmund Freud, "Childhood and Screen Memories," *The Psychopathology of Everyday Life* (1901), *SE* 6 (1960): 43-52; and Otto Fenichel, "The Economic Function of Screen Memories," *The Collected Papers of Otto Fenichel*, 1st ser. (New York: Norton, 1953), 113-16. Fenichel points out that screen memories function both to mask a traumatic childhood experience and to keep it perpetually present (in innocent, symbolized form) later on.

64 Indiana on the Trimble mansion: "I can remember my father taking me into this room where this man was lying, and it was particularly conspicuous because over the coffin was a large sculptured relief," quoted in Carr, "Indiana," 14. See Carr's notation about Indiana's substituting the word *coffin* for Coffman in telling about his first grade teacher, Chapter 1. On childhood interest in the "architecture of death," see Carr, "Reminiscences," 18. The artist said that for a brief period as a child he wanted to be an undertaker. The information about Thanatopsis was provided by Indiana, notes to chapter, 2 Sept. 1992.

65 Carr, "Indiana," 13; Indiana, interview, Vinalhaven, 27 July 1990.

66 The Calumet in the dream inspired Carr to make the vaginal connection. Carr, "Indiana," 26-42.

67 Indiana, quoted in Carr, "Indiana," 26-31, 35-42. Ironically, this dream was reported only weeks before Indiana learned of his father's death.

68 Indiana, quoted in Carr, "Indiana," 31-35. Carr interpreted this dream also to refer to the artist's own death.

69 Carr, "Indiana," 27.

70 Lacan, "Eye and the Gaze," *Four Fundamental Principles*, 75-76.

71 Lacan, "What Is a Picture," and "Line and Light," *Four Fundamental Principles*, 96 and 108.

72 Rosalind Krauss, *The Optical Unconscious* (Cambridge: MIT Press, 1993), 184.

73 I cite from Bloom, *Agon*, 125-26; he seems to be condensing from several places in Lacan, especially from "The Deconstruction of the Drive" and "The Partial Drive and Its Circuit," in *Four Fundamental Principles*, 161-86.

74 Wendy Steiner, "The Semiotics of a Genre: Portraiture in Literature and Painting," *Semiotica* 21.1-2 (1977): 117; Jean Paul Eakin, *Fictions in Autobiography: Studies in the Art of Self-Invention* (Princeton: Princeton University Press, 1985), 277; Vladimir Nabokov, *Speak, Memory: An Autobiography Revisited*, rev. ed. (New York: Putman, 1966), 309-10.

6
LOVE

1 In the late 1980s Indiana painted the imaged word on one side of a chunk of the Berlin Wall, and the word *WALL* on the other. Indiana was the only American artist invited by Cal Worthington, a former diplomatic analyst in Berlin, to paint one of the segments of the Wall that Worthington brought out of Berlin; the other 113 artists are all Russian. The painted fragments were shown at the United States Art Expo in New York City in 1991. See Paul Elmowsky, "The Plaza, the Artist, and the Wall: The Forbe Report," *Sunstorm Arts Magazine*, October 1991, 13.

2 Lucy Lippard's comment is from *Pop Art* (New York: Praeger, 1966), 122. Many other, similar comments could be cited, as, most recently, Simon Morley's "Robert Indiana in Perspective," *Art Line International Art News* (Winter 1991-9 10. Indiana, interview, Vinalhaven, 5 May 1992.

3 It is not my intention to psychoanalyze the artist, only to find patterns in the work that co respond with his verbal discourse about them, and to explore the mutual illumination of wor and image. It may be noted here, however, tha re-creating a troubled childhood as happy, as "feeling loved," is found by Alice Miller to be characteristic of creative ("gifted") individuals See Miller, "The Drama of the Gifted Child," *Prisoners of Childhood*, trans. Ruth Ward (New York: Basic, 1981), 3-29.

4 Indiana, quoted in Barbaralee Diamonstein, "Robert Indiana," *Inside New York's Art Worla* (New York: Rizzoli, 1979), 151. This story is fre quently repeated by the artist, including to me in interview, Vinalhaven, 12 January 1991. Ind ana recounts that Earl Clark never attended th church and that Carmen, who identified herse as a Christian Scientist, rarely went – but they enrolled him in Sunday school classes when h was about age seven.

5 Robert Indiana, *Trilove* (New York: Bouwerie Editions, 1969).

6 Indiana, interview, Vinalhaven, 13 January 19 On Pike, see William Stringfellow and Anthon Towne, *The Death and Life of Bishop Pike* (Ga

den City, N.Y.: Doubleday 1976), 295-315. Besides Earl Clark, Pike may have been another divorced personality on Indiana's mind in 1961 when he painted *The President*. This reading would link father and dean as paternal personas or imagoes. The artist also has referred to Pike as "an extremely interesting man – thoughtful, kind, and intelligent" (Indiana, interview, Vinalhaven, 15 June 1992).

7 See James A. Pike, *Beyond Anxiety: The Christian Answer to Fear, Guilt, Inhibition, Frustration, Indecision, Loneliness, Despair* (New York: Scribner's, 1953), 99, 100-103. Indiana especially recalls reading another small book on love published by the cathedral, one that, unfortunately, is no longer in print and that has not been located by the cathedral's archivist. For meanings of *agape* see the *Oxford English Dictionary*, 1989 ed. Reinhold Niebuhr, a colleague of Pike's, points out, "The *agape* form of love in the New Testament fails to be appreciated particularly in . . . the notion of sacrificial love"; Reinhold Niebuhr, *Christian Realism and Political Problems* (New York: Scribner's, 1953), 139-40. Pike himself, some years earlier, when he was dean of divinity at Columbia University, had appointed Neibuhr to Columbia's faculty.

8 Aldrich had given the museum a fund for new acquisitions and had asked to see every work purchased with this fund. *Love Is God* was one such purchase. Larry Aldrich, interview, Ridgefield, Connecticut, 26 November 1990. The lieutenants' names were King and Dole. Information from brochure, *The Aldrich Museum of Contemporary Art* (Ridgefield, Conn.: Aldrich Museum, n.d.). The phrase "God is love" appears in several places in the Bible, but perhaps best known is 1 John 4:8. In her writings Eddy capitalizes Love as a synonym for God.

9 The segments of shades of gray also appear around the pentagon in the central mandala of *The Figure 5*. The artist recalls that at the time of *Love Is God* he was working on the *Brooklyn Bridge* and *Mother* and *Father*, paintings that also required an exhaustive range of grays, a fact that influenced the color decisions of the one commissioned by Aldrich. The report again connects Earl and Carmen with the imaged word *LOVE*.

10 Indiana, interview, Vinalhaven, 28 August 1989. The most recent recounting of this incident, by a writer who checked with both Indiana and Kelly, is in Paul Taylor, "*LOVE* Story," *Connoisseur* (August 1991): 95.

11 See W. J. Rorabaugh, *Berkeley at War: The 1960s* (New York: Oxford University Press, 1989), 38 ff, 187-89. According to Rorabaugh, the students by this time were incensed by any incidents of verbal hypocrisy. In March a student named John Thomson sat down on the steps of the Student Union with the word *fuck* pinned to his chest. When Thomson was arrested by university police for public obscenity, fellow students protested that another student, as part of a fraternity prank, had recently paraded freely on campus as "Miss Pussy Galore" and had not been reprimanded. See also Lawrence E. Davies, "Kerr's Resignation of Berkeley Is Laid to Conflicts with Regents," *New York Times*, 11 March 1965. Another person in circles close to Indiana, seeking to legitimize "foul" language as honest expression, was Ed Sanders, member of the rock group the Fugs and editor of an underground paper *Fuck You* from 1962 to 1964. Of course, much beat poetry from the fifties used raw language and expletives. An obvious example of usage change was that the word *Negro*, was superseded by *black* in this period; proponents of that exchange hoped to commemorate and simultaneously reverse the nineteenth-cen-

tury use of *black* as a pejorative term by whites. On the autonomy claimed by youth cults' generalizing neologisms, see Clifford Adelman, *Generations: A Collage on Youthcult* (New York: Praeger, 1972), chapter 4.

12 Indiana, work records, Star of Hope, Vinalhaven. Rosalind Krauss, "Boston Letter," *Art International* 8, no. 9 (November 1964): 42.

13 In 1972 Indiana said the 1964 *LOVE* was "a return, after several years of fascination with the circle (symbolic . . . of the eternal) as the dominating form in my work, to the quartered canvas." In *Robert Indiana* (New York: Galerie Denise René, 1972). Lettering and typeface handbooks have long noted the expressive potential of the different styles. See the discussion of typefaces in American advertising in Marc Treib, "Eye Konism (Part Three): The Word as Image," *Print* 27 (July-August 1973): 51, 75. Indiana's version of Roman letter style was of course inspired by the found stencils.

14 Indiana, telephone interview, 15 June 1992. "Cat's eye" and "phallus" are reported in Taylor, "*LOVE* Story," 49, 95. For a discussion of printed text as speech act, see Sandy Petry, *Speech Acts and Literary Theory* (New York: Routledge, 1990).

15 Diamonstein, *Inside New York's Art World*, 153. The series of prototypes were not available to research, but the artist reports that the cards were executed in a variety of color combinations (Indiana, telephone interview, 15 June 1992). He says it was a gift to benefit the Junior Council, and thus the museum, which owned his *Moon* and *American Dream #1*. Indiana has often reported on the popularity of the card, as in his interview with Diamonstein; and interview, Vinalhaven, 13 January 1990. MoMA reissued the 1964-65 card in 1993.

16 Events confirmed by the artist's journal. Note that the artist had not seen his father since the late fifties in California. When he died, Earl Clark lived in Florida. On Trimble funeral see Arthur C. Carr, "The Reminiscences of Robert Indiana," Oral History Research Office, Columbia University, 60. For Indiana on Earl and Phillips 66, see Donald Goodall, "Conversations with Robert Indiana," in *Robert Indiana* (Austin: University Art Museum, University of Texas at Austin, 1977), 40.

17 Jacques Lacan, *Le Séminaire, livre XI*, quoted in Shoshana Felman, *Jacques Lacan and the Adventure of Insight* (Cambridge: Harvard University Press, 1987), 62.

18 Dore Ashton "The 'Anti-Compositional Attitude' in Sculpture: New York Commentary," *Studio International* 172 (July 1966): 44-47; and Mel Bochner, "Primary Structures," *Arts Magazine* (June 1966): 32-35 are just two of many reviews that commented on the general trend. For the Dwan exhibition, see A[my] G[oldin], "Arakawa," *Arts Magazine* (March 1966): 67.

19 Indiana, personal interview, 13 January 1991; Grace Glueck, "Eleanor Ward Is Dead at 72; Dealer for New U.S. Artists," *New York Times*, 7 January 1984.

20 Indiana did three *LOVE* Walls, two in 1966 and one in 1969. It is possible that they reflect some lingering recollection of Peter Blake's *The Love Wall* (collage, 1961), which was shown along with Indiana's own work in the 1962 "New Realists" show at Sidney Janis. (Like Indiana works of the same period, Blake's also included numbers and beware-danger stripes in that work.) Compositionally and formally, however, the "love walls" of the two artists are enormously different. On Earl Clark's mathematics, see Donald Goodall, "Conversations with Robert Indiana," 31.

21 Ashton, "'Anti-Compositional Attitude,'" 46.

22 Lucy R. Lippard, "New York Letter," *Art International* 10, no. 6 (Summer 1966): 115.

23 Robert Indiana, work records, Star of Hope, Vinalhaven. Quotation is from William Katz, interview, New York, 12 February 1990. The five-color example is not listed in Indiana's work records. The increased production could not be solely because he was preparing for a show in 1966, for his production of paintings for the year of his previous one-man exhibition was much smaller (number of paintings recorded in 1963, eighteen; 1964, twenty; 1966, thirty-two; 1967, seven; 1968, twelve; 1969-70, fifteen). The decline after 1966 came when Indiana was working on ten-panel *Autoportraits*, which counted as single works, and the twelve-foot *LOVE* sculpture.

24 Current legislation is referred to as the Copyright Law (Title 17, United States Code); see also chapter 9, "Works Created Before 1978," in William S. Strong, *The Copyright Book: A Practical Guide*, 2d ed. (Cambridge: MIT Press, 1989).

25 Indiana, note to author, 2 September 1992; Richard Brown Baker, "Taped Interview with Robert Indiana (September-November 1963)," transcript (Robert Indiana Collection, Archives of American Art, Smithsonian Institution, Washington, D.C.), 31. Mondrian's style was employed in the "Go-Go" look of Yves Saint Laurent (fall 1965), and Riley's in dresses marketed by none other than Aldrich himself. Susan Rubin Sulieman, *Subversive Intent: Gender, Politics, and the Avant-Garde* (Cambridge: Harvard University Press, 1990), 198-99; and her sources, Max Horkheimer and Theodor W. Adorno, "The Culture Industry: Enlightenment as Mass Deception," *Dialectic of Enlightenment*, trans. John Cumming (New York: Continuum, 1982); and Thomas Crow, "Modernism and Mass Culture in the Visual Arts," *Modern Art in the Common Culture* (New Haven: Yale University Press, 1996). Crow states that the cycle begins with material that the artists glean from subcultural groups, which is first recycled as high art.

26 William Katz, interview, New York, 12 February 1990; Indiana, interview, Vinalhaven, 13 January 1991. Walter Benjamin, "The Work of Art in the Age of Mechanical Reproduction" and "On Some Motifs in Baudelaire," in *Illuminations*, ed. Hannah Arendt, trans. Harry Zohn (New York: Harcourt, Brace, and World, 1958); Harold Bloom, *Agon: Towards a Theory of Revisionism* (New York: Oxford University Press, 1982), 230.

27 Each was hand-cut and polished to a mirror finish by Tritell Gratz of Hunters Point, New York, under supervision of Herbert Feuerlicht (Robert Indiana, work records, Star of Hope, Vinalhaven). On Goodman, see Constance W. Glenn, *The Great American Pop Art Store: Multiples of the Sixties* (Long Beach: University Art Museum, California State University; Santa Monica, Calif.: Smart Art, 1997).

28 Indiana, interview, 13 January 1991; telephone interview, 15 June 1992. The patent suggestion emerged in further discussion with Goodman and her lawyer.

29 "Highs & Lows of Hippiedom," *Time*, 7 July 1967, 18-19. The caption reads: "At 'love-ins,' such as this one at Lantana, Fla., college kids wear exotic garb and decorate themselves to look like the moving, multihued objects that fill the visions of psychedelia." See Todd Gitlin, *The Sixties: Years of Hope, Days of Rage* (New York:

Bantam, 1987), chapter 8. The Elysian Park event took place on 27 March, 1967; "Love-In," *Oxford English Dictionary*, 1989 ed.; Language Research Service, Merriam-Webster, Inc., letter to the author, 25 October 1990. It was only among the earliest spin-offs from the massive "Human Be-In," also known as "A Gathering of Tribes," in San Francisco's Golden Gate Park two months before (January 1967), at which "love" rhetoric abounded (Gitlin, *The Sixties*, 208-9).

Todd Gitlin, *The Whole World Is Watching: Mass Media in the Making and Unmaking of the New Left* (Berkeley: University of California Press, 1980); and Andrew Ross, *No Respect: Intellectuals and Popular Culture* (New York: Routledge, 1989), 143-44. For Gernreich's dress, see *Newsweek*, 25 April 1966, 57.

See also Ross, chapter 5: "Uses of Camp," in *No Respect*; and Susan Sontag's "Notes on 'Camp'" (1964) in *Against Interpretation* (New York: Dell, 1966). The theatrical context for camp in the fifties was pointed out to me by George Hersey.

Ross, *No Respect*, 146-47. On the gay component, I was influenced by Jonathan Katz's talk "Culture and Subculture: On the Social Utility of Queer Artists in Cold War American Art," at the College Art Association Annual Meeting, Washington, D.C., February 1992. Michel Foucault, "What Is an Author?" *The Foucault Reader*, ed. Paul Rabinow (New York: Pantheon, 1984).

Philip Fisher, "Jasper Johns and Museum Art," in Fisher's *Making and Effacing Art: Modern American Art in a Culture of Museums* (New York: Oxford University Press, 1991). Whiting, chapter 1, "Shopping for Pop," in *A Taste for Pop: Pop Art, Gender, and Consumer Culture* (New York: Cambridge University Press, 1997).

34 Ross, *No Respect*, 166; Marco Livingston, "Do It Yourself: Notes on Warhol's Techniques," *Andy Warhol: A Retrospective* (New York: MoMA, 1989), 65.

35 Foucault, "What Is an Author?" 118; Ross, *No Respect*, 168; Warhol, *The Philosophy of Andy Warhol (From A to B and Back Again)* (New York: Harcourt, Brace, 1975), 77.

36 Indiana says that he learned this practice from Kelly; notes to a draft of this chapter, 2 September 1992. Warhol, trained as a commercial artist, sometimes signed on the back as well.

37 John de Menil to Robert Indiana, 26 June 1967, the Menil Collection, Houston. The pavilion was to have continued the idea of the Rothko Chapel, earlier commissioned by the Menils, in that it was conceived as a "church" filled with specifically commissioned contemporary art. But the projected pavilion never materialized, and the *LOVE Cross* joined the contemporary religious works in the Menil collection.

38 Jacques Derrida, "Limited Inc abc . . .," *Glyph 2* (1977): 167.

39 Jameson, "Periodizing the 60s," in *The Sixties Without Apology*, ed. Sohnya Sayres, Anders Stephenson, Stanley Aronowitz, and Fredric Jameson (Minneapolis: University of Minnesota Press in Cooperation with *Social Text*, 1984), 208; Gitlin, *The Sixties*, 203-6.

40 Slavoj Žižek, *Looking Awry: An Introduction to Jacques Lacan Via Popular Culture* (Cambridge: MIT Press, 1991), 9, 133; Indiana, interview, Vinalhaven, 13 January 1991.

41 *Self-plagiarism* is a term previously used by David Goldblatt in an article of that title in *The Journal of Aesthetics and Art Criticism* 43, no. 1 (Fall 1984): 71-77. Goldblatt analyses the term, however, via assumptions about creativity, origi-

nality, "aesthetic progress," and aesthetic value that are not relevant here, where Indiana's repetition of *LOVE* is viewed as a long-term process that can be compared to the writing of poetry. *LOVE* rings were issued in 1968 (Robert Indiana, work records, Star of Hope, Vinalhaven); Indiana, interview, Vinalhaven, 5 May 1992. See also "Love's Ring," *New York*, 17 February 1969. Information concerning the *LOVE* spin-offs and rip-offs was obtained from the artist in interview, Vinalhaven, 13 January 1991.

42 Indiana recalls being approached about the paperweights by a Mr. Gold of a small company in Conshohocken, Pennsylvania, but the artist rejected the idea as grossly acquisitive, and the product as too poorly made. This was the rip-off that opened the floodgates. Robert Indiana, interview, Vinalhaven, 13 January 1991.

43 On Segal's book see Elizabeth Long, *The American Dream and the Popular Novel* (Boston: Routledge, 1985), 118-37. On another level, *Love Story* is a sixties revision of the traditional town/gown novel. There is an often told story that Indiana's dealer in the early seventies, Denise René, approached Segal about making a museum purchase of a major Indiana *LOVE* because it would reciprocate the image's boost in selling his books. Segal's reply was that it worked the other way around, and purchased nothing (Indiana, interview, Vinalhaven, 13 January 1991). The same year the novel appeared, the film *Love Story*, starring Ryan O'Neal and Ali MacGraw and directed by Arthur Hiller, became an instant box-office blockbuster. The movie did not recycle the *LOVE*-based designs.

44 Gitlin, *The Sixties*, chapter 10; see also William L. O'Neill, *Coming Apart: An Informal History of America in the 1960s* (New York: Quadrangle, 1971), chapters 11, 12; Glenn, *Great American Pop Art Store*, 28. *SHIT* was a folding paper image and a poster. Robert Indiana, interviews, Vinalhaven, 13 January 1991, 15 June 1992; and Diamonstein, *Inside New York's Art World*, 154.

45 Robert Indiana, interview, Vinalhaven, 13 January 1991; William Katz, interview, New York, 12 February 1990.

46 The hologram was also shown at Finch College, New York, as part of the exhibition "N Dimensional Space," organized by Elayne Varian, which also included work by Lloyd Cross, E. N. Leith, George Ortman, and Bruce Nauman. Reviewer Douglas Davis called *LOVE* the most impressive piece in the show (*Newsweek*, 15 June 1970). The serigraph was commissioned by the Louisiana Museum of Contemporary Art in Humlebaek, Denmark, which also purchased Indiana's 1969 painting *Terre Haute #2*. A print exhibition, "Indiana Graphic," ended its European tour at this museum. John Canaday, "Aesop Revised, or the Luck of the Orthopterae," *New York Times*, 3 December 1972.

47 Richard Masheck, "Reviews," *Artforum* (February 1973): 80.

48 John Perreault, "Having a Word with the Painter," *Village Voice*, 7 December 1972, 34.

49 Vivien Raynor, "The Man Who Invented 'Love,'" *Art News* 72, no. 2 (February 1973): 59.

50 Indiana, interview, Vinalhaven, 13 January 1991; and Diamonstein, *Inside New York's Art World*, 165. The three unique works are a six-foot-square, red-blue-green *LOVE* painting (1966) and the twelve-foot *LOVE* sculpture (1970), both in the Indianapolis Museum of Art, and the *Great LOVE (LOVE Wall)* (1966) in the Carnegie Institute in Pittsburgh. Other works are in private collections, and others are in Europe – the 1968 *LOVE Rising (Black-and-White LOVE Wall)* in Neue Galerie-Ludwig Collection, Aachen, Germany. David Kunzle's comment is from "Pop Art as Consumerist Realism," *Studies in Visual Communication* (Spring 1984): 24. Indiana had other reasons to leave New York. He had never purchased his Spring Street loft building, and his landlord there decided to renovate. Indiana already owned the old Oddfellow's lodge on Vinalhaven Island, which offered the space he needed (Indiana, interview, Vinalhaven, 13 January 1991).

51 Perreault, "Having a Word with the Painter," 34.

52 On Steinberg see Harold Rosenberg, *Saul Steinberg* (New York: Knopf, 1978). Steinberg's monster-word cartoons were introduced in *The Inspector* (New York: Viking, 1965). Indiana says that he was aware of Steinberg's cartoons, but this three-dimensional letter quality was already associated in his own mind with the movable type pieces he used in Edinburgh (interview, Vinalhaven, 15 June 1992). On *The Oxbow*, see Matthew Baigell, *Thomas Cole* (New York: Watson-Guptill, 1981), 16. On the expanded field of sculpture see Rosalind Krauss, "Sculpture in the Expanded Field," *The Originality of the Avant-Garde and Other Modernist Myths* (Cambridge: MIT Press, 1985), 276-90.

53 Peter Plagens, "Robert Indiana," *Artforum* (October 1971): 90; Indiana, interview, Vinalhaven, 13 January 1991.

54 See George Gent, "5-Ton Sculpture Says It in a Word," *New York Times*, 30 November 1971. The whole event provided the centerpiece for John Huszar's film *Robert Indiana Portrait*, released in 1973. News clipping from *Indianapolis News*, n.d. [1971], in a scrapbook in Indiana's miscellaneous records, Star of Hope, Vinalhaven; "Indiana's Latest Love," *Art News* (January 1979): 8-9. Pike's body was found on 7 September 1963 (see Stringfellow and Towne, *Death and Life of Bishop Pike*, viii).

55 They also repeat the sizes of the some of the principle, original *LOVE* series: forty-eight inches and seventy-two inches square.

56 Diamonstein, *Inside New York's Art World*, 160.

57 Indiana, interview, Vinalhaven, 5 May 1992. The twenty-four-inch series is much simpler and the paintings include fewer whole words than those of the midsize set. The later and largest version of the *Decade: Autoportraits*, on the other hand, is even more formally complex than the midsize group. Its variations on the te forty-eight-inch compositions replace the central IND of each with monumental numbers denoting the consecutive years and "Indiana" spelled out in full around the bottom of the great mandala in each.

58 In 1965 *The Calumet* went on loan to the Whit House; in 1975 *Decade: Autoportrait (1965)* (1972-75) was exhibited at the Corcoran Bienni and reproduced as the catalog cover. The DIE in this painting refers, among other things, to his father's death. In this case, the Autoportrait is red, white, and, blue.

59 Harold Bloom, *A Map of Misreading* (New York Oxford University Press, 1975), 74.

As surrogate name, *LOVE* is much like Gertrude Stein's circular poem "Rose is a rose is a rose is a rose": a name that works like a metaphor, as *rose* was Stein's metaphor for love. In one painting by Demuth, the repeated word – *Love, Love, Love* – has prompted the contention that it is a poster portrait of Stein. Indiana wanted very much to buy that painting when it went on sale in the seventies.

1 Indiana, interview, Vinalhaven, 5 May 1992.

2 Bloom, *Map of Misreading*, 102-3.

3 For this and information following: Rudy Maxa (Washington Post Service), "That Love Stamp Is Still Stirring Up Waves," *Philadelphia Inquirer*, 25 March 1973. Details also obtained from Indiana, interview, Vinalhaven, 13 January 1991, and telephone interview, 15 June 1992. Indiana recalls that the idea was really promoted by one particular committee member who was a graphic designer himself and an enthusiast of Indiana's work.

4 Indiana, interview, Vinalhaven, September 1986; quotation from Jeff Goldberg, "Love," *The Unmuzzled Ox* 4, no. 2 (1976): 19. Borglum's best-known works are the heads of four presidents on Mount Rushmore; the French sculptor Bartholdi designed the Statue of Liberty.

5 Jameson, "Periodizing the 60s," 208.

6 Jacques Lacan, *The Séminaire of Jacques Lacan*, Book 1, *Freud's Papers on Technique 1953-54*, ed. Jacques-Alain Miller, trans. John Forrester (New York: Norton, 1991), 190-91.

7 Claude Lévi-Strauss, writing of bricolage in *The Savage Mind* (Chicago: University of Chicago Press, 1966), 21.

8 Joshua Decter, "General Idea," *Arts Magazine* 63, no. 1 (September 1988): 102.

69 The quotation from Stein is the opening line of "Rooms" in *Tender Buttons*, her multipart prose-poem originally published in 1914; see *The Selected Writings of Gertrude Stein*, ed. Carl Van Vechten (New York: Vintage, 1990), 498. Bloom on crisis poetry is from his discussion of the "Crossing of Solipsism," or "Death of Love," in *Agon*, 224-25.

70 *Agon*, 17.

Index